SPACE SHUTTLE

THE FIRST 20 YEARS

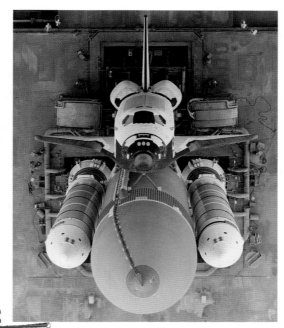

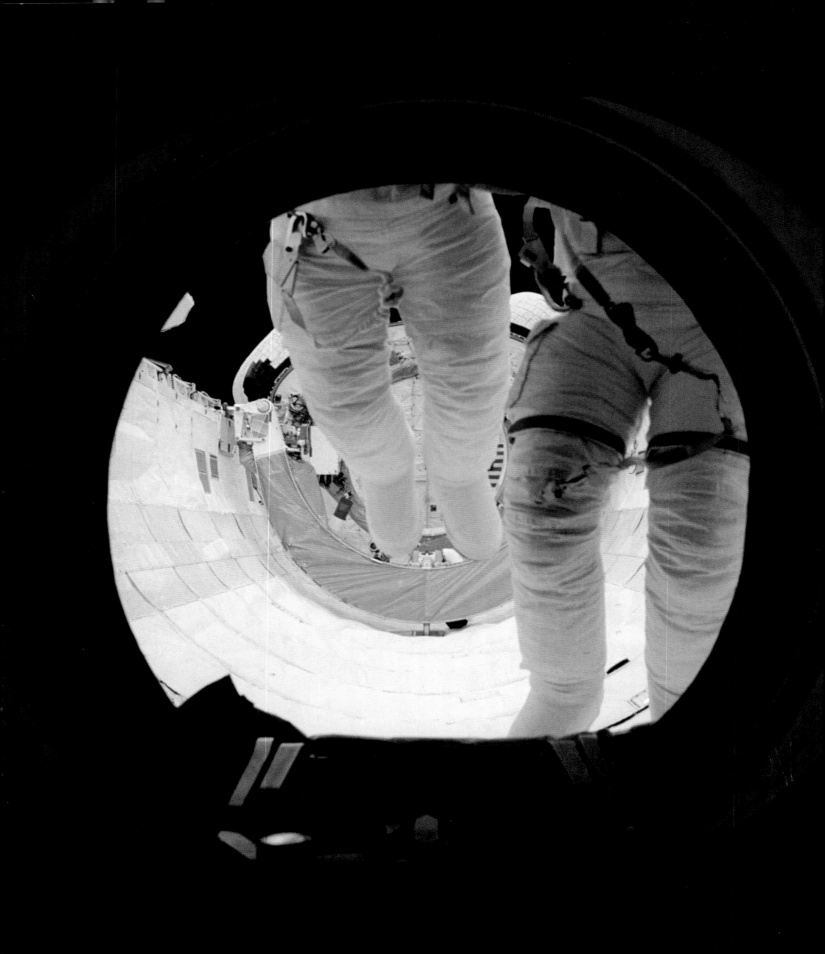

A spacewalk ends, STS-54.

SPACE SHUTTLE

THE FIRST 20 YEARS

EDITED BY
TONY REICHHARDT
FOR AIR&SPACE/SMITHSONIAN MAGAZINE

SMITHSONIAN INSTITUTION
WASHINGTON, D.C.

DK PUBLISHING, INC.
LONDON, NEW YORK, SYDNEY, DELHI, PARIS, MUNICH, and JOHANNESBURG

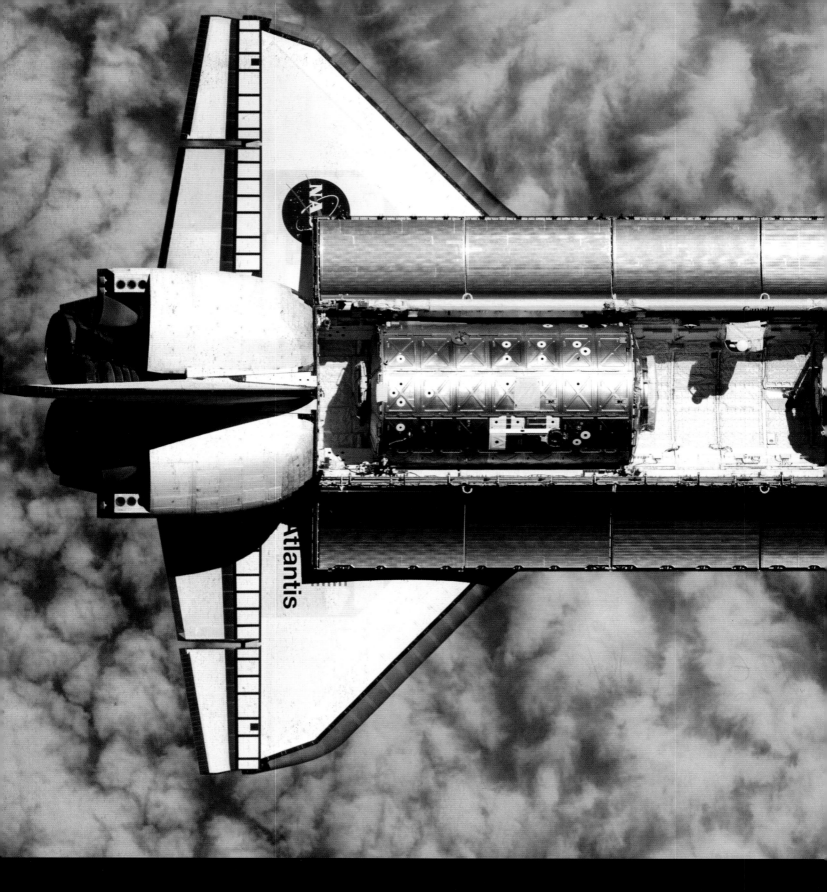

CONTENTS

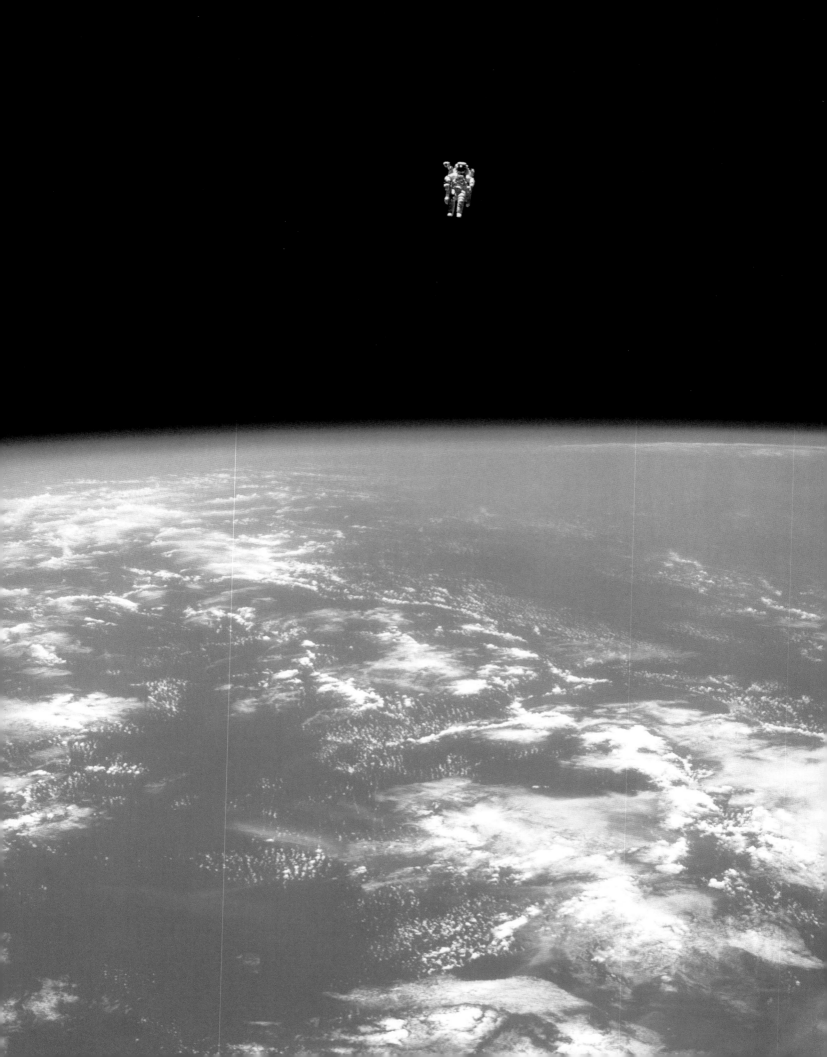

Twenty Years and Counting

Free-flying in space, Bruce McCandless tests the Manned Maneuvering Unit jetpack, STS-41B.

THE OTHER DAY I received from the Kennedy Space Center a commemorative postal cover honoring the STS-108 flight of space shuttle *Endeavour*. As I glanced at the mission insignia, the thought suddenly struck me—20 years have gone by since the first orbiter ventured into space. Over that time more than 100 shuttle flights have returned new knowledge about the universe and our home, the Earth. That's four times more missions than Mercury, Gemini, and Apollo put together.

Looking at the mission patch, something else leapt out at me. Three of the names on the insignia were Russian. The space shuttle has indeed become international, and instead of racing each other expensively to the moon as we did in my day, the two space superpowers have joined forces to take the next steps beyond Earth.

After my last Apollo flight in 1970 I was assigned to help with design studies for this new space vehicle, one of my last major jobs before leaving NASA in 1973. Back then it was still undetermined what final form the shuttle would take. Should it have straight or swept wings? What about ejection seats, since it had no escape rocket? And the booster—do we use solid rockets or a manned winged booster for a land recovery? Those early years saw many design tradeoffs, as engineers sought to create a vehicle that could routinely carry large payloads to orbit and back.

What we have today is a fully operational spacecraft with an impressive 20-year history of accomplishment. Over that time, the space shuttle and the gallant crews who fly it have written their own legend in the annals of the American space program.

James A. Lovell was selected as a NASA astronaut in 1962, and flew in space four times, on Gemini 7, Gemini 12, Apollo 8, and Apollo 13. As the command module pilot and navigator for Apollo 8, he made humanity's first voyage beyond Earth orbit.

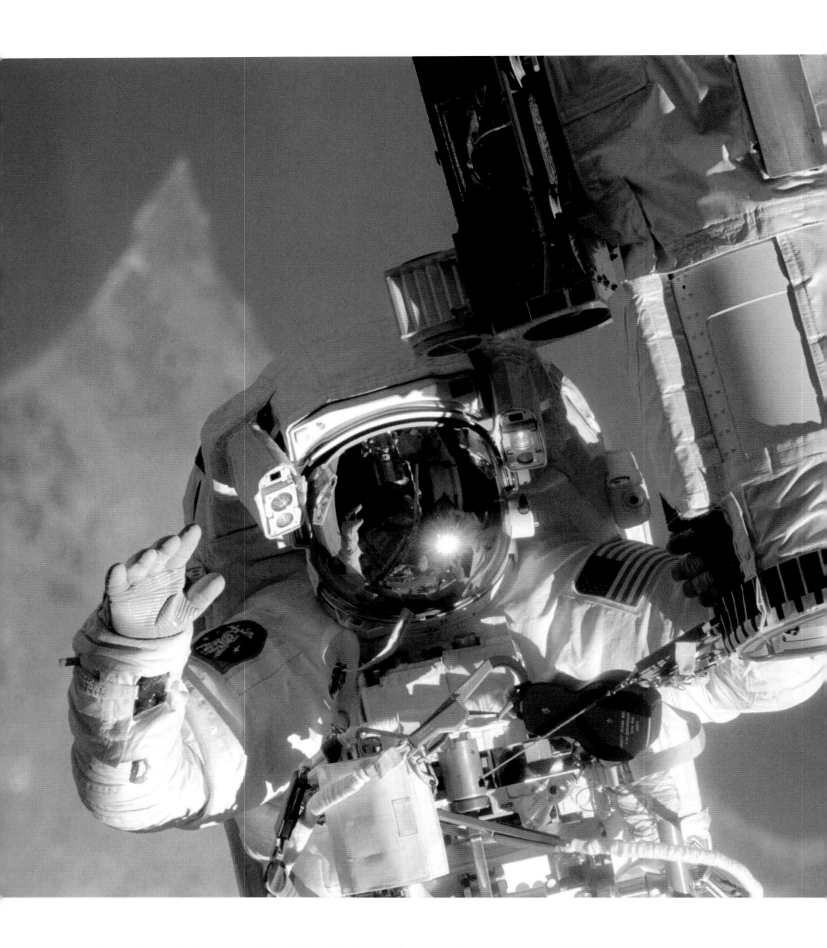

Spacewalking outside the International Space Station, Mike Gernhardt floats next to the shuttle's robot arm, STS-104.

How This Book Came About

THE ASTRONAUTS' STORIES in this book were collected over a period of about a year, beginning in summer 2000. In anticipation of the 20th anniversary of the first space shuttle flight in April 2001, the editors of *Air & Space/Smithsonian* wrote almost all of the more than 250 people who have flown on the shuttle since 1981 to ask for their reminiscences. (The 20 or so Russian cosmonauts who have flown on the shuttle are a glaring omission, which we hope some future book will redress.)

Nearly a third of the 250 responded—current astronauts as well as the many more who have left NASA since flying in space. Some wrote their stories, while others preferred to talk, with veteran space journalist Beth Dickey doing two-thirds of the interviews and editor Tony Reichhardt most of the rest. The subject matter was largely up to the astronauts—these are their experiences, as they remember them.

The editors then pulled excerpts from the interview transcripts, edited them for syntax and clarity, and in some cases condensed them. The astronauts reviewed the excerpts before publication, so that the final versions represent their stories, the way they want them told.

The photographs in the book are drawn mostly from NASA's archives at the Johnson Space Center in Houston. Many are being published here for the first time. Over the course of four trips to Houston, Jon Schneeberger, longtime photo editor for space at *National Geographic* magazine, systematically went through hundreds of thousands of frames of film shot by shuttle astronauts in orbit, looking for images that may have been overlooked.

Rather than a political or technical history of the shuttle era, then, this is an album of pictures and travelers' tales told by the people who have been to our farthest and most exotic frontier. Most books about the shuttle have ignored this personal perspective—strange, considering that what distinguishes this launcher from others is that it carries human beings, not just machines, into space.

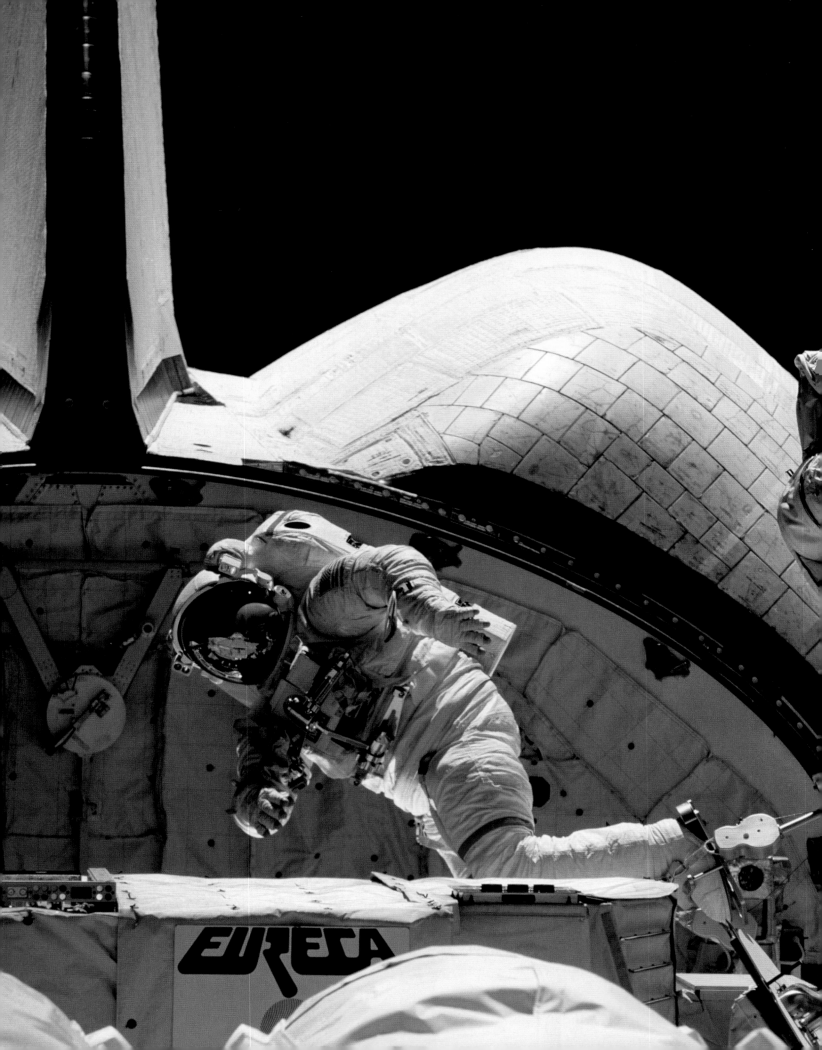

People Mover

IN JANUARY 1972, the Apollo moon program was already beginning to wind down. Even with two lunar landings still to come, and with astronauts reaching new levels of ease and sophistication in working on the moon, public attention was fading, and congressional appropriations for space exploration were drying up. So NASA was busily planning its Next Big Thing.

The Next Big Thing, as it turned out, would focus less on the destination than on the means of getting there. The nation would build a space shuttle, a reusable vehicle that could lift off like a rocket, carry people and cargo into Earth orbit, then land on a runway like an airplane, ready (after a bit of servicing) to fly again. In his January 5 statement approving development of the shuttle, President Richard Nixon said, "I have decided today that the United States should proceed at once with the development of an entirely new type of space transportation system designed to help transform the space frontier of the 1970s into familiar territory, easily accessible for human endeavor in the 1980s and '90s."

At the time of Nixon's announcement, John Young, who would command the first shuttle mission nine years later, was deep in training for Apollo 16, his fourth spaceflight and second trip to the moon. Sally Ride was studying English and physics as an undergraduate at Stanford, where she was also the top player on the women's tennis team. Hoot Gibson was getting ready to ship off to Southeast Asia to fly combat missions for the Navy. Rhea Seddon, his future wife and fellow astronaut, was in medical school in Tennessee. Mario Runco was playing ice hockey for the City College of New York, on his way to becoming a meteorologist, and Kalpana Chawla was still a schoolgirl in her native India.

That all these people would fly on the space shuttle during its first 20 years was not forseeable in 1972, but it was implicit in Nixon's promise. The shuttle was all about making spaceflight routine, and that included opening it up to a wider variety of people than the American-born, white, male pilots who had flown all NASA missions before then.

The idea of a spaceplane was not itself new. While engineers had had to invent the early Mercury and Apollo capsules almost from scratch, the shuttle had some technical legacy to build on. The Air Force and NASA had spent considerable money in the 1950s developing a mini-spaceplane called Dyna-Soar before the project was

David Low in Endeavour's *cargo bay, STS-57.*

11

canceled. The X-15 rocket-plane of the 1960s reached the edge of space, then flew back through the atmosphere to a runway landing (data from those flights would be invaluable to shuttle designers a decade later).

The new Space Transportation System, though, was a much bigger proposition than either of its forerunners. It was designed to carry 65,000 pounds of cargo and seven people into space, stay a week or two in orbit, rendezvous with satellites or space stations, then return crew (and cargo, if necessary) to Earth. The configuration that engineers settled on by 1972 was something NASA had never tried before: The spaceplane itself would have built-in liquid-fuel engines, but to reach orbit it would need the extra lift of large, attached boosters that burned solid rocket fuel—the first time these had ever been used for human spaceflight. Once the boosters lit, there was no turning back. They would burn like roman candles until the fuel was exhausted.

Story Musgrave, who had been an astronaut since 1967, watched this odd hybrid take shape in the 1970s with some trepidation. It seemed to him like "bolting a butterfly onto a bullet." Musgrave was among those astronauts who had arrived at NASA too late for the moon landings, who would not reach orbit until the shuttle took off in the 1980s. That group included a small contingent originally chosen for the Air Force's Manned Orbiting Laboratory (MOL) space station project of the mid-1960s, who were taken in by NASA when the project was canceled before getting off the ground. MOL refugees were some of the first shuttle pilots: Bob Crippen, Richard Truly, Gordon Fullerton, Hank Harts-field, Bob Overmyer, and Karol Bobko.

But it was the "Thirty-Five New Guys" (TFNGs) selected by NASA in 1978 who became the core group of early shuttle astronauts. They included the Vietnam generation of military pilots, men like Rick Hauck, Dan Brandenstein, and Brewster Shaw, who began filling front-seat positions in the shuttle beginning with STS-7 in 1983. Along with these pilots, the first class of shuttle astronauts included scientists like Pinky Nelson, Steve Hawley, Ride, and Kathy Sullivan, who were designated "mission specialists" in the shuttle's segregated work force, people who tend to the payloads and onboard experiments as opposed to pilots and commanders who tend to the vehicle.

The addition of women to the astronaut corps was as celebrated by the public as it was transforming to NASA, the ultimate Guy Culture. When TFNG class member and former biomedical engineer Judy Resnik followed Ride as the second American woman in space on STS-41D in 1984, she pasted on one of the shuttle's mid-deck

lockers, alongside the BEAT ARMY and BEAT NAVY stickers, signs saying "I Love Tom Selleck," and HI DAD.

The astronaut classes that followed (10 more groups have been chosen in the two decades since the shuttles have been flying) further broadened the demographic and occupational backgrounds of shuttle fliers. While pilots and commanders have drawn almost exclusively from the ranks of the military, mission specialists have come from a range of technical and scientific fields. The shuttle program has even fostered some astronauts from within its own workforce. So, for example, five-time shuttle veteran Janice Voss first worked as a crew trainer at the Johnson Space Center before becoming an astronaut herself in 1991. Linda Godwin once worked in Mission Control, and Joe Tanner taught astronauts how to land the Shuttle Training Aircraft before being picked himself.

The crew of STS-64 on board Discovery. *Clockwise from upper left: Carl Meade, Susan Helms, Jerry Linenger, Richard Richards, Blaine Hammond, Mark Lee.*

Finally there are the payload specialists, the non-NASA fliers who go up once or twice with a particular experiment or set of experiments, then return to their careers. Some of these, like life scientist Millie Hughes-Fulford, who flew on the STS-40 research mission, may spend years preparing for a spaceflight. Others, though—particularly in the early 1980s, when NASA was offering rides on the shuttle to attract satellite customers—have dipped only briefly into the world of astronauts. Among these true outsiders were a Saudi prince, Sultan bin Salman Al-Saud, and politicians, such as Florida Congressman (now Senator) Bill Nelson, who flew on STS-61C, the mission before the *Challenger* accident in January 1986. Ironically, that tragic flight was supposed to take public participation in the shuttle program another step further by including schoolteacher Christa McAuliffe as the first "Citizen in Space."

Space shuttle history can be divided into two eras—before *Challenger* and after. Prior to the loss of that orbiter and its crew on mission STS-51L, NASA still clung to the illusion, at least publicly, that the shuttle could help defray its costs through frequent flights for paying customers. Agency employees could be seen in the early 1980s wearing "BEAT ARIANE" T-shirts, a reference to the hot competition with the French-built Ariane rocket for the lucrative commercial satellite launch business. It was this drive to recover at least some money to offset the billions NASA was spending on the shuttle that was partly responsible for the haste and carelessness that led to the *Challenger* accident.

But most astronauts by that time already had given up on the original hope that their space truck would fly 50 times a year, or even the 24 times that was the stated goal as of 1985 (NASA has never again matched the nine missions it flew in that year before *Challenger*). Following the accident, with commercial satellites banished from the cargo bay, and with a new generation of astronaut managers injecting more realism and safety-consciousness to the schedule, some of the old rationales for the shuttle came undone. The military, which had been a reluctant

partner from the very beginning, shifted many of its expensive spy satellites back to conventional rockets, and mothballed a fully built West Coast shuttle launchpad that was just months away from its first flight when *Challenger* exploded.

While NASA methodically worked off the shuttle-dependent backlog of payloads stranded after the accident, the agency shifted its attention to designing a space station—the *next* Next Big Thing that visionaries had always seen as an integral part of any true "space transportation system." But the station, too, has struggled with money problems, even as its construction has proceeded nearly flawlessly.

By the shuttle's 20th anniversary in 2001, no one could claim it had succeeded in economic terms. It takes far too many people to operate and maintain between flights, and people cost money. But it would be unfair to blame the high cost of space travel on the shuttle alone. In all those 20 years, no other rocket, whether the French Ariane or the American Delta and Titan—none of which can match the shuttle's capability or statistical reliability—has made significant progress in bringing down the price-per-pound to orbit (currently about $10,000). Every few years some upstart company looking for venture capital promises "airline-style" launch operations, but no one seems to get beyond the hype. So if space travel is still prohibitively expensive, don't pin it on the shuttle.

IF THE SHUTTLE HAS BEEN a financial disappointment in its first 20 years, what exactly has it accomplished, other than to keep flying for a very long time? (*Columbia* made its debut in 1981, the same year fax machines and desktop computers were introduced, and before CD players and cell phones. The earliest computers on Spacelab had 64 kilobytes of memory, an embarrassingly low amount for a toy today).

What it has done, just as promised, is to make spaceflight routine. Every two months or so, seven people go up, do their work, come home again, and hardly anyone notices. Shuttle pilots routinely dock their 100-ton vehicle with a space station that is already the size of a small office building and still growing. A single spacewalk used to cause palpitations in Mission Control, but now astronauts routinely step out four or five times in a single mission. They service telescopes, connect lines and wires like your local cable technician, handle multi-ton satellites, and fix things in orbit when they break down.

We on the ground can watch all this happening with an immediacy we never could before, because in the space station era, astronauts have started wearing small TV cameras on their helmets, so we can see the action from their point of view. The spacewalker's hands float out in front of him (us), while he (we) handles a torque wrench, assembling a space station. Too cool, and too weird. Without fanfare, the age of virtual space travel has arrived.

The shuttle may be a victim of its own success in a media-saturated age where "routine " is a synonym for "dull." Far more attention was paid to the fiery destruction of Russia's troubled Mir station in March 2001 than to the assembly of NASA's much more advanced station, which was snapping together, like clockwork, at the same time. Screenwriters and TV news producers like danger and disaster. Astronauts and NASA flight controllers do their best to factor those things out. The two perspectives are fundamentally mismatched.

And so the shuttle, now inextricably linked to the space station (a destination at last!) enters the new millennium with an uncertain role in American culture.

Space travel was the great forward-looking adventure of the late 20th century. Today the easy destinations, like the moon, have been reached. Venturing further will require operational sophistication of the kind astronauts have learned, and are still learning, on the space shuttle.

Rather than ask "What has the shuttle accomplished?" we might instead ask, "What should we do with the skills these people have acquired?" Many shuttle veterans lament the fact that two decades after STS-1, and three decades after the last moon landing, the space program is nowhere near as bold as it could be. If astronauts haven't yet gone to Mars, it's mainly because we haven't asked them to. Our failing, not theirs.

But there is another likely course for the evolution of human spaceflight in the 21st century. Along with sending a few people farther out, we will send many more people *up*.

At work on Atlantis' *flight deck, STS-101.*

When millionaire Dennis Tito visited the space station within weeks of the shuttle's 20th anniversary, commentators heralded a new age of space tourism, where finally *we* would get to go.

They must not have been paying attention. The shuttle's primary accomplishment to date is that it has ferried lots of people—pilots, doctors, scientists, engineers, politicians, some who never even set out to become astronauts—up to the orbital frontier, and so has extended human culture beyond the planet of its origin in a small but significant way. About 400 individuals have now been to space, more than sailed on Columbus' three ships, the Mayflower, and the first voyage to Jamestown combined. Two-thirds of them have flown on the shuttle. Most you wouldn't recognize if you bumped into them on the street. And, as the stories in this book show, they have more interesting things to say about life in space than the "Wow, it's great up here!" that we got from Dennis Tito.

For years the cry has gone up, "When will more people get to travel into space?" While we weren't watching, it started.

The space shuttle is an expensive vehicle to operate,

no question about that. But when you need the capability

of humans in space, it's the only thing like it in the world, ever.

— BREWSTER SHAW

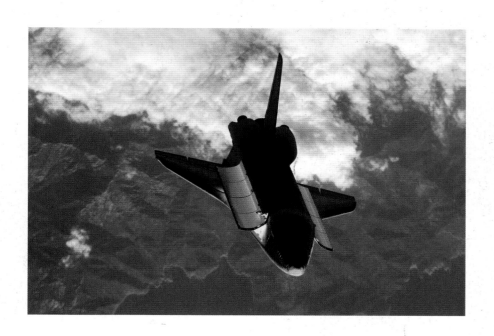

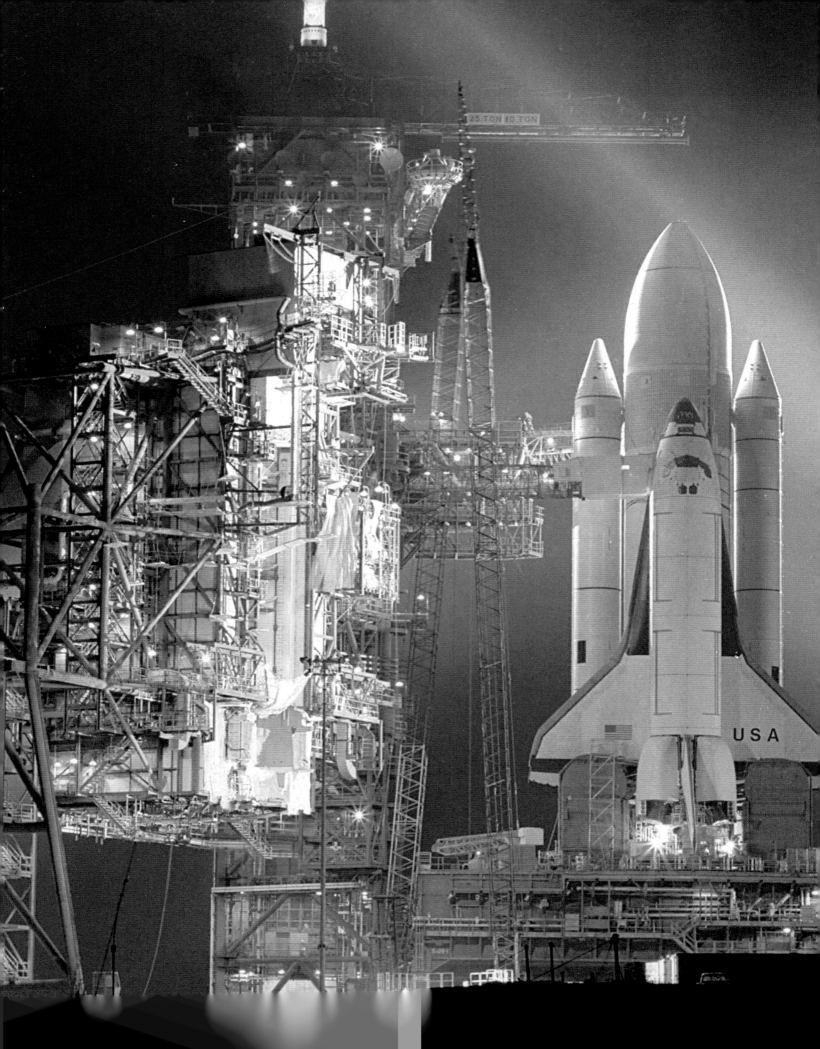

1981

STS-1

STS-2

1982

STS-3

STS-4

STS-5

HALF ROCKET, HALF AIRPLANE

The space shuttle's debut on April 12, 1981, was less an epic journey into the unknown than a by-the-book engineering test flight. The new vehicle's subsystems—from its reusable main engines to its heat-protection tiles—had been tested separately, but never all together. A series of atmospheric drop tests four years earlier had shown that the orbiter could fly like an airplane; now it had to prove spaceworthy as well. It is still the only time in history that astronauts were onboard a new launch vehicle on its first test flight.

For all the novelty and complexity of the Space Transportation System (STS), *Columbia*'s 54-hour maiden voyage was straightforward and workmanlike for its crew, John Young and Bob Crippen. After the landing, first-time space flier Crippen remarked: "Except for the fact that I was floating with my feet up in the air, I was doing the same thing we've been doing the past three years, and it felt just as natural as it can be."

The second, third, and fourth flights went further down the test-flight checklist: making sure all systems worked in the extreme heat and cold of space; flexing the robot arm; gradually increasing the launch and landing weight in the cargo bay. With the landing of STS-4 on July 4, 1982, NASA declared its new launch system operational. Soon the two-man test flight crews would yield to crews of four, then five, then seven people. The age of the space shuttle had arrived.

Columbia waits on the pad before its first launch, March 1981.

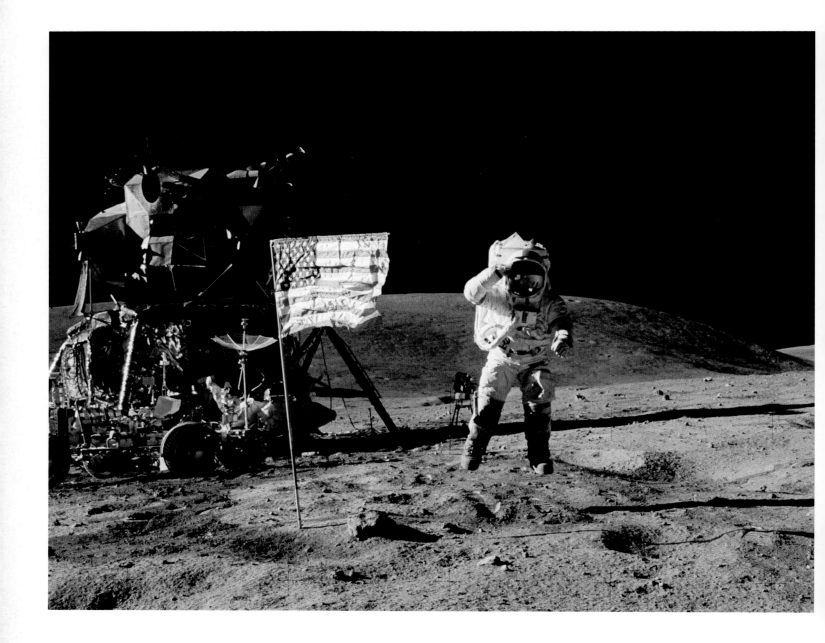

JOHN YOUNG | **The country needs that shuttle**

Apollo 16 commander John Young does a jump/salute on the moon moments before learning that the new space shuttle has been approved. Nine years later, he commanded the first shuttle mission.

John Young and Charles Duke were on the lunar surface on April 21, 1972, when astronaut Tony England in Mission Control radioed up the following message:

ENGLAND: This looks like a good time for some good news here…The House passed the space budget yesterday, 277 to 60, which includes the vote for the [space] shuttle.

YOUNG AND DUKE: Beautiful. Wonderful. Beautiful.

DUKE: Tony, again I'll say it, with that salute, I'm proud to be an American, I'll tell you….

YOUNG: The country needs that shuttle mighty bad. You'll see.

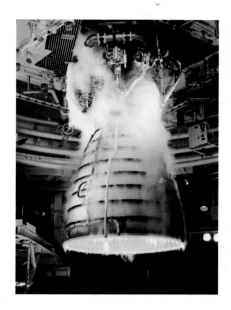

JACK LOUSMA | **A lot more people were going to fly**

The shuttle's reusable, high-performance main engines (shown during a test firing) proved an engineering challenge that delayed the first launch. Joining Young (left) on STS-1 was Robert Crippen, who had been an astronaut since 1969 but had never flown in space.

When the space shuttle was first proposed, a reusable vehicle was generally thought to be a good idea. There was always the question, though, of where it would shuttle *to*. At first it was going to shuttle to a space station, which seemed to make a lot of sense—this would prepare us for flights to Mars. We would use the space station as a spacecraft assembly node, and launch from there. We had all hoped there would be a mission to Mars before the end of the century, but then the space station fell out of the plan because NASA couldn't afford both it and the shuttle.

Still, a reusable shuttle meant that a lot more people were going to fly. In the 1970s, they were talking about flying twice a month. And they were talking about astronauts flying four times a year, which got a favorable reaction because people wanted to fly often. It also seemed quite ambitious, knowing how hard we had to work to get ready for a spaceflight. I trained for Skylab for two and a half years, and two years for my STS-3 shuttle flight. Of course, you wouldn't have to train nearly as much for multiple shuttle flights, because once you were up to speed, the next flight would be much like the one before it. It was feasible. But there was always the question of whether we would get to that flight rate. Today we're flying only six or seven times a year. Getting ready turned out to take longer than we had expected.

GORDON FULLERTON | **I missed the whole first part of the flight**

Approach and Landing Test (ALT) Free Flight #1

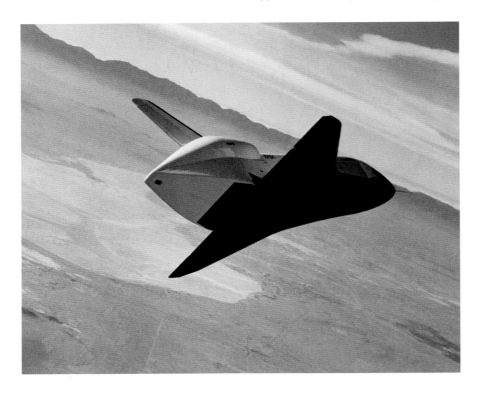

The prototype orbiter Enterprise *glides to a landing over the California desert in 1977.* Enterprise *was not space-qualified—it was used to verify the shuttle's aerodynamic characteristics.*

In August of 1977, Fred Haise and I were the crew for *Enterprise*'s first free-flight approach and landing test—the very first instance of a shuttle orbiter flying in the atmosphere. Our 747 carrier aircraft, with the orbiter on top, climbed to somewhere around 25,000 feet and pushed over. Fred hit the button to initiate the separation, seven explosive bolts released us with a loud *kabang*, and as predicted, we went straight up. We literally dropped the 747 at separation.

A chase plane flying alongside us called "vertical clear" as soon as he saw us clear the 747's tail. Then we started a right shallow turn, and the carrier started a shallow left turn. Very soon thereafter, another chase plane called "lateral clear," meaning we were clear to push over and start getting the orbiter's nose down for the approach and landing.

So Fred was doing all that. But even before we cleared the tail—immediately after the release—one of our four general purpose computers, the heart of the orbiter control system, had failed. I saw a big "X" on one of the displays in front of me, so it was clear it wasn't getting current information. The procedure for a GPC fail, which we had practiced a lot, was for the copilot, which was me, to pull some circuit breakers and turn off some switches having to do with the sensors that went through that particular computer. I referred to a cue card on my instrument panel, and I suddenly got very busy, turning around backward to pull circuit breakers on a panel behind my right shoulder. I did all that, and made the call to Fred when I finished.

Then I realized, kind of as a shock, "Hey, wait a minute! We're flying great. It's stable and Fred is right on plan." I missed the whole first part of the flight, which of course was the big thing we were testing, how the shuttle flew as an airplane. We were probably down to 15,000 feet by the time I was back looking out the windshield to see what was going on.

HOOT GIBSON | **We owned the place immediately**

I was one of the "Thirty-Five New Guys," the TFNGs, chosen in 1978. We referred to the guys who were already there as GVA's, Grizzled Veteran Astronauts. There had not been an astronaut selection in nine years, and I'd have to say we were more than welcomed. We really felt like we owned the place immediately when we came in.

Still, we had to walk very slowly before we figured out how to jog, because everything was different about space. It was a difficult adjustment for me, because I had come out of the flight test community where I was at the very top. Then I came through the door at NASA and didn't even know how we generate electricity on a spacecraft. I didn't know how we get hydraulic power, I didn't know we had to worry about thermal problems like hydraulic fluid or propellant getting too cold in space. You would think being involved in high performance jet fighter aviation for nine years, I would be right at home. But I felt really stupid in terms of what I knew.

Our class of 35 really was a giant family, and it was such a fun group. We were so big they had to break us into two groups for training, the red group and the blue group. Every Friday night we'd have happy hour somewhere. The old astronauts, the GVAs, acknowledged that "Gee, we haven't done this sort of thing for years now." We had red versus blue football games, a big event with referees in uniforms. We had New Year's Eve parties together, we had Christmas parties together, we really did everything together. We were like a small squadron within the overall astronaut corps, which is like a squadron itself.

We had a 20-year anniversary party in 1998, with almost all of the surviving TFNGs. Of course, we had lost four of them aboard *Challenger*. We had five of the six original women astronauts, and they posed for a picture. I'll never forget the depressing feeling we had, because it was so very apparent that Judy Resnik, who'd been on *Challenger*, wasn't in the photo. We really were in each other's hearts, our little subset of the astronaut corps.

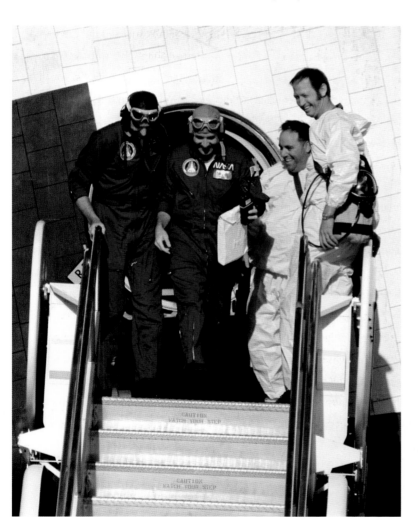

Joe Engle (left) and Richard Truly were one of two crews to pilot the shuttle in the atmosphere before it launched into space. They teamed up again for the STS-2 mission in November 1981.

The Apollo command module had a launch escape system. If you needed to save your life on the launch pad, you could fire it, and it would rocket you up 5,000 feet and a mile out to sea. But the shuttle didn't have anything like that. So one of the basic differences was the risk we were taking. I felt a lot more risk in flying the space shuttle than I had in flying the command module on the Saturn rocket for my Skylab mission in 1973.

The shuttle did have ejection seats for the first four test flights, but they weren't really made for use during launch—their prime purpose was for emergencies during the approach and landing at the end of the mission. There were some phases during the ascent where they might have been useful, but it was never clearly defined what they were. It wasn't useful on the launch pad. You'd have hit the ground before you had the chute open. During other parts of the launch profile you might have ejected into the exhaust plume of the rocket, or your parachute might have opened prematurely due to the overpressure from an explosion after ejection, or who knows what. I was never able to get any definition as to when it might be possible to safely use them during a launch.

The shuttle orbiter is attached to its twin solid rocket boosters and giant external fuel tank for the first time during vibration tests at the Marshall Space Flight Center in Alabama, October 1978.

BOB CRIPPEN | **I think we're really going to do it**

STS-1

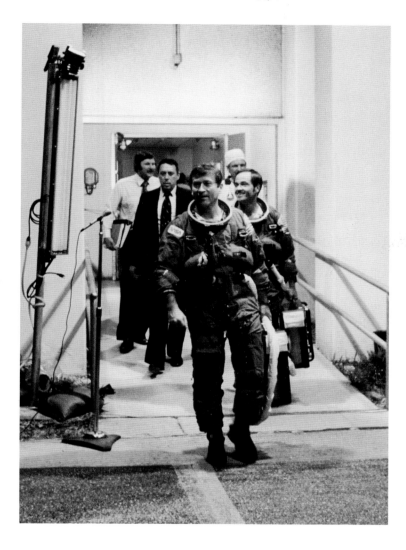

Young and Crippen walk out to the pad for their first launch attempt on April 10, 1981. On their second try two days later, Columbia roared into orbit a few seconds after 7:00 a.m. (overleaf).

The shuttle is a very complicated vehicle, and I fully anticipated we would have to do several countdowns before we launched for the first time. Sure enough, on April 10, 1981, our first attempt, we developed a problem with our backup computer listening to the primary computers. John Young and I were strapped in, on our backs, for six hours. That was long enough, and six hours is still used as the maximum time for keeping crews strapped in before scrubbing a launch.

We tried again on April 12. I wouldn't have been surprised if we had encountered another problem. But when the count went inside one minute, I said something to John to the effect that, "I think we're really going to do it." That was when I started to get excited. This was something we had worked toward for many years, and it was finally going to be a reality.

The main engines, which ignite about six seconds prior to liftoff, made a pretty good racket when they lit. But it's the solid rockets that get your attention—there is no doubt you are headed somewhere. We later learned that the shock wave bouncing off the launch platform had damaged some of the structure holding our forward fuel tanks. We also began to notice debris coming by the windows—later determined to be ice and some of the insulation from the external tank.

The big shocker was when the solids burned out. We went from accelerating at about three times normal Earth gravity to less than one-g. It also went from being very noisy to very quiet. I initially thought all the engines had quit, but my instruments quickly verified that was not the case. We were up high enough that we couldn't hear the engines back in the rear of the vehicle because there was very little atmosphere.

The powered flight took a total of about eight and a half minutes. It seemed to me it had gone by in a flash. We had gone from sitting still on the launch pad at the Kennedy Space Center to traveling at 17,500 miles an hour in that eight and a half minutes. It is still mind-boggling to me. I recall making some statement on the air-to-ground radio for the benefit of my fellow astronauts, who also had been in the program a long time, that it was well worth the wait.

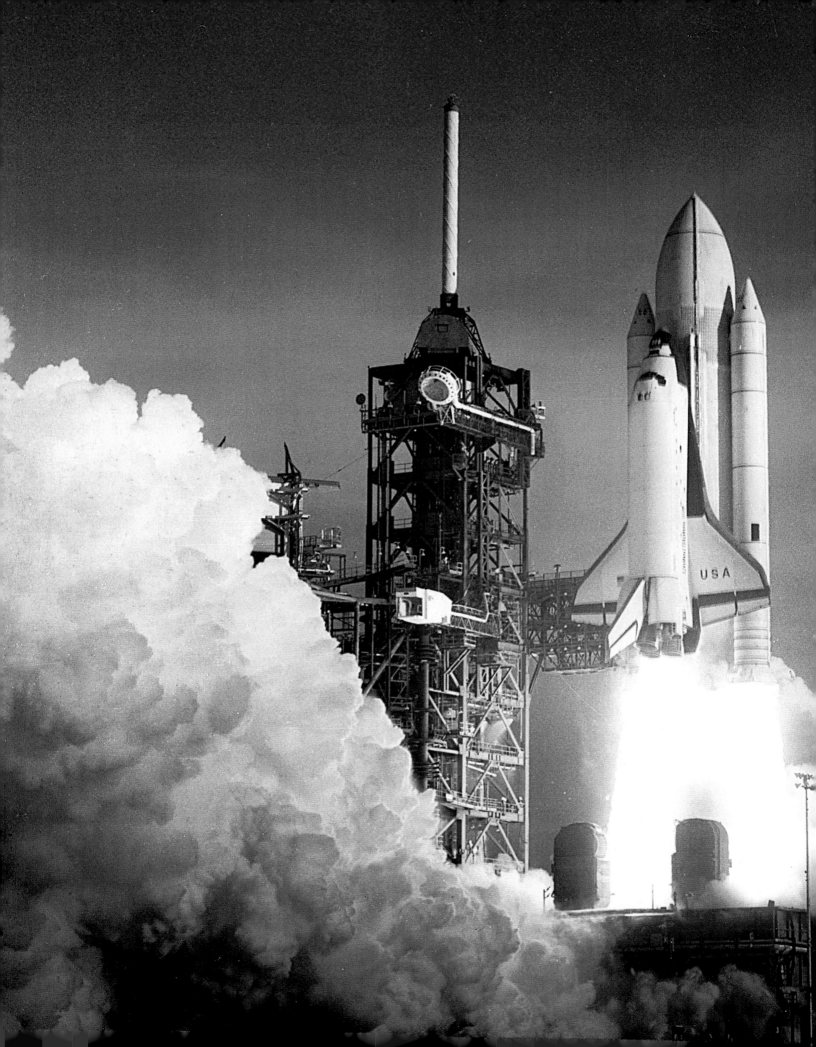

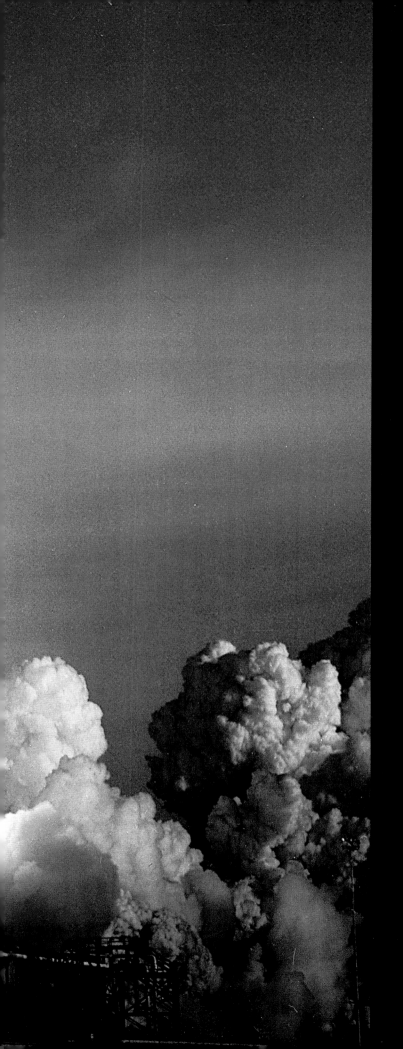

John and I had been trained as test pilots, and this probably was the greatest flight test one could hope to participate in.

—BOB CRIPPEN
STS-1

DAN BRANDENSTEIN | **I was almost yelling at them**

I think I was more excited about being Capcom [the astronaut in Mission Control who talks to the crew] for the first shuttle launch than I was about my own first flight two years later, because it was the first flight of a new vehicle, and it had people onboard the very first time out. They had done all the analysis and everything, but the thing I worried most about was the clearance during liftoff. I had been down at the Cape and had seen the relatively tight tolerances between the solid rocket boosters and the tail of the vehicle as it passed the tower. That was my concern before the launch—if we can get past the tower, I'm going to feel a lot more comfortable.

During the launch, I made all the calls to the crew that I was supposed to, and it went very well. I still go back to listen to the tapes. The first call or two I was almost yelling at them. I was kind of pumped up, I guess. And I did breathe a sigh of relief after we cleared the tower. In the control center, at least at that time, we didn't have the launch on TV. The flight director wanted everybody focusing on their job, and didn't want them looking at TV. So it wasn't until our shift was over that we actually saw that first shuttle liftoff.

Crippen during a rare free moment on STS-1. The astronauts spent most of the busy two-day flight checking out their new vehicle, and took few onboard pictures.

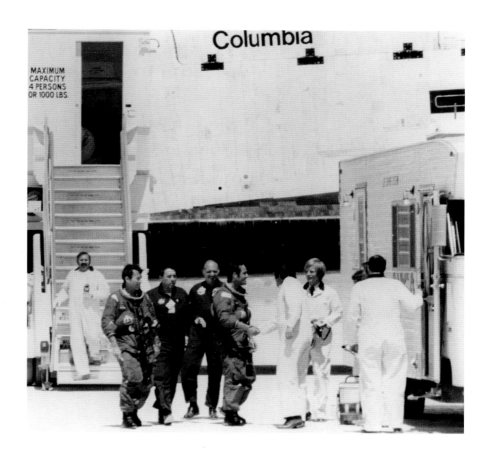

The first shuttle landed on a dry lakebed rather than a runway. Despite preflight speculation that the orbiter's insulating tiles might come loose, they weren't a problem.

JOHN YOUNG | **We got infinitely smarter**

STS-1

Because we were flying this vehicle for the first time, we had to be respectful of what we didn't know. That's why we had hundreds of meetings beforehand, where we sat around and talked about uncertainties. It was the reason why we landed on the lakebed at Edwards Air Force Base in California, so if anything went wrong we could land anywhere and accommodate our ignorance. Before the flight we were practicing simulations for hundreds of things that could go wrong. You've got 2,000 switches and circuit breakers in the vehicle, and most of them are not where a two-person crew could even reach them during ascent or entry. I think we had some failure scenarios where Crip [Bob Crippen] would actually unstrap, get up, and go back in the back during entry. But for ascent you couldn't do that.

It was a pretty good test flight, and we discovered a lot of things. For example, coming into the atmosphere at Mach 25 we got a really bad sideslip that we didn't expect, where the orbiter slipped sideways four degrees and dropped in attitude. Fortunately the software canceled it out. If it hadn't, we wouldn't be here.

Chris Kraft, who was the director of the Johnson Space Center at the time, put it best: He said we got infinitely smarter after the first flight. We were really pretty ignorant of the characteristics of the vehicle before then, but it worked pretty darn well.

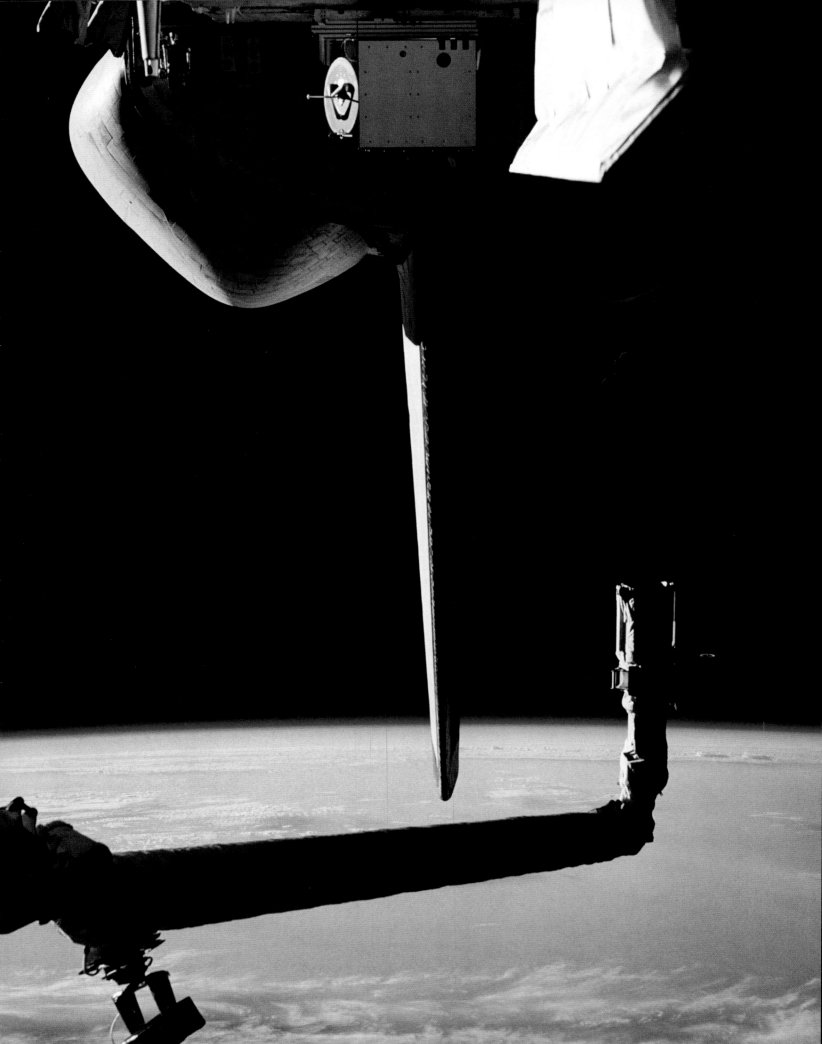

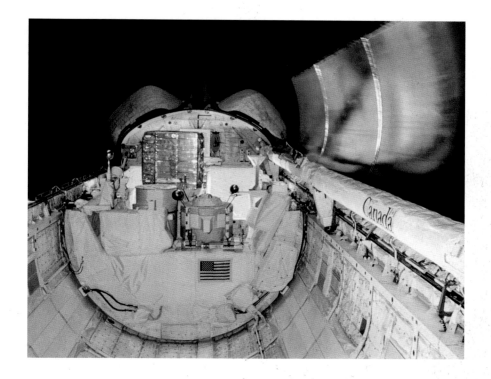

Key systems evaluated during Columbia's first four orbital flights included the Canadian-built Remote Manipulator System (RMS) arm (opposite, on STS-2) and the cargo bay doors, shown opening on STS-3.

MIKE COATS | **The banana effect**

On STS-4, I was the Capcom in Mission Control. One of the tests we did during that flight was to point the shuttle toward the sun for an extended period so that one side heated up and the other side cooled down. The orbiter bends like a banana, because the hot side expands while the cold side contracts. The engineers worried that too much of this "banana effect" might be a problem, so they wanted more data on it.

Chris Kraft, the head of the Johnson Space Center who'd been a flight director since the Mercury days, was standing behind us in the control center when the shuttle crew went to close Columbia's payload bay doors after one of these thermal tests. And they wouldn't close. We were about to lose communication with them—back in those early flights they had to be over ground stations for us to talk to them. And it was not a good situation that they couldn't close the doors. If they'd had an emergency and needed to come home in a hurry, they wouldn't have been able to.

We had already signed off with the crew when Kraft yelled out to me as the Capcom, "Tell them to reverse attitude so we can start warming up the other side." I called up for them to change attitude so they could start warming up the top of the orbiter instead of the bottom. Fortunately they heard and said okay. The next time we came within communication they had changed attitude and were warming up the other side, and eventually they got back to where they could close the doors. But watching the excitement run around the room was kind of fun.

BRIAN DUFFY | **How cool is that?**

In 1982 I had just finished my second fighter assignment in the Air Force. I had come back from Okinawa, and I was going to start test pilot school in California on the sixth of July. We rolled into town at Edwards Air Force Base on the third, and the space shuttle landing was scheduled for the Fourth of July. The President was going to be there, and it was going to be a big deal. We checked into the quarters—my wife was six months pregnant with my daughter, and we had a one-and-a-half year-old son. I was flying the F-15 at the time, and my new challenge was to make it through test pilot school and become a test pilot. I never even considered the space program. It was beyond my imagination even thinking I'd ever be qualified to be part of that.

We were sitting on a hillside viewing area, and could see thousands of cars and RVs out on the dry lakebed. We watched the space shuttle come in, and I heard this double sonic boom— shock waves from the orbiter's nose and tail— which was a surprise to me. I watched this vehicle come back from space, land on the lakebed, roll out and stop. And I couldn't help but think, how cool is *that*? These guys were just in space, and they came roaring back into the atmosphere, landed this big glider on a runway, and stopped it right where they wanted it. I just marveled at the technology it took to do that, and the people it took to make that happen.

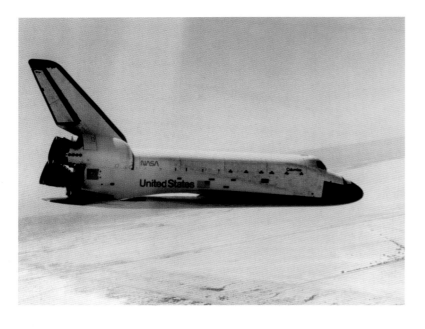

The world's first reusable spaceship comes in for a landing, STS-1.

Of course, I did become an astronaut a few years later. On my first three shuttle flights, we landed in Florida each time, but on STS-92, after a couple of days of trying to land at the Cape, we reached the point where we needed to land soon. We were out of fuel, out of food, out of everything. They brought us into Edwards, and we landed on runway 22, which I've seen a thousand times from my flying in the Air Force and from practicing shuttle landings. The night after the landing we stayed out at Edwards, and I was thinking back to the days when I first saw the shuttle land. And I could say, yeah, it really *is* cool.

MIKE MULLANE | **Now I can put in a swimming pool!**

I think most astronauts felt there was a significant chance of failure on STS-1. Sure, there had been multiple ground tests of the liquid and solid boosters, and billions of dollars and a decade of work had been spent on computer models to validate all other aspects of the vehicle. But there was no getting around the fact that when STS-1 lifted off, it would truly be a grand experimental "first" that carried a reasonable chance of failure.

I watched the liftoff from NASA's facility in El Paso, Texas, where we keep the Shuttle Training Aircraft. I was there with a small group of other astronauts ready to fly chase in T-38s if *Columbia* had to abort to the nearby White Sands, New Mexico shuttle landing strip. In breathless silence we all watched the TV broadcast of *Columbia* rising into the sky. As each milestone of the flight was reached, the extreme fear of failure began to moderate. When the solid rocket boosters separated, there was an audible exhalation of breath. Then the abort calls ticked away, signaling different times during the ascent when various launch abort "windows" opened and closed—"Two Engine TAL, Negative Return, Single Engine TAL, Press to MECO." With each call, the smiles brightened on our faces and the same unspoken thought began to energize the room: This was *really* going to work!

Then, finally, that blessed call reached our ears—MECO. Main Engine Cutoff. Even though *Columbia* had yet to burn its smaller maneuvering engines to reach orbit and there were a thousand other things that could still jeopardize the mission, we roared our joy at having the most dangerous part of the flight behind us. I remember the first comment that came after our cheers. One of our group said, "Now I can put in a swimming pool!" We all knew exactly what he meant. We had a job after all.

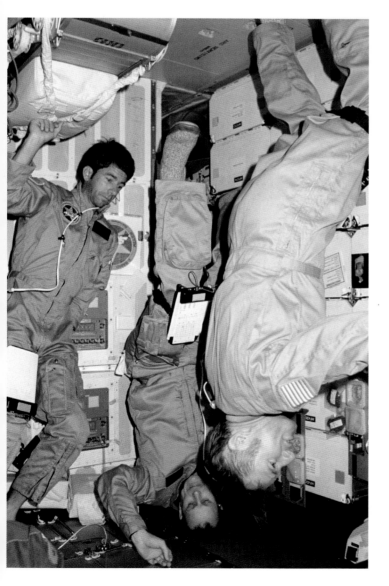

With STS-5, the shuttle graduated to crews of four or more. Left to right: Bill Lenoir, Bob Overmyer, Vance Brand. Joe Allen took the picture.

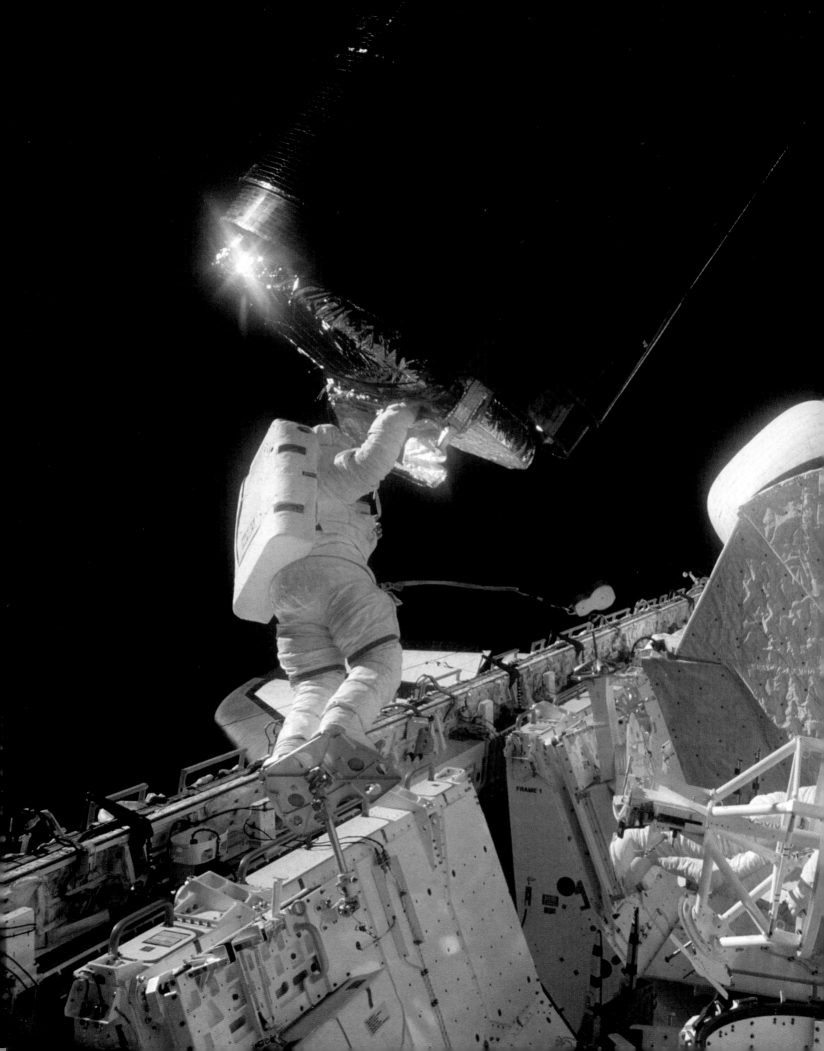

The shuttle established itself in its first few years as a capable, if sometimes finicky, space truck. More than half the missions in the early 1980s carried commercial satellites, which were delivered—as many as three per flight—to low Earth orbit for paying customers.

Occasionally things went wrong after the satellites left the shuttle, which led NASA to add pick-up and repair to its standard satellite delivery service. On two such missions, STS-51A and STS-51I, astronauts captured malfunctioning satellites and either fixed them in orbit or returned them to Earth. These semi-improvised rescues expanded the range of tasks the shuttle could accomplish, and produced some of the most dramatic and visually spectacular moments in spaceflight history.

Three more orbiters—*Challenger, Discovery* and *Atlantis*—joined the fleet between 1983 and 1985, but NASA struggled with launch schedule delays due to frequent repairs or hardware switch-outs. The European-built Spacelab research module added an extra "room" on selected missions for conducting experiments in orbit. And a new generation of space traveler, including women, African-Americans, and foreign nationals, finally got the chance to fly in space. By the end of 1985, more people had flown on the space shuttle than on all previous U.S. spacecraft put together.

Joe Allen holds onto a 2,600-pound communications satellite he has just retrieved from orbit, STS-51A.

STS-6

STS-7

STS-8

STS-9

1984

STS-41B

STS-41C

STS-41D

STS-41G
STS-51A

1985
STS-51C

STS-51D, 51B

STS-51G
STS-51F
STS-51I

STS-51J, 61A
STS-61B

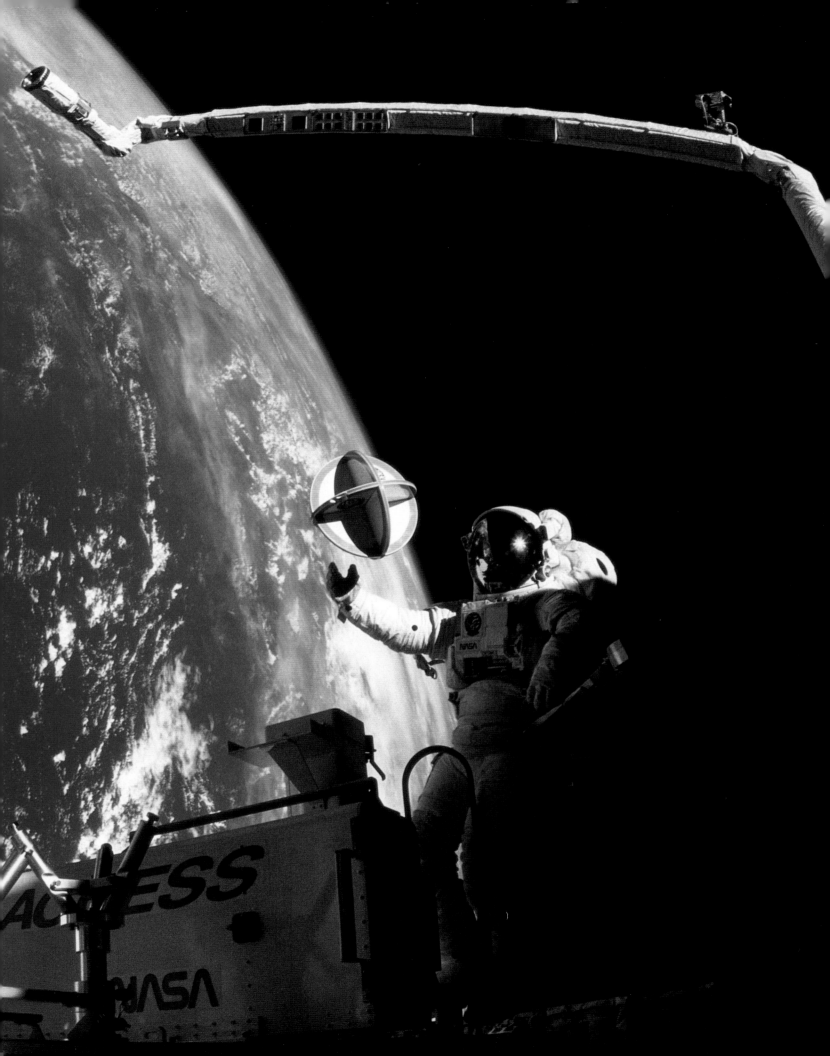

CHARLIE WALKER | **Outsider**

STS-41D, STS-51D, STS-61B

Considering that I wasn't even a NASA astronaut, it's strange that no one flew as many shuttle missions as rapidly as I did in those early years. At first I was to fly on only one. I ended up launching on three. Three flights in 15 months, and almost three weeks in orbit altogether.

I attribute it to two things. First, I was the expert on a type of commercial research that NASA was very interested in encouraging, and second, I got along with the career astronauts. I was an outsider, and that was never lost on me, but I didn't ask for much, and I accepted my niche. Hey, what would you put up with to fly to space?

As a commercial payload specialist, I received no more than a generalized, abbreviated training. Basic shuttle systems and safety, training with the crew (at the discretion of the mission commander), and very little flight familiarization in jets was the plan. My first flight was the fifth for the electrophoresis experiment, which used an electric field to separate and isolate pure materials in the absence of gravity. My employer, McDonnell Douglas, had an agreement with NASA that allowed our biotechnology experiment to fly up to seven times. When I launched on mission 41-D in 1984, I didn't expect to fly more than once.

West German scientist Ulf Merbold was the first non-American launched on a U.S. spacecraft, on the STS-9 Spacelab mission in 1983. Opposite: Woody Spring releases a free-flying target used to test the shuttle's ability to hold a steady position, STS-61B.

But because the device worked only fitfully on that flight, we needed another chance to get the expected results. NASA agreed to allow me and the experiment to fly again, and quickly, on mission 51-D in April 1985. Because that flight was very successful, our R&D program advanced, and I was again asked to fly. So the seventh flight in our series, the third with me along, launched the following November. My backup was scheduled to fly in the summer of 1986, this time with larger production-scale equipment. But when his training didn't go as smoothly as hoped, management was considering putting me up as number one again. I had my doubts. I was tired of the pace. Too much of a good thing too fast!

Of course, it ended up being a moot issue. The *Challenger* accident in January 1986 led to a cessation of shuttle flights for 32 months, stalling our momentum and raising questions about commercial reliance on the shuttle. At the same time, the rapid onset of genetic engineering in pharmaceutical research sent our business plans into a flat spin. Our project didn't recover and never flew again. What might have been? We'll never know.

MIKE COATS | I thought we'd be a lot higher

STS-41D

On 41-D we had the first on-the-pad abort in the shuttle era—the main engines lit, but they shut down a few seconds before liftoff due to an engine problem. It was a very difficult time for my wife. She was on the roof of the Launch Control Center, a few miles away. First she saw a lot of smoke from the engines firing, then she heard the announcement, "Abort, abort, abort." Then the sound wave hit them, this big boom, after they had declared the abort. She thought something had exploded.

For us inside the shuttle, of course, it was a huge disappointment. There was probably 10 seconds of silence after the engines shut down, where all you could hear was the seagulls screeching because the noise had shaken them up. Then Steve Hawley says, "Gee, I thought we'd be a lot higher at MECO [Main Engine Cutoff]." That kind of broke the ice and got everybody laughing.

There was a cracked hydrogen valve feeding a fire, and they were dumping water on the shuttle to try to put the fire out. So when they finally got us out and we walked out of the elevator at the bottom of the launch pad, we had to literally walk through a waterfall. This is back when we still wore our thin blue flight suits instead of those bulky orange pressure suits. We got completely soaked to the skin, because it was a drenching downpour. Then we got in the astronaut van, which was air-conditioned and very cold. As we were driving away, there's a window in the back of the van, and all of us were looking back at the shuttle on the launch pad, shivering and soaking wet like drowned rats.

Later that day they let us go, because it was obvious we weren't going to fly for a while. I took the family over to Disney World, and about four hours later we're standing in line at Space Mountain. And my wife said, "Well, this isn't quite what you thought you'd be doing today, is it?"

Beginning with STS-6, NASA placed several large Tracking and Data Relay Satellites (TDRS) in orbit to transmit data, voice, and TV signals from the shuttle. The gold-covered antenna unfurled after deployment from the cargo bay.

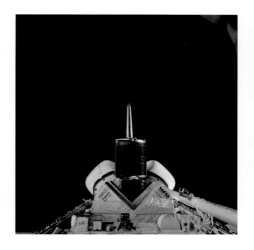

BOB CENKER | **This one was mine**

STS-61C

A familiar scene from the early 1980s: A commercial satellite pops upward from the shuttle payload bay. After the orbiter moves off to a safe distance, a booster rocket attached to the satellite will fire to send it to a higher orbit.

At the time of our 61-C mission in 1986, the Satcom was the highest-powered communications satellite ever built. It was a three-kilowatt spacecraft, which is tiny now, but at the time was a lot. And this was mine. I had worked on it at RCA for two years—it was the first spacecraft where I had been manager of systems engineering, so I was technically responsible for it.

When we deployed the satellite from the shuttle, I was lying on the ceiling, watching through binoculars, and it was surreal. I just lay there for about 15 or 20 minutes before it went into darkness. I saw the omni antenna go out, and I remember calling back, "We have the omni deployed." It was this 10,000-pound thing floating free out of the cabin, spinning at around 40 or 50 rpm. To me it all seemed to be in slow motion.

I remember being warned about the sound the satellite makes as it leaves the cargo bay. The first time they did one of these deploys, I'd been told that it scared everybody on board, because you mostly have silence in space. I mean, you hear fan noise, but people are attuned to the quiet. And when the satellite is deployed, you've got these explosive bolt cutters that release it. The shuttle is an all-metal structure, so the sound just rips through the vehicle. By the time of our flight we had been forewarned, though, so I wasn't particularly surprised when it happened.

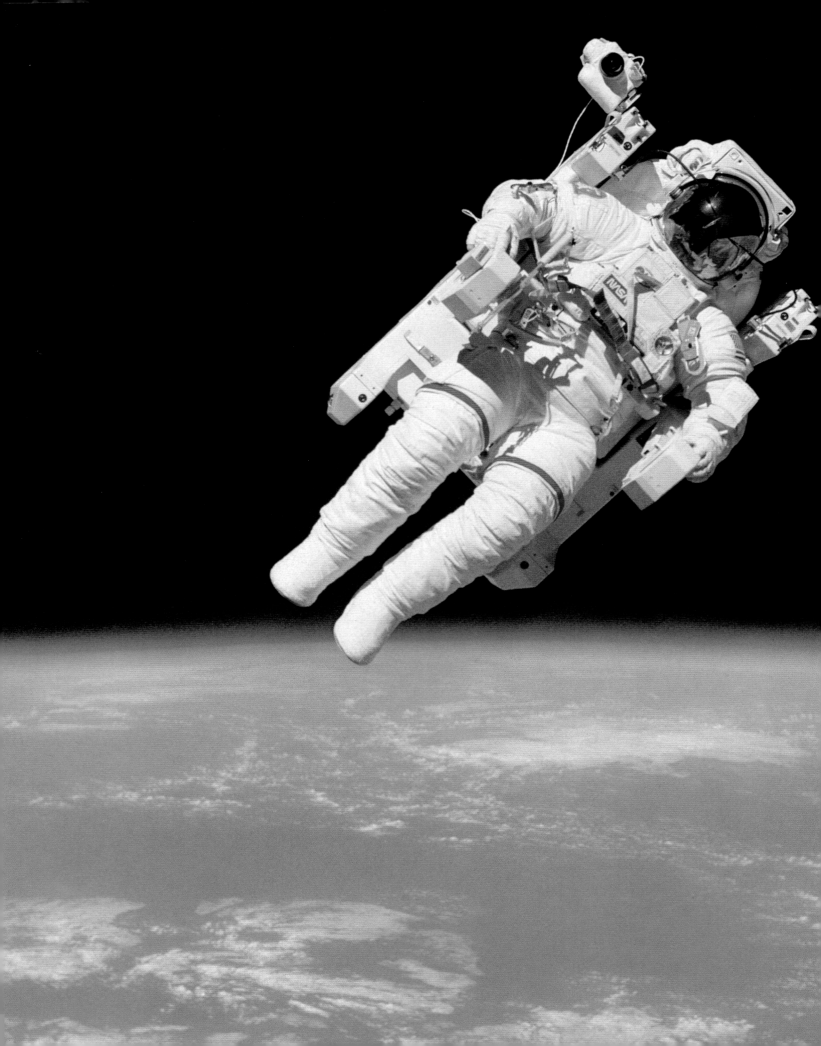

Test-driving the Manned Maneuvering Unit jetpack in orbit, STS-41B. Bruce McCandless took the MMU as far as 320 feet from the shuttle—the first time an astronaut ventured outside a spacecraft without being attached to a safety tether.

HOOT GIBSON | **NASA photo by Hooter**
STS-41B

By the time we came to the first tests of the Manned Maneuvering Unit jetpack on 41-B, we felt positively snakebit. We had already on this flight stranded two commercial satellites in worthless orbits after their onboard rockets failed, and a balloon target we were going to use for rendezvous tests had blown up. Now we get to the MMU, and it couldn't have gone better. Bruce McCandless first did a couple of brief test flights in the cargo bay, staying very close in case anything should go wrong. As we were approaching sunrise on one of our daylight passes, he was cleared to make the translation out to 300 feet from the shuttle. He started floating away, and I picked up the Hasselblad and thought, "I don't believe the image I am seeing out of this camera." The horizon was right there, and Bruce appeared at about a 30-degree angle because we in *Challenger* were 30 degrees from the vertical.

I started shooting, and I got very, very serious about these photos, because I thought to myself, "If I don't mess this up I'm going to get an *Aviation Week* magazine cover out of this." I must have taken three light ratings for every photo that I shot, and tweaked the focus six times for every time I squeezed the button. I shot a whole series of photographs of the MMU, and, sure enough, they made two *Aviation Week* covers. I've been very proud of those photos, because they have become some of the most used NASA photographs of all time. You see them everywhere, including the subscription cards inside *Air & Space* magazine. They never have my name on them. It never says, "NASA photo by Hooter." But I know who shot it.

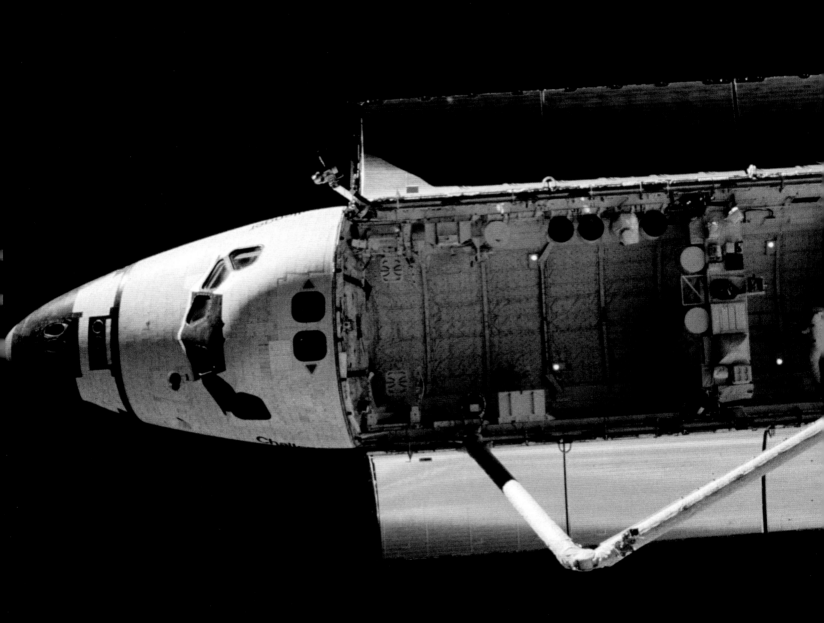

The view from out there: This is what McCandless saw looking back at Challenger during his famous untethered spacewalk (photo on preceding pages). Note the tiny figure of his partner, Bob Stewart, in the cargo bay. Opposite left: McCandless tries out a grappling device used to capture satellites in orbit. On the next mission, Pinky Nelson (flying the MMU at the bottom of the photo, opposite right) tried, but failed, to use the same device to dock with the ailing Solar Maximum Mission satellite. The crew eventually captured "Solar Max" with the shuttle's robot arm and repaired it in space.

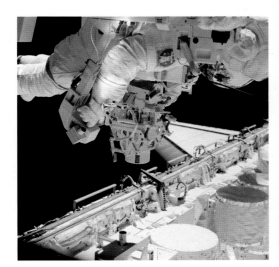

PINKY NELSON | **Flying solo**

STS-41C

Flying the Manned Maneuvering Unit, the jetpack we used in the mid-1980s, is absolutely amazing. First you back yourself into it—the backpack on your spacesuit locks into the unit. And it's a beast. It's really big. It wraps around behind you. You pull the controls up in front of you, and you have two little gauges, just like a fire extinguisher, one for each gas tank. Lights tell you when the jets are commanded to fire.

You're in this contraption that holds the MMU, and before you release from it, you first make sure to undo all your tethers. The last thing you want to be is a helium balloon on a string. You make sure you're untangled and that everything is turned on and in the right modes, and the other astronauts on board talk you through the checklist. Then you undo your feet, and it's a sensation like no other. I imagine it's like a skydiver stepping out of an airplane.

When I started out during mission 41-C—before flying over to rendezvous with the Solar Maximum Mission satellite, which we later fixed in orbit—the first thing I was supposed to do was a little test flight. I had planned all along to fly up to the back window of the space shuttle, where Bob Crippen and Terry Hart and Dick Scobee had their noses pressed up against the windows. For me it was so satisfying to do that. Here I was, the only non-test pilot on the crew.

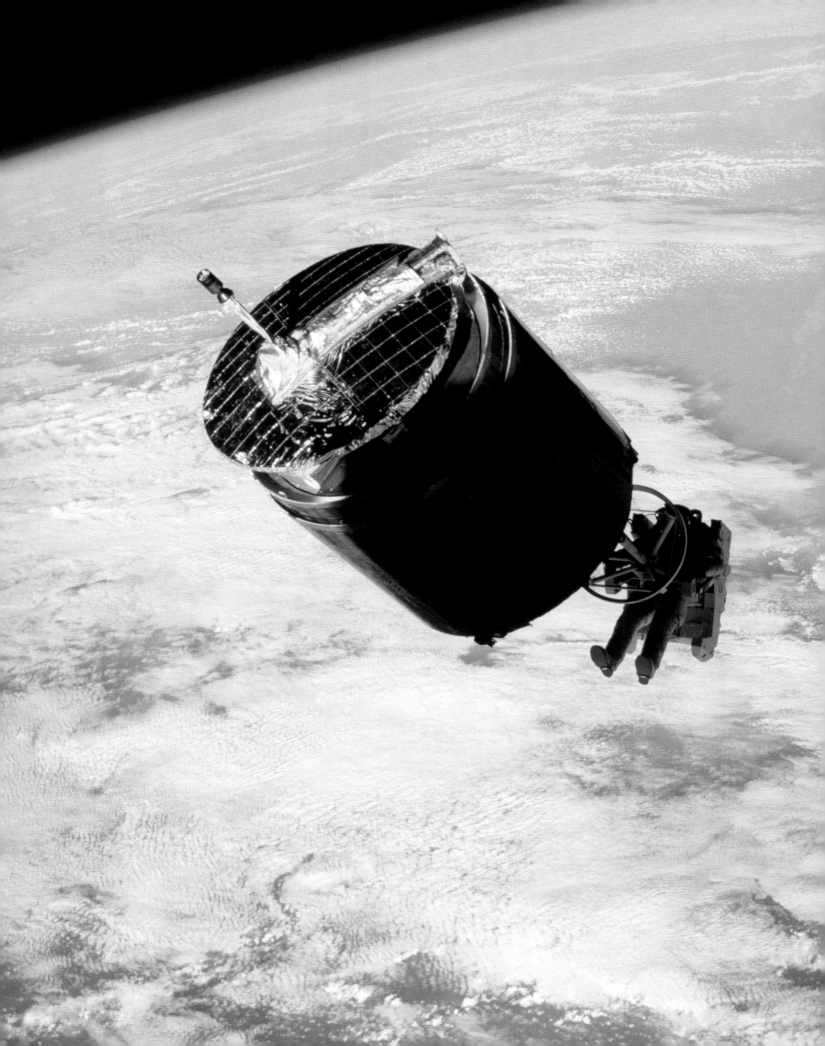

SULTAN BIN SALMAN AL-SAUD | **Wear your NASA costumes**
STS-51G

Top: Saudi Prince Sultan bin Salman Al-Saud flew as a payload specialist on STS-51G in 1985. Above: Owen Garriott, who lived on the Skylab space station for two months in 1973, returned to space 10 years later for the first shuttle Spacelab flight, STS-9. Opposite: Dale Gardner rustles a wayward satellite to be returned to Earth. The satellite was eventually sold to another owner and relaunched six years later on a Chinese rocket.

I was working for the Saudi Arabian Information Ministry in 1984 when I saw a news flash, something about the Arab Satellite Communications Organization recruiting to send people to space with the ArabSat satellite that was going to be launched from the shuttle. I never really gave it a second thought. But shortly afterward I was invited to a reception where I met the gentleman who ran the ArabSat organization. He and others were discussing the shuttle flight, and someone said that Saudi Arabia most likely would provide the astronaut. He was saying how interesting it would be to go into space, and I said that for me, it would be a dream come true.

A few days later I received a call asking if I would join a group of people from Saudi Arabia to be nominated for the program. And I said yes. The list grew eventually to something like 15 people, mostly from the Saudi Air Force. I told my parents my name was going to be put on a list, although I didn't think it would ever come up.

When I asked my father about it, he did not want to make the decision on his own. He went to the head of the family, his brother, King Fahd. The King turned it down. He said, "Let somebody else do it." I was really disappointed. Even if there was only a 10 percent chance I'd get to do it, I wanted at least to go through the process. So I asked my father to ask again, and the King was still hesitant. He thought there might be talk about how the Royal Family had just pushed in their own guy. I appreciated that, but I explained that this was not going to be Saudi Arabia's choice. And I wanted to be put to the test on my own merit. So he approved.

I was in fact chosen to fly on mission 51-G, and our crew managed to accomplish the mission successfully. After the shuttle landed in June 1985, our government put us on an airplane back to Saudi Arabia—the whole team, including my backup, Abdulmohsen Hamad Al-Bassam, and the entire science team. We landed in Taif, in the mountains of Saudi Arabia, where the government had its summer residence. I had planned to wear my national costume, and my backup had, too. But I got a call in the plane from my father, who said the King had told him, "Make sure these guys come off the plane wearing their NASA costumes." I hadn't wanted to do that. We wanted to appear like ordinary people so everybody would think they could do this, too.

Of course, it was my way of seeing things at the time, but the King was wiser. He understood that people saw us in a certain way. I tried to convince His Majesty on the phone, but it was basically an order. So we dressed in our NASA suits and got off the plane. At that moment I realized why he wanted us to do it, because it meant a lot to people. The country came out in the streets. I could not believe that our people had that kind of excitement in them. And I knew at that point that one of the main goals of our mission was successful. It enthused people and got them thinking about science and the future, and how we in Saudi Arabia were about to shift gears and go into a new era.

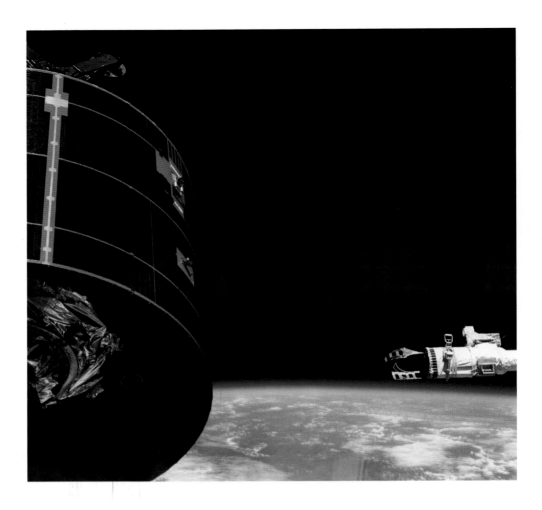

RHEA SEDDON | **You remember the deploy switch, don't you?**

STS-51D

Our 51-D mission in 1985 was supposed to have been a plain vanilla flight. It was five days, two satellite deployments. But on our second day in orbit, things were not going right. The Syncom satellite we deployed from the payload bay didn't work—the rocket motor that was supposed to raise it to a higher orbit didn't fire like it was supposed to, and now it was stranded in a useless orbit.

Mission Control told us to separate from the satellite. But rather than have us move off to a great distance, they kept us close in, as if they were thinking of something. Our commander, Bo Bobko, started asking, "What do you have in mind?" They began to unfold the story rather slowly. "We're going to see if re-rendezvousing with the satellite might get us something." Then they gave us more details: "We think we're going to send two guys out to hook something to the end of the arm that might turn on a switch. You guys remember the deploy switch, don't you? From your visit to the factory?"

Well, it had been over a year since we'd visited the factory where the satellite was made, and nobody ever showed us the deploy switch that fires the rocket motor. We didn't even know where it was. But they told us, "There's this little thing sticking out from the side that flips over when the satellite comes out of the cargo

With Rhea Seddon at the controls, Discovery's robot arm, equipped with a jury-rigged "flyswatter" device at the end, moves in to trip the activating switch on a stranded satellite's rocket motor, STS-51D.

bay. That's the only single-point failure we can think of. That switch didn't flip. And there may be a way you can flip it."

We're thinking, "*Whoa!*" We had trained for a rendezvous with a free-flying satellite many moons ago, but our mission had since been changed, and we never even completed the training. Then they said I would flip the switch using the shuttle arm. And I hadn't trained to do that. We started thinking, "Man, that satellite's got a big, live rocket motor attached to it. If we do something that turns it on at the wrong time, or we bump it and it fires off, that's going to kill us, right?" And of course, Jeff Hoffman and Dave Griggs, the two people who were going out on the spacewalk, had just the minimum EVA training, since there wasn't supposed to be one on this flight. So we're thinking, "How are we going to pull this off?"

Mission Control had to uplink through our teleprinter, our little teletype machine, instructions for how to build this flyswatter thing that the EVA guys would attach to the arm so I could use it to flip the lever. They couldn't uplink pictures, just a description. We would say, "Okay, you want us to take this thing, and fold that thing, and stitch this thing, and you want us to cut holes here, right?" And they would say, "Almost."

They outlined the whole plan, then asked, "Do you think this is feasible to do?" Meaning, "Do you *want* to do this?" Bo wisely said, "Let me caucus with the other people up here." We had some concerns, but in the end we were willing to give it a try. I think we had a gazillion questions about what if this or that happens. But we knew there were a lot of smart people on the ground doing the same thing. And that's one of the neat things about being an astronaut. Before you do something, you know at least 50 other people have asked the right questions and come up with the right answers.

When Jeff and Dave finally went out into the payload bay, it took them a while to figure out how to use some of the tools, how to stabilize themselves and help one another, since they hadn't had much EVA training. They attached the flyswatter and did a superb job, but it wasn't very pretty.

When it came my turn, I was thinking, "Oh, Lord, don't let me mess this up." I was very, very focused on moving the arm, catching the switch with the flyswatter, then backing out so the arm didn't get tangled up. I was looking out the window and at my TV screens. I did get three good contacts with the switch, but the motor didn't start up. We had to leave it for another crew to go up and repair the Syncom four months later.

When we got back everybody said, "You must have been so upset that the motor didn't turn on." But it was just the opposite—we were really excited! We did everything we possibly could have done, and we had pulled off all that stuff. If the motor had turned on, maybe we would have been five percent happier. But we were still pretty happy.

The crew of 51-D watches from Discovery's flight deck as the Syncom-IV-3 satellite looms out the window. Overleaf: The first shuttle spacewalk, STS-6. Story Musgrave (left) and Don Peterson tried out new spacesuits and other equipment in a mostly empty cargo bay.

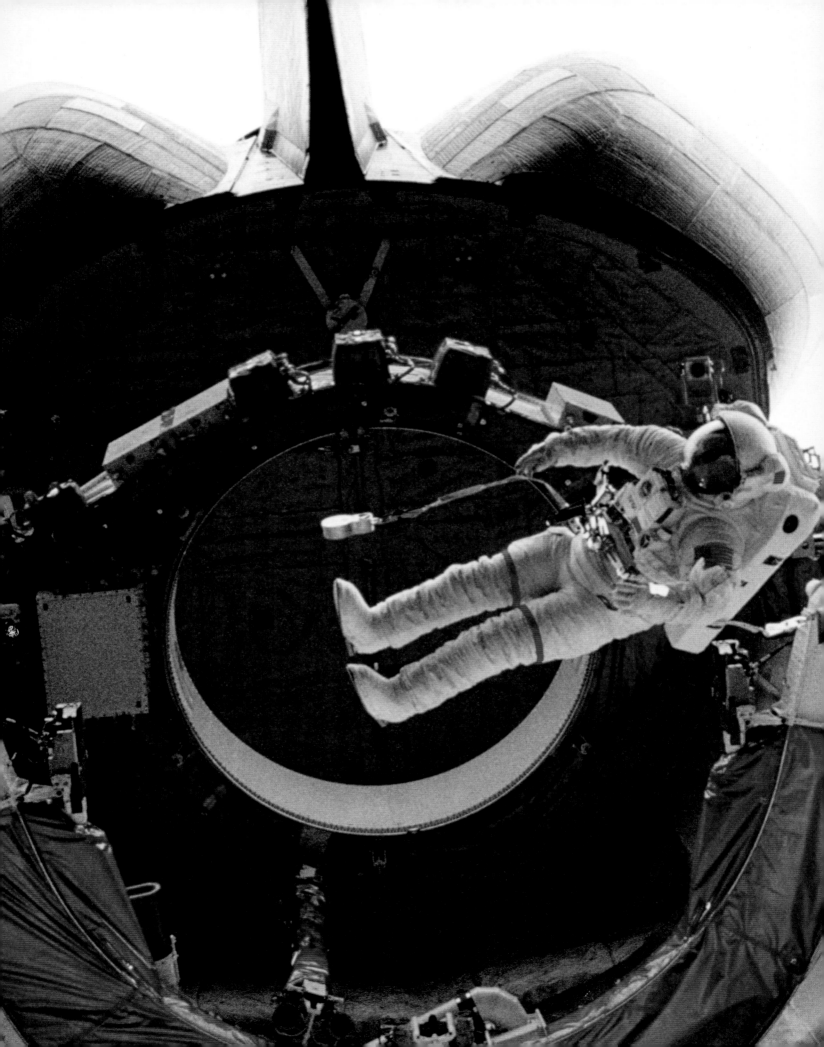

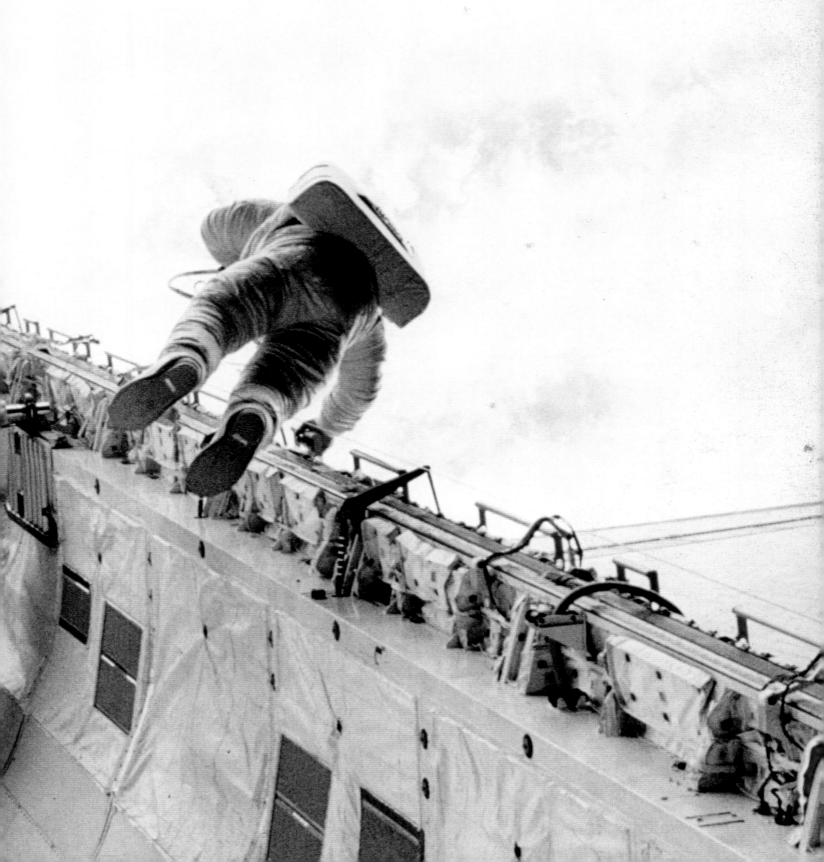

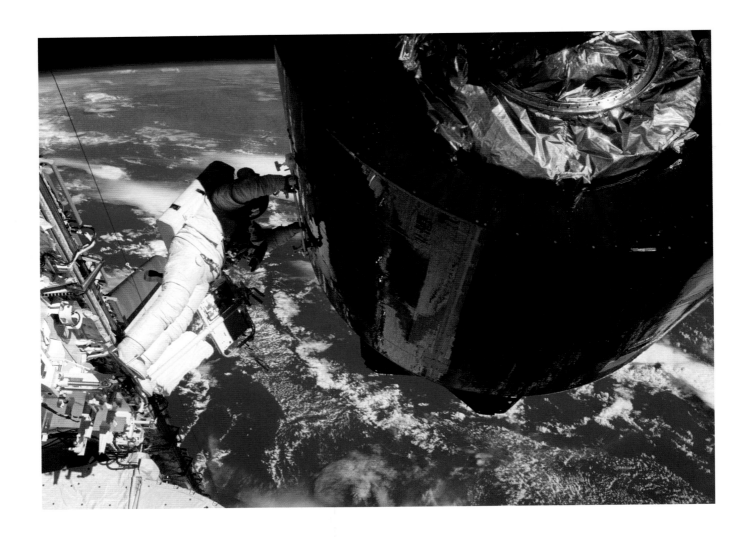

LOREN ACTON | **The Coke and Pepsi flight**

STS-51F

Coca-Cola had gotten permission do an experiment in space to see if they could dispense carbonated beverages in weightlessness. They got approval to build this special can, put significant money into it, and were all set to fly it on one of the early shuttle missions. This was during the "Cola Wars," when Ronald Reagan was in the White House. And somebody at a high level at Pepsi found out about this, went to their contacts in the White House, and said, "This cannot be allowed to happen—that Coca-Cola would be the first cola in space."

So the Coke can was taken off the mission it was supposed to go on, and Pepsi was given time to develop their own can so they could both fly on the same flight. It turned out that our 51-F mission ended up getting the privilege of carrying the first soda pop in space. Well, we got our cans for training. And indeed, the Coke can had had a lot of work put into it, and was designed to dispense a beverage without stirring up the liquid. The Pepsi can, when it showed up, looked like a shaving cream can. In fact, the Pepsi logo was just stuck on a paper wrapper, and when we peeled it off, indeed it was just a shaving cream can. It still had the shaving cream logo on it. Pepsi understood that this had nothing whatsoever to do

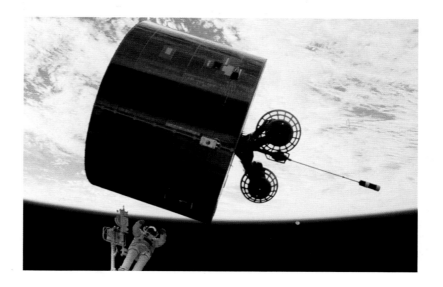

Opposite: Bill her handles the Leasat 3 satellite during the STS-51I repair mission in 1985. Above, right: Later in the flight, his spacewalking partner Ox van Hoften gives the 15,000-pound satellite a shove to set it spinning and on its way to a useful life in orbit.

with soda in space. It had to do with PR.

During training, the legal beagles at NASA headquarters got into the act. The rule came down that the cans would be covered during testing, so that no logo could be seen. And we would not be photographed during this testing. Then the directive came that the cans would be covered, but now we could be photographed. Then the next ruling was that the cans would be uncovered, the logo had to be visible, we could be photographed with still cameras, but we were not to be photographed with movie cameras. One thing after another came down, and this stupid thing was taking more time than our serious experiments. But we all took it in pretty good humor.

Well, the morning before the launch there is always a briefing, during which all the last-minute things that need to be talked about get talked about. We were about halfway through a briefing on the latest data concerning the sun—our flight had several solar physics experiments—when who should walk in but the chief counsel of NASA, who began to brief us once again on the Coke and Pepsi protocols.

At that point—and non-NASA payload specialists like me could get away with things that maybe career astronauts couldn't—I just blew my stack and said, "We've been getting ready for this mission for seven years. It contains a great deal of science. We have a very short time to talk about the final operational things that we need to know. We don't have time to talk about this stupid carbonated beverage dispenser test. Please leave." He turned and walked out.

But we did do our test in space. The red team did the Pepsi, and the blue team—we were divided into shifts—did the Coke. We took the still photographs, and we showed the logo. And indeed, the Coke can dispensed soda kind of like what we're used to drinking on Earth. And the Pepsi can dispensed soda filled with bubbles—fun to play with in zero-g, but not very drinkable. Still, when I'm giving talks in schools, they are a lot more interested in Coke and Pepsi than they are in solar physics.

HOOT GIBSON | **The end of innocence**

STS-61C

It was January 18, 1986, and we were having a difficult time getting back to Earth. Two days in a row, bad weather at the Florida landing site had forced us to wave off for another day. After the second try, I wrote a song that Pilot Charlie Bolden and I sang to Mission Control the last thing before turning in for the night. It was to the tune of "Who Knows Where or When?" and we sang in two-part harmony:

It seems that we have talked like this before / the Deorbit Burn that we copied then / but we can't remember where or when

The clothes we're wearing are the clothes we've worn / the food that we're eating's getting hard to find / since we can't remember where or when

Some things that happened for the first time / Seem to be happening again!

And so it seems we will Deorbit Burn / return to Earth, and land somewhere / But who knows where or when?

Mission Control loved the song. They had made their own joke, drafting a "Wanted" poster of my entire seven-man crew that said, "WANTED. IF FOUND, RETURN TO EARTH!"

In the early morning hours of January 18, we again woke early and went through the long, laborious process of configuring the shuttle for reentry. Once again we were all in our suits and helmets, hoping to land in Florida. But the weather still wouldn't cooperate. So they told us to go around one more time and land at our backup site at Edwards Air Force Base in California. We made the required changes to move the landing site, and with about 45 minutes remaining until the engine burn, suddenly found ourselves with nothing to do but wait. And that last orbit turned out to be one of my most memorable from the five spaceflights that I flew.

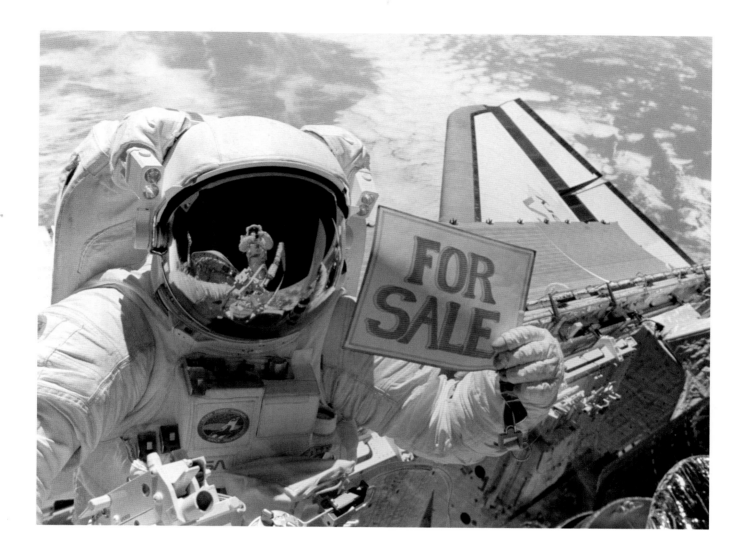

Opposite, left: Kathy Sullivan (left) and Sally Ride synchronize watches before boarding Challenger for mission STS-41G. Opposite, right: Joe Allen (left) and Dale Gardner pose with a friend, STS-51A. Above: On that same flight, Gardner advertises the two satellites he and Allen (reflected in the visor) have just salvaged from orbit.

We crossed the coastline of Baja California south of San Diego, and saw all the lights of the city shining like so many stars. I had served there at Miramar Naval Air Station and was able to make out the lights of the airfield from 160 nautical miles up. Next we watched as Phoenix and Tucson rapidly came into view, followed very quickly by El Paso. All of us had trained extensively there, flying the Shuttle Training Aircraft. We watched in silent awe as our tour of the southern U.S.A. crossed over San Antonio and Houston. We saw the Mississippi River Delta and New Orleans shining in the early morning darkness. Pensacola, Florida, where Charlie Bolden and I had trained as fledgling Naval aviators, swept gracefully by. As we finished our pathway toward the Atlantic Ocean, barely visible under the clouds was the Kennedy Space Center and Cocoa Beach, our intended landing site. It was the only part of the United States that had any bad weather to spoil our view.

In many ways, that mission ended the golden age of the early space shuttle program. The launch of Challenger was only 10 days after that, and none of us will ever forget the heartbreak associated with the loss of our friends and compatriots on mission 51-L. That last orbit of 61-C will forever live in my memory as a moment of beauty and silence that marked the end of innocence.

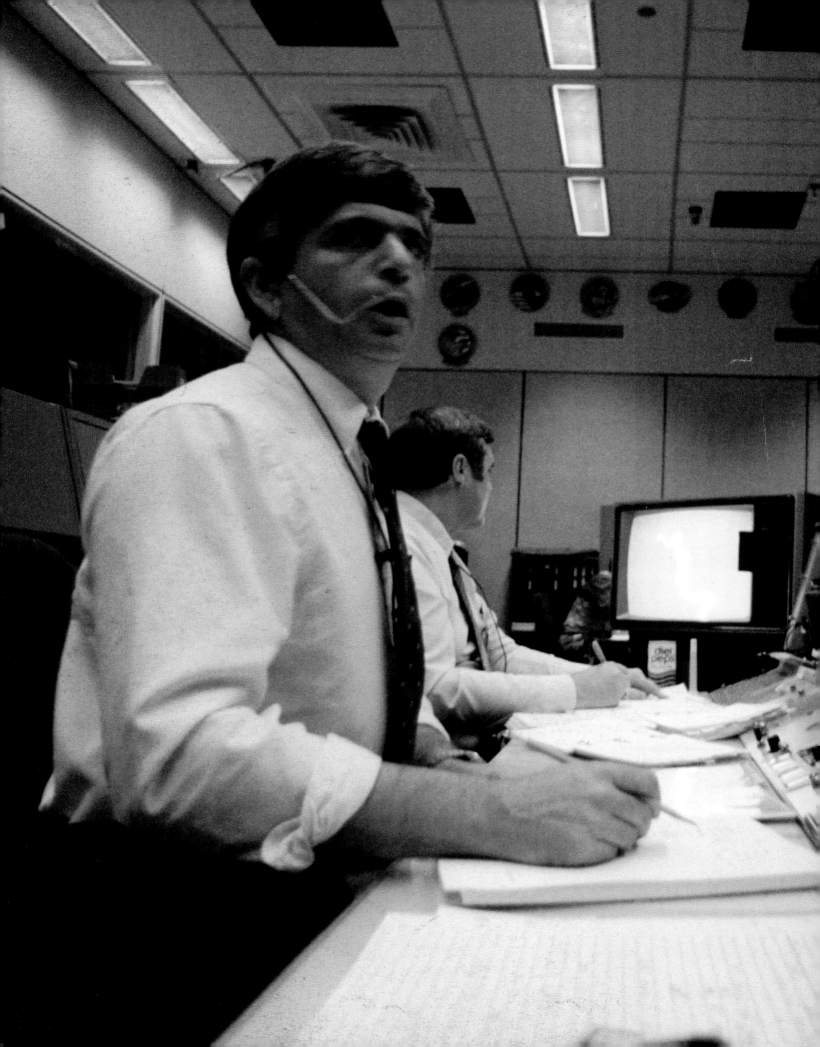

1986
STS-61C, 51L

1987

1988

STS-26

STS-27

The crew of STS-51L perfectly embodied the diversity of background that had become commonplace on shuttle flights by January 1986: three pilots, two engineers, a physicist, and a schoolteacher, who was onboard to kick off a new era of "Citizens in Space." That a single malfunction—hot gas leaking past a seal on one of *Challenger*'s twin solid rockets—could end their lives came as a shock to the nation and was a horrifying reminder of the shuttle's risky complexity. The *Challenger* accident was the first in-flight loss of astronauts in the history of the U.S. space program.

The shuttle program stood down for more than two and a half years while NASA examined both the technical and institutional reasons for the disaster. The solid rocket boosters were redesigned and a replacement orbiter, *Endeavour*, commissioned. Commercial satellites, with the attendant schedule pressure that had been an underlying cause of the accident, were banished from the shuttle. And astronauts moved into senior management positions, where they worked to rebuild the program with safety in mind. For the people who flew the shuttle, it was a dark period. "The national press was just godawful, unforgivably rude and crude and intrusive," remembers Pinky Nelson, who had the distinction of flying on the missions immediately before and after *Challenger*. "We spent a lot of time shielding the families from what was going on."

Flight controllers react to data showing a
"major malfunction" on Challenger, *STS-51L.*

BRIAN DUFFY | **We managed to keep surviving the problems**

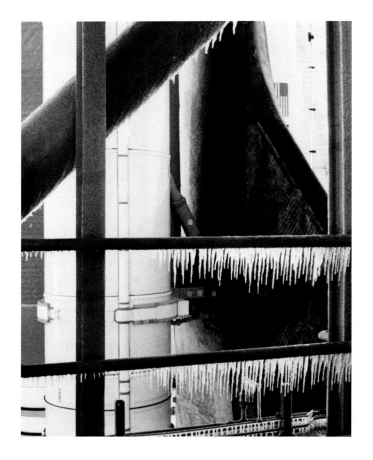

Icy cold at the launchpad on the morning of January 28, 1986, ultimately led to the failure of O-ring seals that held in hot exhaust gas on one of Challenger's solid rocket boosters.

I arrived at NASA six months before *Challenger* happened, and I knew nothing about flying in space. Here we were in the Monday morning meetings that the astronaut office holds. John Young was the chief of the office, and he would regularly become pretty emotional about mistakes that were being made and the way NASA was trying to push the launch schedule. He was not happy. I heard him more than one time say, "We're going to kill somebody around here." Being new to the business, I would just sit in the back row and listen and think, "Is this normal? Is this the way they operate in NASA?" That's not the way we had done it in the Air Force. I was more or less an observer, but I could sense that people were very unhappy with a lot of the management decisions and the way things were going. From a new guy's perspective it was confusing. Here we were, America's premier space program, but on the inside it was a totally different picture.

We flew about five flights in the second half of 1985, and had an awful lot of trouble getting 61-C off the ground in January 1986. They had nearly killed those guys when they accidentally drained liquid oxygen out of the tank before aborting the launch. We managed to keep surviving the problems, and I just thought that was a way of life. I thought you had problems like that, and you managed to get past them. When *Challenger* happened, I just thought, "*Wow!*" and thought back to what John had said.

BOB CENKER | **Did you know anybody on the crew?**

I was on an airplane for L.A. and had a radio with me. I heard there had been an accident, that *Challenger* had exploded. And if I could have reached through the radio and throttled the announcer, I would have, because he said they see parachutes. He said they're going looking for the crew. And I'm thinking, "This guy obviously has not a clue what he's talking about."

The guy sitting next to me on the plane looked at me. I think I started shaking—I was in bad shape. He said, "Are you okay?" I said, "The *Challenger* just blew up." And he said, "Oh, no." Then, "Did you know anybody on the crew?" I said, "Yeah, I worked with them. I was on the last shuttle flight." He got the stewardess, who asked if she could get me something. I had a drink, which is something I very seldom do.

Because Christa [McAuliffe] and I were both payload specialists, we had a closeness. We were going to exchange pictures after we both returned as spaceflight veterans. I talked to her right before she left for the Cape. She was gathering up her stuff, and because I'd just come back she said, "Tell me what it's like, tell me what it's like." And I said, "Nope, nope, you gotta go. Nothing I can tell you would ever prepare you for it." I said, "When you come back, we'll talk."

I remember having dinner months earlier with Christa, her backup Barbara Morgan, and my backup, Jerry Magilton, another engineer from RCA.

STS-51L mission and payload specialists practice emergency escape procedures at the pad, three weeks before launch. Foreground: Ron McNair, Greg Jarvis, Christa McAuliffe. Background: Judy Resnik and Ellison Onizuka.

We were talking about risk, and how any one of us would do anything to get to go into space. Because Christa wasn't in the space business, she would ask during our training, "What happens if this or that goes wrong?" One of the things that impressed me about the NASA folks was that they would answer, "Well, if that goes wrong, it's a loss of crew." It was not a flip response. It was not a joke, but there was no hiding it either. You're going to die. It was simply a statement of the facts.

Christa understood that. That was one of the problems I had when people said she had no business being there. It does not take a rocket scientist to realize that you are risking your life. And nobody ever misrepresented it to Christa, at least not in my presence. Nobody ever said, "This is safe."

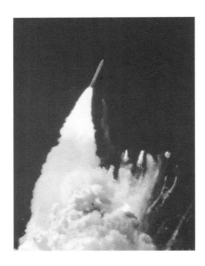

Above: One of Challenger's *still-thrusting solid rocket boosters emerges from the fireball. Opposite, above: The cloud from the explosion appears as an oval smudge east of Cape Canaveral at center of this GOES-6 weather satellite photo taken six minutes after launch. Opposite, below: A 15-foot piece of debris from one of* Challenger's *rudder-like elevons washed up on a Florida beach in December 1996, nearly 11 years after the accident.*

BILL NELSON | **Why was I spared?**

I had just returned from my own shuttle flight 10 days earlier. Congress was back in session, so I went back to Washington. I had the whole staff in my office with NASA TV turned on, explaining to everybody what was happening inside the shuttle during the countdown. When *Challenger* exploded, we saw it on the far camera shot—it wasn't the close-up that we later saw replayed over and over. It wasn't immediately apparent what had happened, and by the time it sunk in, everybody in the office had dispersed. I was in there by myself.

I went back into the little bathroom in my congressional office, got on my knees in front of the sink, and said, "Why was I spared?" We'd had four launch scrubs on my own flight, and we found out after the fact that if we had gone ahead and launched on any one of those four, it would not have been a good day.

During the congressional investigation of the accident, we heard from two engineers from Morton Thiokol, the company that built the solid rocket motors. They had begged their management to stop the launch of *Challenger* the night before when the temperatures got so frigid. Of course, management didn't pay any attention to them, even though they specifically argued that the O-ring seals that were supposed to hold in the exhaust gasses were going to fail in the cold weather.

I pulled these engineers aside during a recess in the hearings, and asked them why they had not made the same objection only a few weeks earlier during our first launch attempt on December 19, when it was 41 degrees, and *Challenger* had launched in 36-degree weather—only five degrees difference. They said, "Congressman, it wasn't until we got the solid rocket boosters back from your launch that we noticed there was blow-by of hot gasses, which alerted us to the problem with the O-rings."

PINKY NELSON | **His mission just blew up**

It just breaks my heart every time I see a picture of Mission Control right after the *Challenger* came apart. Jay Greene, the flight director, is in charge, and his mission just blew up. The professionalism that he and everybody else in Mission Control exhibited during that time was really something, which says a lot about NASA. The role that Flight Director Gene Kranz played in Apollo 13, well, that was Jay's role. Only this time they didn't make it.

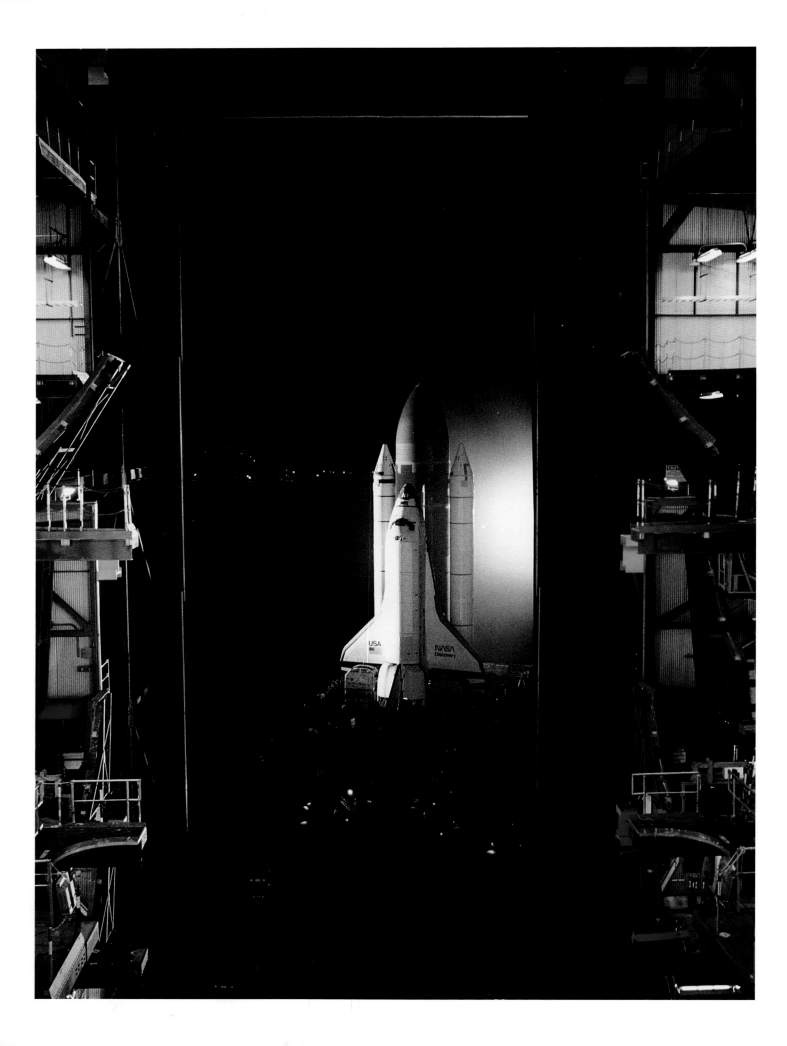

RICK HAUCK | **Tough days**

The *Challenger* explosion crushed all of us who worked in the astronaut office. Beyond the unfathomable loss of our friends and the horrific pain inflicted on their families, our own professional world was disintegrating. When would we fly again? *Would* we fly again? It didn't occur to me that this was an avoidable accident. Every bit of my experience at NASA since I arrived in mid-1978 bespoke professionalism

and caution. I'd never seen a more dedicated group in my aviation career. By this time I had flown two missions on the shuttle, and I always knew I was putting my life at risk when I launched. But deep down inside, I "knew" NASA had the formula for success. I was wrong.

I wasn't prepared for the public pillorying NASA received at the hands of the press, Congress, and the public. It was if they were jilted lovers. We were all the bad guys. In some ways it reminded me of the atmosphere surrounding my return from flying combat in Vietnam: being the object of pent-up anger and frustration. Those were tough days.

FRANKLIN CHANG-DIAZ | **A certain kind of battle scar**

Opposite: Discovery rolls out from the Vehicle Assembly Building toward the launch pad, July 4, 1988. STS-26 carried the first all-veteran astronaut crew since Apollo 11. Above, from left: Rick Hauck, Dick Covey, Mike Lounge, Dave Hilmers, Pinky Nelson.

My first shuttle flight was the last flight before the *Challenger* accident. And even though we'd had delays and difficulties in launching, I never, *ever* thought there was a tremendous danger, even though I knew intellectually that there was. So the transition from my first flight to my second flight in 1989 was one of maturity, I think—a certain kind of battle scar that you now have, and will never erase. In that respect I was more scared on the second flight than I was on my first flight. I realized I was vulnerable. Nevertheless, it was extremely important to me, and I've flown multiple times since.

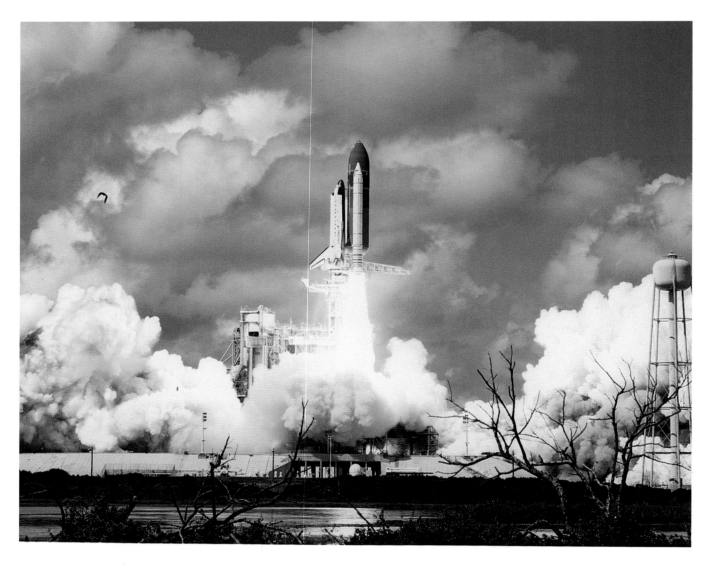

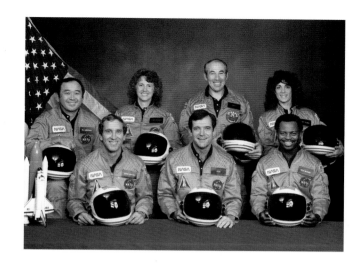

Opposite, below: Liftoff of STS-26, September 29, 1988. Opposite, above: Mission controllers listen to an in-flight tribute by Discovery's astronauts to their fallen 51-L comrades, right: (front row) Mike Smith, Dick Scobee, Ron McNair; (back row) Ellison Onizuka, Christa McAuliffe, Greg Jarvis, Judy Resnik.

RICK HAUCK | **Buen viaje**

If anybody had told me back in the days of Project Mercury that we would go all these years, dealing with all these complexities of space travel, and would have only one failure, I'd have thought that was wishful thinking.

—JOHN GLENN

The first shuttle mission after *Challenger* was relatively simple: Launch a NASA relay satellite from the cargo bay and conduct a number of in-cabin experiments. The other (and in fact most important) objective of STS-26 was a safe launch and return. During training for the flight, our crew talked about how to recognize the sacrifice of the *Challenger* crew while we were in orbit. Dave Hilmers suggested that we each compose a few sentences that could be stitched together into a sort of eulogy. We worked very hard to find the right words.

Throughout training we would receive letters of encouragement from all over the world. As launch approached they grew steadily in number. A few that arrived the day before launch:

"Our thoughts are with you and we pray for a safe launch and journey. God bless America."

"Good luck. All the prayers and wishes of the American people are riding with you."

"Way to go, guys. I wish I could go with you."

"I wish you all the luck in the universe to succeed in this new mission of humanity. We, all the human beings, are proud of brave people like you. When you pass over Colombia be sure that there is one Colombian who is wishing the best for all of you. *Buen viaje y muchos exitos.*"

Some have asked me if it took unusual courage to fly that mission. On the contrary, I was convinced that NASA and its team of contractors would do all they could to minimize the risks. I told my family that this would be the safest mission NASA ever launched. And all did go smoothly. On the third day of the mission, we each delivered our part of the eulogy with deep emotion. It was the only time during any of my flights that I had the sense the world was listening.

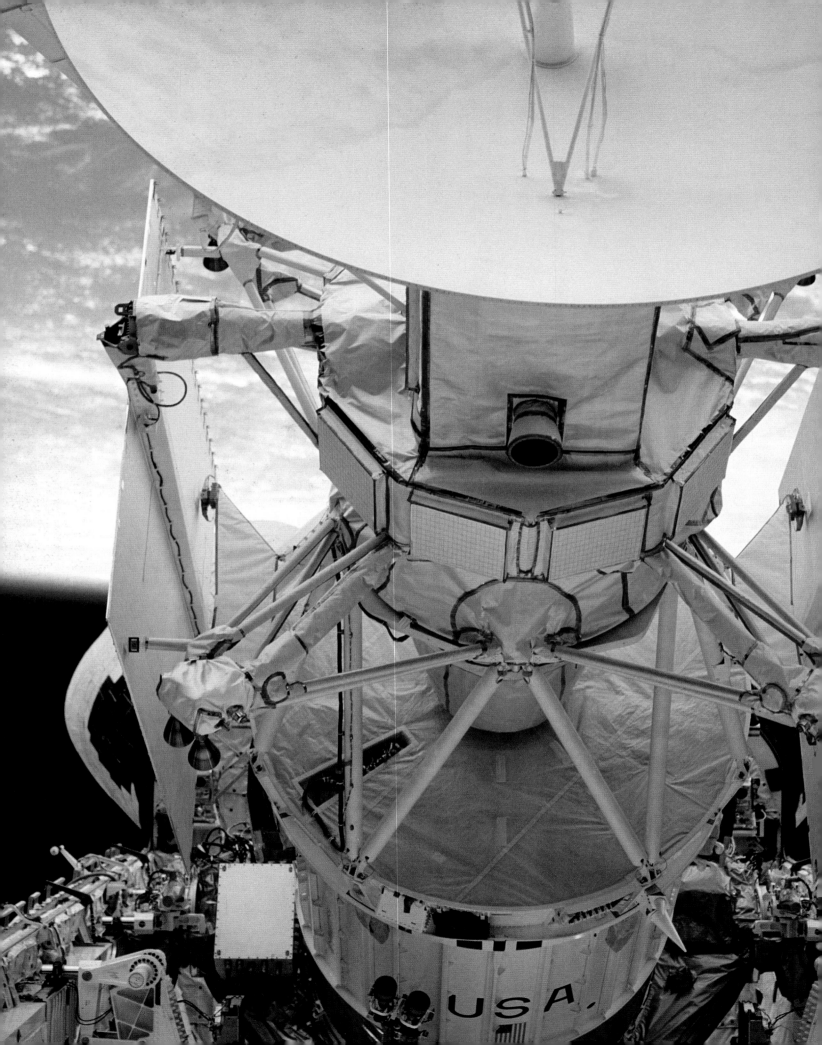

The years immediately following the STS-26 return to flight were among the most productive in the shuttle's history, as a long backlog of payloads finally made it to the launch pad. Among them were several high-value planetary and astronomy missions: the Hubble Space Telescope, the Galileo probe to Jupiter, Magellan to Venus, and the Upper Atmosphere Research Satellite, which pointed its instruments not outward, but back at Earth. In a bravura display of the shuttle's versatility, astronauts re-visited Hubble three years after launch to correct a defect in its optics and made two more service calls in orbit before the decade's end.

The early 1990s was also a period of recovery for the Defense Department's space program, which, like its civilian counterpart, had been set back by the *Challenger* accident. Most of these flights were conducted under a shroud of secrecy, with little information relayed to the public. Along with astronomy and military satellites, the shuttle flew a series of Spacelab research missions carrying dozens of international experiments in disciplines ranging from materials science to plant biology.

The Space Transportation System reached a new level of operational maturity during these years as the flight rate increased, the on-time launch record improved, the shuttle team honed its skills, and a fourth and final orbiter, *Endeavour*, joined the fleet.

The Magellan spacecraft rests in Atlantis' cargo bay before beginning its journey to Venus, STS-30.

1989

STS-29
STS-30

STS-28
STS-34
STS-33

1990

STS-32
STS-36

STS-31

STS-41
STS-38
STS-35

1991

STS-37, 39

STS-40

STS-43
STS-48

STS-44

1992

STS-42

STS-45

STS-49
STS-50
STS-46

STS-47
STS-52

STS-53

1993

STS-54

STS-56, 55

STS-57

STS-51
STS-58

STS-61

1994

STS-60
STS-62
STS-59

STS-65

STS-64, 68

STS-66

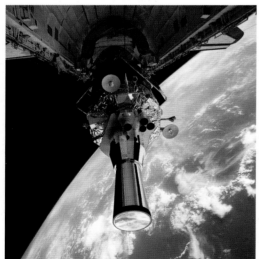

HOOT GIBSON | **A medal we could only wear in a safe**
STS-27

One of the highlights of my career came after STS-27, the first classified mission after the *Challenger* accident. My crew and I got to debrief the Joint Chiefs of Staff in the Pentagon, and since I was the mission commander, I got to lead the debrief. We showed them our classified movie, which was top-secret and had to be carried by a courier in a locked briefcase attached by a handcuff to his wrist. It was really serious stuff. We made another unclassified movie for the public, but the top-secret version showed the payload and how it worked. At the end of the briefing the chairman of the Joint Chiefs said, "Gentlemen, thank you very much. I think we all owe you a standing ovation." They all stood up and applauded. It was a top-secret moment that nobody ever got to see, but it was one of the highlights of my whole career.

Then we all hopped in a little van that took us to CIA headquarters for a cere-mony. The head of the CIA, who was then Judge William Webster, pinned the National Intelligence Achievement Medal on each of us and on our two lead flight directors. We took pictures and had coffee and doughnuts, and I presented Webster with a flag and banner and patch we'd flown on the shuttle.

After the ceremony we were walking out the door, and there was a security agent standing there with his hand out. He says, "I've got to have that medal back." Mike Mullane, a mission specialist on that crew who is just as funny as can be, says, "Wait a minute—you mean to say you just gave us a medal we can only wear in a safe?" The security agent says a little bit sheepishly, "Well, yes, I'm afraid that's true. But anytime you're here in the D.C. area you can come back here and see your medal. Not only that, but you may not tell anyone you received a medal or that any of this ever happened today."

That's the way it stayed for about four and a half years. Then in 1993, they gave us our medals, gave us the citations, and said that anything in the citation is now unclassified. The citation says that we launched aboard *Atlantis* and deployed a major new intelligence satellite for the United States with the shuttle arm. We sepa-rated away from it, and it had a problem. We re-rendezvoused with it and assisted with fixing it, separated again, and left it. And it went on to be a major success.

Still today, those are the only things we're allowed to say about STS-27. It was the first time we were allowed to acknowledge that we got off a satellite up there, even though anyone who walked out at sunrise could see it going over.

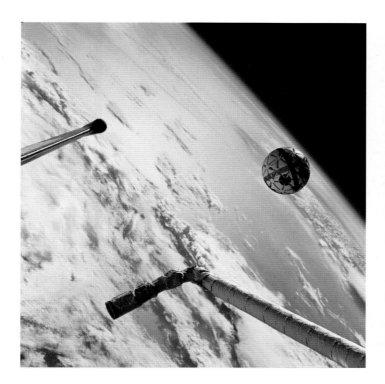

FRANKLIN CHANG-DIAZ | **Oh well, the tether broke**

STS-46 and STS-75

What looks like a soccer ball is actually a free-flying, camera-equipped satellite tested during a spacewalk on STS-87. Such a camera might be used in the future to inspect spacecraft. Right: The experimental Tethered Satellite reels out from its supporting mast, STS-75.

Opposite, above: STS-27 commander Hoot Gibson. Following the Challenger *accident, crews wore bulky pressure suits for added safety during launch and entry. Opposite, below: A Defense Department DSP early warning satellite prepares to deploy from Atlantis, STS-44.*

I was on two flights where we reeled an Italian-made tether out into the ionosphere to test its ability to generate current. On the second flight the tether was behaving just perfectly as it deployed. We were looking out at this satellite on a string, which was reaching out almost 20 kilometers—13 miles—from the shuttle. It was a beautiful sight, and reminded us of flying a kite as little kids.

The tether had almost reached its final position when I heard from the back Jeff Hoffman saying, *"Whoa, whoa, whoa!"* followed by something like, "The tether snapped!" I was looking at data on a display screen, and saw the signature of what appeared to be a tether break. It was a very clean break. There was no sudden jolt or anything like that. The satellite on the end of the line just went away, and there was still a point of light dangling off the end where it had snapped, which told us it was high voltage on the wire that was causing a small ball of plasma to form right then and there.

It's funny, because I don't remember having any kind of emotional reaction to all this. I just thought, "Oh well, the tether broke, so we've got to do this, that, and the other." It didn't dawn on me what had truly happened in terms of the disappointment until we had gotten through all the excitement of reconfiguring everything.

But the experiment itself was a major success, because we did generate the 5,000 volts that people were expecting to generate. And the current circulating through the tether was about three times higher than what we thought was going to come through. The concept was definitely viable.

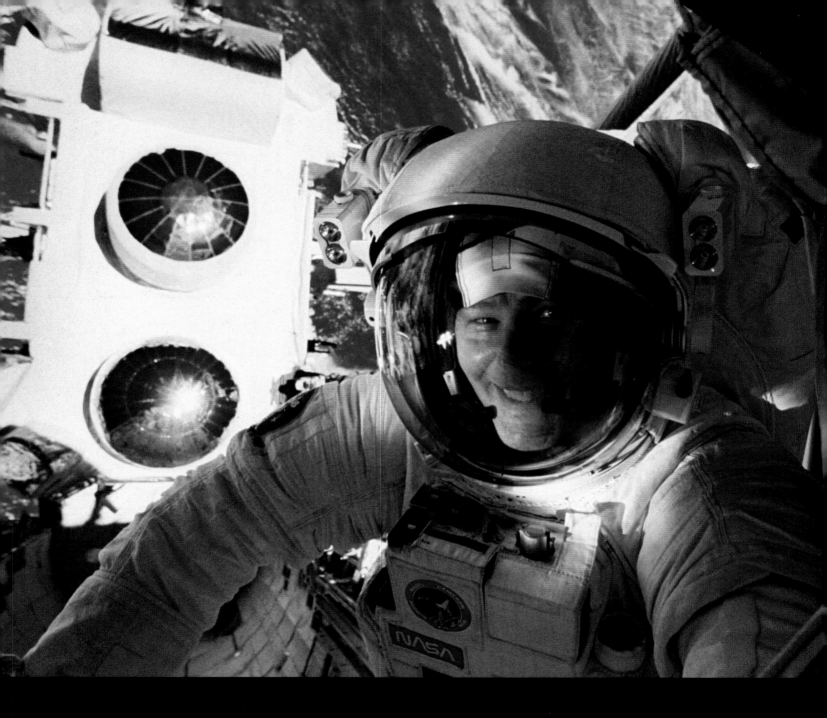

Jerry Ross, photographed from inside the shuttle moments after fixing a balky antenna on the Gamma Ray Observatory, STS-37. Opposite: The Long Duration Exposure Facility (LDEF) was returned to Earth on STS-32 after nearly six years in orbit. On board were a variety of materials, from paint samples to tomato seeds, being tested for the effects of prolonged exposure to the space environment.

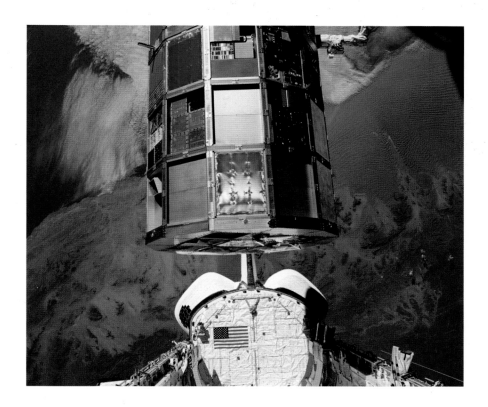

STEVE NAGEL | **With a few shakes it came loose**
STS-37

After we lifted the Gamma Ray Observatory out of the bay and deployed the solar arrays prior to releasing it in space, I should never have said this, but I said to Jerry Ross, "We're out of the woods now." Then the ground sent the command for the high-gain antenna—a dish antenna on a 10-foot-long boom—to deploy, and it didn't move at all. So we went to our contingency plans, one of which was to fire jets on the orbiter to shake it free. I never had any confidence in that, because the arm is so spongy with the satellite on the end that you fire a jet and it doesn't do anything—all the motion is damped out by the time it gets to the satellite. The next step was to move the arm at its maximum rate, then stop abruptly. Well, the arm moves too slowly to shake anything. So I said to Jerry, one of the two designated spacewalkers on this flight, "You and Jay [Apt] might as well start checking out your spacesuits."

So outside they go. The Gamma Ray Observatory wasn't built for spacewalk servicing like the Hubble Space Telescope, but it was built to be EVA-friendly, so you could climb around on it. Jay hung out on the left side of the cargo bay, Jerry went down the right side, and—this is the low-tech part—started shaking the antenna boom. It turned out a thermal blanket was hung up on a bolt or something, so he just grabbed the boom—he's a pretty strong guy—and with a few shakes it came loose. That was 17 minutes into the space walk, a very short time. I took a picture [opposite] of Jerry right afterward, and he's looking through the aft window just beaming.

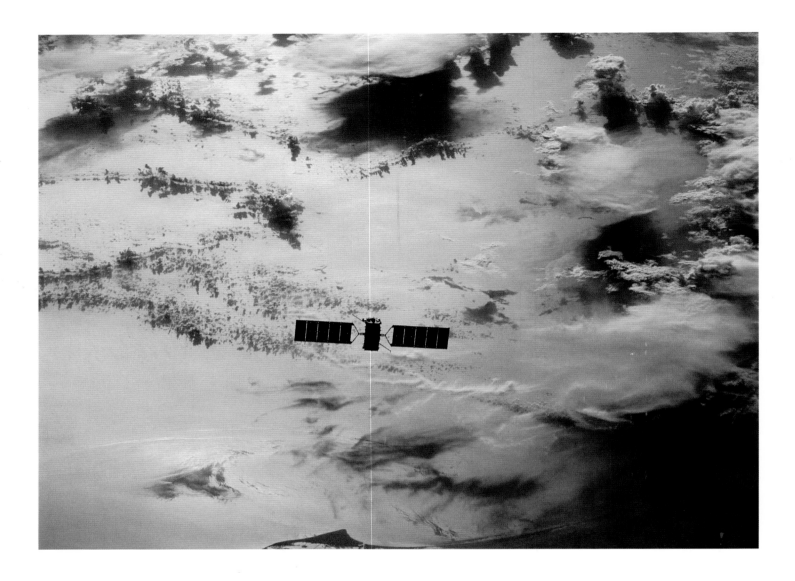

ANDY ALLEN | **I never remember being more scared**
STS-46

On my first flight, STS-46, we had a European free-flying satellite called EURECA. After we released it from the shuttle, we were supposed to fly in formation at a distance of 1,000 feet while they did all the testing and checkout from a control center in Germany. On the dark side of the Earth you couldn't see the satellite very well, so I just flew off the radar, making sure we stayed about 1,000 feet away. After about six hours of this, everybody else was hungry and went downstairs to get something to eat. So I was up on the flight deck all by myself, flying formation.

On a night pass we have about 10 minutes where we lose radio contact with the ground. We had just entered one of those periods, so there was no contact with Mission Control and no view of the satellite. I'm up there by myself, and all of a sudden the radar starts picking up what we call "range rate," which tells you the satellite is either coming at you or going away from you. The range was going down, so the satellite was coming at *Atlantis*. At first I thought it was a problem with the radar, but the rate kept increasing.

It finally got to the point where I figured if it was really true, it was either going to

The orbiting EURECA spacecraft passes over Florida's east coast, STS-46. Cape Canaveral pokes up into the frame at bottom center.

hit us in a few seconds, or I had to do something about it. So I did some pretty aggressive maneuvering using the reaction-control jets, which, when you fire them, sound like cannons going off. It vibrates the whole vehicle, and it's a very loud boom. I fired off enough of those things that Loren Shriver, the mission commander, screams up from the mid-deck, "What are you doing with all my prop?" because we were very conscious of conserving propellant, and here I was wasting it. He said it facetiously at first, but then when I kept pounding off those jets, he realized he'd better come upstairs.

Loren's a pretty calm, quiet guy, and he just says, "Okay, where is the satellite?" I say, "I don't know." It's still dark, we're still out of contact with Houston. The satellite is so close that it's broken radar lock, but we don't know if it's next to our wing or our window. The rest of the crew comes upstairs and starts looking for the satellite, shining flashlights out the window.

Communication with Houston returns, and they call up wondering what's going on. Because the media and everybody else are listening, Loren just answers back that we've had a change in range rate on the satellite and we're still sorting through it all.

What had happened, as it turned out, was that the control center in Germany had tried to rotate the satellite but had sent the wrong command, which fired all the satellite's jets. Unbeknownst to Mission Control and to the crew, they fired all the jets in such a fashion as to send EURECA toward us at four to five feet per second. They couldn't have planned it better if they had wanted to hit the orbiter, and at 1,000 feet, you didn't have a whole lot of time to react.

Our simulations before the mission had shown that if you fired the shuttle's jets in the direction of the satellite when it was inside about 700 feet, we would destroy its solar arrays, which meant the satellite would be useless. It got well within 700 feet, and I was still firing those jets. We're all looking out different windows, trying to find the satellite and waiting for the sun to come up. I never remember being more scared. Am I going to be written up in *Aviation Week* magazine as the astronaut who destroyed a satellite that cost hundreds of millions of dollars? I was floating there, more scared than when I'd had bird strikes in airplanes and almost gotten killed.

We eventually found the satellite. Jeff Hoffman was the first to pick it out, and he took a picture of it. The solar arrays were beautiful. As a matter of fact, it turned out the picture showed a sunrise over the Kennedy Space Center, and it won a photo award in *Aviation Week*.

The SEPAC (Space Experiments with Particle Accelerators) instrument (black spheres) carried on STS-45 generated artificial auroras to study the electrical environment around the shuttle.

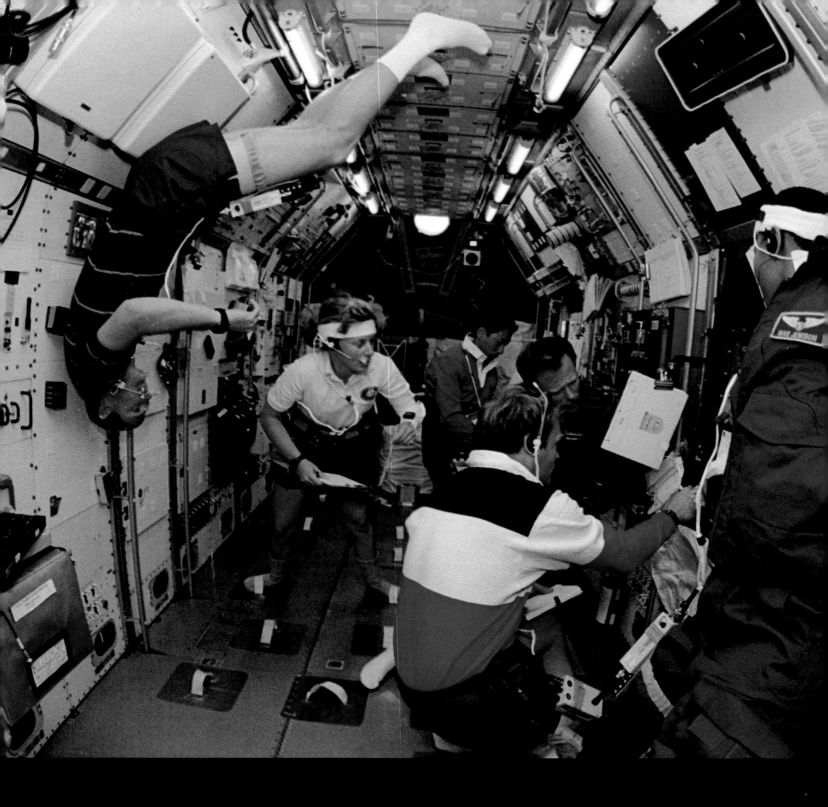

A change of shift inside Spacelab, STS-47. From left: Curt Brown, Jan Davis, Japanese payload

specialist Mamoru Mohri, Mark Lee, Hoot Gibson, Mae Jemison. Opposite: The Galileo spacecraft

drifts away from Atlantis before firing its onboard rocket to head toward Jupiter, STS-34.

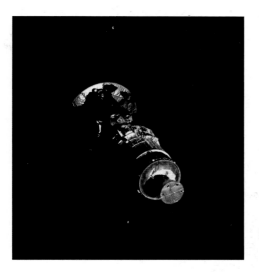

FRANKLIN CHANG-DIAZ | **Part of me was riding on that spacecraft**
STS-34

Deploying the Galileo spacecraft to Jupiter was memorable to me because it represented something I have always strived for—to be able to leave Earth and move out to other planets. It almost seemed like a part of me was riding on that spacecraft when we deployed it from the cargo bay.

Because Galileo's batteries contain plutonium, it also was the first time a shuttle launch became engulfed in the controversy over launching nuclear material into space. It was striking to drive through the gates of the Kennedy Space Center and see all these demonstrators trying to stop the launch. The topic of nuclear power is going to come up over and over again as we move into space. It's a key issue we are going to have to resolve, because the survival of people in space, far away from Earth, will totally depend on the use of nuclear power.

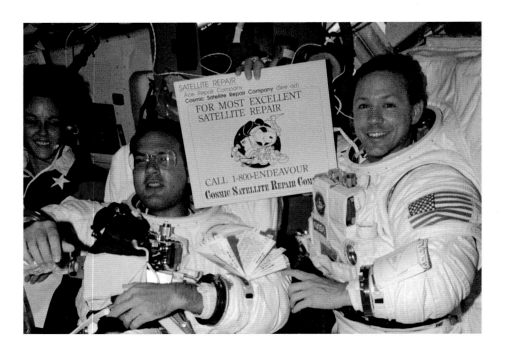

RICK HIEB | Why don't we send three people out?

STS-49

We had already tried twice on STS-49 to capture the INTELSAT satellite, with no success. We were kind of moping around, struggling to figure out what we could possibly do differently. Everybody was getting ready for bed when Kevin Chilton, the pilot on the mission, floated up to the flight deck and said, "Hey, Rick, let's figure out something else we could do." My first thought was, "Okay, Kevin is a smart guy, but we've already looked at all the possibilities, and there are no other answers here." But Kevin and I started brainstorming, and various other members of the crew heard us talking and started coming up. Pretty soon nearly the whole crew is crowded around the flight deck, thinking of this and that and the other idea.

Kevin and I had been thinking we could manually grab the satellite somehow. The problem was where—we just couldn't come up with a place to grab it. We looked at the top of the spacecraft where all the antennas were, and that didn't seem to make any sense. And Bruce Melnick said, "Well, why don't we send three people out?" That had never been done in the history of the space program, partly due to questions about safety, and partly due to practical concerns like how you'd fit three people in the airlock. When Bruce said that, though, a big mental switch flipped over, at least for me. In my mind, having a third set of hands out there meant that we would be successful, although we weren't yet sure how.

Meanwhile, the ground was telling us to go to bed. They knew we were still up, because we hadn't turned off the screens on our computers. After they nagged us a couple of times, we finally reached over and turned off the screens so they would think we'd gone to bed. Meanwhile we stayed up and talked for quite a while longer. Ultimately we were so excited about the idea we called the ground again and said, "Well, we didn't go to bed yet, but we have this idea."

The STS-49 rescue of INTELSAT-VI, a communications satellite stranded in the wrong orbit by an errant rocket launch two years earlier, didn't go according to plan. Pierre Thuot (right) and Rick Hieb tried to stabilize the satellite using a "capture bar" designed specifically for the mission, but failed on two consecutive spacewalks. The crew improvised a third, three-man spacewalk—the first in shuttle history— and pulled off the repair.

PIERRE THUOT | **Ready, ready, grab!**

STS-49

Every time I watch the video from STS-49, I say, "God, I can't believe we did that." If somebody had suggested to me before the mission that we were going to send three astronauts out on a spacewalk, I would have said, "No way, it'll never happen." But here we were, the three of us out there working. When we got ready to grab the slowly rotating satellite, I was on the end of the arm. Rick Hieb was in the best position to see, so he was going to give the command, "Ready, ready, grab!" He said, "Ready, ready..." then I yelled, "*Abort!*" because the satellite had a slight wobble, and even though it was only rotating slowly—a revolution every three minutes—the part I was supposed to grab had tilted up out of my reach just as I was supposed to grab it. So we said let's hold up, we'll wait until it comes around again. When it did, Rick said, "Ready, ready, let's do it!" We all grabbed the satellite, and it was very easy. I actually thought the other two guys had stopped it from rotating, so little force had I applied. Very gently the thing came to a stop, and Dan Brandenstein, who was flying the orbiter, asked if we had a good grip. Rick responded, "Yes, sir," and that's when Dan called out, "Houston, I think we've got a satellite."

Three STS-49 astronauts hold onto the 4.5-ton INTELSAT-VI minutes after their six-handed capture in Endeavour's *cargo bay.*

Overleaf: Mike Foale and Claude Nicollier upgrade the Hubble Space Telescope during its third scheduled service call, STS-103.

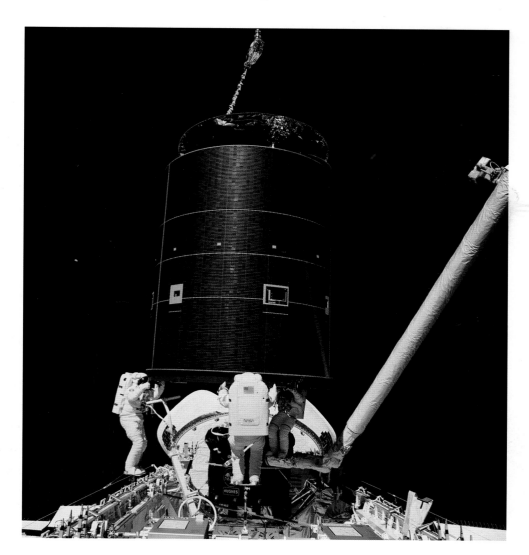

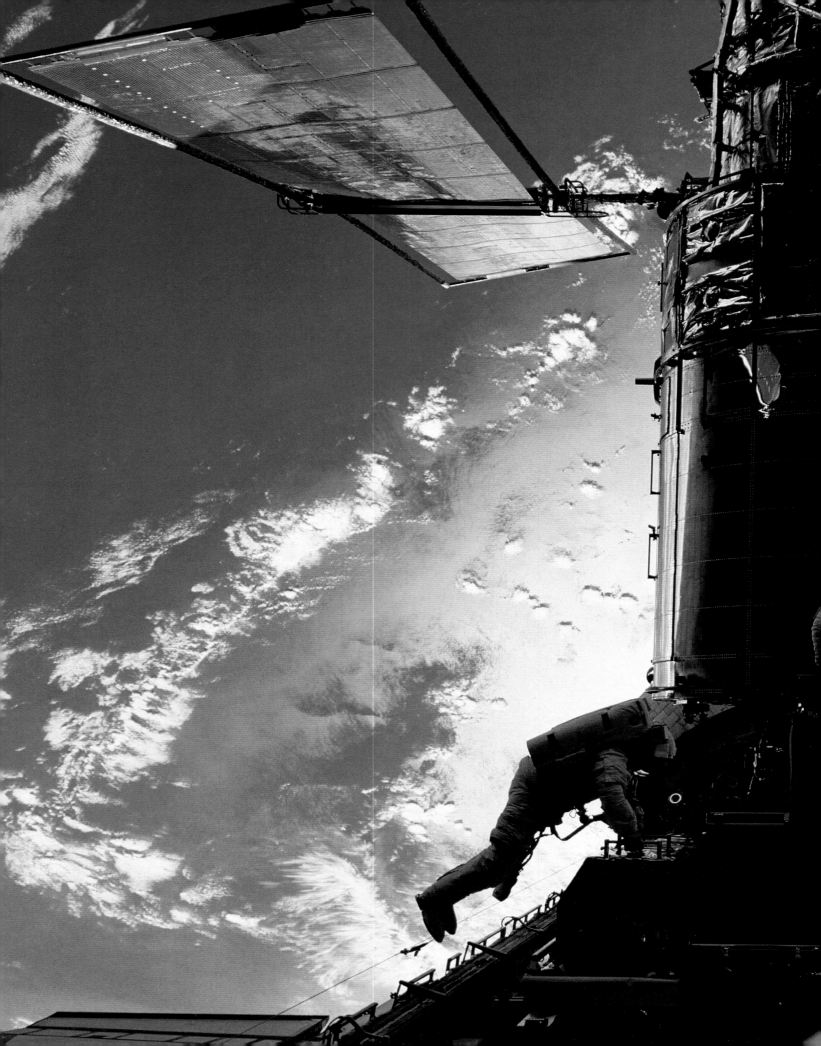

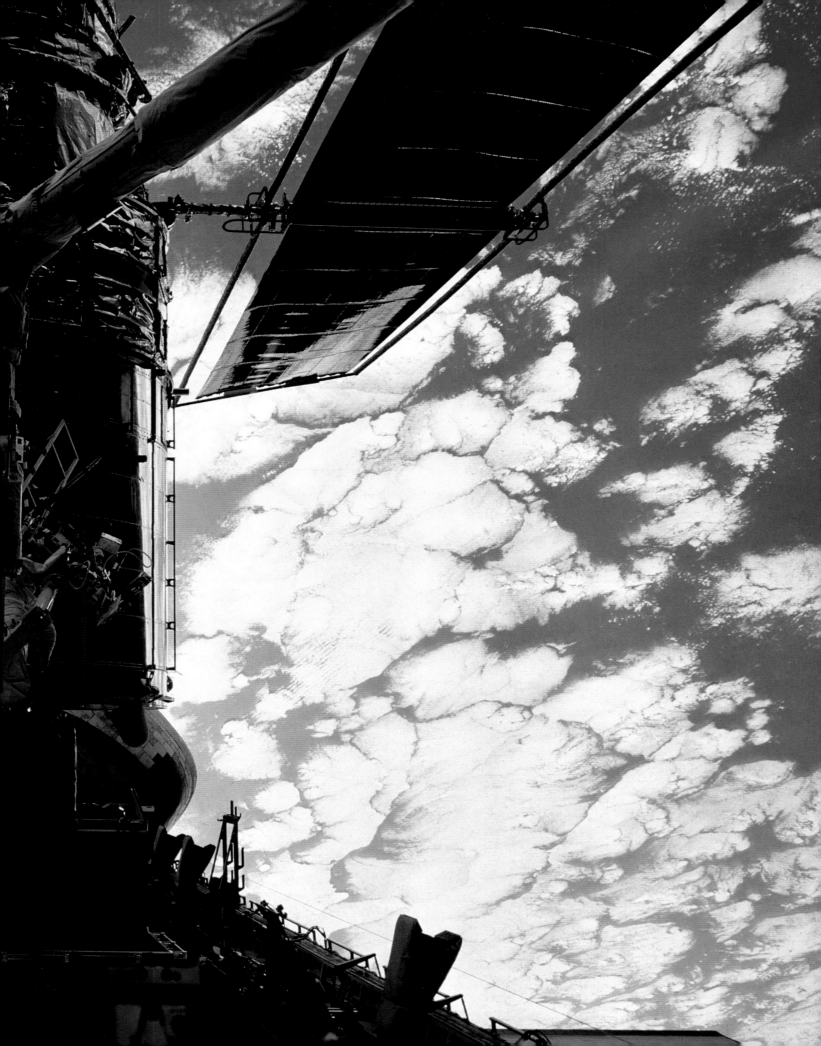

There was no doubt in my mind from the moment I was assigned to the Hubble deployment mission about the historical significance of what we were doing—that was one monster flight.

—CHARLIE BOLDEN
STS-31

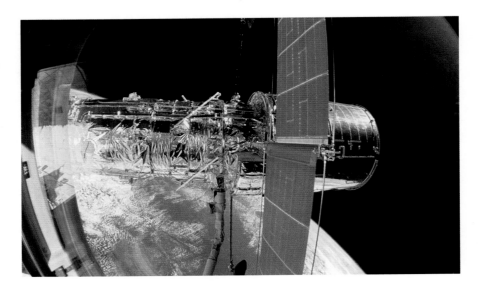

LOREN SHRIVER | **Somebody get a camera!**
STS-31

Before STS-31 we had of course simulated how we would deploy the Hubble Space Telescope, and who would be where during the deploy sequence. But Bruce McCandless and Kathy Sullivan ended up having to get suited up in the airlock, because there was some worry that they might have to go outside to help if the telescope's solar arrays got stuck. Steve Hawley was operating the arm. Charlie Bolden was trying to keep track of other stuff, and I was trying to make sure we were flying away from the telescope properly. Steve and I were at the back windows. He let go of the telescope, and started backing the arm out of the way. We said, "Wow, look at that!" and then in unison, "Camera! Somebody get a camera!" Guess what? With Bruce and Kathy downstairs, nobody had a camera documenting this humongously historic event. By that time we were several yards away from the telescope. Luckily we had a large-format IMAX camera in the cargo bay, and that took a good picture of the actual release moment.

Above: The Hubble Space Telescope is checked out while still attached to the shuttle's robot arm before being released in orbit, STS-31. Right: Bruce McCandless, Steve Hawley, and Loren Shriver (left to right) watch the pre-release action from Discovery's flight deck.

KATHY SULLIVAN | **I join the ranks of the nameless people**

STS-31

Hubble is my proudest professional accomplishment at NASA. And I don't mean just my flight in 1990 when we deployed it. I also spent a lot of time in the water tanks we use for practicing spacewalks, helping to verify tasks for the later repair missions. Where does the spacewalking astronaut need to stand? What angle do you need to approach it from? There had to be specific tools to accommodate all the astronauts' reach limits. All that stuff had to be considered, down to how many turns does it take to back out this or that bolt.

Every time a servicing mission goes up and does five spacewalks' worth of magic to keep this incredible telescope working in orbit, I join the ranks of the several thousand nameless people who always stood behind me on my flights. My fingerprints are all over the repair crews' success, and I take pride in that. We astronauts get the blue flight suits and the great ride, but my role in the Hubble program gave me even more respect than I already had for the people who make shuttle flights happen.

The Hubble Space Telescope flies free again after being refurbished and re-released in orbit, STS-82.

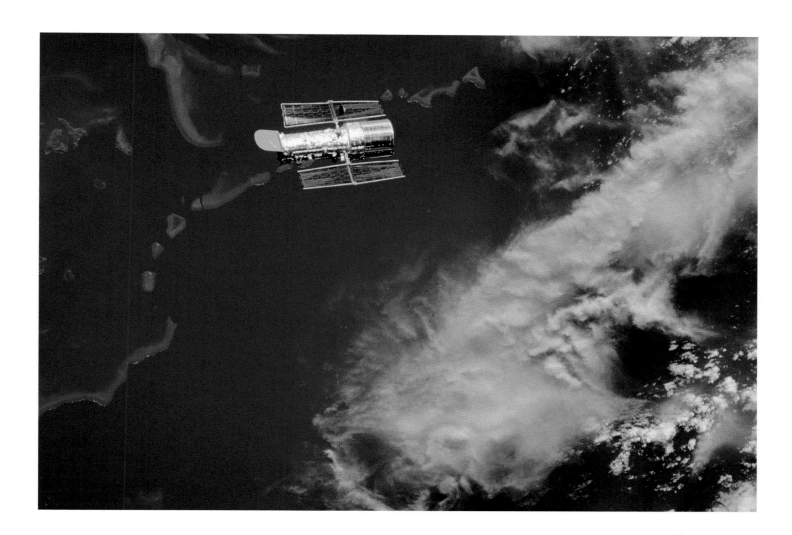

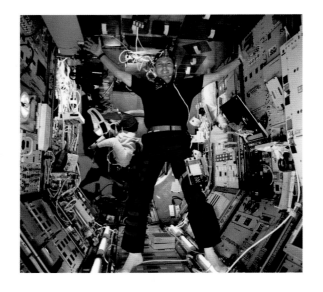

German payload specialist and physicist Ulrich Walter cavorts inside Spacelab during the German-sponsored Spacelab D-2 flight, STS-55. Below: A 45-foot-diameter antenna unfurls to test how inflatable structures would behave in space, STS-77.

CHARLIE PRECOURT | **Everybody spoke our language**

STS-55

My first flight, STS-55, was a German-sponsored Spacelab mission. There were 91 different experiments in 13 different categories, with two teams working around the clock. Because we had both German and American crew members, the flight was kind of a model for international cooperation. But as it turned out, the Germans are so good at speaking English that they really solved a lot of problems for us. I remember being in a simulation before the flight. We went over to Oberpfaffenhofen, which is outside Munich, where they had their control center for payload operations. We sat on the console and watched them play through scenarios to learn what to do, for example, if a furnace used for materials processing experiments goes down—how would you re-prioritize the crew's time in orbit to get the most science? They had a mission management team go through how long it would take to fix that furnace versus having a crew member continue doing other experiments.

I'm sitting in the control center watching this whole process, and the janitor comes in to sweep the floor. And even he speaks perfect English. I'm thinking, "This is so easy with everybody speaking our language." I remember watching the controllers at this center, and they would all speak English with each other. If they were sitting at the console on a headset, they wouldn't revert to German just because they were leaning back to talk to a colleague. They only went to German when they left the room on a break. It made a huge difference in our productivity.

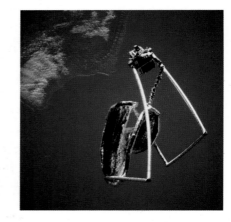

JEFF WISOFF | **Like going on a treasure hunt**
STS-68

The Space Radar Laboratory we carried on STS-59 and STS-68 was an amazing instrument. I remember we put a segment in the crew movie showing first what humans see looking down on the Sahara desert, then what the radar sees. It is just amazing; you can see old rivers underneath the sand and things of that sort. It's like going on a treasure hunt. One capability I was excited about was the ability to see very small movements of land masses from space. What they did is they put Global Positioning System sensors on the face of one of the volcanoes on Hawaii and tracked the movement over the five months between the two flights. They were able to superimpose radar images taken on STS-59 and STS-68 and detect centimeter-scale movements of the volcano face. In the future, an automated radar satellite could actually track the build-up of pressures in volcanoes and fault lines, and might be able to predict earthquakes, or at least provide an early warning. Right now it's a very labor-intensive thing to manually plant sensors along fault lines to measure those changes.

STS-59 radar image of the region in southern Oman around the "lost city" of Ubar. Archaeologists used such false-color images to map ancient trade routes (horizontal reddish streaks) to Ubar, which was identified in 1992 near the dry stream bed (white area) at the center of the image.

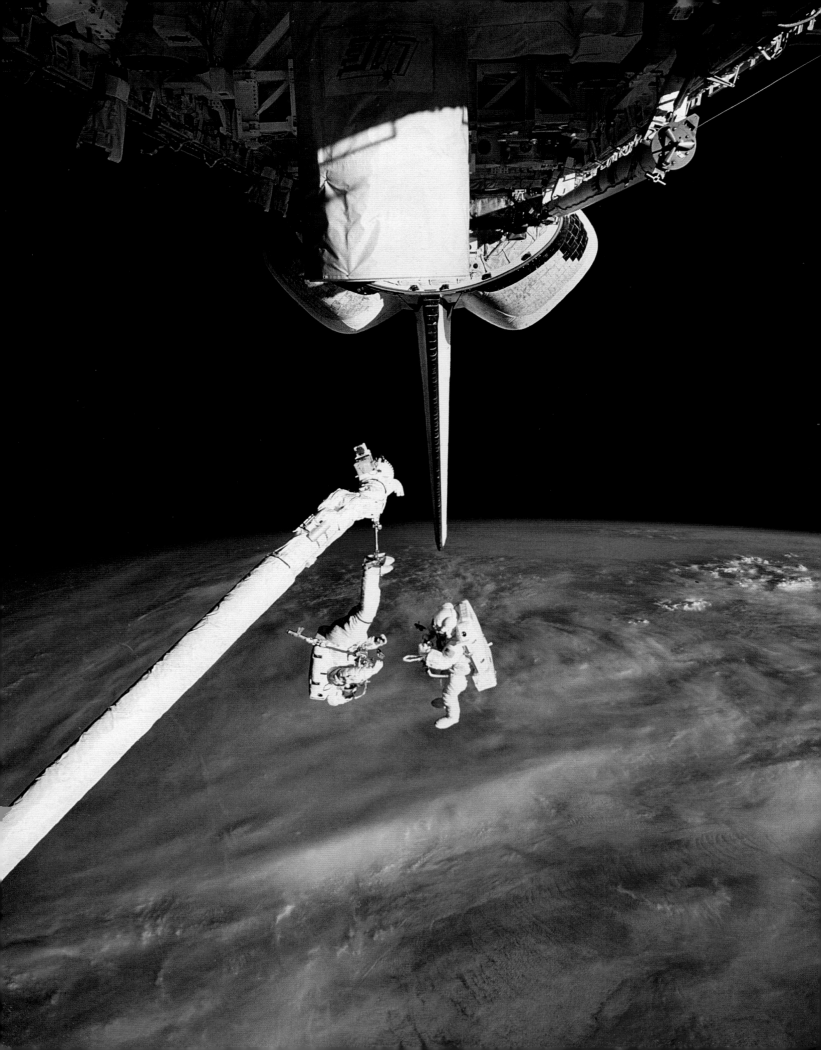

Flying the SAFER backpack
was easy. If anything, I was
impatient because I wanted
it to go faster.

—MICHAEL LOPEZ-ALEGRIA
STS-92

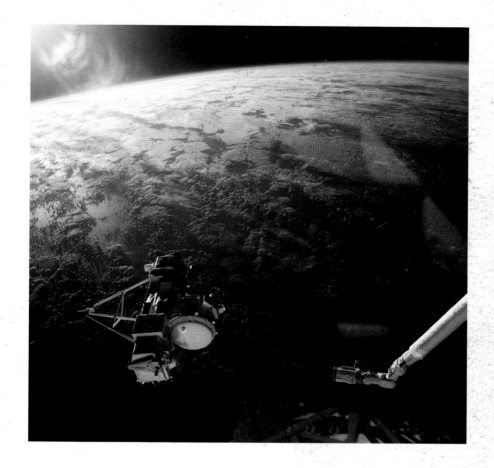

JERRY LINENGER | **Totally free of the shuttle**
STS-64

The one thing I'll always picture from STS-64 is watching Carl Meade and Mark
Lee out there testing the new jetpacks, spinning on the end of the arm, totally free
of the shuttle and the Earth below them. It's one of those pictures that's pretty
much imprinted in my brain, even though I wasn't doing the spacewalk. Every
astronaut knows that is one special operation—being an independent spacecraft,
out there floating free.

*The SAFER jetpack (opposite), first tested on
STS-64, was designed not for transportation,
but as a means of returning to the shuttle in
case a spacewalker's safety tether came
unattached. Above: An instrumented platform
sponsored by the Pentagon's Strategic
Defense Initiative (SDI) office is released for
later retrieval, STS-39.*

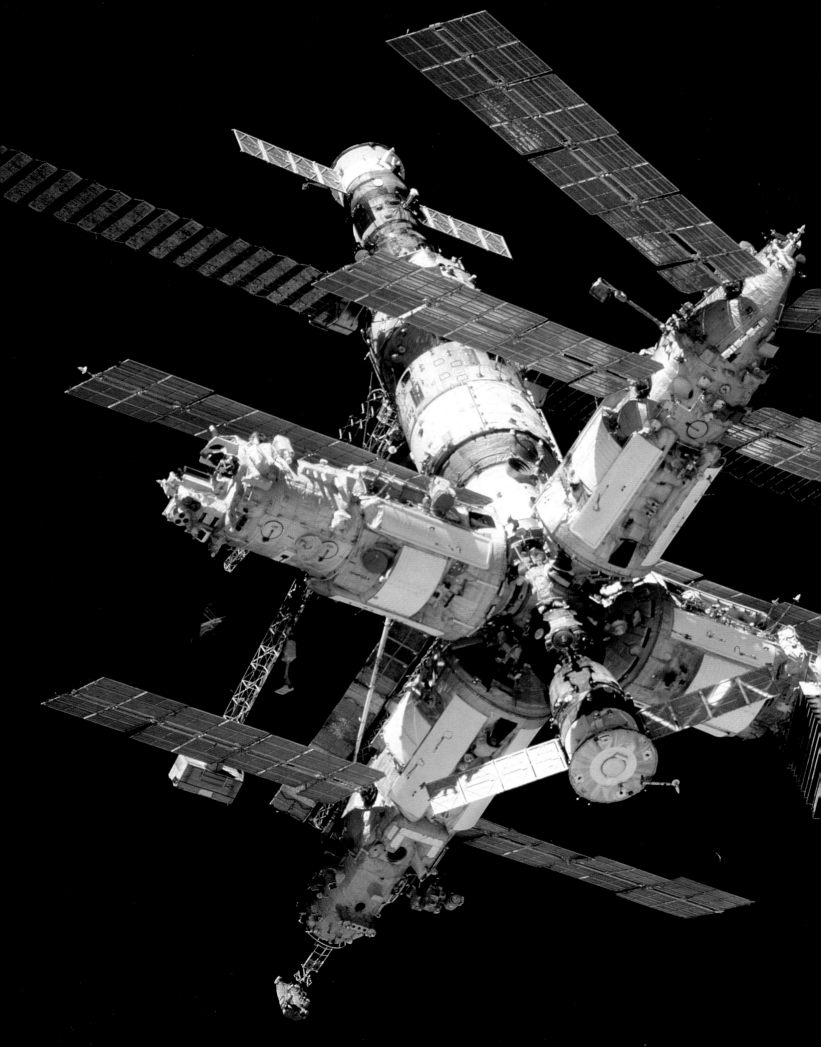

1995
STS-63
STS-67

STS-71
STS-70

STS-69
STS-73
STS-74

1996
STS-72
STS-75
STS-76

STS-77
STS-78

STS-79

STS-80

1997
STS-81
STS-82

STS-83
STS-84

STS-94
STS-85
STS-86

STS-87

1998
STS-89

STS-90

STS-91

STS-95

STS-88

By the time Norm Thagard, the first American to live on board Mir, took up residence on the Russian space station in March 1995, it was already nine years old, four years past its design lifetime. Over the next three years, six more U.S. astronauts—Shannon Lucid, John Blaha, Jerry Linenger, Mike Foale, Dave Wolf, and Andy Thomas—would serve tours on Mir as part of what NASA and the Russian space agency called Phase One of their merged space station programs.

The U.S. guests conducted experiments and gained valuable experience living for months at a time in orbit, while shuttle pilots got hands-on practice docking with a space station. Language and cultural barriers proved difficult, and two onboard mishaps —a fire during Linenger's stay in February 1997 and a collision with a Progress supply craft four months later—strained relations between the two space agencies. The accidents led to jokes on American late-night TV about Mir as an aging rust-bucket, but the astronauts who lived there believe the rap was unfair. Indeed, the shuttle astronauts who visited Mir for a few days at a time during crew changeovers remember mostly the warm hospitality with which the resident cosmonauts received their visitors. Says Terry Wilcutt, who commanded STS-89, the eighth of nine docking missions: "On the working level, astronaut to cosmonaut, there was no conflict at all."

Mir as seen from the departing shuttle Atlantis, STS-81.

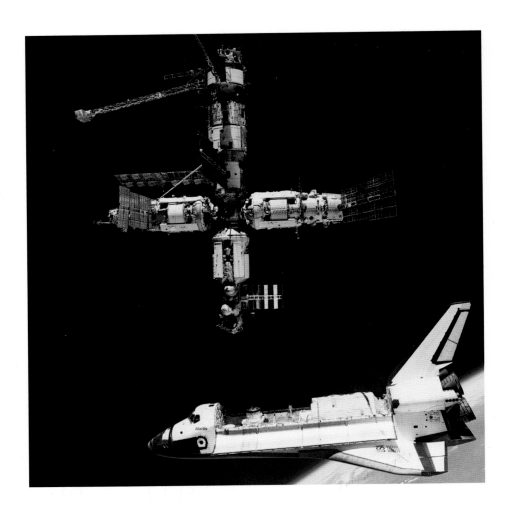

CHARLIE BOLDEN | **Unequal partners**

STS-60

I'm a pretty liberal kind of guy, but at first I was not enamored of the partnership with the Russians, because I honestly did not feel that they had been equal partners over the decades. I'd been led to believe that we had given them information from our space flights, and that we had received little or no information from them in return. Taking quite a naive and immature approach, I didn't think that was fair. I wasn't ready to sign up for them learning all about our shuttle systems.

Once I had an opportunity to meet Sergei Krikalev and Vladimir Titov, the two cosmonauts who would be assigned to train with us for STS-60, I soon became a believer in what we were doing, and I still support the partnership wholeheartedly. After that flight, which had Sergei on board as the first Russian to fly on the shuttle, I had no question of the value and importance of our cooperative exploration efforts. The Russian government brought the whole crew over for some postflight events, and we had an opportunity to observe the way the Russian people live. When you went out to the test facilities and saw a brand-new engine being fueled through a line that was rusting and corroding, you had to come away with a tremendous amount of respect and admiration for the people in the Russian space program, who were able to accomplish all that they accomplished.

Cosmonauts inside a Soyuz transport vehicle took this photo of Atlantis *and* Mir *shortly after the shuttle undocked, STS-71.*

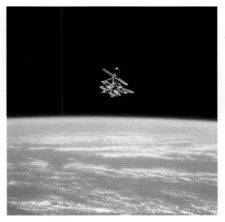

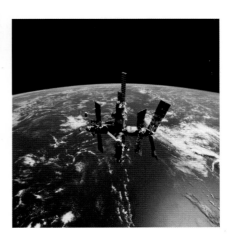

EILEEN COLLINS | **Permission to come closer**
STS-63

Close, closer, closest: The shuttle took about an hour to close the last half mile between itself and Mir during orbital rendezvous.

STS-63 was the first shuttle mission to rendezvous with Mir, as practice for the first docking later that year. The first plan was for us to come within 1,000 feet of the station and stop there. But during training we realized we weren't going to learn a whole lot at 1,000 feet. We needed to get closer. So we made our case with the Russians, and after weeks of discussion, it came down to 300 feet. Then we got down to 100 feet. We kept training, and kept saying, "Let's go closer." So next thing you know, the Russians agreed to have us come within 30 feet.

Then right after we launched, three of the orbiter's maneuvering jets failed. One of them had a leak, and we couldn't have picked a worse jet, because this one was pointing toward Mir. The Russians didn't know if they wanted us to come close now, because we might contaminate the station with fuel from the leaky jet.

But our NASA flight directors and their support teams put together a plan to shut off fuel to that thruster. They convinced the Russians that we had our act together, and that no matter what happened, we were going to be safe. When Mission Control called to tell us the Russians had agreed to the close rendezvous, we said, "Ha! We already know!" Vladimir Titov, who was on board the shuttle with us, had gotten on the radio and called his cosmonaut friends on Mir, who had already heard the news from Russian Mission Control.

In hindsight this was one of the major successes of the shuttle-Mir program, because we had a real-time failure, and in three days were able to come to an agreement and do the mission as planned. It showed that we can work together in space, and when it really came down to it, we had the same goals.

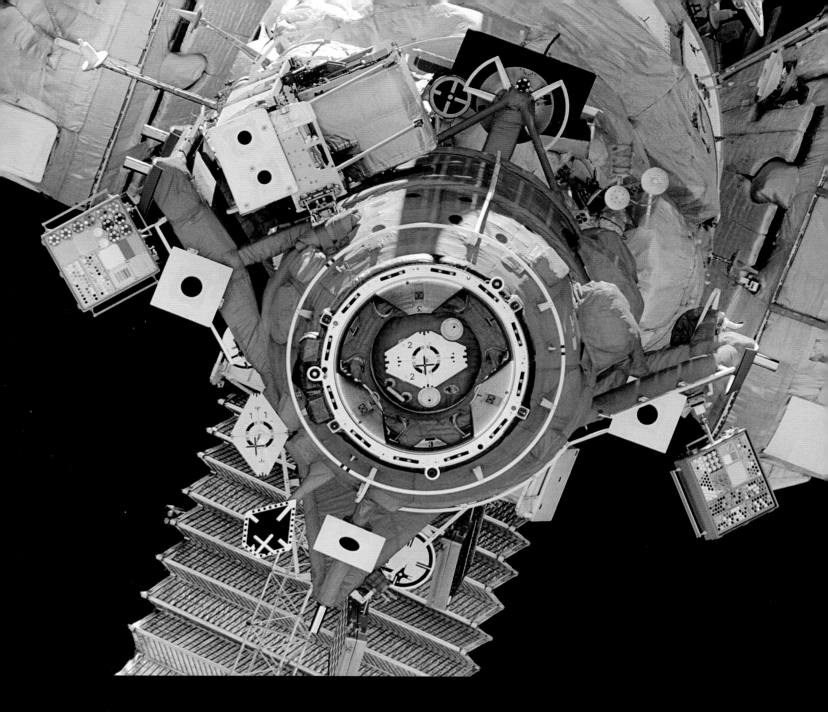

When Mir was about 100 miles away it looked like a star on the horizon, and the star just got brighter and bigger over the course of a few hours. Then, when we got within about a mile or two, we were coming out from the night side of Earth, and all of a sudden the sun came up behind Mir. It just lit up the solar panels. The whole thing looked like it was made out of gold, like some heavenly object that had just appeared out of nowhere.

— BERNARD HARRIS, *STS-63*

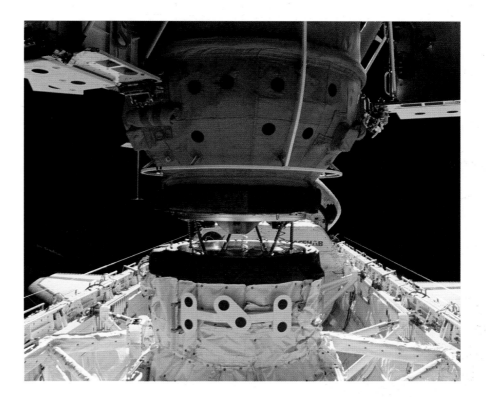

The shuttle made its final approach to Mir's docking target (opposite) very slowly—barely more than an inch per second. U.S. and Russian engineers developed a new docking system to latch the two vehicles together (above).

RICH CLIFFORD | **Approaching a spider**

STS-76

Coming up to dock with Mir, approaching that tremendously large piece of machinery, it goes from being a very bright light to looking like a spider. Then all of a sudden, the station's huge solar power array looks like it's 10 inches from your window. And you're thinking, "It's a good thing we're not slightly off axis."

We approached very slowly, at just an inch per second, and I didn't feel a thing when we docked. I was looking out the back window and also at the display for the orbiter docking system, splitting my view between the two. I got the capture indicator light on my panel, and I expected to hear a bang or a clunk or feel some movement of the shuttle. But we approached so slowly that the two vehicles just merged.

Right after we did our docking on STS-76—the third time the shuttle had docked with Mir—I reached over and touched Kevin Chilton, our commander, and said, "Congratulations, Chili." And he did this big jump. You can even see it on the video. He was just so focused on the docking.

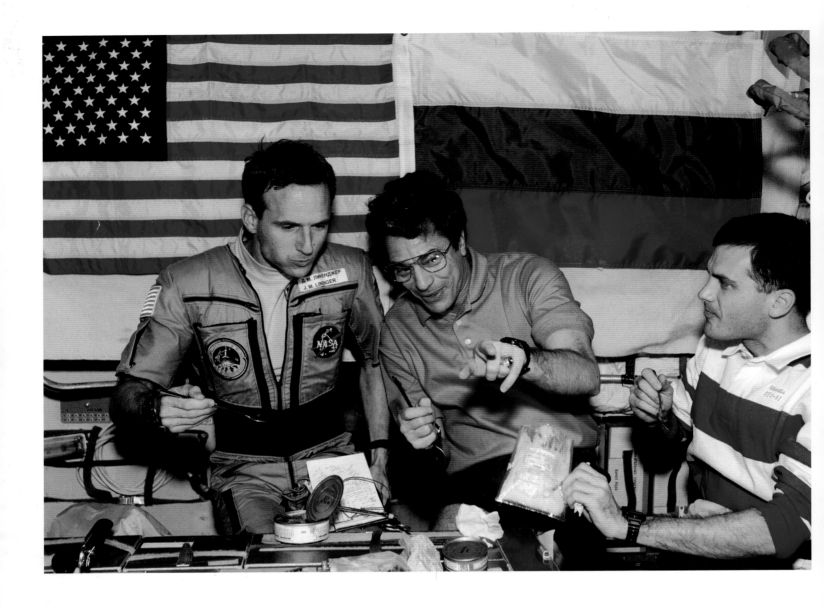

New arrival Jerry Linenger (left) shares a meal with John Blaha (center), whom he's replacing on Mir, and STS-81 crewmate Jeff Wisoff.

JOHN BLAHA | **Life on board Mir**

Mir 22

I wake to an alarm clock every morning at 8:00. By 8:30 I am talking to folks all around the world on the ham radio. This is a great way to meet folks and receive news from planet Earth. I usually am finished with breakfast at 9:30. I have a lot of exciting experiments that I perform until 12:30. Then I run on the treadmill and use expanders to maintain my muscle strength. After cleanup, Valeri, Sasha, and I eat lunch together, and talk about what we have been doing in the morning and what we will be doing in the afternoon. We do science experiments for another four hours, then have another hour of riding the bicycle before dinner. After dinner I usually spend one to two hours preparing for the next work day. It now is 10:00 p.m. I'll spend the next two hours looking at our beautiful planet, looking at the stars, finding planets, and watching movies. I have 50 fantastic movies, a few Dallas Cowboy games, etc., as selections. *(Written to family while on board Mir, 1996)*

JERRY LINENGER | A couple of thimblefuls of water
STS-81

During my first few days on Mir, John Blaha and I had many private conversations tucked away in a corner of the station. John had been living there for four months, and he did his best in those five days of overlap to show me the things that weren't working as advertised. We went through how the toilet works, how the treadmill works, and how he did his routine. He explained in detail how he cleaned himself after working out on the treadmill. There's a trick to it. Water is in short supply up there, and therefore you need to use two or three thimblefuls, which you put on a little four- by four-inch piece of towel. He would cut the towel into about five or six sections to conserve towels, because there's no way to keep delivering new towels. He showed me how you can make a couple of thimblefuls of water go a long way. Some of those techniques came in handy, because sanitation was not an easy task up there. During your treadmill sessions you would definitely be sweating, and our T-shirts would get soaked. And our supply of shirts and shorts was such that we could only change every two weeks.

Through-the-window view of Scott Parazynksi (left) and Vladimir Titov working outside Mir while the shuttle is still docked, STS-86.

Overleaf: STS-79 photograph of the Russian space station in orbit.

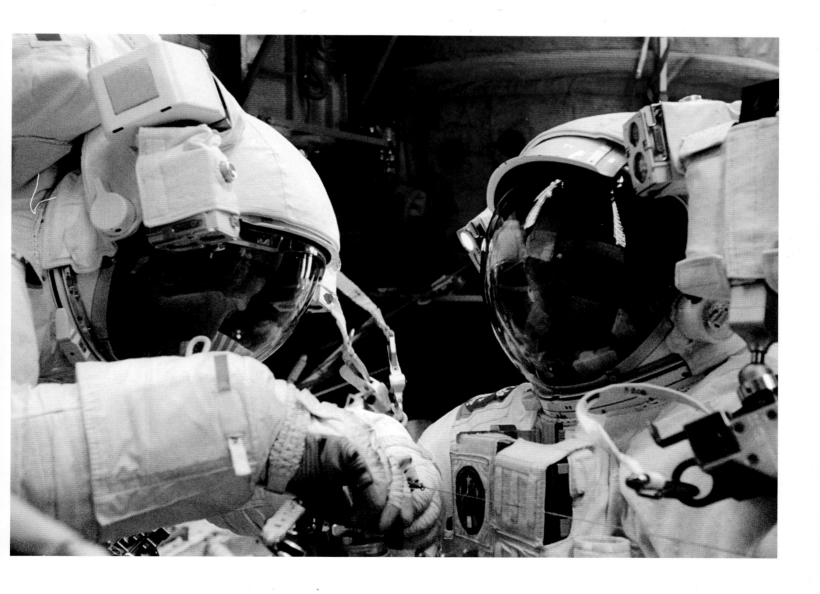

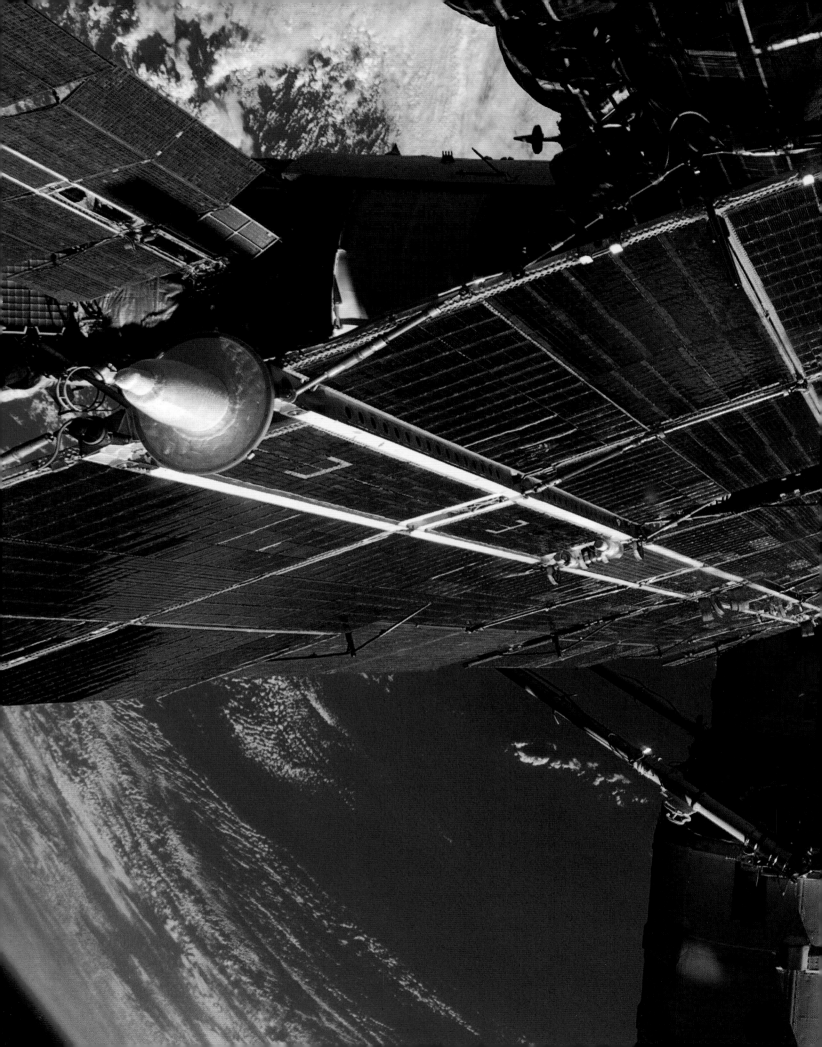

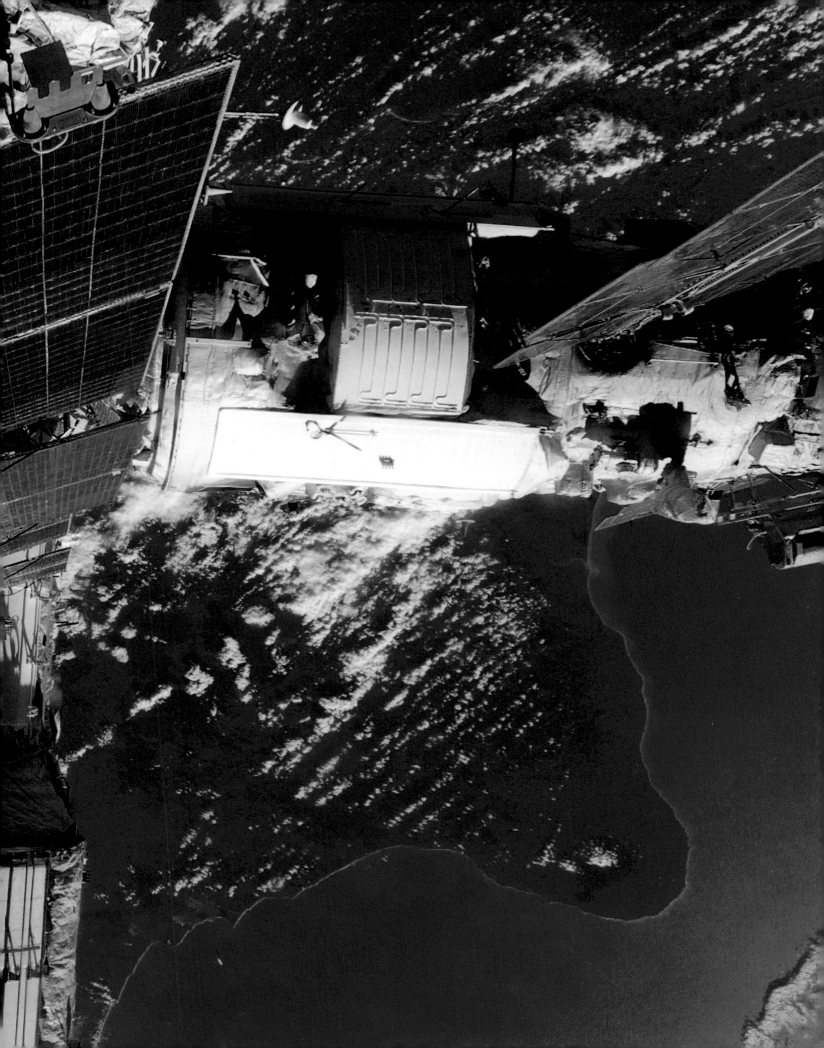

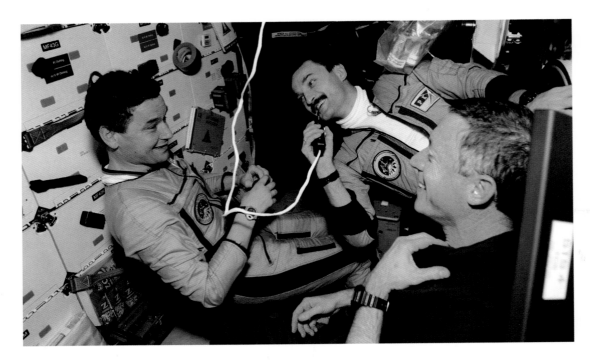

NORM THAGARD | **What's wrong with the Americans**

Mir 18

Shuttle visits were social occasions for Mir's long-term residents. Above: Mir 22 Commander Valeri Korzun (left) and Alexander Kaleri with STS-81 Commander Mike Baker. Opposite: Sharing fresh fruit on STS-81, and a sing-along with Charlie Precourt, Gennady Strekalov, Bonnie Dunbar, and Greg Harbaugh during STS-71, the first of nine shuttle docking missions.

My Russian crewmates and I were supposed to have a 90-day stay on Mir, and it wound up being 115 days because of shuttle delays in coming up to bring us home. I'm not sure Gennady Strekalov, the flight engineer on the station, ever wanted to fly the mission in the first place, and he was basically ready to go home. They had called him out of semi-retirement for the flight, and his daughter was getting married in September. This was late June, and if the shuttle didn't pick us up, we might have had to stay as long as six months, when we'd come back in the Russian Soyuz spacecraft docked to the station, which has a lifetime in orbit of only six months.

Weather was bad at the Cape, so they canceled the shuttle launch. Gennady, Volodya Dezhurov, and I had all been looking out the window, and we could see that the weather was bad over virtually the whole southeastern U.S. But after we passed over, Gennady says, "There was nothing wrong with that weather. It was clear down there!" Well, Volodya is behind Gennady, and he kind of boosts himself up so he's a little higher than Gennady, and starts pointing down toward the top of his head and looking at me like, "What is he *thinking*?"

Now, Gennady is usually just a sweetheart, the nicest guy in the world. But he was frustrated, and this was about the only time I ever remember him really trying to goad me. He looks at me and says, "There's absolutely no excuse for a crew not to launch for anything other than a problem with a rocket. We'll just stay up here and go back on the Soyuz." He's looking at me, and he's telling me what's wrong with the American shuttle program. So I just said, "That's fine with me, Gennady. I'd like to go home on the Soyuz. I've never done an entry on a Soyuz. You, on the other hand, are going to miss your daughter's wedding." And that kind of shut him up. The shuttle launched three days later.

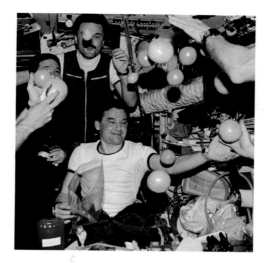

EILEEN COLLINS | **There was always music playing**

STS-84

Spending five days docked to Mir during the STS-84 mission is a very special memory for me. The base block, or core module, of the station was warmer than the rest of Mir, which I liked. The lights were on, and it seemed there was always music playing, some type of Russian folk music. There were things everywhere, very cluttered—cameras, cables, experiments, personal items.

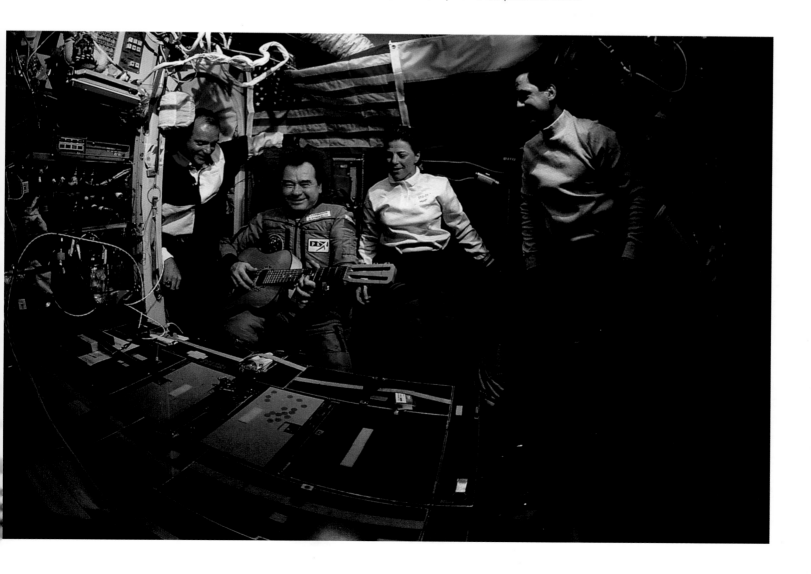

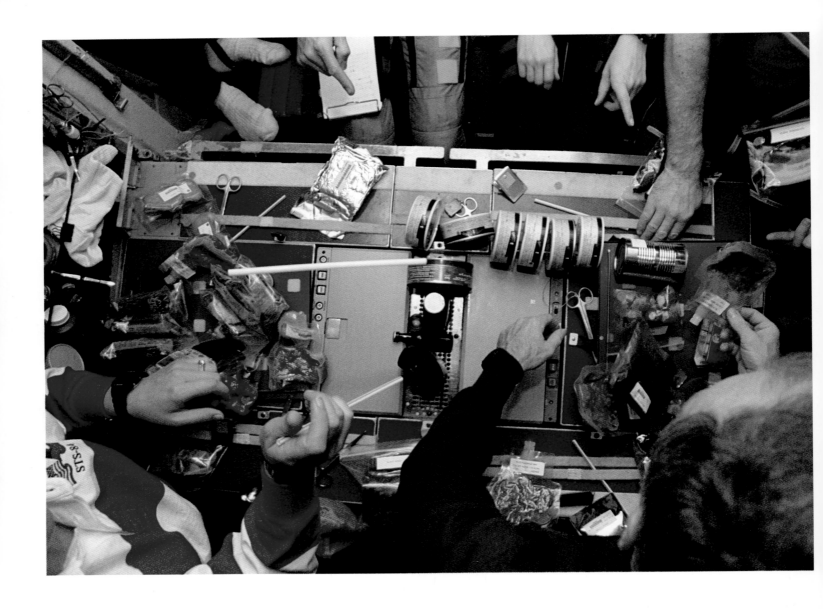

JEFF WISOFF | **Like being in a space deli**
STS-81

The dining table in Mir's base block, or central module, was a natural gathering place when shuttle crews came calling, as in this STS-84 scene.

I had the best meal I've ever had in space on board Mir. It's customary when the shuttle docks that the crews have a big meal together, and when our STS-81 crew arrived, the cosmonauts had recently had a supply ship come up. They had a big round ball of cheese, and they had a fresh salami or summer sausage. They had an ax, and they were chopping this thing up and tossing out pieces to us. It was like being in a space deli, and was actually a very good meal. Then they served us some of their normal supplies, although they picked out their best things. We did the same. We had them over to the orbiter and made a big meal for them. Jerry Linenger had his birthday while we were up there, and Marsha Ivins had made a birthday cake and brought it up. So we shared the birthday cake and some of the things we like best from our food inventory—dehydrated shrimp cocktail, some red beans and rice, a few other things. That was a very fun occasion.

The lighting on *Mir* was darker and the air more warm and humid than on *Atlantis.* It immediately reminded me of my great-grandmother's house in upstate New York.

—SCOTT PARAZYNSKI
STS-86

MIKE FOALE | **He looked a bit like a hermit**

STS-84

When I replaced Jerry Linenger on Mir after his five-month stay, I was very curious to see what he would look like—whether he'd have long hair, whether he'd be frenetic or calm after his experience with the fire on the station. When I saw him, he definitely had the look of someone who had been a bit isolated, not only from 7-Elevens and Stop-N-Go's and things like that, but also from other people. He looked a bit like a hermit. He was very keen to talk to us in English. He had taken very seriously his research duties inside Mir's Spektr and Priroda modules, which had quite a lot of U.S.-built equipment in them. That tended to keep him away from the other two Russian crew members. He was thirsting for contact at that point and was very glad to be going back to Earth, because he missed his family.

I think he also felt quite at risk on Mir. He tried to tell me about that. I listened, but I had my own opinions as to what was a significant risk and what wasn't, and I didn't always agree with Jerry. For example, he talked about how a Progress re-supply vehicle had only narrowly missed crashing into Mir. He was quite shaken up about that. I heard it, I understood it, but I still didn't really understand how bad that could be. He told me about the fire. The fire was just a history event for me.

Then, of course, I was on Mir a month later when a Progress did collide with the station. A few months after we returned to Earth, I finally got back a notebook I had left inside Mir's Spektr module, which we'd had to seal off after the collision. On about page 30, Jerry had written a secret note to me. I hadn't looked at that page before, but it said, "Good luck, Mike, I wish you the very best. Be very careful here."

Jerry Linenger (right) briefs his Mir replacement, Mike Foale, STS-84.

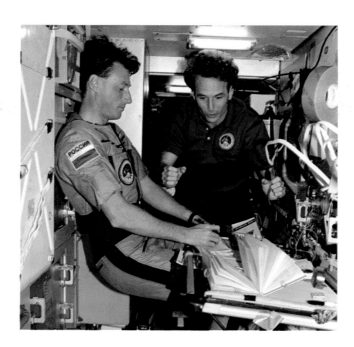

Solar arrays on Mir's Spektr research module were damaged when an unmanned Progress cargo vehicle crashed into the station during a manual docking test in June 1997.

MIKE FOALE | **Collision in space**

Mir 24

The day before the Progress supply ship was supposed to rendezvous and dock with Mir, Vasily Tsibliev, the station's commander, talked about a near miss that had happened during an earlier test of the manual docking system. He said he didn't want to do this test again. He was quite clear—he didn't think it was a good idea. But we didn't think it was something that was going to kill us, either. So we just went to bed. I didn't think anyone was particularly nervous.

In the morning we woke up and got everything ready for the docking. It was midday, 12 o'clock exactly, Moscow time. I was trying to watch for the approaching Progress through the back of the Kvant module, but I couldn't see it. I kept calling on the headset to Vasily and Sasha Lazutkin, "Can you see it, Sasha? Can you see it, Vasily?" Vasily had a view of the station through a television camera on board the Progress, but Sasha couldn't see the Progress through the window. It was only about four minutes from docking time, and I thought, "To hell with this, I

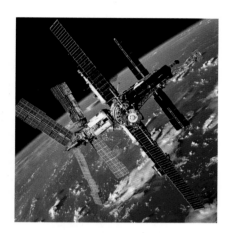

Top: Shuttle crews photographed the Russian station during post-docking "fly-arounds" to document the damaged arrays (left). Above: STS-71 view of Mir's exterior.

better go see where it is." I floated over from the Kvant and kind of hovered behind Vasily. I could see the station there in his television view as the Progress was coming toward it, and thought, "Well, it's right there. I guess he's coming in." It didn't look like it was going for the docking port, though.

As I was hanging there watching, Vasily wasn't saying anything, except that once or twice he called out ranges, which he was recording on tape. Then Sasha, who was looking through a big window, suddenly said, "Vasily, move away!" Then he said, "Michael, we'll go to the Soyuz," which was our lifeboat in case of an emergency. I paused for a second to ask myself, "Is this really serious?" And I could tell it *was* really serious. Sasha was generally never agitated, and he was terribly agitated.

I went to the Soyuz and pushed off pretty fast, and I bumped Vasily a little bit. He tells a story that in nudging his right arm, I made him change the orientation of the Progress, but I don't believe it had any effect at all.

As I went flying toward the Soyuz, very lightly touching the walls of the station as I moved, I heard a big *crrrunch*. I felt the station move two or three inches relative to me. Then I felt the shock of the collision through my fingertips, that's all. It's not like being in a car crash, where you're all belted in and you feel the impact. Here I wasn't attached to anything. But I felt it in my hands, and I knew what had happened.

That was the only time I had any really serious fear of dying. I just thought to myself, "Is there going to be depressurization?" Then I thought, "Open your mouth in case the air rushes out." I didn't want to burst my lungs. It's a diver's response. If you're in a decompression chamber, you open your mouth so you don't get an embolism. But there wasn't any kind of *whoosh*, and I could tell the air wasn't rushing out of my lungs. Then I thought, "There should be an alarm." And right about then, bang, the alarm started going off. It's very obnoxious. It's very, very loud. You can hardly speak over it.

I thought then that the Progress must have crashed into the back of Mir's base block, or core module. But within two or three seconds, I knew nothing had broken so badly that the air was leaking out very fast. It was bad enough that we were probably going to have to leave, but not so bad that our lives were threatened. I was just thinking to myself, "I've only been here six weeks and we're going home already. I can't believe it." As it turned out, we were able to seal off the damaged module and remain on board for our full stay.

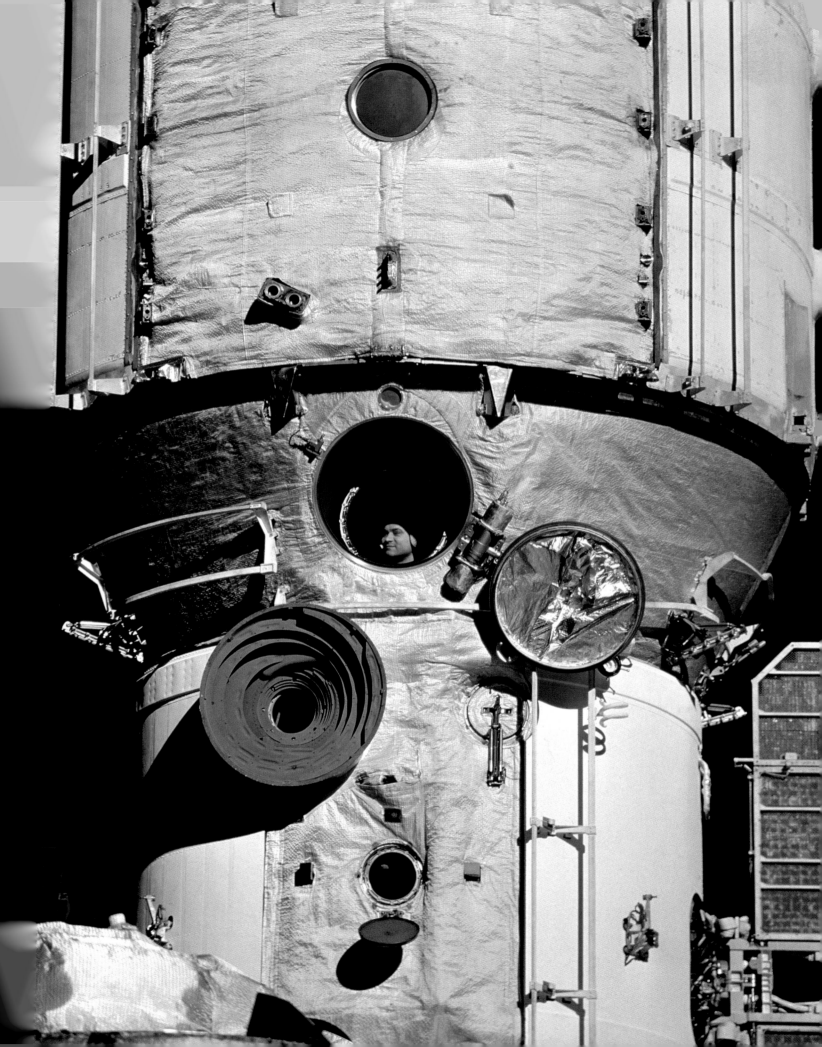

> Long flights give you more time to reflect, look around, experience your surroundings. I got to know the nooks and crannies on Mir very, very well.
>
> —MIKE FOALE
> *Mir 24*

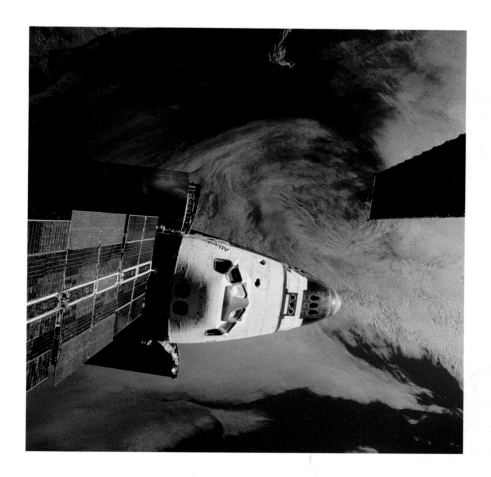

JERRY LINENGER | **Coming out of a cave**
STS-84

I felt an overwhelming emotion watching that shuttle, with the U.S. flag out on the wing, coming up underneath Mir to get me. Getting ready to come home was a very joyous time for me. At one point while the shuttle was still docked, I remember Jean-Francois Clervoy and I bundled up an old wad of duct tape into a ball and started playing catch with it in the shuttle. It was just this great moment of joy in playing. It's a very distinct memory, that feeling that I'd done a job well, and I was just as carefree as can be with the shuttle attached once again.

After being accustomed to living on the Mir station—knowing the dark crevices, the smells, and the sort of cramped nature of it—the shuttle was almost brilliant white. It was organized like I've never seen anything organized. Everything was in its place, everything was clean, sparkling, sterile almost. It's pretty close to coming out of a cave into the sunshine. Mir did its job, but it was an outpost up there. It had been up there a lot of years, and it had its wear and tear. Moving from that cave into the shuttle made me feel I was heading back to the real world of Earth, where things are bright and sunny.

Opposite: STS-63 astronaut Bernard Harris was photographing Mir from Discovery when he happened to catch cosmonaut Valery Polyakov's face in the window. Above: Atlantis docked to Mir, STS-79.

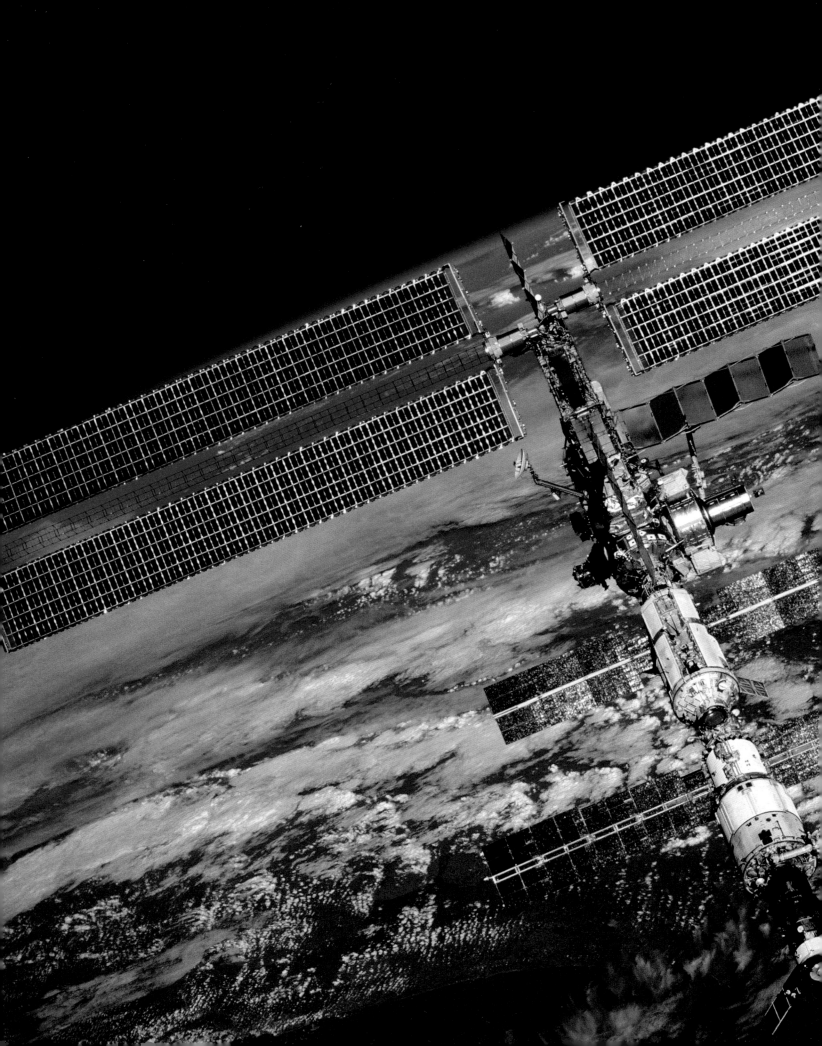

1999

STS-96
STS-93

STS-103
2000
STS-99

STS-101

STS-106
STS-92
STS-97

2001

STS-98
STS-102

Design of the International Space Station began in January 1984, when the shuttle had flown just nine times. But years of redesign, budget reversals, and policy shifts delayed the project so that the first piece didn't reach orbit until November 1998. When the STS-88 crew entered the fledgling outpost a month later, the Space Shuttle Era gave way at last to the Space Station Era. Finally, after nearly 20 years of shuttling into orbit, there was someplace to shuttle to.

The early station assembly flights were construction work, pure and simple. With the shuttle's robot arm doing the heavy lifting of attaching cylindrical modules, power arrays, and girder-like truss structures, astronauts did the detailed follow-up, connecting lines and cables on the outside of the station. The work required a record number of spacewalks, but the well-trained assembly crews made it look routine.

The first long-term residents boarded the station in November 2000, stayed for four and a half months, then moved out so a new crew could take their places—the beginning of a permanent U.S. presence in space. Before opening that new chapter, however, the shuttle gave one last nod to the past—John Glenn's return to orbit after 37 years—and provided a preview of space research to come, with the science-packed STS-90 Neurolab mission in April 1998.

The International Space Station's winglike solar arrays dominate in this photo taken in August 2001, following delivery of the third long-duration crew.

DAVE WILLIAMS | **Sensory override**

STS-90

Neurolab was probably the most complex and challenging scientific flight we've done on the space shuttle. As a neuroscientist, it was an amazing experience for me to be doing research in orbit for some of the best neuroscientists in the world. Every day was a unique opportunity to learn how the human nervous system functions in space. All the members of the payload crew were veterinarians, physicians, or researchers, and not only were we making observations on ourselves, we were observing how animals adapted to space. It was incredible to see baby rats who had

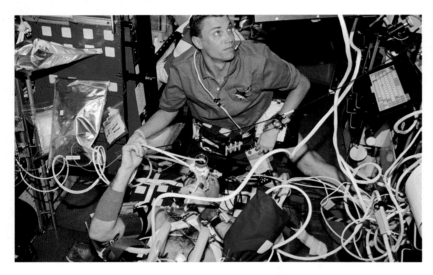

never walked on Earth learning to mobilize in space. They got around by pushing off with their hind paws and grabbing on with their forepaws, somewhat as humans do.

One experiment from York University in Toronto had to do with how eye-hand coordination changes in space. You had to put your face into what looked like a box with a very restricted visual field. You looked at a target on a computer screen, then, with your hand outside the box, you had to track the target. I did this myself on flight day one, which is when you get all the fluid shift in your body as a result of weightlessness. Your face gets puffy and full. I'm standing vertically in the Spacelab, and intellectually I know that the ceiling of the lab is above me, the floor is below me, and I have my foot in foot loops. But as soon as I put my face into that restricted visual environment, I immediately felt like I was upside down. It was such an incredible sensation that I did it a few times. I'd take my head out, look around the Spacelab, and feel right-side up. Then I'd stick my face back in, and immediately would feel like I was upside down.

They were running video footage as part of the experiment, and I probably looked like a pigeon sticking my head in and out like that. It took me a while to figure out what was going on. My body "knew" that the only time my face feels that full on Earth is when I'm upside down, standing on my head. So when I removed the visual cues and was relying solely on my perception, I immediately felt like I was upside down. But when I looked around the lab, the visual cues overrode the sensation of facial puffiness, and I felt right-side up again. I was moving my head back and forth, thinking, "Wow! This is really cool! If we could make a ride like this in Disney World, people would love it."

Jim Pawelczyk runs an experiment with Rick Linnehan as the test subject during the STS-90 Neurolab mission, which studied how the brain and nervous system adapt to spaceflight.

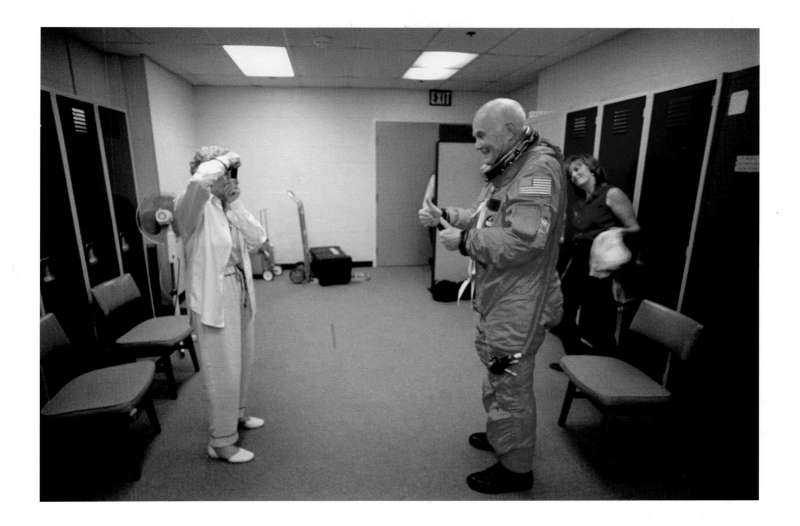

SCOTT PARAZYNSKI | **Boarding passes, please**
STS-95

Astronaut-turned-Senator-turned-astronaut John Glenn is photographed by his wife, Annie, during training for STS-95, his first spaceflight since orbiting inside a cramped Mercury capsule in 1962.

Our STS-95 crew had been teasing John Glenn for weeks that he was a shuttle "rookie." During his five-hour Mercury ride in 1962, he didn't have the opportunity to really experience weightlessness as we do now in our voluminous shuttle. All he could do back then was loosen his seat restraints a bit. To have a little fun with John and fellow rookie Pedro Duque (the first Spaniard in space, nicknamed "Juan Glenn" by our crew), each of us veterans on the crew had a "Shuttle Boarding Pass" tucked into the pockets of our orange pressure suits by the suit technicians. As we disembarked the Astrovan at the base of shuttle *Discovery* on launch day, we were greeted by a stern SWAT team officer, who demanded to see our boarding passes. All five of us veterans dutifully produced our passes, and watched in amusement as poor John and Juan frantically searched through their pockets. It had been 37 years since John's last flight, and there was no way he was going to miss this opportunity! We howled in laughter, and were then in the perfect frame of mind to go launch into space.

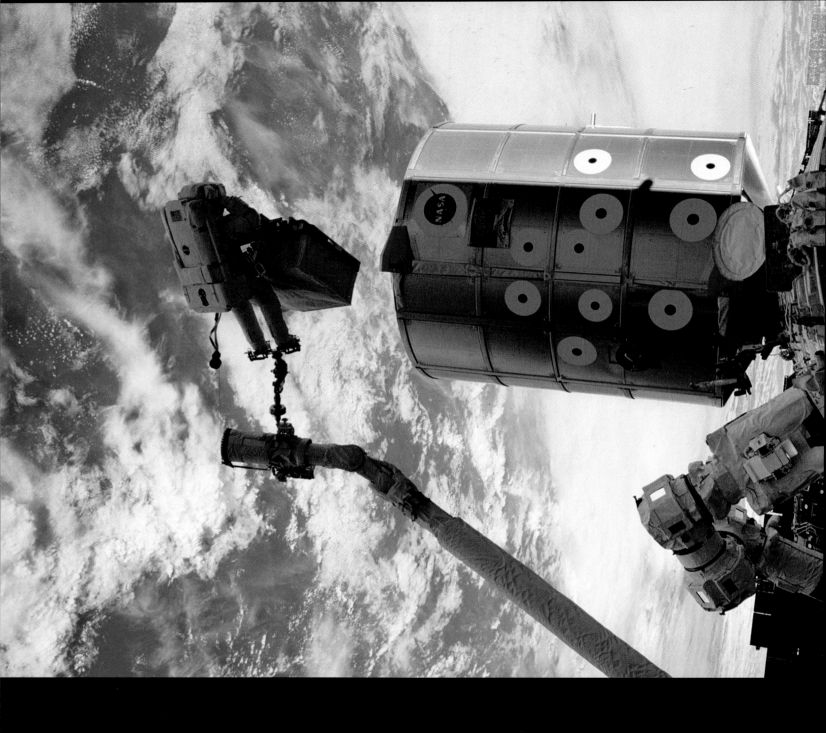

Scott Parazynski hauls a spare part for the station's electrical system, STS-100. Opposite: The station in May 2000, with two modules—Unity (top) and Zarya—and one set of solar power arrays in place.

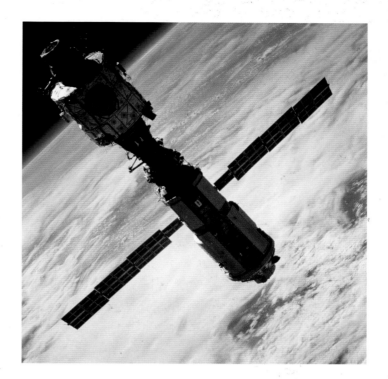

BOB CABANA | **45,000 pounds of trouble**

STS-88

When we rendezvoused in orbit with the Russian Zarya module during the first space station assembly flight, we couldn't see it out the windows after it got inside the payload bay. We were flying near it, seeing it with just the cameras, for 17 minutes. And I got the heck scared out of me.

We were waiting until we got over a Russian ground communications station so we could grab it with the shuttle arm. I had gotten Zarya's grapple fixture about three feet from the end of the arm, so Nancy Currie could move in and grab it. It was perfectly stable. But then the orbiter did an automatic firing of its jets to stay within a set attitude, which moved us toward it. All of a sudden the Zarya, this 45,000-pound mass, is heading down into the payload bay and toward the arm. I'm looking out the window, watching the cameras and—*Bam! Bam! Bam!*—firing the jets to move it away. Nothing's happening, because we were in a mode called B-DAP, which only allows very small firings. Real quick I put it in A-DAP and backed away from the Zarya. Now I've got to get everything stable again, move back in, go back to the B-DAP, fine-tune everything, and get ready for Nancy to grab it again. Which I did. But it got our attention.

Normally, Jim Newman loved to give advice during these kinds of operations. "What do you think about this? Why don't you do that? I think you need to go down some." When that happened, it was just dead quiet in the cockpit. Nobody said anything.

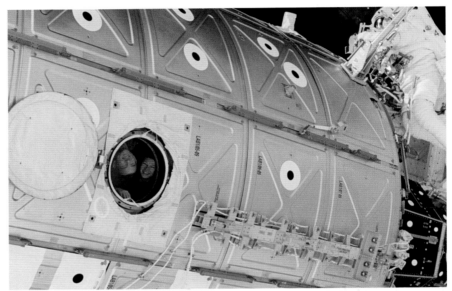

Susan Helms, shown during winter survival training in Russia, was one of two Americans on the station's second "expedition" crew. Right: Helms and fellow long-term resident Jim Voss peer out from the Destiny laboratory module while Scott Parazynski works outside, STS-100.

SUSAN HELMS | Homeless

ISS Expedition Two

Before I went up to live on the space station for five and a half months, I moved out of my place, put all my possessions in storage, and moved into the astronaut crew quarters earlier than most people do. I didn't want telephone or credit-card bills, or anything except a bank account where my paycheck could go. I figured if I didn't have a home back here to worry about, the space station could become my home. I put my family affairs in order, and my sisters and my parents knew how to communicate with me in space. My sister had power of attorney, and I could count on her to take care of anything that popped up while I was gone. I had the luxury to do all this because I'm single, and I know not everybody does. But I wanted it to be like a military deployment, like Navy guys who go out on a ship for six months and put all their stuff in storage.

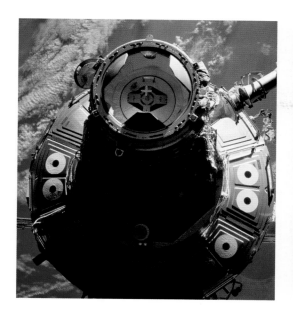

CARLOS NORIEGA | **Tree topping**
STS-97

A space station docking port looms large in this close-up view taken as Atlantis *approaches, STS-101. Right: Spacewalking STS-97 astronauts placed this picture of an evergreen tree—a tradition in building construction—at the end of one of the new station's solar power arrays.*

After we installed the large "P6" solar power array on the space station on STS-97, we placed a picture of a tree on top of it. Joe Tanner, who was my partner for the spacewalk, and I came up with that together. It was in keeping with the tradition of steel workers, who, when they build a tall structure, put a tree on top. You can find different accounts of where the tradition began and why they do it, but it's supposed to bring luck to the building.

We thought it was appropriate, but at first we couldn't come up with a way to do it. Then in the last few months before the mission, they added a new task, which required us to transport some small arrays and probes to attach to a box way up high on the structure. They needed to come up with a bag for us to carry them in, and while they were in the design process, I said, "Hey, by the way, can you put this silhouette of a tree on the bag for us?" They gave us a strange look, but when we explained why we wanted it, all of a sudden you could see them brighten up. They verified that it wasn't going to have any thermal problems or anything like that, and they put that little green tree on there for us. Our flight director had worked on a construction site, so he was real excited, and we worked with a lot of people on it, including the guys who bent the steel to make the P6 array up in Tulsa. They're not construction workers, but it just seemed a good thing to do.

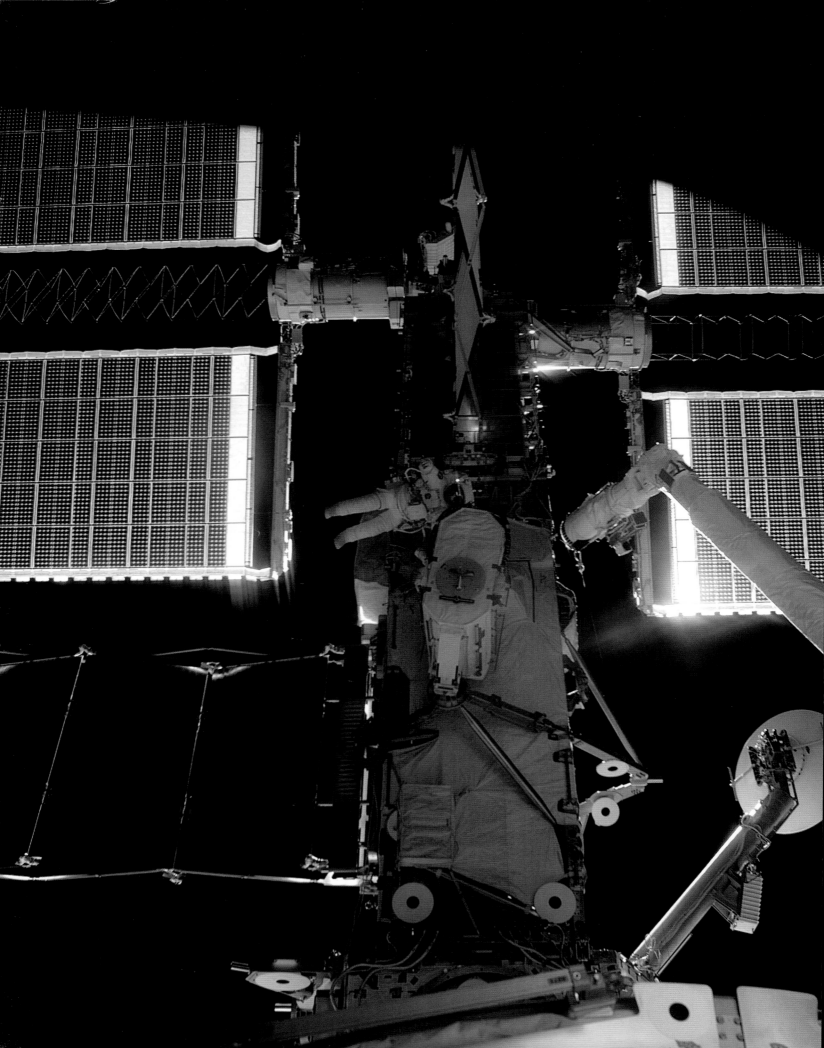

The only time you can really appreciate the size of the space station is when you're out on the arm, away from it. The farther away the better. The size of the thing, the three-dimensionality, and all the detail—the wires and cables and fluid lines and connectors—it's pretty complicated. You're thinking, "It's amazing that this thing is even up here."

—MICHAEL LOPEZ-ALEGRIA
STS-92

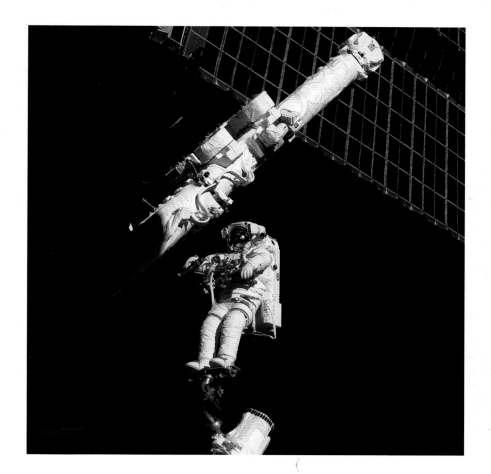

JEFF WISOFF | **Assembly line**
STS-92

On past shuttle flights we used to fly individual payloads, and if something went wrong, you just brought the payload back, fixed it, and flew it again later. Now, with the space station assembly, we have this long string of fights where every flight depends on the one in front of it. So you feel a lot of pressure—you don't want to be the one who holds up the assembly line. There are only so many things you can do to deal with contingencies in orbit. If you get a bolt that is really stuck, and you don't have a tool to saw it off or something, you could end up holding up the line. There's always this holding your breath that every part of the assembly is going to work.

Opposite: Patrick Forrester installs a device containing spare ammonia for the station's cooling system, STS-105. Above: Canadian astronaut Chris Hadfield stands on the shuttle's robot arm while working on the larger and more capable arm newly attached to the station on STS-100.

Crowding the hatchway to the station's Destiny laboratory module are the combined crews of STS-100 and Expedition Two. Bottom row, from left: Chris Hadfield, Umberto Guidoni, Kent Rominger, and Susan Helms. Middle row: Jim Voss, Expedition Two Commander Yuri Usachev, and Yuri Lonchakov. Top row: Scott Parazynski, John Phillips, and Jeff Ashby.

JIM VOSS | **Who came up with this color?**

ISS Expedition Two

Before I visited the space station for a few days during STS-101, I wasn't sure I would be able to live there when I returned for my long stay the following year. I really wondered if I would react weirdly to being up there and not being able to go outside. But spending time inside the station, I found that I liked the environment, and I decided I actually *could* live there.

There are quite a variety of different spaces on board, and they have different effects on you. I found that being in the Node, a kind of connecting room between modules, was an extremely pleasant experience. Even though it's smaller than the other station modules, it's still much larger then any other volume I'd been inside in space, and it has a very pleasant soft lighting. Before this flight I had always laughed when they talked about using a pinkish, coral color for the Node interior, and I had thought, "Who came up with this color?" But whoever it was did a wonderful job, because it made it the most pleasant place to be on the space station. That was where I went whenever I wasn't able to sleep, or when I wanted to be alone to listen to music or write in my notebook.

TOM JONES | **It was like stepping into somebody's home**
STS-98

Being up on the space station for months doesn't really appeal to me. I have a very shuttle-oriented viewpoint. So when we visited there in February 2001, I was prepared to say, "I'm just going to do my work and get my butt back to the shuttle."

I was very surprised, though, when we docked. Bob Curbeam and I had the job of opening up the hatch, and there's a little porthole next to the hatch handle. There were Sergei [Krikalev], Shep [Bill Shepherd], and Yuri [Gidzenko] on the other side with their noses pressed up against the glass. It was a neat moment to have people appear on the other side, where a few minutes before there had just been empty space.

And it was really fun to step into their living room. The space station is slightly warmer than the shuttle, so it's got a cozy atmosphere. You step into their "foyer" in the node. Then as you float up through the hatch and down the hall, you can see their living quarters, just like the back bedroom off your house. It was like stepping into somebody's home. It wasn't a laboratory, it wasn't a submarine, it was somebody's house. And it was personalized in the way it was organized and decorated, so you respected the fact that we weren't just going to take it over. Even the lab module we had just attached to the station was going to be *their* lab as soon as we got it turned on.

It was very nice to have a welcoming committee, but it was all very informal. We didn't do any fancy schmancy ceremonies. We just came over and said, "Hello, we're glad to be here." And then everybody got to work.

Departing Expedition Two crew members receive commemorative mission shirts from their Expedition Three replacements, STS-105. From left: Rick Sturckow, Vladimir Dezhurov, Mikhail Tyurin, Susan Helms, Frank Culbertson, Yuri Usachev, Jim Voss, Patrick Forrester.

Overleaf: One of the station's 115-foot-long solar arrays and its supporting mast.

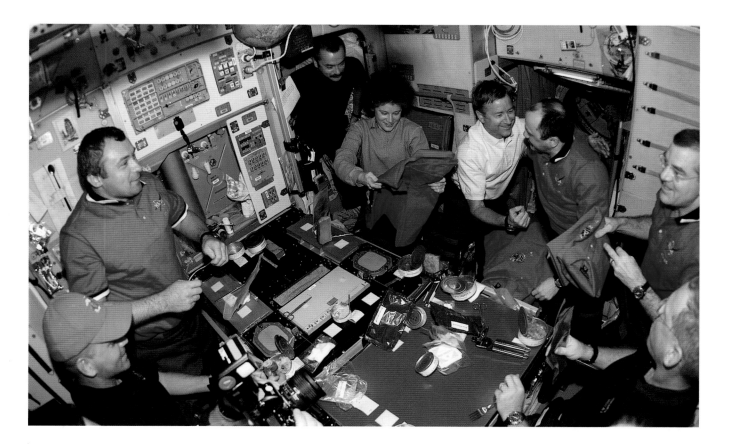

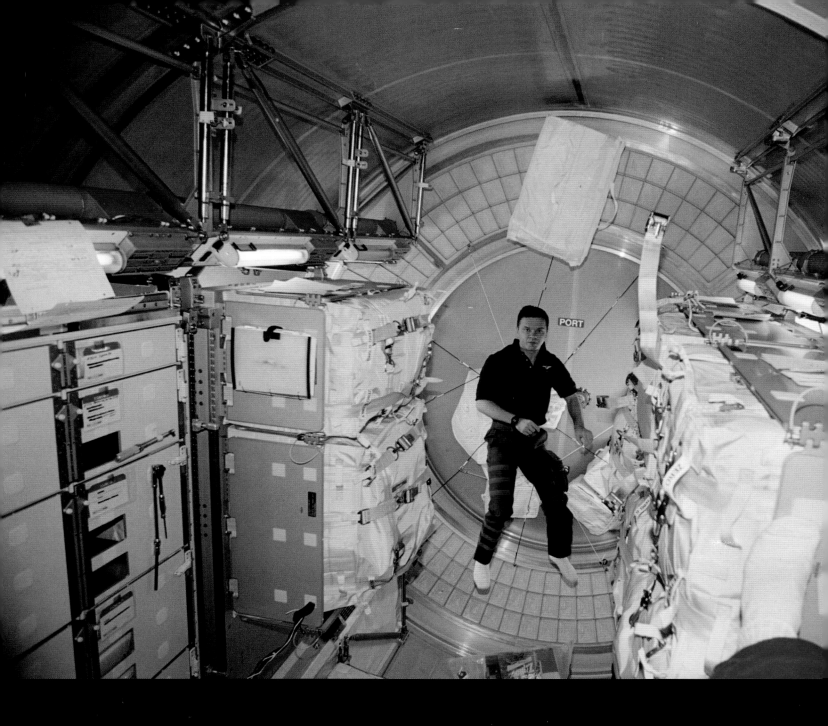

Expedition One crew member Yuri Gidzenko floats inside a detachable cargo module—used to transport material to and from the station—shortly before both returned to Earth in March 2001. Opposite: The International Space Station as it appeared in September 2000, with the U.S.-built Unity (top) and Russian Zarya and Zvezda modules in place. A three-person Soyuz craft—the crew's lifeboat in the event of an emergency—is docked to one end of Zvezda.

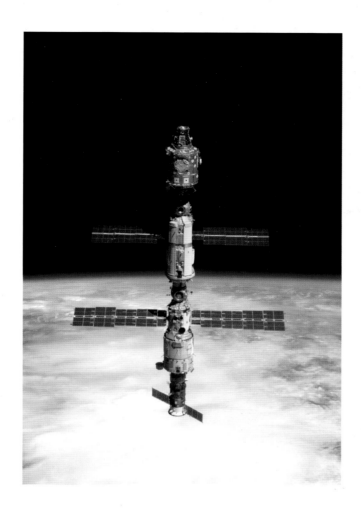

DAN BARRY | **Stranded in the middle of the room**

STS-96

Entering the space station from the orbiter for the first time in 1999 was an exhilarating experience. Even with just two modules—Unity and Zarya—in place, the station's volume was 10 times that of *Discovery*'s flight deck and mid-deck combined. I floated exactly to the center of Unity, where I could not reach the walls, and got stranded in the middle of the room. It's not easy to get stranded—I had to have my friends help me get perfectly still. Once I was stationary, my brain remained convinced that I could somehow maneuver or kick myself over to the wall. But when I reached out an arm, my body moved back and my center remained in the middle of the room. I instinctively tried moving fast, then slow, then bicycled my legs. None of it helped. I just had to wait for the air currents to drift me to the wall. Sneezing and spitting didn't do much good either. On the other hand, throwing clothing as fast as I could produced enough reaction to send me to the opposite wall.

To fly in space is to see the reality of Earth, alone.

The experience changed my life and my attitude toward life itself.

I am one of the lucky ones.

— ROBERTA BONDAR

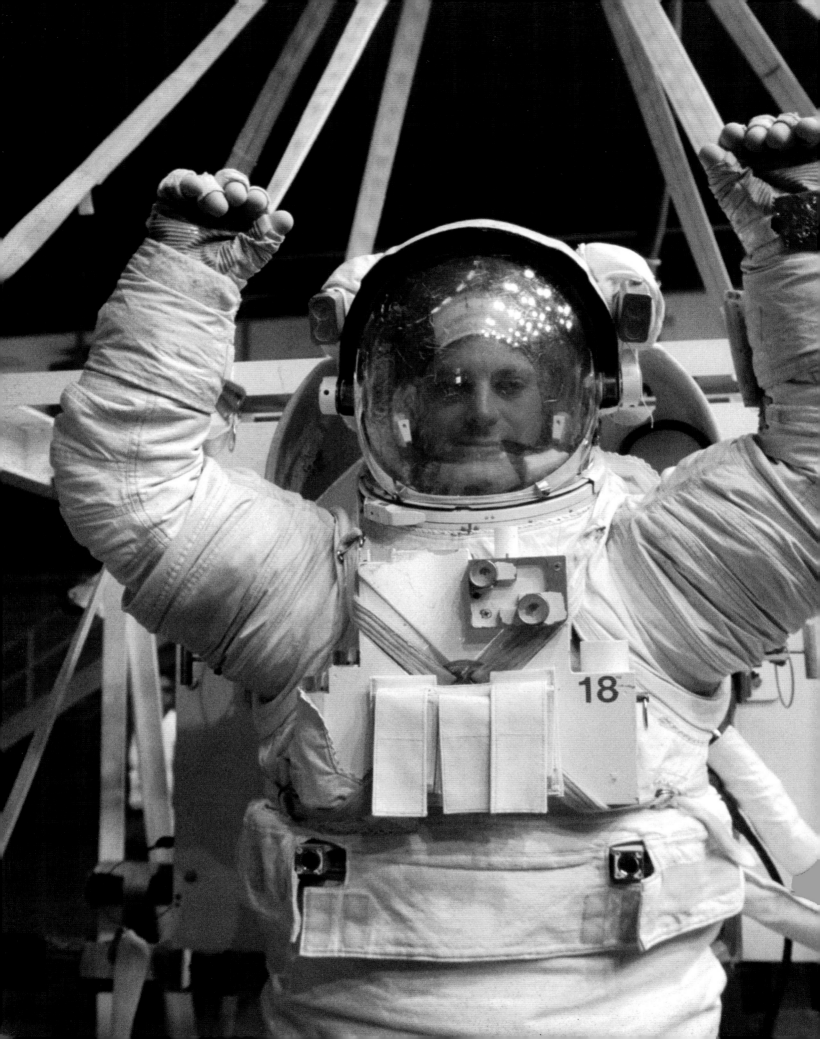

Most of an astronaut's career is spent on the ground, and most of the people who work on the shuttle are not astronauts. It takes thousands of engineers, scientists, technicians, secretaries, and laborers to get the vehicles and crews ready to fly, a fact that isn't lost on the grateful few who actually go into space.

Shuttle astronauts fall into two general categories—the pilots who fly the orbiter, and the mission specialists (typically career astronauts) and payload specialists (typically not) who tend to experiments, deploy satellites, and conduct spacewalks. Training is tailored to the task, so that on any given day the pilots might be flying approaches and landings in NASA's Shuttle Training Aircraft, while their crewmates are across the country, learning protocols for an experiment they'll perform in orbit months later.

Anything that can be simulated ahead of time is, so that by launch day there are as few surprises as possible.

Dave Wolf prepares to be submerged underwater during spacewalk training for the STS-58 mission.

KATHY SULLIVAN | **My mother said I could**

I get asked at least once a day how I became an astronaut. Like all complex questions, the answer to this one has many facets. There's academic record, a science background, excellent health, and, for me, a lifelong quest to find a career that would let me make my living by knowing our entire planet. But I think the real answer may just be that my mother said I could.

There really was just that clear a moment, one fall day in 1977. I had just found out I would be invited to the Johnson Space Center for astronaut interviews, a major milestone in the selection process. I was a graduate student in Nova Scotia and already knew I had a great post-doctoral fellowship in deep-sea submersibles waiting for me at Columbia's Lamont-Doherty Geological Observatory (such an exciting job to me that I had almost forgotten about my NASA application!). When I told my folks the NASA news, my mother asked what it meant for my future. My reply: "It means that when I'm done here I'll be going either 10,000 feet down or about 200 miles up!" After a long, pained silence on the line, she came back in a small, squeaky voice with, "Isn't there *anything* interesting on the surface?"

I don't remember the rest of that conversation, but I'll never forget what

Nancy Sherlock (Currie) hangs on to her parachute harness during a training course for astronaut candidates in 1990.

happened the next day. She called back to retract her comment. Her exact words were, "If I had the opportunities ahead of me that you have, it would mean the world to me to have my mother's support, and you have mine completely."

Recently, almost exactly 20 years after her death, I found a long-lost picture from my childhood that reminded me how consistent she was in her encouragement and support. Three-year-old me has leapt off a swim platform in a lake. The photo looks over my mother's shoulder, capturing me in full flight, feet pulled up beneath me and arms reaching for the sky. She waits in the chest-deep water, arms outstretched to catch and protect me. She really taught me how to fly.

BOB CENKER | What are you doing that one of us couldn't?

Before I asked my wife to marry me—this was in 1974—I had said, "They're designing a space shuttle, and they're going to be taking applications for normal people to become astronauts. And I intend to apply—can you accept that? I don't want to blindside you with this five years from now." After taking a day to think about it, she said yes.

Well, I did apply, but got turned down twice. Now it was 1985, and I was working for RCA. I was 36 at the time. I got on the scale one morning, muttered

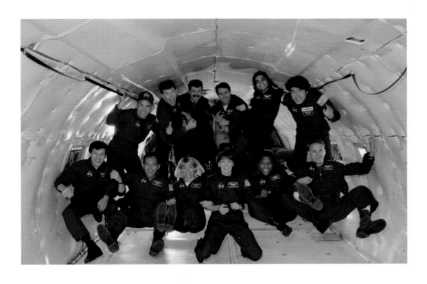

About half the 1995 class of astronauts floats inside NASA's KC-135 training aircraft used to provide short bursts of weightlessness.

something about my weight, and said to my wife, "I guess you don't have to worry about that prenuptial agreement." And that was the day I got the call about flying on the shuttle. NASA's policy at the time was that if a company was flying a major payload—which RCA was with the SATCOM satellite—it could apply for a "payload specialist" seat if there was room. So my getting to fly was really a classic case of being at the right place at the right time. And I'll take that.

I frankly didn't consider myself to be an astronaut for some time, because I didn't help fly the shuttle. My training was not nearly as intense as the career astronauts' training. The physical requirements weren't as demanding. I remember on New Year's Eve, just a few days before our 61-C launch in 1986, our crew was in isolation. We had all had a couple of drinks, and we were sitting around talking about the meaning of life. I don't even remember how the topic of payload specialists came up. The career astronauts on the crew said, "You know, Bob, nothing against you. We enjoy working with you. But we have to wonder—what is it *you're* doing that one of us could *not* do?" Because there were guys in the astronaut office like Franklin Chang-Diaz, who was also making his first flight on 61-C, who'd been at NASA for three or four years. And here I am, I walk in off the street and in six months I'm going. I didn't perceive an edge to their question. It was sincere.

So I told them, "Obviously, you guys can do anything I'm doing. But the one thing I'm doing that you're not is—I'm going back to work at RCA after I come back. And I'm going back to work on the space station. Would you want to drive in a car designed by somebody who'd never even ridden in one?"

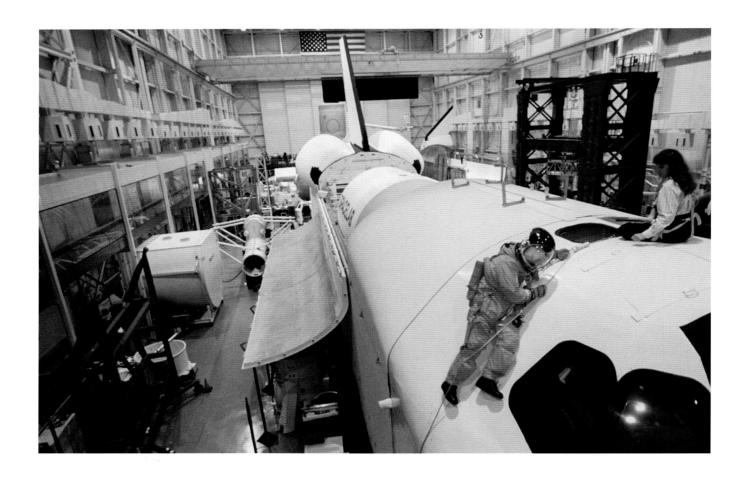

RICK HIEB | **No one place you can put it all together**

Top: John Glenn rappels from a mockup of a shuttle orbiter while learning emergency escape procedures before his STS-95 flight. Above: Tammy Jernigan practices underwater for her STS-96 spacewalk outside the International Space Station.

Before a flight, you're always questioning yourself. Am I good enough? Am I trained enough? Will I screw up? All of those things go through your mind, and you really don't know how good the simulations are prior to flight, because we train on so many simulators. You use the motion base simulator, which moves you around in several axes, to train for launch and entry. You go to the fixed base simulator—a mockup of the shuttle flight deck—to practice on-orbit work, and you go to the engineering simulator to practice rendezvous. You fly the Shuttle Training Aircraft to practice approaches, and you fly T-38s to get a general airplane feel. You go to Brooks Air Force Base in Texas to be spun on the centrifuge. There are literally dozens of simulations that you do, and each of them has its strengths. But each of them has weaknesses, too. There's no one place you can go to put it all together until launch day.

But after being in orbit for a few days, the overriding sense I always had was, "By golly, we're trained really well." The human brain must be astonishingly good at separating the good stuff about a simulation from the bad stuff, because when I got up there I felt very comfortable and ready to do my job.

Emergency bailout practice in the Neutral Buoyancy Laboratory, a large pool at the Johnson Space Center in Houston.

BREWSTER SHAW | **We died in the simulator again today**

It was just prior to the STS-9 flight, and I was training with John Young. We would spend a lot of time in the simulator. John would be in the commander's seat, I'd be in the pilot's seat. We'd do all these aborts and all these disaster scenarios, and every once in a while I'd screw up big time and we'd crash and burn in the simulator. Then I'd go home at night, and around the dinner table I would talk about how the day was and say things like, "Well, we died in the simulator again today."

When it came time to go into quarantine before the flight and I was saying goodbye to my family, my youngest son started to cry. I thought it was just because I was leaving. But later his mother told me that he thought I was going to die, because I'd told him about crashing in the simulator. So I learned that you have to be very careful what you say to children.

MIKE McCULLEY | **I could do no wrong**

I was very pleased and flattered to be the first pilot in my 1984 class of astronauts to be assigned to a flight. And I think I know exactly why that was. One night in the fall of 1985, I happened to be at the Kennedy Space Center when the Shuttle Training Aircraft, the one we use to practice landings, was scheduled to fly. For some reason the prime crew couldn't go, so I got to fill the slot—a really good deal for me, because astronauts who had not yet been assigned to a flight were at the bottom of the pecking order.

John Young, the Gemini and Apollo veteran who headed the astronaut corps, had a habit of riding along on these training flights. On this very dark night, we also took up Congressman Don Fuqua, who chaired the House Science Committee and therefore had a lot of control over the shuttle program.

My performance in the training aircraft was usually at least average, although I doubt I was at the top of the heap in terms of my ability to always land it in the right spot, at exactly the right time. But that was one of those nights when I could do no wrong. In fact, about halfway through, I was really hoping the airplane would break so I could quit while I was ahead, because every single approach I was making was absolutely, totally, and completely dead-on. It was magic. It was like athletes who get in The Zone.

John was happy, Fuqua was happy, the instructor was happy. We finished 10 approaches, or whatever it was, and got out. We're walking across the ramp, and John has his hands on my shoulders, bouncing a little bit, telling me how impressed he was, and how well I'd done on a dark night, etc. I remember saying to him, "I bet you say that to all the girls." And he said, "No, this is wonderful, this is wonderful!"

Two mainstays of astronaut training—the T-38 jet used to maintain flying proficiency, and the larger Shuttle Training Aircraft for simulating shuttle landings. Bottom: STS-103 astronauts Scott Kelly (front) and John Grunsfeld in a T-38.

Top: STS-97 crew members Joe Tanner (left) and Carlos Noriega check out the orbiter's docking system. Above: Ukrainian cosmonaut Leonid Kadenyuk works with a plant biology experiment to be carried on his STS-87 flight.

When I was a kid in the early 1960s, there was a cartoon series on TV called "Space Angel." It was sort of a precursor to "Star Trek" in that it brought some intelligence to the science-fiction genre. I remember thinking as I watched that if this is what space exploration was like—which I reasonably believed was the case—then this is what I wanted to do when I grew up.

Fast forward to 1999, Mario Runco in Building Nine at the Johnson Space Center. I was scheduled to do a hardware evaluation, where astronauts see if a certain piece of hardware will work in space based on their previous flight experience. This particular evaluation was of a life sciences glovebox destined for the Japanese Experiment Module on the International Space Station. I had my hands inside the glovebox, which lets you manipulate fluid samples and the like without their floating around and getting all over the place.

The glovebox was set up on a stand that was entirely too low for my height, so I'm slumped over like the Hunchback of Notre Dame. The Japanese engineers who designed the hardware are asking me things like, "Can you reach the test-tube files over there on the right side?" and "Can you turn on the light switch on the top?" I'm being objective, of course, but I'm not a life sciences person, I'm an Earth scientist, and this kind of stuff is simply not exciting to me.

At one point in the evaluation, they open the lid of the glovebox and drop in a rubber rat. It plops on the floor of the box and rolls around a bit in front of me. I'm looking through the glass at it, and I'm thinking, "Okay, now what?" Then this mini-guillotine, one that Marie Antoinette would have been proud of, gets lowered ominously into the box. They didn't really want me to do it—they needed the rubber rat for the next evaluation—but they asked if I thought I could "dispatch" the rat without a problem. At that point I just went off-line mentally and thought to myself, "Gee, this is not exactly what I had in mind back when I was watching 'Space Angel.'"

RICH CLIFFORD | **Teamwork**

Astronauts are not a bunch of clones, and that's what makes the job so exciting. Everybody has a different personality and a different skill mix. Each has a different life outside the office. Before one of my flights I had disagreements with one crew member, but in orbit it was just a remarkable experience. I think we all realize that we're in a difficult, dangerous situation, and it requires everybody doing their part to make it successful. Any one person could make a mistake that could cost the rest of us our lives. So you get very close, and you get comfortable with everybody's skills. You cross-train, and you know there's somebody backing you up on every task that you do. If you get behind you can call on them, and they're going to do it the right way. The teamwork is outstanding. And that's something I've used in my daily life since leaving the astronaut corps—the idea of building the team.

Wilderness training, Russian style. STS-86 crew members light emergency flares during a practice session for their trip to the Mir space station.

I have many colleagues in academia who work long, long hours to achieve their goals, and have to spend time away from their families. Astronaut training is a special flavor of that, because it's focused on doing an almost perfect job, on a very tight time schedule, on a specific date in the future. There's no escaping it. It's like this train coming at you, and you can't get out of the way.

It starts to accelerate around nine months prior to launch. Instead of working a couple of hours each day on your mission and the rest of the time on your primary desk job, the mission begins to consume your whole life. The scheduler, if he's good, will give you a reasonable chance to get to the gym and eat your lunch every day. If he's not, you'll wind up with 10 hours of work, and, by the way, you can catch the gym on your own time that night. And hope you see your family, even though we're turning you out of the simulator at 10 o'clock. There's a mental burden you carry that you can't get rid of.

Then from six months to three months before launch, you begin to lose track of the weekends, because you might have to fly to the Cape and work on a Saturday, because that's the only time they're not working on the lab module and you can get access to it. From three months to launch it's just crazy, out of control. Any hope you have for routine tidying up of your desk, forget it. You have to do that at night. My wife and I have desks that face each other at home, so from 7 p.m. to 10 p.m.—that is if I'm home at 7—I'm typing at my laptop, getting my e-mail done. She's sitting over there wondering when I'm going to come up for air and talk to her.

STS-88 commander Bob Cabana inspects one of Endeavour's front windows while a technician cleans the outside.

Astronauts constantly come back from flights saying that the schedule is too intense and that they need to back off. Not only are you worried about the flight, you see obvious signs that your family is worried, too. There's nothing you can say to your wife to assure her this is going to be safe, and that's a very helpless feeling.

In those last few weeks, you lose track of what's coming up tomorrow. You just know your scheduler has you committed, and you shouldn't worry about whether you have any free time, because you don't. You just hope there will be some cancelled class or you'll finish early and you can maybe grab half an hour at your desk. To get off that treadmill is all you want at the very end. I can't wait to get into quarantine, where we're isolated from everyone for the last few days before launch. Because then I'll get some rest.

MILLIE HUGHES-FULFORD | **They were up all night**

STS-99 Mission Specialist Janet Kavandi
checks her communications headset before
an underwater practice session.

You get to know the support people really well, especially the suit technicians, the team that puts your orange flight suit on you before a launch. They make sure all the valves are closed or open as they should be, and that you have all your survival equipment. You're very intimate with them, because they're seeing you running around the crew quarters in your long johns, and they're with you a lot in the last six months of training.

Three days before my STS-40 flight, we were up on the launch pad gantry in our suits, and the mosquitoes were biting any exposed part of our bodies. It was really bad—we looked like we had the measles. The suit techs saw this and heard us say in our debriefing that evening, "Hey, we were really bitten out there." That was at 10 at night, and we went to bed an hour later.

When we showed up for practice the next morning at 9, those guys had made us mosquito netting for our heads and gloves for our hands. That meant they'd had to go out into the community and wake up the people who owned the fabric shops, buy the fabric, go back, and sew it all together. They were up all night.

GARY PAYTON | **The frost on the tip of the iceberg**

Mission Commander Charlie Precourt (in front) and the rest of his STS-84 crew (from left, Eileen Collins, Carlos Noriega, Ed Lu, Jean-Francois Clervoy, Mike Foale, and Elena Kondakova), with astronaut Mario Runco (end) assisting, are briefed on emergency escape procedures at the launchpad.

On launch day the other guys were getting strapped in, and I walked back outside to the catwalk that stretches from the fixed service structure to the vehicle. The shuttle is creaking and groaning and venting liquid hydrogen and liquid oxygen, and I realize that three and a half miles away, about 300 people are looking at telemetry from this entire stack. And everything has to be just right before we launch. Then I realize that back in Houston, there are probably another 3,000 people looking at the same telemetry to make sure everything's just right before we launch. Then there's the military payload control center, with a few hundred people looking at hundreds of telemetry points. And I began to realize that the five-man crew on our flight was just the tip of the iceberg. In fact, we weren't even that. We were like the frost on top of the tip of the iceberg. The real smarts and the real talent of the space program are those thousands of people sitting in consoles, making sure everything is just right before we fly.

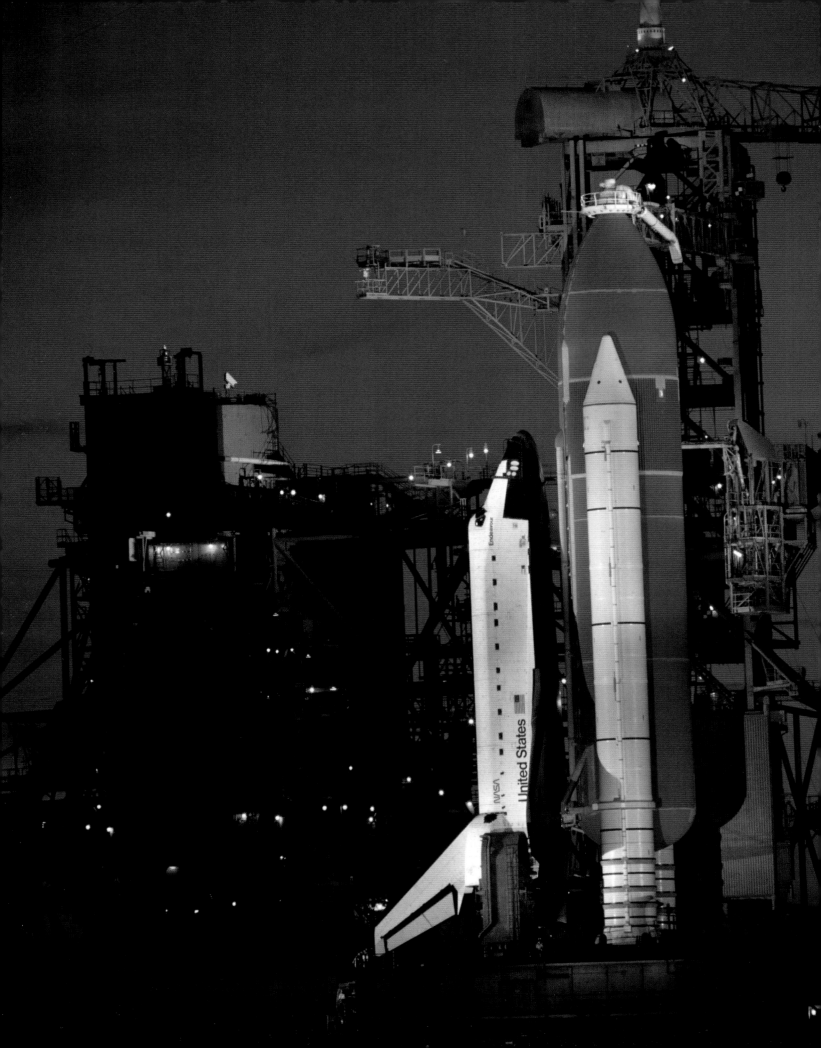

The buildup to liftoff is one of the most ritualized parts of the space shuttle experience, from the traditional pre-launch breakfast to the gladiator-like suit-up in a room at the Kennedy Space Center to the theatrical walkout to the Astrovan that drives the crew to its waiting rocket. Emotions are high and senses are sharp as the astronauts arrive at the pad, pile into the elevator up to the 195-foot level, and board the vehicle one by one. Then they lie on their backs and wait.

"People always ask, 'Were you afraid?'" says veteran shuttle Commander Bob Cabana. "I've been up four times, and each time I went, I was a little more aware of what I was risking. But that's before the launch. Once I'm strapped in, it's total peace, a piece of cake. It's just like being in the simulator. You know what's going to come."

Endeavour *waits on the launchpad prior to the STS-68 launch in September 1994.*

ANDY ALLEN | **Boo-hoo evenings**

The worst thing about flying in space is saying goodbye to your kids. My process in the quarantine period before launch was to get my will all squared away and write notes and letters to my kids. In case of my death, here are all the instructions, here's what you need to do. It really gets sad, so I had at least one boo-hoo kind of evening before each of my flights. On each flight I also did something special for the kids. In case I didn't come back they would have something, whether a cassette recording or a letter or a recording of songs.

Having been in the Marine Corps and been on aircraft carriers and had gazillions of close calls as a fighter pilot, nothing is as stretched out as getting ready for a spaceflight. The whole emotional part of it was surprising to me—I wasn't expecting it. Partly it was because my kids, at least the oldest one, were at an age where they understood what was going on. Daddy might blow up, and he might not come back. The worst part was showing up at the Kennedy Space Center in the airplane a few days before launch and seeing the kids. But you can't go up and hug them, because you're in quarantine. So they cry and cry and cry. It was a long bus ride from the landing facility to the crew quarters. I felt terrible.

In quarantine: During the week before launch, no young children—not even an astronaut's own—are allowed to come in contact with the crew, to reduce their chances of becoming sick in orbit. Contact with adults is kept to a minimum.

MIKE MULLANE | **They all struggle**

The Beach House serves as a pre-launch haven for astronauts and their families.

It's known simply as the Beach House—a retreat used by astronauts and their families in the days before launch. The goodbye that husbands and wives face at the Beach House is one that most could never have anticipated when they were standing at the altar. Handholding couples scatter in search of privacy. Some walk north or south and disappear around the distant bends in the Cape Canaveral shoreline. Others stay close, spreading a blanket just beyond the dune walkover. Still others wait until they are alone in the house. But no matter how they seek isolation, they all struggle with that mix of fear and excitement, now at a crescendo.

By NASA directive, each astronaut selects "family escorts." For each mission, two fellow astronauts are picked to help care for the families after the crew enters quarantine. But escorts also stand ready to play another role. In the event of a mission disaster, their title changes to Casualty Assistance Officers, and they become responsible for helping the families in the darkest of hours.

Usually the spouses choose the family escorts, most often at some social function, perhaps over dessert at a crew party. They make their selections carefully, but with never any mention of the second, grim duty that escorts might have to assume. In the three selections I have witnessed, no one would have ever guessed from the women's discussions that they were picking potential escorts into widowhood.

RICK HAUCK | **Like an invisible force shield**

For several weeks prior to the launch of STS-26, the first flight after *Challenger*, we were put into a limited quarantine to minimize our chances of getting an infectious disease. We would have face-to-face contact only with those who'd been given a physical exam and some counseling. Those who hadn't were required to maintain a distance of 15 to 20 feet.

When President Reagan came to Houston to give a speech in the cavernous simulator building at the Johnson Space Center, the five of us were backstage in our distinctive blue flight suits, awaiting his arrival. As Dick Covey, the pilot on the flight, and I were strolling around the various simulators and mockups, I noticed something odd. Whenever we approached one of the president's security detail (I presumed they were Secret Service), they would move so as to remain a fair distance from us. I quickly realized that they were strictly and very professionally observing the quarantine constraints. I momentarily felt an odd sense of power—as if an invisible force shield was keeping these paragons of subtle strength at bay.

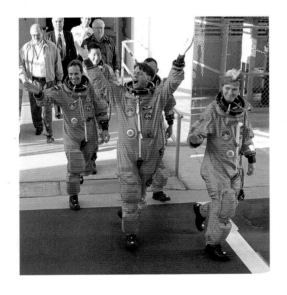

Mike Foale (center) and STS-84 crewmates gesture to well-wishers gathered for their practice countdown. Right: Gases vent from the giant external tank, which is fueled just hours before launch.

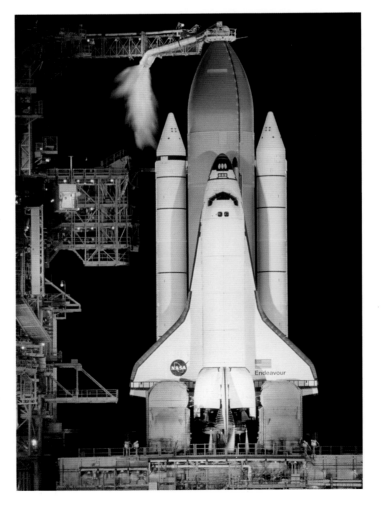

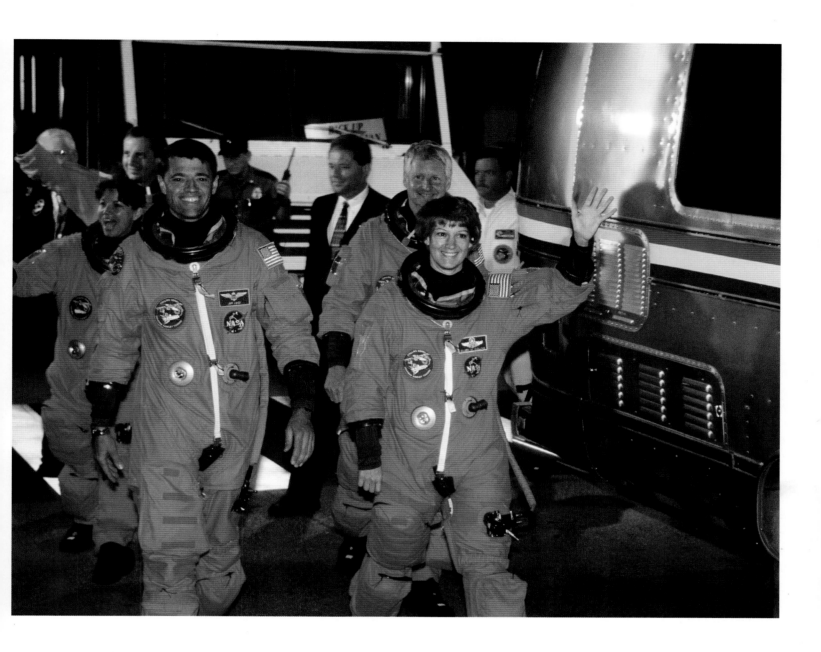

FRED LESLIE | **The Astronaut's Prayer**

Eileen Collins (waving) and Jeff Ashby lead their STS-93 crew as it prepares to board the Astrovan for a late-night launch.

Wearing the awkward orange Launch and Entry Suit, I was trying not to stumble in front of the assembled crowd who had awakened early to see us off. The van slowly made its way to Pad 39B, where *Columbia* had been waiting patiently for weeks due to various technical and weather problems that had postponed our launch six times.

The mood was a mix of excitement and reverence. We stopped momentarily at a viewing area about four miles from the pad, and the head of the astronaut office got up to leave the van. He paused at the door, looked around at us, and said with only a hint of a smile, "I think it's appropriate to repeat the Astronaut's Prayer, which is—'God help you if you screw up.'" He turned and disappeared into the darkness.

JIM PAWELCZYK | **Strapping in**

Our van has just dropped us at Pad 39B at the Kennedy Space Center. A helicopter gunship is circling above. I'm wearing 86 pounds of spacesuit and survival gear over two layers of long underwear. The air is thick and humid; the midday Florida sun raises the temperature in my suit far above the comfort range.

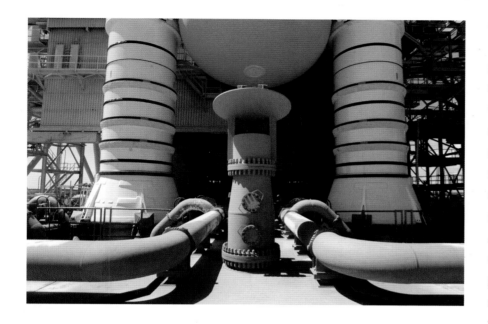

It's impossible to walk without staring at the space shuttle poised above us. Condensed water cascades from the giant external tank, now filled with supercold propellants, into a trench that will divert flames from the shuttle engines and solid rocket boosters. The sight and sound remind me of a waterfall, and the effect is magnified by the sweat trickling down my face onto the neoprene collar constricting my neck. As we ascend the elevator to the crew access hatch 19 stories above the ground, the banter is light. Weather seems to be the major topic of conversation. Because of my position on the crew, I'll enter the orbiter early, which is a mixed blessing: quicker access to the cooling, but I'll have to lie on my back while the rest of the crew enters. The La-Z-Boy people will get no competition from space shuttle seats.

Opposite: Franklin Chang-Diaz (thumb up), Mike McCulley, and Don Williams head for the pad, STS-34. Above: Close-up view of the twin solid-rocket boosters and the shuttle's orange external tank.

Strap-in is conducted by a suit technician who is sweating far more than I. She's been working inside the orbiter for more than an hour, and the air seems stagnant despite the massive circulating fans. She works feverishly; she has only 45 minutes to secure the seven of us. She and I pull, wriggle, and shove until I'm squarely positioned on my parachute, then I lie still as she completes the process. Four parachute clasps. Four seat clasps. Oxygen. Helmet. As my headset is plugged into the "net," I'm greeted by the voices of the officials who will be conducting our launch. Finally, chilled water begins to circulate through a network of tubes sewn into my long underwear, as refreshing as a swimming pool on a hot summer day.

As the rest of the crew enters the orbiter, we have little to say. There are occasional jokes, but everyone is focused on his or her own thoughts. Occasionally we clasp hands in a silent salute to what is to come.

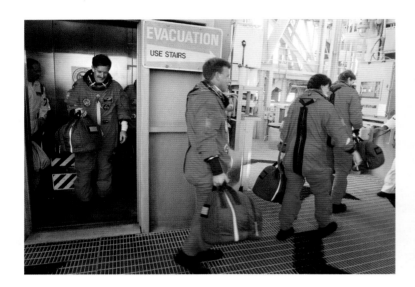
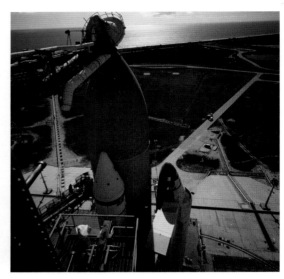

STEVE OSWALD | **The Diaper**

During a practice countdown for STS-104, astronauts take an elevator to the gantry's 195-foot level, just as they will on launch morning. An access arm leads to the White Room (seen from above at right, abutting the orbiter), which provides entry to the shuttle.

I never did figure out how to use the diaper they have us wear during launch. Most people have stories about fluid shifting in your body when you get to orbit, but that stuff actually starts happening on the launchpad when you're lying on your back and the blood starts running out of your legs and into your torso. Your body starts dumping blood volume, and eventually it comes out in the form of urine. I decided that I was going to learn how to use the diaper during our countdown dress rehearsal, which happens about three weeks before the actual launch. So I got up and had the standard breakfast—orange juice, coffee, and all that. Man, by the time I was even strapping in, I knew I had to go to the bathroom. And of course, you're out there for two and a half to three hours. As it turned out, about the time I was going to start to use the diaper, somebody would always talk on the intercom or whatever, and it would break the spell! Like most of us, after 40 years of being trained to not pee while you're lying on your back, it's a hard thing to do. So I was dying!

I think the only real first I had in the spaceflight business was being the first guy to use the bathroom up on the 195-foot level while wearing our orange Launch and Entry Suit. Once we finished our countdown exercise and did the emergency egress drill, I was in that bathroom in a heartbeat, and that's how I made history.

KEN COCKRELL | **I love all you guys**

Technicians help Mike Gernhardt suit up inside the White Room during the STS-104 practice countdown.

We finally got to the launch pad for STS-69, and it looked like the countdown was going really smoothly about two and a half minutes out. I was the pilot on this flight. Dave Walker, the commander, stuck out his hand for everybody to take hold of, and the four of us on the flight deck all grasped hands. And with the best brotherly love that you could imagine, we just said, "You know, it's been really good, this nine or 10 months training together." And Dave said, "I love all you guys, and no matter what happens in the next few minutes, I've really enjoyed this past year." He was saying it from the heart, and it made me appreciate even more that it's the people on the mission that are the important thing.

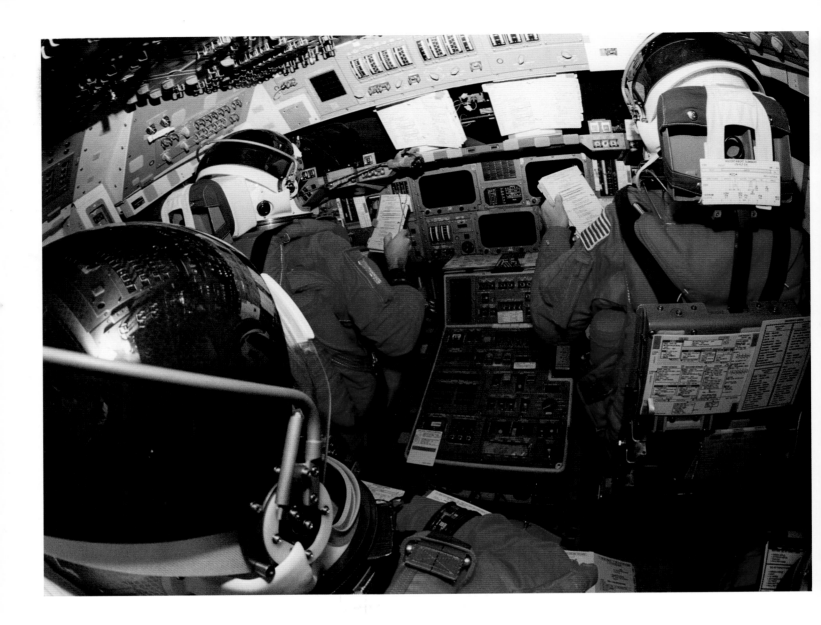

JIM VOSS | **Because I'm scared to death**

Last-minute checklists during a practice session. On launch day, the astronauts wait inside the vehicle for three to five hours after being strapped in.

We were sitting there on the launchpad before the STS-44 launch, and there was a lot of banter in the cockpit, a lot of kidding around and stuff. It was the nervous sort of banter you get on a sports team before it goes out to play. Tom Henricks, the pilot, who like me was about to launch for the first time, noticed that Story Musgrave, who was making his fourth flight, was pretty quiet—he hadn't been joining in all this kidding. And Tom said, "Story, how come you're so quiet over there?" And Story, just as serious as can be, said, "Because I'm scared to death." It got just deathly quiet in the cockpit then. It was really pretty funny. I don't think another word was said for the last couple of minutes before launch, because everybody started thinking, "Well, maybe we need to be thinking about this a little more seriously."

JIM BUCHLI | **Life has been good**

While everything in training has prepared you for launch day, the real deal feels different. The team is totally focused and intense. The vehicle is cooled down, and we smell the orbiter's slightly metallic, dry air as we clumsily crawl in, one by one. We are all business, trying to remain nonchalant about the whole thing. It's like going to war or doing a catapult shot off an aircraft carrier at night—anticipation, adrenaline, fear, excitement, and a "let's do it" attitude are all rolled together.

Standing out there on the walkway 195 feet above the ground before my launches, my own state of mind was: If the launch was successful, great. And if it wasn't…then that's how it is. You're looking up, and you're looking out at the beach both ways, south and north. It's a beautiful, crisp day, the vehicle's creaking. oxygen's blowing off the top a little bit, folks are getting strapped in, and life has been good. You're ready to go do it.

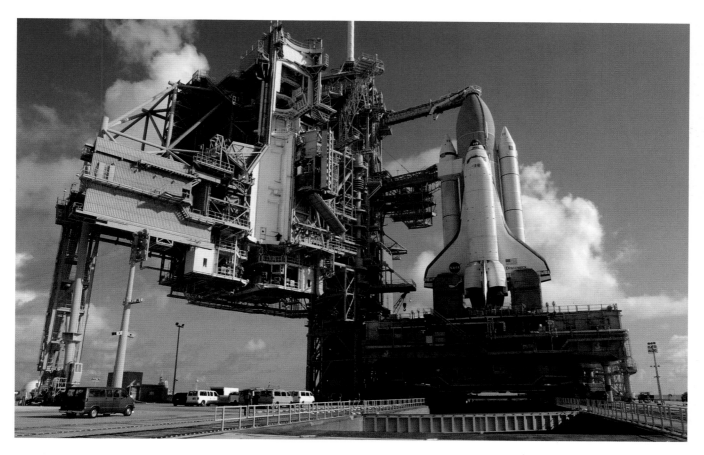

Top: In a launchpad emergency, the crew would ride in these baskets to a bunker on the ground. Above: When the countdown hits zero, no one but the astronauts will be within miles of here.

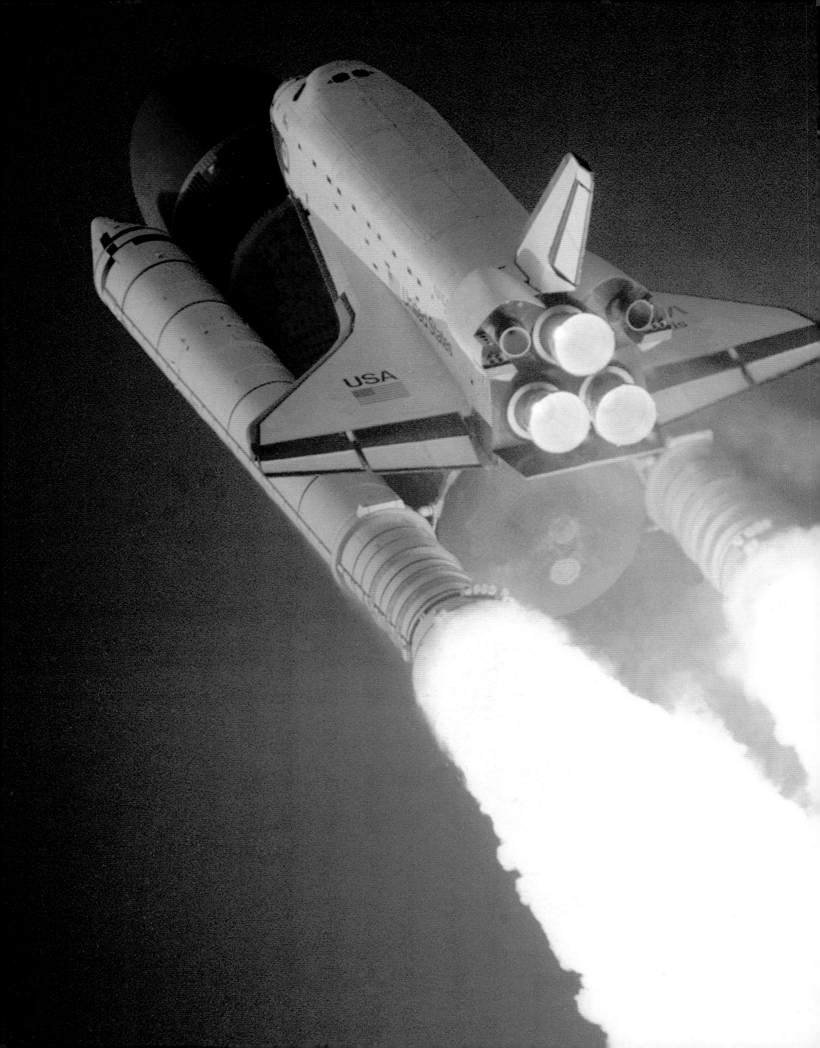

A rocket launch may be the most powerful force a human being can experience—and survive. No wonder, then, that the memory that sticks hardest for many long-time shuttle fliers is their first launch.

Because the vehicle sits upright on the pad, the astronauts start the journey on their backs, with their knees up. Typically, four people are "upstairs" in the cockpit-like flight deck. Three more are seated down in the mid-deck, with little to do (if everything goes according to plan) but enjoy the ride.

Says Scott Kelly, a former Navy test pilot: "The launch looks kind of slow to an observer, but when you're inside there ain't nothing slow about it. I mean, you feel all seven million pounds of that thrust. It's like this giant hand grabs the orbiter and throws it into space."

The whole trip, from zero to 17,500 miles per hour, takes a little over eight minutes.

Atlantis *rockets into orbit, STS-27.*

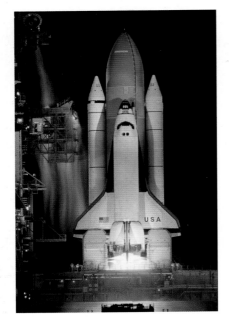

The vehicle explodes, literally explodes, off the pad. The simulator shakes you a little bit, but the actual liftoff shakes your entire body and soul.

— MIKE McCULLEY

Above: Water floods the base of the pad at ignition to absorb the acoustic shock, producing huge billows of steam at launch. Opposite: Liftoff, STS-100.

SCOTT PARAZYNSKI | No mistaking a rocket ship for a simulator

I had studied the systems, read the workbooks, flown the simulators, ridden the centrifuge on a launch profile, and spoken with those who had been there before. But there's no way to really understand what that first launch will be like, or to anticipate the awe and adrenaline you'll feel on the Big Day. All the calls from Launch Control and Mission Control were just as they'd been during all of our simulations. At launch minus two minutes and 30 seconds, the helmet visors came down, oxygen on just as trained. At L-10 seconds, the noise and rumble of the water deluge system far below sounded much as it had in the shuttle motion simulator. Even at L-6 seconds, as the three main engines throttled up, the vibrations and sound transmitted through my helmet were more or less what I had anticipated—although a lot more exciting! At Solid Rocket Booster (SRB) ignition, though, there was no mistaking a rocket ship for a simulator. The kick of the SRBs took us to almost two g's instantaneously, with concomitant roar and rattling in the cabin. The four of us on the flight deck were focused on the computer screens in front of us, following the launch milestones in our procedures. But I did sneak a quick peek at a mirror strapped onto my left knee as *Atlantis* rolled on her back to climb to orbit. I could clearly see the waves crashing on the beach below us, and a scattered cloud deck falling behind us at an amazing speed.

JIM BUCHLI | Strapped on the front of a freight train

When the engines lit, I had no idea it was going to be that much energy, absolutely no idea. I've done catapult shots off of aircraft carriers and flown a lot of aircraft that have pretty good acceleration, but I have never felt anything like that. Within 30 seconds I was thinking this thing had better work, because if it doesn't, it's going to be really tough to turn that much energy in another direction. It's like being strapped on the front of a freight train going down the track at 100 mph. You feel all that mass and force behind you.

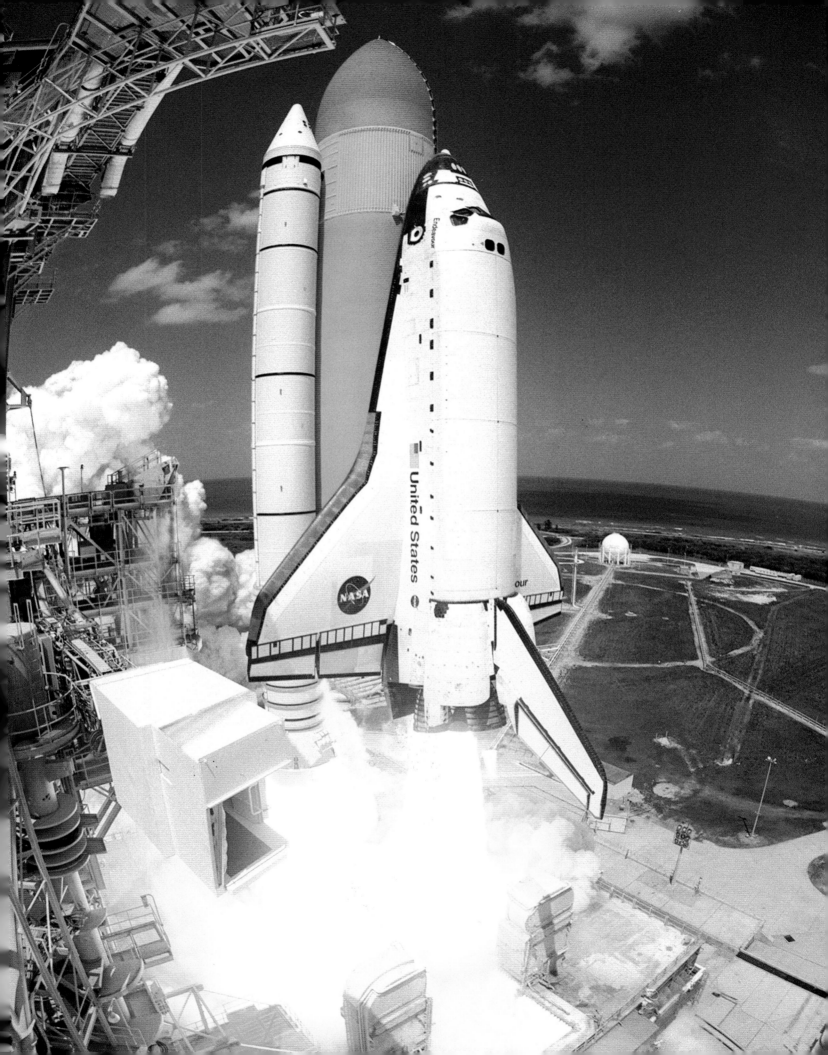

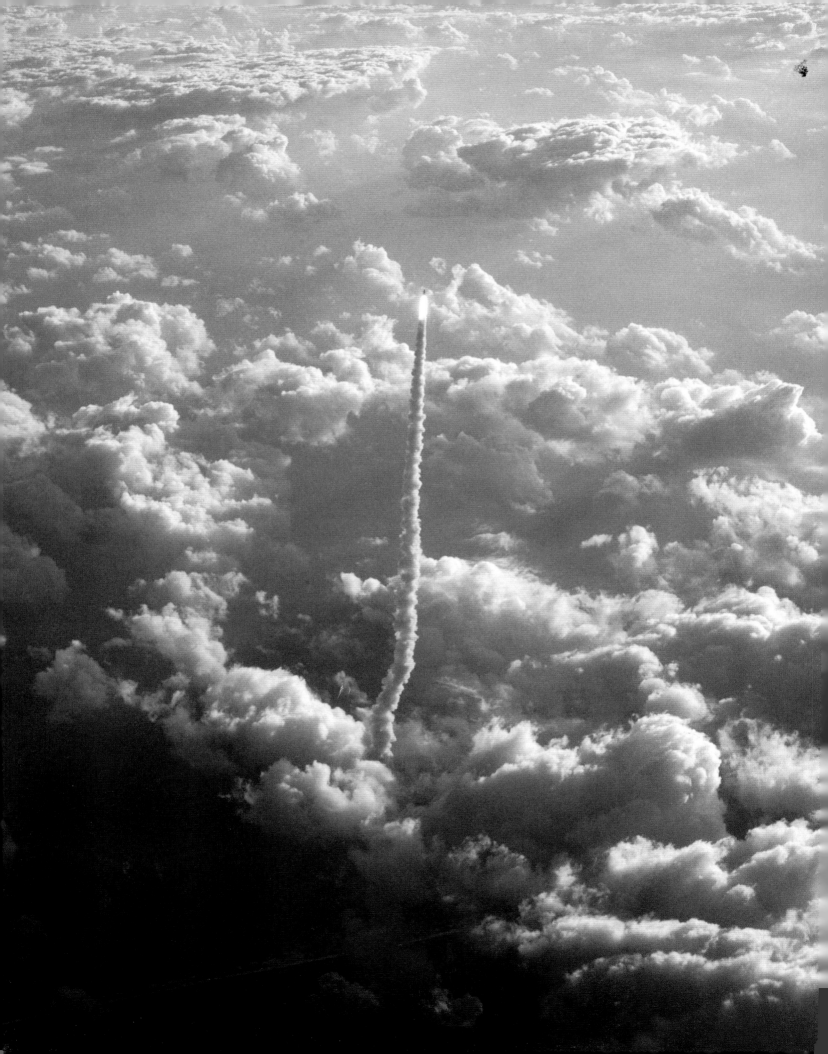

> The only thing I've experienced that could compare to the launch in terms of raw power was the Loma Prieta earthquake.
>
> —LOREN ACTON

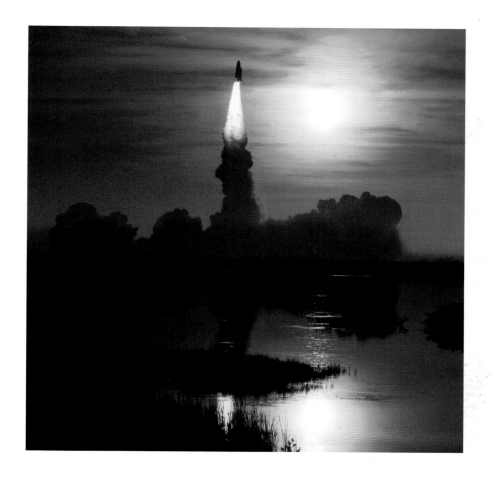

RICK HUSBAND | **Punching through the clouds**

Opposite: Aerial view of the STS-51A launch, taken from a NASA aircraft. Right: Discovery lifts off early in the morning, STS-102.

While we were sitting on the launch pad waiting to launch STS-96, I noticed a thin layer of clouds above us. I don't know how high they were, but my guess is that they were around 10,000 to 12,000 feet. As I sat there, I got to thinking it would be a pretty impressive demonstration of our speed if I had the presence of mind to look out the window as we passed through the layer. We launched shortly after sunrise, and as we ascended, I timed my crosscheck of the main engines and other systems to look out the front window for a few seconds just prior to passing through the cloud layer. Fortunately, I looked just in time to see the layer coming as we punched through—it went by in the blink of an eye. Very impressive.

KEN REIGHTLER | **Would you knock that off!**

Shortly after clearing the tower, the whole shuttle "stack" rolls slightly to keep the vehicle oriented properly.

It's been said that a shuttle pilot has only three main tasks: to start the auxiliary power units (APUs) that power the vehicle's hydraulics, to lower the landing gear, and to make the mission commander look good. That's a joke (I think), but during launch, as long as everything works correctly, there's not much to do except monitor system performance. If something goes wrong, it's a totally different story. There are an incredible number of switches, buttons, levers, display selections, and circuit breakers that have to be manipulated, all in the right order and at the right time.

As a first-time flier on STS-48, I was concerned that my bulky suit and the g-forces pulling on my body would make it hard to reach those switches in an emergency. To bolster my confidence, right after liftoff I started systematically reaching around the cockpit as the g-forces started to build. Watching me go through these exercises with growing anxiety, my commander eventually had enough of me reaching for the engine cut-off switches, and politely asked, "Would you knock that off!" I did (pronto), and the rest of the ride to orbit was a dream come true. By the way, my wife, Maureen, always signed off her daily family message to me with the reminder, "Don't forget to lower the landing gear!" I remembered.

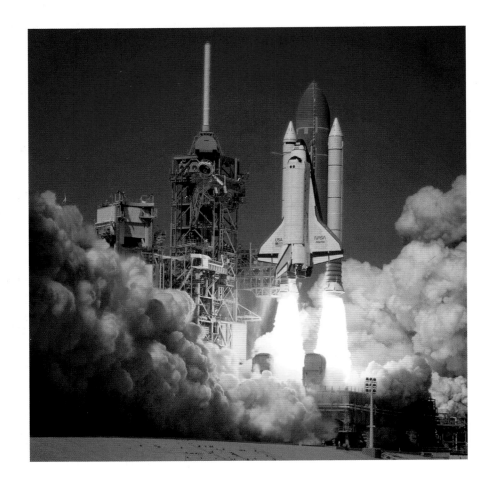

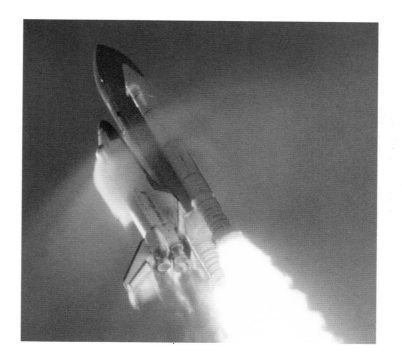

A shockwave coming off Atlantis was caught on motion picture film during the STS-106 ascent. Astronauts ride into orbit head-down.

DAN BRANDENSTEIN | **Dan, how do the engines look?**

During the STS-8 ascent, Dale Gardner couldn't see a whole lot because he was sitting behind my pilot's seat and didn't have the responsibilities of the flight engineer. But we have these overhead windows, like a moon roof on a car, and he could look back over his shoulder and watch the ground disappear. He was commenting, "There are the solid rockets lighting," and "You can see all the way down the coast," and that sort of thing.

After the solids separated, the light level went real low because this was a night launch. A couple of seconds later, Dale said in an excited voice, "Dan, how do the engines look?" As the pilot, I was monitoring the systems, and I said, "Oh, they look fine." A couple of seconds later, he said again, "Dan, how do the engines look?" I said, "They're running fine. They look good."

Then a little while later, "Dan, how do the engines look?"

"They're fine, they're fine." He did that three or four times.

We got into orbit, and that night over dinner I asked Dale, "What in the world was going on?" He had remembered something from long before the first shuttle flight, when they were first testing the engines. They'd start them up and the flame would be very solid and stable coming out of the nozzle. Then, just before the engine *blew up*, the flame would flutter. And from his perspective, looking out that overhead window, it looked like the flame was fluttering, especially as we got higher in altitude where the air pressure was lower. Dale is extremely bright, an amazing individual, and he had put those two data bits together. And because of where he was sitting, he was the only one who saw it. He made a point to debrief the crews after us so that other people wouldn't share his concern.

ROY BRIDGES | I didn't touch a thing

I've waited five years since joining NASA, plus a lifetime of dreams, and launch day is finally here: July 12, 1985. The countdown is uneventful, but we feel the tension as we pass each milestone. We all know of the thousands of things that can keep us stuck on the ground.

At T-7 seconds, the main engines start with a rumble from far below. As the person in charge of all engines, I watch the chamber pressure indicators come to life and surge toward 100 percent. I think, "Wait, what is that?" The left engine indicator seems to be lagging behind. Before I can say a word, it begins to fall to zero, followed by the other engines. With less than three seconds before our planned liftoff, we have an abort. The groans from the rest of the crew are now audible. After all the training and preparation, our mission has ended right here on the launch pad, before it even began.

I take a quick look around to see if there's anything else to be done, and notice my commander, Gordon Fullerton, turning to look at me, his rookie pilot, with appraising eyes. The thought crosses my mind, "Gordo probably is thinking I've done something to screw it up." So I show him both hands, palms up, and say, "Gordo, I didn't touch a thing. It was an automatic shutdown." Funny to me now, but not so funny at the time.

At the beach that night, I find that my kids are mortified that their dad has "lurched instead of launched" in front of TV cameras and their friends. How embarrassing! Everyone wishes I was somewhere else, especially me.

Photographers at the press viewing site, about three miles from the launch pad, watch Columbia *rise into the sky shortly after dawn, STS-32.*

STORY MUSGRAVE | **We're going to Spain!**

When we had an engine go out during the 51-F ascent, the ground made the call "Limits to Inhibit," which is for us an extremely serious omen. Going to "Limits to Inhibit" means the ground is seeing problems that are going to shut you down. So I'm looking through the procedures book, and I'm thinking we're going to land at our transatlantic abort site in Spain. I'm rehearsing all the steps, and my hands are moving through the book, and I'm thinking, "We're going to Spain!" Things are bad. I'm going through the checklist, and I'm deep into the book.

Karl Henize was an astronomer mission specialist on the flight, and he rode in the right hand seat upstairs, next to me. Because it wasn't part of his duty, he hadn't trained in detail for ascent, so he didn't know what was going on. He looks over and sees the top of my page: SPAIN. He's looking, poor Karl, and I'm going down the checklist that I'll be reading to the guys in the front seats when we abort. Karl's looking over at me, and I sense a really severe stare. Then he dares ask:

"Story?"

"Yeah, Karl?"

"Where are we going?

"Where are we going, Karl?"

"Yeah, where are we going, Story?"

I just looked at the top of the page and said, "Spain, Karl." Then I quickly retracted it. "We're close, but not yet."

Of course, we never did get the call for the transatlantic emergency landing, and we ended up making it to orbit and finishing the mission. Our "abort to orbit" went very smoothly, and everyone did just what they were supposed to do. There was never any moment of real anxiety. It was more the momentary sinking feeling of "there goes our mission."

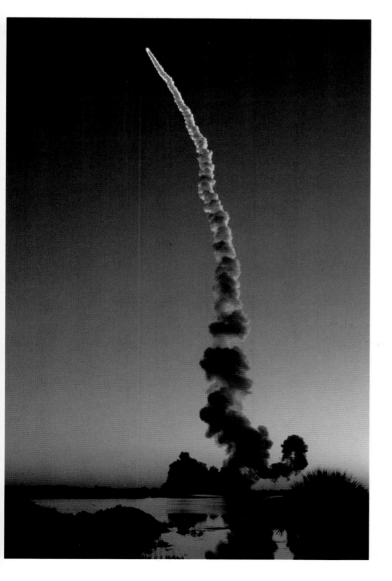

Discovery streaks up and away, STS-102. Two minutes after launch, the shuttle is already moving at more than 3,000 miles per hour.

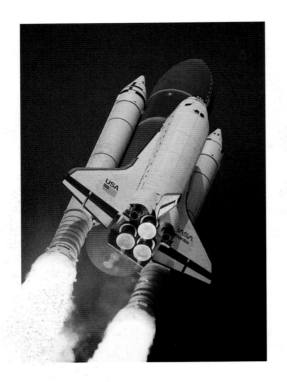

Above: STS-45 launch. After the main engines shut down, the empty external fuel tank drops away (opposite), breaks into pieces in the atmosphere, and falls into the ocean. Above, right: STS-47 pilot Curt Brown, a few minutes after arriving in space.

JEFF WISOFF | **The bear jumps off your chest**

Right before the main engines cut off, you feel like you have a bear sitting on you. It's three g's. Then at the moment of engine cut-off, you go from three g's to zero g's instantaneously. The bear jumps off your chest, and you see your seat belts float upward, which is kind of cool. Then a couple of seconds later, you hear this big clang as the fuel tank comes off. That's actually a little startling to a first-time flier if you haven't been told about it, because the noise in the simulator isn't as loud as the real thing. When the tank comes off, it has a big, empty, metallic, clanging sound, and you're thinking, "Did we hit the tank or come off of it?" The other thing that can be startling is the first time you hear the primary Reaction Control System jets, the ones used to control the shuttle's position in space. The jets on the nose of the vehicle are like cannons going off when they fire. You hear this *boom, boom, boom.*

NORM THAGARD | **The pencil just floated**

On my first launch I was not really sure I was weightless when we reached orbit, because I was still strapped in the seat. So to convince myself that I was, I took the pencil off my kneeboard, put it in front of me, and let it go. And it just floated. I laughed because I thought that was the funniest thing I'd ever seen.

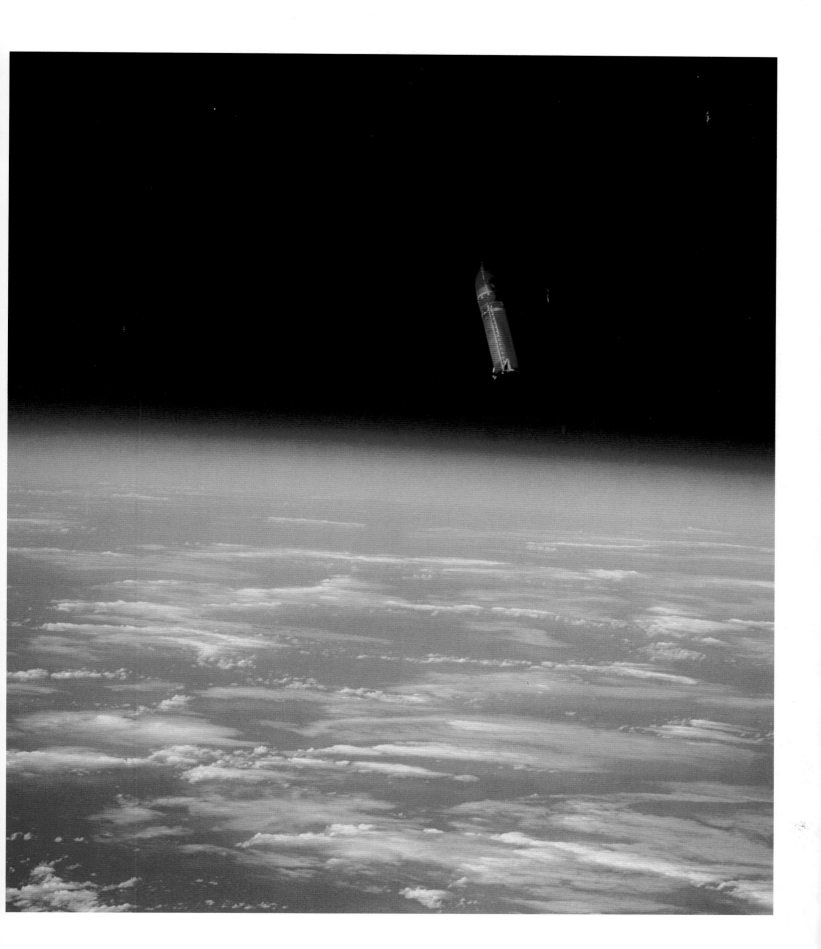

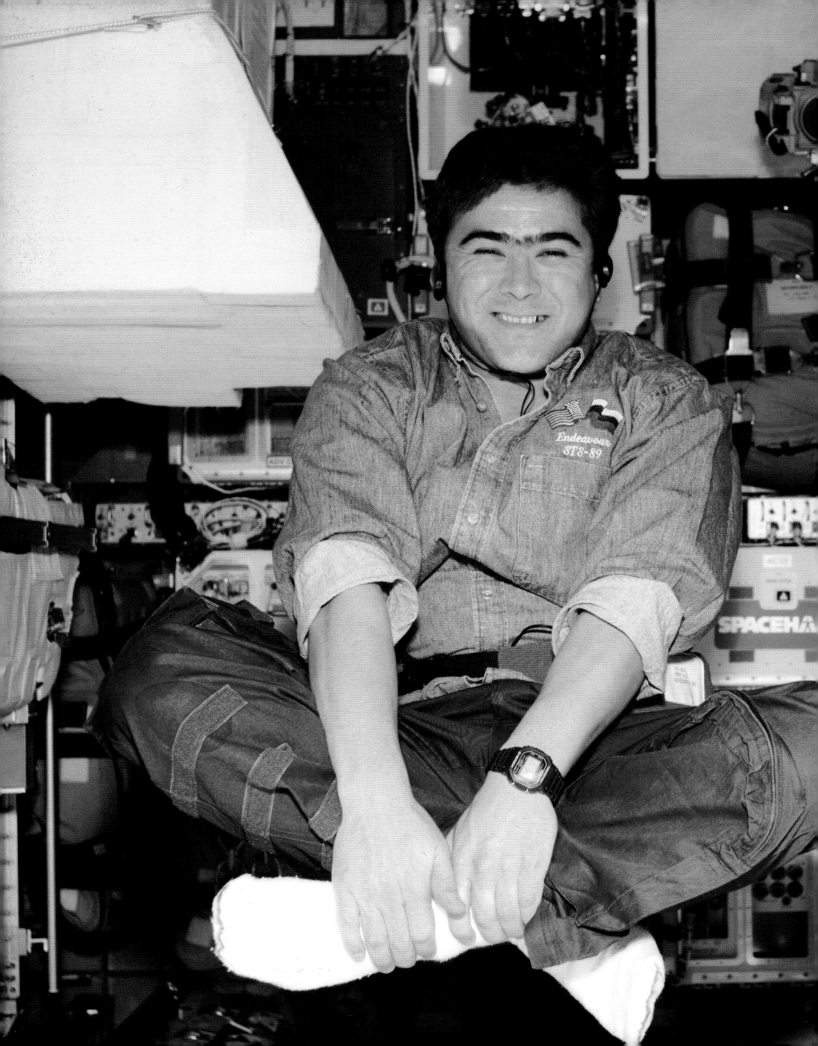

The exhilaration of arriving in space—a moment many first-time astronauts have waited for all their lives—often comes mixed with other emotions. Time pressure is one, as the crew hurries to set up camp and get on with the business of the flight. Then there's the malady NASA calls Space Adaptation Syndrome, or more commonly, space sickness. More than half of all shuttle astronauts—even jet pilots with iron stomachs—experience nausea or other symptoms as the balance organs of the inner ear cease to work properly in zero-g. Some report no problems at all, but three-time shuttle astronaut Pinky Nelson doesn't buy it. "Everybody feels crummy on the first day, no matter what they tell you," he says.

By day three or four, however, most people find weightlessness a joy and become acclimated to this strange world where up is down and you hang in mid-air as if in a dream.

Cosmonaut (and shuttle mission specialist) Salizhan Sharipov floats weightless inside the Spacelab research module, STS-89.

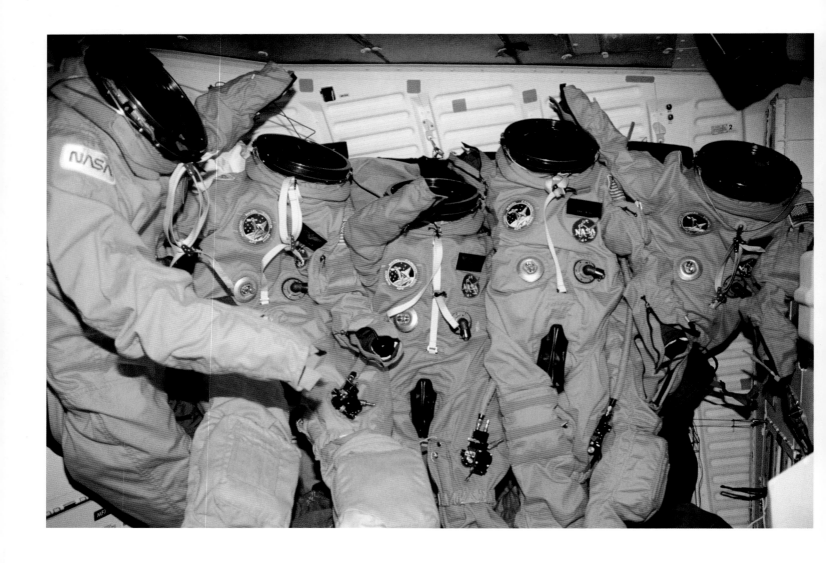

STEVE OSWALD | **Somebody's sock comes floating by**

It never ceases to amaze me, the fire drill that goes on down in the mid-deck in those first couple of hours after we reach orbit. There are a couple of guys trying to help people out of the orange "pumpkin suits" we wear during launch, and it's not unusual to see flight boots floating over here, then somebody's sock floating by, then someone else trying to get somebody an extra barf bag or a towel. It seems that the people you think are going to be fine with space sickness are the ones who never are, and the ones you think are going to be throwing up are the ones who are doing fine. As the commander, you try to figure out how much extra time you need to add to the schedule, based on how many rookies you've got, how they're doing, and so on. But when you stick your head down in the mid-deck for the first time, you never know how your crew will be doing. Sometimes guys are semi-Velcro'ed to the wall, throwing up, while the folks you least expected to be heroes are just chugging along, executing the plan.

FRANCO MALERBA | **Settling in**

One by one, all my crewmates from the flight deck come down to the mid-deck and take off the Launch and Entry Suit we've been wearing during launch. Finally, very cautiously, I also pull myself out of the uncomfortable orange suit, ever so careful not to make any sudden head movement, which might bring on space sickness.

The mid-deck is full of floating bags and helmets. I crawl in the airlock to the back wall of the mid-deck as one would get into a tunnel, to put my suit away and retrieve my on-orbit clothes and "sleeping kit" (which also contains a Walkman and a few tapes of music that each of us has brought on board).

We have one set of clothes per day in orbit. We have chosen the shirts from mail order catalogs: rugby shirts made of pure cotton (an anti-fire fiber), which have our names embroidered on them. After the mission, astronauts are allowed to keep these shirts, which become souvenirs and sometimes collector's items.

Carl Meade (left) and Mark Lee help Blaine Hammond out of his Launch and Entry Suit shortly after arrival in orbit, STS-64. Opposite: A lineup of "pumpkin suits" on the shuttle mid-deck, STS-37.

Each crew member has a color that corresponds to his or her role on board: The commander is red, the pilot is yellow, the flight engineer or mission specialist 2 is green, mission specialist 1 is blue, mission specialist 3 is orange, mission specialist 4 is brown. I am payload specialist 1, and my color is purple.

I find my bags thanks to the color codes, then I turn around to come back in the mid-deck. The room seems to have rotated 90 degrees, with Franklin [Chang-Diaz] levitating horizontally, anchored with his feet to the floor, which now seems to me the side wall. Most strange! I close my eyes with a sense of discomfort, and when I open them again I see Franklin, who has not moved at all, back in the normal upright position. Weightlessness hallucinations!

Marsha Ivins, the flight engineer, who is making her second flight, is like a little bird; small and speedy, perfectly at ease, she floats from one corner to another as a bird would fly to another branch. She can fit in the most incredibly small holes, and seems born in this environment. When she happens to untie her braid, her tiny face is soon encompassed by a halo of long, thick, flowing hair due to the lack of gravity.

STEVE OSWALD | **A catheter in his arm**

If you're going to get queasy, it's usually going to be during your first day or so in space. So I would take a tablet of the anti-nausea drug that we use, Phenergan, before I went to bed on the first night. It would also help put me to sleep, which is not easy for some folks, especially on their first flight. I didn't sleep worth a hoot the first two nights of my first flight.

Most folks use Phenergan via intramuscular injection, a shot in the butt. That works okay, but even that takes a while to take effect. The best way I ever saw it given was to a guy on one of my flights. He was a veteran of several flights, and he had always gotten sick. He figured it was going to happen again, so he talked one of the flight docs into giving him a catheter, and he launched with this needle inserted into a vein in his arm. When we got to orbit and he started to feel bad, he would give himself a couple of cc's of Phenergan. Of course, it went directly into the bloodstream, and you could just see the color come back in his face. It was amazing!

Senator Jake Garn during his STS-51D flight in 1985. Garn was spacesick during the mission—a malady that affects most shuttle fliers to one degree or another.

I noticed in the first four days of my flight that the muscles in my legs were twitching, firing all the time. My brain wasn't getting any input from my muscles, and it was like it was saying, "Hey, where's gravity?"

— RICK LINNEHAN

One of the bothersome things about weightlessness is the lengthening of the spine. In space, the vertebrae relax apart, causing people to "grow" one to two inches. It takes a while for the muscles in the lower back to stretch and accommodate this growth, and a lower backache is a common complaint among astronauts in the early days of a mission. It certainly was for me and my four male crewmates as we prepared for our first sleep period on mission 41-D. For some reason, however, Judy Resnik, our lone female companion, had no pain. Are women more flexible? Was it because Judy was so petite? I don't know. But, for whatever reason, she didn't have back pain. As we males were passing around the aspirin bottle just before zipping ourselves into our sleeping bags, Judy's wit came to the fore. "I don't believe it!" she said. "Here I am going to bed with five men, and they all have backaches."

Judy Resnik, the second American woman in space, and her STS-41D crewmates: (counterclockwise from upper left) Charlie Walker, Mike Mullane, Hank Hartsfield, Mike Coats, Steve Hawley.

Dave Williams (left) and Jay Buckey, both first-time space fliers, peer out the shuttle's aft flight deck windows during the STS-90 Neurolab flight. Opposite: Discovery docked to the International Space Station, with sunglint below, STS-105.

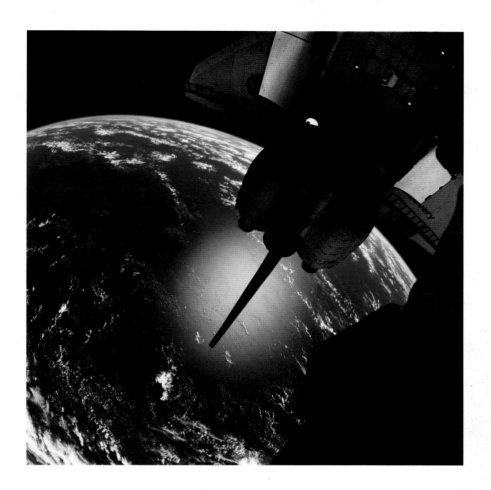

JIM VOSS | **It was like someone grabbed me**

When we got to orbit it was nighttime, so you couldn't really see Earth. I went downstairs, took off my Launch and Entry Suit, and stayed down there helping everyone else get out of their suits and get the things we needed for on-orbit operations. Then, after about an hour, I had something to do on the flight deck so I went upstairs. By now it was daytime, and it was the first time I had ever seen Earth from space. It was like someone grabbed me. I just latched onto the window, and whatever it was that I was going to do went completely out of my mind. The view out the window was so spectacular that I had to think, gosh, I just have to stop here and look for a minute, because one of the reasons for being here is to experience this sort of thing. I don't even remember if I finished what I was doing.

I tell people that zero-g is like swimming in air, but it's not quite. You push off walls and ceilings and glide through open hatchways. It's almost like a seal gliding through the water.

—GUY BLUFORD

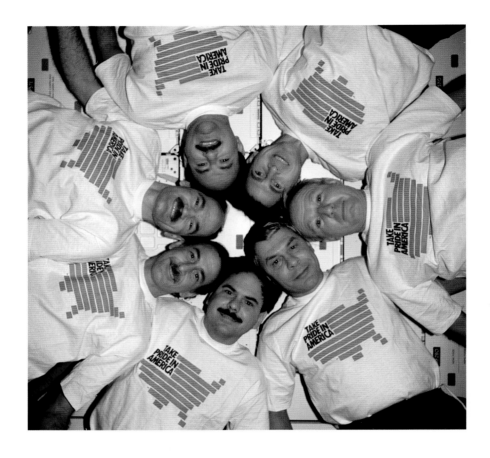

JIM VOSS | **Can you see this hot tub?**

"Heads together" is a favorite pose for group shots in orbit. Clockwise from the "3 o'clock" position: STS-35 mission Commander Vance Brand, Bob Parker, Ron Parise, Jeff Hoffman, Guy Gardner, Mike Lounge, and Sam Durrance.

It's funny how your mind sees things and re-orients you in space. One day during the STS-53 mission, I went inside the airlock, where we sometimes store equipment, to get a videocassette that I wanted to replay to the ground. I'd stuck it in a big white bag with a bunch of other cassettes, and the only way to find it was to stick my head deep inside the bag. When I finally pulled out, my head was sticking out of the airlock's round hatch. And my first thought was that I was in a manhole, or a hot tub. I started laughing, because it was such a strong sensation. The whole world had turned sideways, and the wall was now the floor. I was sitting there, and I just started laughing. My crewmates looked at me kind of strangely and asked what the heck was going on. I said, "Well, I'm in this hot tub right here. Can you see this hot tub?" Then I sat up on the edge of the round hatch, and other people starting laughing too. I said, "Come on over here and get in the hot tub with me." Dave Walker, the commander on the flight, said, "I'll humor him." He came over and sat, then he started talking about how "yeah, it's a hot tub." Eventually everybody joined me except for Guy Bluford, who was kind of hanging back, saying, "I don't believe you guys, and I'm not coming over there." We were all just laughing and carrying on.

RICK LINNEHAN | **Rats in space**

Rodents have flown on several Spacelab missions, including STS-90 (above), which focused on how the brain and nervous system function in space. Below: Dale Gardner tucks into a cozy spot beneath the mid-deck storage lockers, STS-51A.

As a veterinarian, what amazed me on our STS-90 Neurolab flight was how well the adult rats adapted to space. They actually adapt faster than people do. Within a day or two, I was watching the rats push off their cage wall and float across to grab another wall. They didn't seem to be hindered much by getting around in zero-g. I watched some of them take floating balls of water, hold them between their forepaws, and float on their backs like you would in a pool, sucking down the water—which is a lot to do, brain-wise, when you think about it. Some of them were so relaxed, like it was no big deal to them. It takes us humans a while to get used to manipulating things in freefall, and these guys were doing it on the second day.

BOB CENKER | **Something against my back**

The sensory deprivation of floating weightless, the fact that I wasn't touching anything, drove me nuts at first. If you look at early pictures of me during the 61-C flight, you'll see me stuffed in a corner, jamming myself into a tight space so I could feel something against my back. When I slept the first night, I actually put my arm inside one of the foot restraints so I could feel the floor against my shoulder.

DAN BARRY | **Learning to fly**

On my first shuttle flight I learned to float. On my second, inside the space station, I learned to fly. For three days my job was to move bags of equipment from the Spacehab laboratory module at the back of *Discovery* to the Zarya module at the end of the station. In those three days I learned a brand new sport—flying. It is magical. The only difference between the movies and real life is that you can't change direction in midflight. I learned how to push just right so that I flew without tumbling and without crashing. I learned to carom off walls to move around an obstacle. I learned to compensate for a heavy bag I was carrying. I arranged trains of multiple bags, flying in formation, with me as the sheepherder. It was exhilaration beyond imagination.

Japanese astronaut Koichi Wakata floats inside the International Space Station's Zarya module, STS-92.

TERRY WILCUTT | **They'd truly adapted to zero-g**

All the long-duration crew members who spent time on Mir said that after about
a month, they noticed a difference in themselves. They'd truly adapted to zero-g.
I could see it with Shannon Lucid when we went up to bring her home after six
months on Mir. She was so graceful it was amazing. There was never an unnecessary
motion. She could hover in front of a display when anyone else would be constantly
touching something to hold their position.

STS-94 Payload Specialist Greg Linteris enters
data in a laptop computer inside the Spacelab
research module.

The wide-angle view that astronauts have of Earth—half a continent at one glance, an entire country framed in a single, small window—is not possible from anywhere else. For reasons both personal and scientific, therefore, the largest number of photos taken on the shuttle by far are of the planet below.

Astronauts have learned which missions offer the best scenery; high-altitude, high-latitude flights are among the most coveted. What you see out the window, however, depends on where and when you have the chance to look out. At any given moment, it's a fair bet the shuttle is passing over ocean. Some find it hard to recognize even familiar landscapes when seeing them at different orientations than they're used to from an atlas. Still others find it educational, even transforming, to see the world with no map lines.

Lake Van in eastern Turkey,

photographed by the STS-41G crew.

CHARLIE BOLDEN | **I wanted to see Africa**

The number one place on Earth I wanted to see was Africa, the place of my heritage. I put in a lot of time studying geography before my first flight, and I had all these places I was going to see for myself. When we finally got spaceborne, very soon after the external tank separated, I could see this thing coming up that looked like a big island, and it was the continent of Africa. It was awe-inspiring, and in fact, it brought tears to my eyes. The frustrating part was, it looked nothing like I thought it would look, and I was completely confused as to what I was seeing, because it was such a massive continent, with no lines to delineate between the countries. I really didn't know what I was looking at for days into the flight. I think the same thing happened when I viewed Vietnam, where I had flown combat missions during the war. When I was there, I could point down and say, "Hey, there's Saigon, and there's Da Nang, and boy, there's where the Ho Chi Minh Trail went up through Laos." I never really got an opportunity to orient myself that way in space, and it was a disappointment.

KEN REIGHTLER | **Observers rather than inhabitants**

I can vividly remember my first glimpse of Earth from orbit. It was my turn to go down below and get out of the bulky orange suit we wear during launch. As I released my straps and floated out of the seat, I stopped for a moment to look out the overhead windows. The orbiter was inverted, flying over Asia, so I was looking straight down at Earth. I was totally unprepared for the colors, textures, detail, and vastness of the scene below. It literally took my breath away. No amount of training, or looking at slides and movies, can prepare you for that moment. I no longer felt a part of what was going on below me. It was as if we were observers, rather than inhabitants, of Earth.

STS-61 view of the Arabian peninsula, facing south-southwest toward Africa. The Gulf of Aden is to the left, the Red Sea to the right. Above: European Space Agency astronaut Gerhard Thiele holds a 70mm Hasselblad camera used often for Earth photography from the shuttle, STS-99.

MILLIE HUGHES-FULFORD | **The iridescence of life**

Clouds over the Pacific, STS-80. The shuttle's orbit never strayed more than about 28 degrees north or south of the equator on this flight, so the crew saw less of Earth than if they'd flown to the 51-degree orbit of the International Space Station.

When you look down on the planet and realize how small it is, it's really very interesting—you have emotions you didn't think you were going to have. My name is not "Moonbeam," but when you look at the planet and realize it's the only place you can see that has life on it, you start feeling very protective toward it. It's like a delicate crystal ball, and it looks alive. The first time I looked at it, I thought it *was* alive. When I'm looking at living cells in a microscope, they have a glow to them that dead cells don't. And the whole planet had that iridescence of life about it. It moved me.

KALPANA CHAWLA | **I wonder about sailors on ocean voyages**

The flight deck is our favorite place. Except for the floor, it has windows facing all directions; overhead, aft, to the sides, and forward. On our STS-87 flight, the overhead windows provide the best orientation for viewing Earth. Often, the only time we are free to float by the flight deck windows is just before or after the eight-hour sleep period. Sometimes we have breakfast by the windows as well, sipping tea from a foil bag with a straw, or eating oatmeal from a plastic container. Most of the research on the ship, however, is done in the mid-deck where there is only one small circular window. Twice on my flight, while everyone else is asleep, I float out of my sleep station to the mid-deck window and remove the metallic cover. An ocean dotted with atolls and shoals and rings of reefs enclosed in other ring formations moves by. I wonder about sailors on great ocean voyages, urged onward by the unknown.

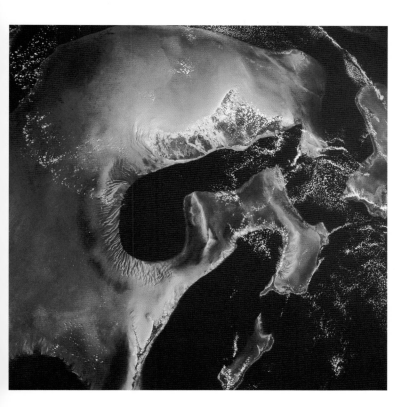

The Bahamas, as seen from onboard
Discovery, 184 miles above Earth, STS-29.

Prior to the flight, I promised myself to look at Earth during one complete orbit. The opportunity comes late in the flight. As I float near the windows on the flight deck, continents and oceans move by. South America is covered with thunderstorms as sprays of lightning shimmer through the clouds. As clouds give way, I can discern the coast and make out small settlements by their lights. The Earth, a curved, dull-black dome below us, looks alive in its display of lights. Stars hang everywhere in the sky, some clearly farther away than others, hardly any twinkling. My crewmate, Takao Doi, hands me binoculars and guides me to M42, a nebula in the Orion constellation. It looks like a far-away green castle, and our spaceship, a white chariot, seems bound for it.

An hour and a half later, we are almost back where we started. It has taken us just 90 minutes to cover the whole planet. Just 90 minutes! That phrase starts to ring like a mantra in my head. The realization that Earth is such a small planet is overpowering. It seems to me like a harbor, luring space explorers with the colors of life. I picture gentle waves slapping the shorelines, trees waving their branches in the wind. I feel we must search for another such harbor. Mars, perhaps? The moons of Jupiter?

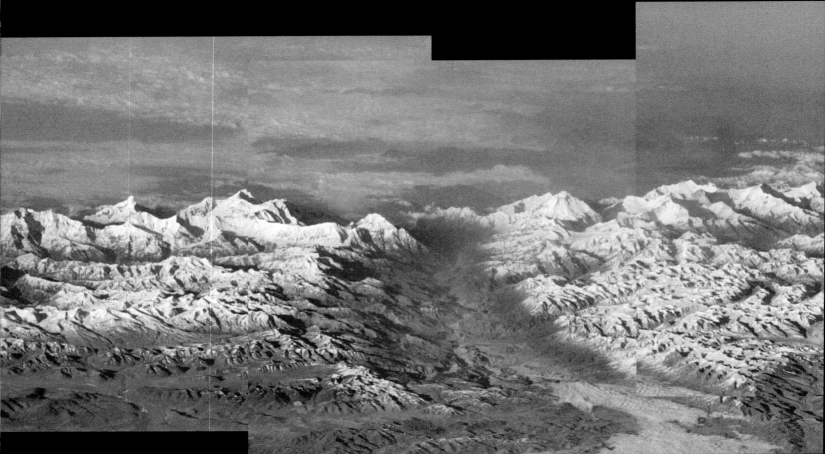

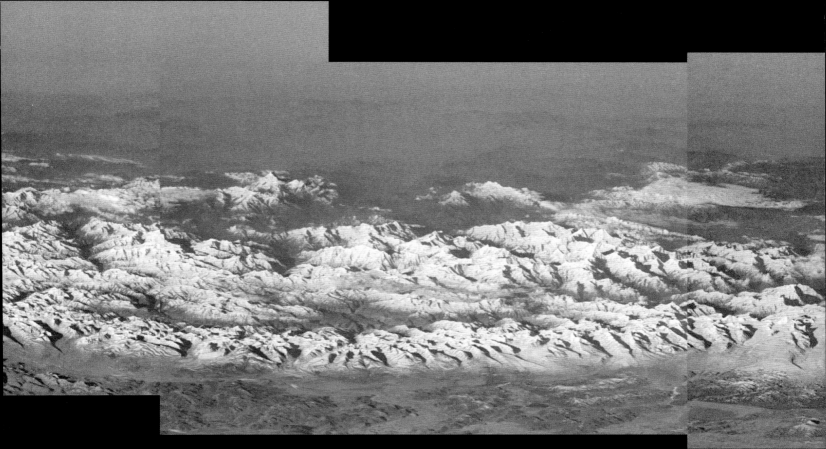

RHEA SEDDON | **A beautiful, cloud-filled sky**

We had a small, round window in the back of the Spacelab. I glanced out one time in orbit, and thought, "What a beautiful, cloud-filled sky." Then I thought, "It *can't* be a cloud-filled sky. The 'sky' up here is black." So I went over to the window and realized I was looking down at the ocean with clouds floating above it. Through the window it had looked very blue, just like the sky.

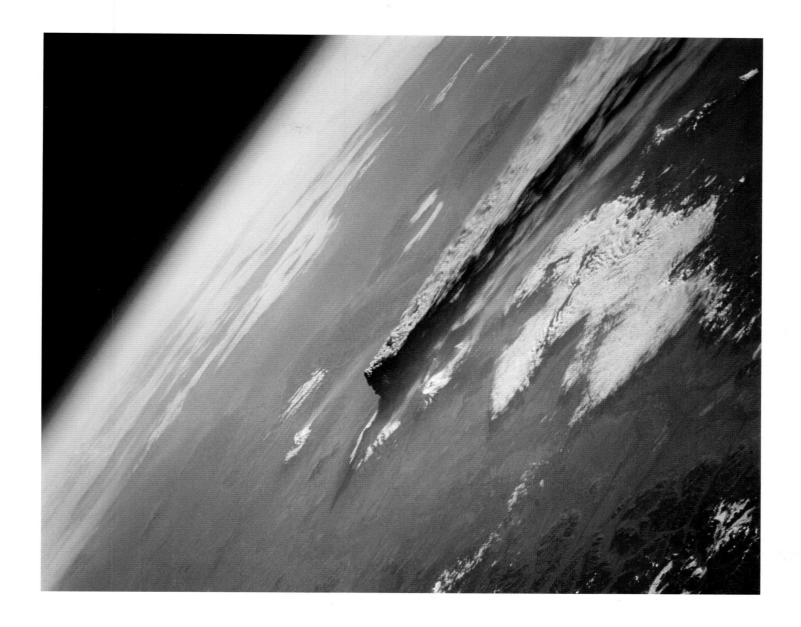

JEFF WISOFF | **Volcano**

The STS-68 crew took this photo of Kliuchevskoi, an erupting volcano on Russia's Kamchatka Peninsula, shortly after reaching orbit on September 30, 1994. Opposite: The STS-37 crew saw smoke from a different source—oil fires in Kuwait, deliberately set by Iraqis at the end of the Gulf War, February 1991.

There was a volcano in Kamchatka that exploded during our STS-68 flight. When we saw it for the first time we wondered, "What is that in the distance? It looks like a huge, black thunderstorm on the horizon." The amount of stuff in the atmosphere was so tremendous I thought it must be a weather system. It was huge, covering the whole horizon. Mike Baker, the commander, was the first to realize it was a volcano, When we got up close, sure enough, it was spewing out all this stuff. It was neat to tell the ground about it, then have them confirm, "Yeah, we just found out this thing is erupting." It shows how much change nature can produce in a short period of time. You had this huge eruption, then by the end of the flight it had largely stopped erupting. There was still a small smoke trail, but it had re-snowed on top of the soot. In the span of 10 days, it was almost white again and pristine, except you could see a crevice in the side of the mountain where it had exploded.

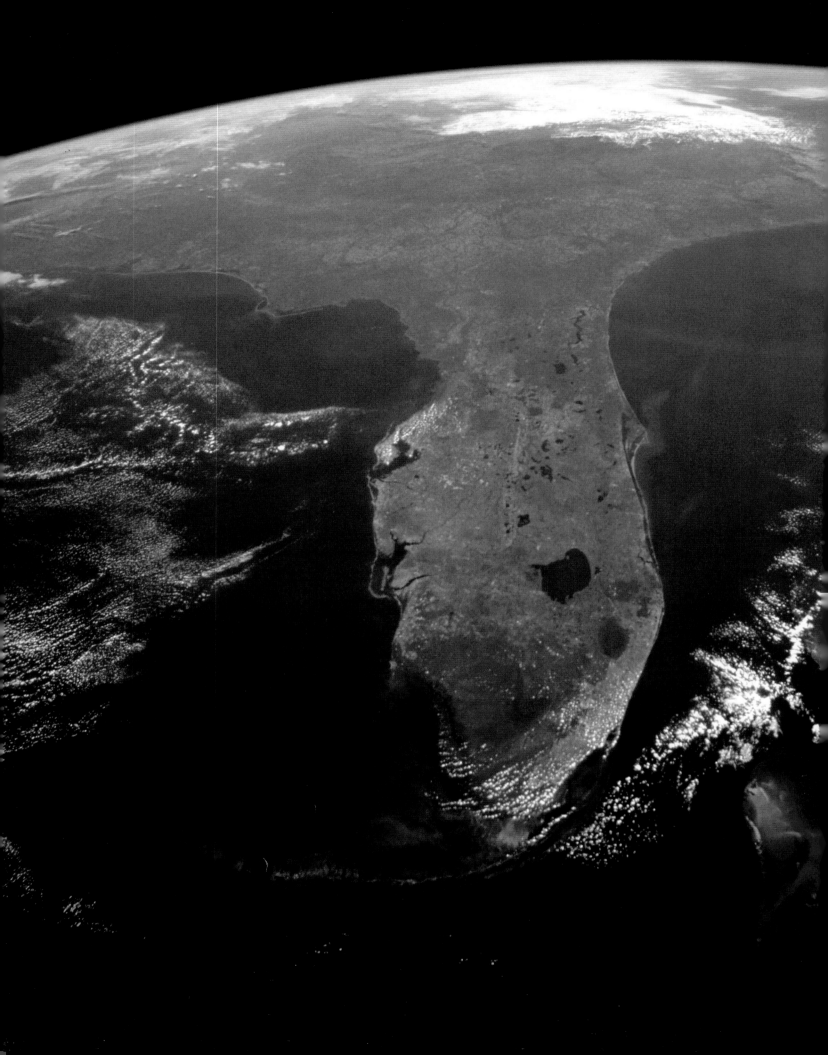

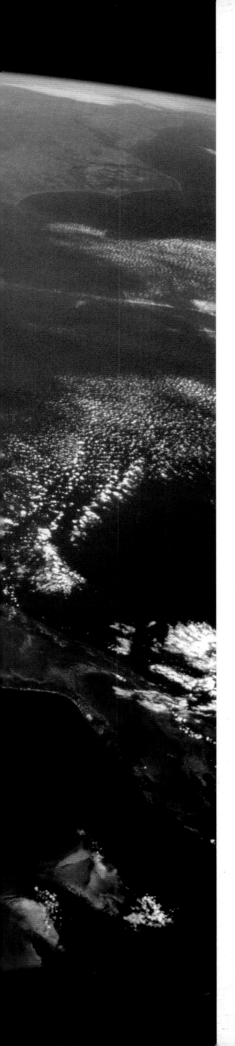

Jim Voss brushes up on geography during his stay on the International Space Station, May 2001. Opposite: The shuttle's home base, Florida, as seen from orbit, STS-95.

SCOTT KELLY | **The whole United States in one view**

I realized how broad your view is from 320 nautical miles up during one night pass on our STS-103 mission to service the Hubble Space Telescope. It was perfectly clear. There wasn't a cloud below. We were going over Houston, and I could see Miami, Cape Cod, Chicago, Los Angeles, all as they appear on a map. With the exception of a little corner up by Seattle, you could see the whole United States at once. It was really amazing.

STEVE NAGEL | **Glass-bottom boat**

The materials science experiments on STS-61A required a very stable attitude from the shuttle, called a gravity gradient free drift. We were nose down with our right wing forward, and we turned off all the jets. The orbiter would just roll real slowly, maybe 10 or 15 degrees over 30 minutes to an hour. You get in the nose of the vehicle, and it's like you're in a gondola. We've got six windows up there, so it was like one of these glass-bottom boats in Disney World, and here's the Earth coming by from right to left. I was eating dinner, looking down on the United States and South America. You always see lots of thunderstorms down there, and I remember the southeast coast of South America, looking down at the lights of Montevideo and Buenos Aires at night. Then I saw a falling star—a meteorite—below us and thought, "This is too much."

MAMORU MOHRI | **Suddenly the Universe had a grand design**

I was on an eight-day Spacelab flight, conducting an experiment that obliged me to monitor—for up to four hours at a time without interruption—the behavior of monkey kidney cells as they divided, grew, and developed in microgravity. The research had to do with whether living organisms, after a four-billion-year history in the one-g environment of Earth, could thrive in the near absence of gravity. Profound as that question is, the experiment demanded hours of monotonous observation. Cells grow as slowly in space as they do on earth!

I was into my third hour of observation. Right eye crinkled, but tenaciously attached to the curvature of the microscope eyepiece, I felt a growing physical discomfort, which may have been aggravated by the microgravity environment. By the fourth hour, it had evolved into a throbbing headache. Still, I continued to peer carefully down the drawtube of the microscope. Another 20 minutes passed, and as my headache became angrier, I knew I needed a break. I raised my head and "stretched" my eyes, closing them tightly and then opening them wide, eyebrows raised as high as possible.

Previous spread: Dunes in the Sahara and the port city of Nagoya, Japan. Below: Blue water, red desert—STS-82.

Still floating, but with feet anchored through loops beneath my workstation, I raised my arms over my head and stretched. How good that felt! Then, in the process of lowering my arms, I bumped my left hand against the shuttle's porthole window. As I did, I turned my head to the left, glanced out the porthole, and saw the Earth spinning below.

Below me lay the khaki-colored grasslands of Africa, rocky desert pavements, lush tropical forests—the endless variety that is Africa. I watched as the Blue Nile and the White Nile met at Khartoum. As I continued to study the Earth turning slowly beneath me, the patterns and contours of its surface appeared suddenly familiar. I recognized features and shapes I had seen just minutes before—not through the space shuttle window, but through the lens of a microscope. I was stunned! The configuration of Earth below looked remarkably like the living cells I had been examining. There was an extraordinary and indisputable similarity—a repetition of the microscopic in the macroscopic—molecular nature mimicking itself on a gargantuan scale.

Suddenly for me, the Universe had a grand design. Years have passed since that flight of 1992. But a later shuttle flight dedicated to mapping Earth in 2000 has merely confirmed my feeling about a continuum in the design of a seemingly limitless universe.

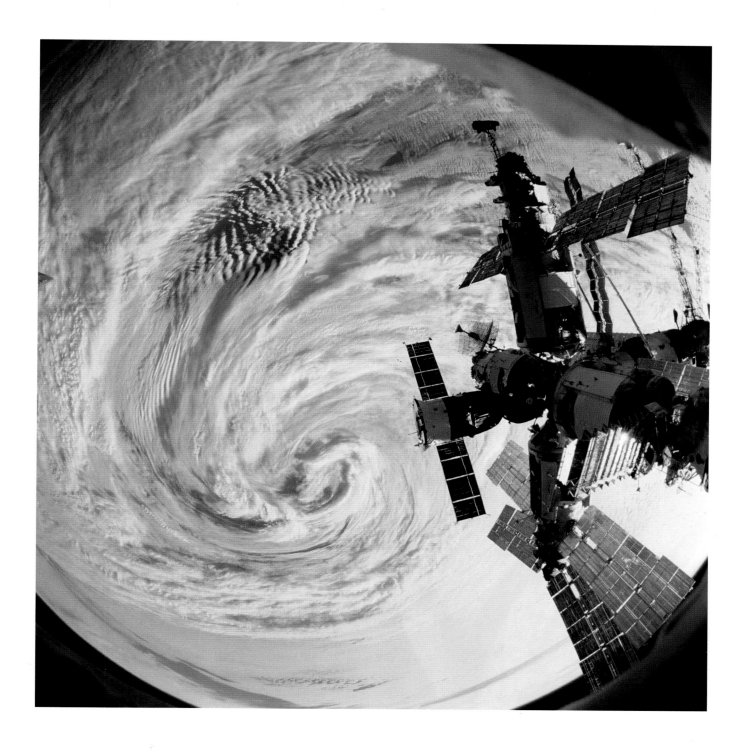

NORM THAGARD | **Where does that road go?**

The Russian Mir space station is backdropped by a storm system over the Indian Ocean in this view from Atlantis, STS-79.

During my four months on Mir, I got to watch winter come to the southern Andes and Tierra del Fuego. You could watch the mountain lakes start to ice over, and some of the passageways between the Atlantic and Pacific. I was also really intrigued by a road down in Argentina or Chile that seemed to run from a port city down to the southwest, as though it were heading down toward Tierra del Fuego. I remember thinking, "At some point, I've just got to go down there and rent a car and find out where that road goes."

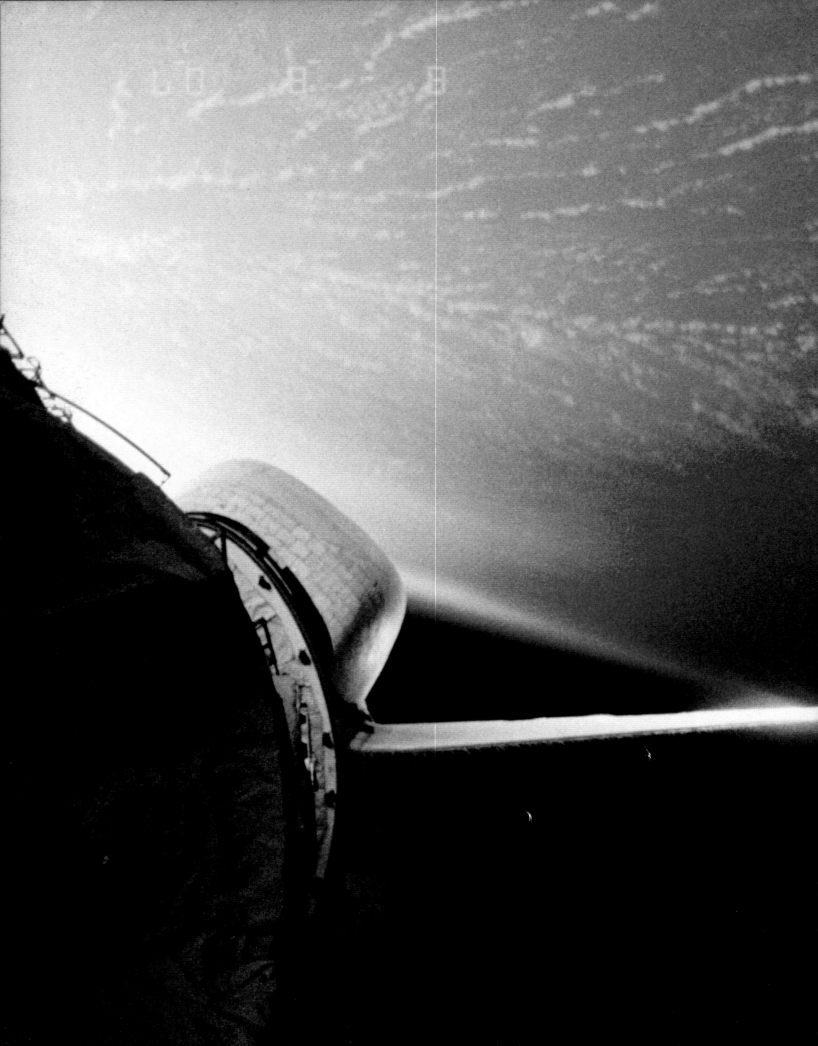

Idle moments are few and far between on most shuttle flights. The crew's work day is "timelined" in five-minute increments, with tasks planned out long in advance for maximum efficiency. The timeline is a constant goad, and a yardstick by which astronauts measure how well their mission is going.

While the pilot and commander watch over the vehicle and maneuver it in space as needed, mission specialists and payload specialists conduct whatever business—research, construction work, or in-orbit repair—the crew was sent up to do. By policy, NASA builds an eight-hour sleep period into every day of the mis-

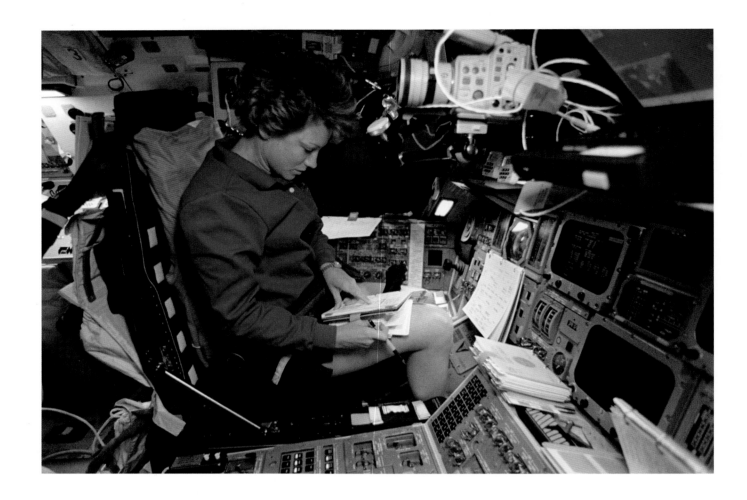

HOOT GIBSON | **You had to have the checklist**

Eileen Collins in her commander's seat on the flight deck, STS-93.

STS 61-C was my first flight as mission commander, and one of our rules during training was to always have two people doing everything. That, and you always had to have the checklist in front of you. It didn't matter how well you knew how to do a particular job, it didn't matter how many times you had done it, it didn't matter how simple it was, you had to have the checklist in front of you, and you had to have two sets of eyeballs. If you ever got caught doing a procedure by yourself, or if you got caught doing it without the checklist, you had to buy beers for the whole crew. We drank a lot of beer, and I had to buy a lot, too—I wasn't immune from the rule.

Our goal was to fly that entire flight and never have Mission Control call us and say, "Hey guys, you missed a switch." Well, we didn't quite make it. We missed one switch on about the sixth day. But that's not bad considering it was a somewhat complicated flight. The rule really paid off—it was a great way to do things.

KATHY SULLIVAN | **Photon torpedoes**

Above: "Get Away Special" canisters attached to the cargo bay wall on many shuttle flights have carried small experiments for students, university scientists, even private citizens. Above, right: The Wake Shield Facility, designed to create an ultra-clean vacuum in its wake as the shuttle moves through space, is backdropped against the southern lights, STS-60.

One of the key experiments on my third flight, STS-45, was an electron beam generator mounted out in the payload bay, which looked something like a giant coffee can swaddled in white insulation. The idea was to inject known amounts of electrical charge into the upper atmosphere, then to measure the "aurora" that resulted with a special camera.

The first firing of the beam was scheduled on the red crew's shift, while my blue shift crewmates and I were down on the mid-deck making supper. Tired and hungry after our own workday, and figuring we should leave them in peace to work through this first big run of the experiment, we were absorbed in our meal chores when hoots and bellows and shouts of "Ohmigod, look at *that!*" broke out up top. Now, there's a firm (although unwritten) rule among space fliers that there shall be no sentences ending in "that," as in "Ohmigod, look at *that!*" or "What the #%@# was *that*?!!" So the four of us zoomed up to the flight deck and crowded toward the windows.

The next beam firing was just seconds away. A bulb of bright blue light was building around the top of our "coffee can," a bizarre glow that seemed almost to drip over the edge of the can and down the sides. Suddenly this whole blob of blue leapt from the coffee can, off into space and down toward Earth. We thought we could even see the curve of its path as it followed Earth's magnetic field lines.

Who says photon torpedoes only exist in science fiction movies? That day I saw one for real! The icing on the cake was that we had George Lucas's Oscar aboard our flight. Just a few days after making our own real photon torpedo, we taped the presentation speech (complete with floating statue) that awarded him the motion picture academy's Thalberg award. I love his films, but our photon torpedoes were much better!

I had envisioned that my 1985 Spacelab mission was going to be like a seven-day camping trip in space. John Bartoe and I were going to go up—we were both non-NASA scientists picked for this one flight, and we'd been friends for years—and we were just going to have a hell of a good time.

It didn't work out like that at all.

For one thing, I got sick as a dog. Thirty seconds after the engines shut off, I felt like my stomach and my innards were all moving up against my lungs. It was just awful, kind of a cross between car sickness and stomach flu. I was sick for four days, and I learned very quickly that you cannot unfold your barf bag as fast as you barf.

Then, looking back on it, I overdosed on responsibility. I was so focused on trying to do a perfect job of everything that it really filled my field of view. I might as well have been working in a physics lab on Earth for the first several days. I hardly took time to look out the window and to experience what was going on. And when I screwed something up, I felt lower than a snake's belly. I felt like I wasn't measuring up, or maybe not performing as well as the other guys, and I got more and more depressed as the flight went on.

And, of course, I did screw up. About the middle of the mission, I was setting up an image-intensifying camera in the overhead window to take pictures during a firing of the shuttle's maneuvering engines over Hawaii. This was to observe the interaction of gases from the engine firings with atomic oxygen and other gases in the very thin atmosphere. The reason we were doing it over Hawaii is that they had big telescopes on the ground looking up. And, of course, there was just a one-time chance to do this.

I got the camera all set up well in advance, practiced taking the sequences, and everything was looking good. We did the experiment, I took my series of exposures, and I was beginning to disassemble the apparatus when somebody said something about what they had observed from the ground. And the word "red" was mentioned. All at once I realized I had forgotten to include the red filter in the setup, which meant that my exposures were useless. So after I got all the stuff disassembled, I just went and climbed in my bunk.

My own experiment, and part of the reason I had been included on the flight, was an instrument called SOUP, which was designed to study the Sun's magnetic fields. But it had not worked right from the start. About eight hours into its activation sequence, it had shut itself off and would not accept the turn-on command. The crew did everything it could, but ended up having to just forget it. Then, not long after my mistake with the camera, the instrument came back online. But when Bartoe or someone came down to tell me SOUP was alive, I was feeling so bad I didn't even get up to go look.

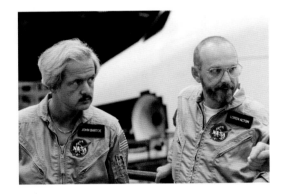

John-David Bartoe and Loren Acton,
both solar physicists, were among the first
non-NASA scientists to fly on the shuttle,
on the STS-51F Spacelab 2 mission in 1985.
Opposite: Moonrise over Columbia's
open payload bay doors, STS-9.

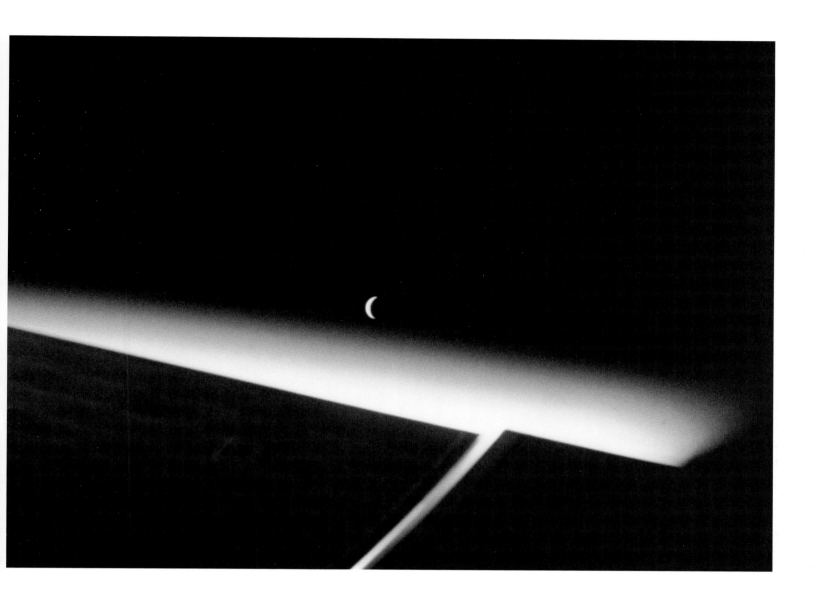

I had another experience up there that I didn't expect. I was extremely tender-hearted, on sort of an emotional knife-edge with respect to my colleagues on the ground. I found it very, very challenging to say anything of a personal nature without choking up. As long as I was talking business, I didn't have any trouble, but if I was saying thank you, or they were thanking us for something, I would choke up.

All these things added up, so that by the time the flight was over, I was just a wreck emotionally. I was able to contain it, and other people wouldn't necessarily have realized it, but boy, I sure felt rotten.

After we landed in California, on the flight back to Houston, everybody was chattering and I was just sitting there morose. When we landed and got off the plane, though, there was this tremendous crowd of drunken scientists to welcome us! And at that point, the healing began. I began to realize that perhaps the rest of the people on the experiment team didn't view me as the failure I had viewed myself.

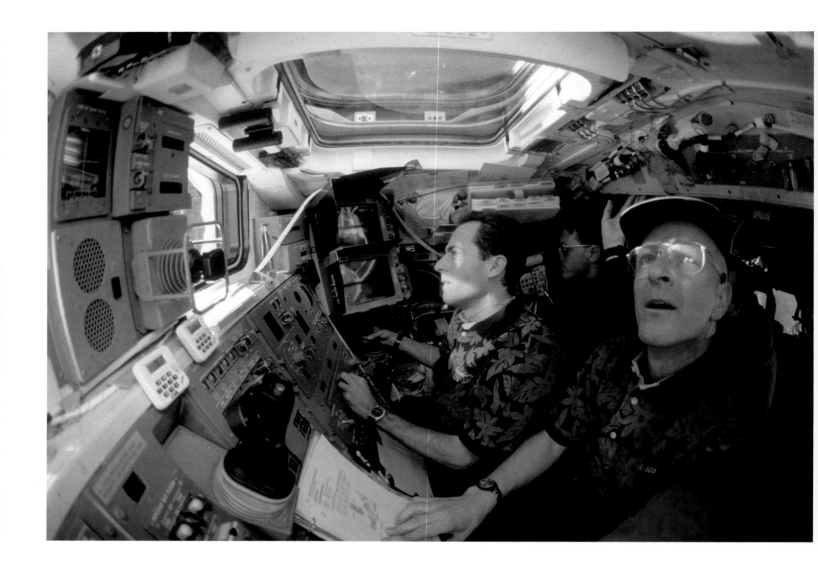

CHARLIE PRECOURT | **Patient, timely inputs**

French astronaut Jean-Francois Clervoy (center) works the shuttle's robot arm from the aft flight deck while Claude Nicollier of Switzerland (foreground) assists during the STS-103 Hubble Space Telescope servicing mission.

For a pilot, the response of the shuttle is totally different from that of an airplane. You pulse the jets, then you wait for the response. It takes a while for the input to take effect. Say you want to move directly above the space station. You'd do some "up" pulses with your hand controller as well as some pitch change pulses to rotate the vehicle as you move up. You do a set number of pulses, predicting what the response will be. Then you stop and wait 45 seconds or so to see what happens. Then you correct it. It's not aggressive control; it's patient, timely inputs. If it's not where you thought it was going to be after 45 seconds, you shouldn't wait too much longer. If you do, you might need a much bigger correction.

KEN REIGHTLER | **Did you hear what I heard?**

STS-90 Payload Specialist Jay Buckey *wears micro-binocular glasses while conducting in-orbit experiments on rodent motor skills.*

For the first 42 flights of the shuttle, no crew had ever had to maneuver to avoid a piece of space junk. Given the vastness of space and the small size of the objects, I never considered it a real possibility. But on flight day four of STS-48, we were advised by Mission Control of a potential collision between the orbiter and the spent upper stage of the Soviet Cosmos 955 spacecraft, which was about the size of a car. As time went on, the positions of the two bodies were refined, and calculations still predicted that we would get too close for comfort. So a short seven-second engine burn using our reaction control jets was required, lowering our orbit and creating a wide 10-mile berth between us and the upper stage.

We were all busy conducting experiments and other duties, so no one gave this operation much time or attention. I didn't even take a look out the window to see if I could see the intruder go by. I just wanted to be sure we didn't make the news back home. NASA management considered this a rare occurrence. After all, we had flown 42 consecutive flights without having to perform an evasion maneuver. But as it happened, the same scenario played out on the very next mission! That made a lot of people sit up and take notice of the orbital debris problem.

More than two years later, on STS-60, we were carrying the Spacehab module in back, which essentially doubled the amount of onboard lab and storage space. The module was connected to the crew cabin by a long tunnel. One day mission Commander Charlie Bolden and I were working in the Spacehab when we heard a loud noise—a "boom" like someone pounding on the roof of your car. We looked at each other as if to say, "Did you hear what I heard?" My first thought was that we had been hit by space debris. I waited for an alarm to go off signaling a loss of pressure. It never came, but Charlie and I quickly agreed that evacuation was the right thing to do. Arriving back on the flight deck, we found all systems working normally. A discussion with the ground revealed that they weren't tracking any debris in our vicinity, nor were there any other unusual data coming down from the orbiter. We went back to work, but that night I slept with one eye open.

After landing, an inspection revealed no damage that could have been caused by a collision. The best guess anyone could hazard was that uneven heating of the Spacehab had caused a slight shift in the structure, and that what we heard was just everything sorting itself out. But to us, the event would always be known as the "Big Bang."

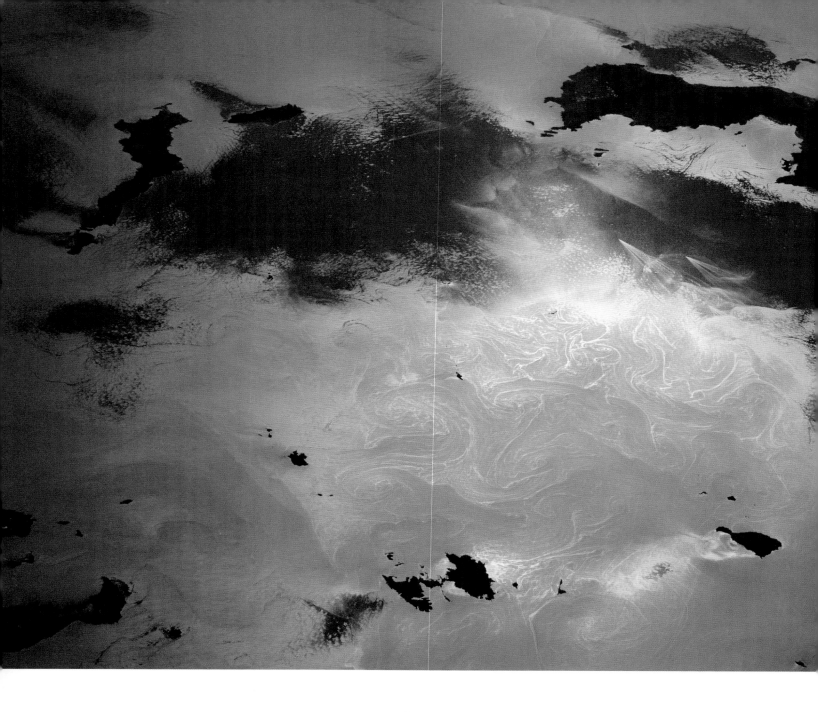

MARIO RUNCO | "He's making that sh-- up!"

My first flight, STS-44, was the shuttle's first unclassified Department of Defense mission, and we did an experiment designated M88-1, Military Man in Space. Observers on the ground would tell us in pseudo-code over the radio, "We want you to look for a certain type of ship or ground vehicle in this vicinity, or at such and such location, and we'd like you to give us as many details as possible about what you can ascertain from passing overhead." Because of the call signs, the conversations would go something like, "Shoehorn, Shoehorn, Shoehorn. This is *Atlantis, Atlantis, Atlantis*. Over." It just got sickening hearing those calls over and over again. Actually, the ground guys were hoping after a while that we would drop the triplet

In this scene photographed off the northern coast of Crete during the STS-61A mission, two V-shaped ship wakes are visible in the blue water just above a web of spiral ocean eddies.

and just say, "Shoehorn, this is *Atlantis*. Go ahead. Over." They were waiting for us to take the lead, but being rookies and not wanting to deviate from the procedure, it never happened that way. Today it probably would.

We were coming up over our Naval base at Guantanamo Bay, Cuba, and the ground guys asked us to tell them how many ships we could see in port. Tom Henricks, the pilot on the flight, used this huge set of binoculars out one of the overhead windows. I used a digital camera with a powerful zoom lens out the other. Tom would study the area visually while I would snap images that flashed up instantly on a TV monitor. After the pass, we got together to discuss what we had seen and study the images.

I had a difference of opinion with Jim Voss, who was also on the flight, over how we should conduct this experiment. Jim thought the observer should not be able to use any prior knowledge—he tried to be purely objective in his observations. I argued that since we were intelligent observers, we could use whatever knowledge we had to make sense of what we were seeing. I'm a Navy man, and I knew that when I saw three little things together, with a pointy side at one end and a blunt side at the other, they were more than likely nested destroyers or frigates. In addition, I had been to Guantanamo Bay, and I knew the layout and knew where to look for what. Tom was an Air Force guy, and he used his knowledge for observing airfields. Unfortunately for Jim and Tom Hennen, the Army guys on the flight, they had the hardest job of trying to find things that were often camouflaged by the terrain. Jim didn't make it any easier on himself with his "objectivity."

The embarrassing moment came when Tom and I were up on the flight deck making our report to the ground about the Guantanamo observation. I was doing the talking at the time, and most of the rest of the crew was down on the mid-deck. We were using a wireless communication system where each crew member had his own personal microphone unit; however, the units were paired such that when one crew member pressed his button to talk, another person's mike would also go hot. I was paired with Jim. So in the middle of my report, I hear Jim say to everybody else on the mid-deck, "Aww, he's making that sh-- up!" He was half kidding and half serious. Jim had forgotten that his mike was hot, and his ill-timed words went out over the air-to-ground radio. It must have brought Mission Control to its knees with laughter! It certainly disrupted my concentration, as our transmission was abruptly cut off and we all broke into an uproar of laughter. I must admit I was a bit miffed, too. But that quickly passed, and after a minute or so passed for us to regain our composure, I pressed on with the report. Of course, I figured they didn't believe a word I said after that. As it turns out, though, we did in fact count the correct number of ships in port that day. And as for the wireless communication system, it was never carried on any of my subsequent flights. Coincidence? You decide.

RICH CLIFFORD | **Shooting the tunnel**

Astronauts are allowed to take up a limited number of personal items, including mementos for themselves, family and friends. Photos are a popular choice, whether a snapshot of Elvis or a pet cow.

The time I had with my crewmates in orbit is something I will cherish forever. On my first flight, STS-53, Jim Voss and I—two Army guys—had a wrestling match. We were like a flying furball in the middle of the cabin, trying to get a foothold on each other. Every time you pushed one way you'd go off in the opposite direction. It was the exhilaration of doing something you'll probably never get a chance to do again. We were like kids.

Guy Bluford was watching Jim and me, and then Bob Cabana, wrestle. He got this big grin on his face and said, "You guys mind if I join in? I've never had a chance to do that on my first three flights."

On my third flight, STS-76, we had this long, 35-foot tunnel leading from the shuttle mid-deck to the Spacehab laboratory module in the back. We took a large rubber band—called a Dyna-Band—that we used for exercise and stretched it across the airlock hatch on the mid-deck. Then we'd shoot ourselves down the tunnel. One of the crew members would shoot you down, and we had a competition to see who could do it without touching the tunnel walls. Nobody ever made it.

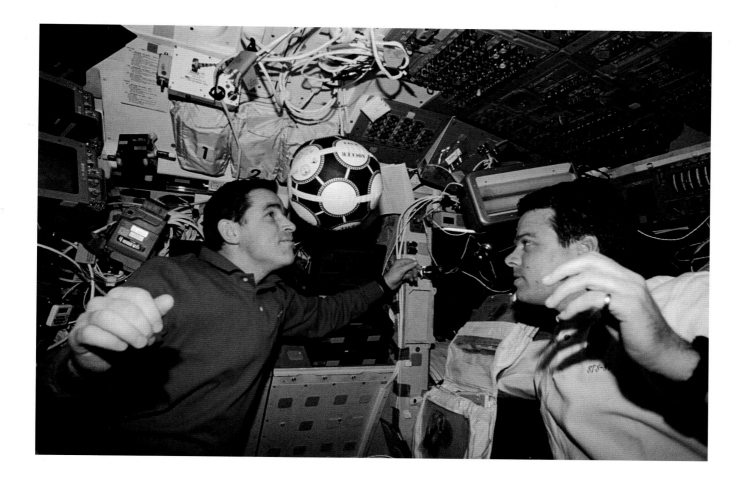

SCOTT PARAZYNSKI | **Zero-g, 3-D tennis**

Kevin Kregel (right) and Ukrainian cosmonaut Leonid Kadenyuk play with an inflatable soccer ball on Columbia's *flight deck, STS-87.*

Science missions are always busy, with hardly a minute to look out the window between scheduled research tasks. Because of that frantic pace, flights of ten days or more always include a half day off for the crew to just gaze out the window or experience zero-g. During our time off on STS-86, French astronaut Jean-Loup Chretien and I decided to float back to our Spacehab research module to practice space aerobatics—most consecutive spins without touching the wall; helicopter spins followed by pulling your arms in against your body, which sped us up to blinding rates; triple Salchows with half-gainers; floating down the long tunnel to the Space-hab without ever touching the walls.

Then it came time to play "Zero-g, 3-D tennis," which another French astro-naut, Jean-Francois Clervoy, and I had invented on an earlier flight. A wadded-up ball of omnipresent gray tape was the ball, and two of our Flight Data File (FDF) books were the rackets. This, time, though, Jean-Loup and I had the huge volume of the double Spacehab module to play in. Forehand, backhand, overhead, under-hand, and off the walls, we perfected a gymnastic racket sport that had us both laughing hysterically and sweating profusely. A few years down the road, on the International Space Station or enroute to Mars, astronaut crews might compete for the universal championship in this incredible sport!

MILLIE HUGHES-FULFORD | **I thought I was all alone**

It was the last day of the STS-40 mission, and Rhea Seddon and I were among the last people to prepare Spacelab for closeout. I was busy cleaning up and looking in on the animals to make sure they were doing well. (We were told if an animal died in flight not to come home!) After I made sure they were okay, I looked around to find I was the last one in the empty lab.

I checked the Spacelab camera, and made sure it was off. I was free and really alone for the first time in eight days. I had my Walkman, and during the flight had found that my favorite "space music" was "Watermark" by Enya. The flowing music and the empty Spacelab created the perfect atmosphere for some space acrobatics—just me, the music, and total freedom from gravity. I "worked out" until I was hot, sweaty, and tired. Then I went to the Spacelab window to rest and enjoy the passing view.

As I looked out, the Earth was in darkness, and I saw great lightning storms below. The storm cells were almost a hundred miles across. When the lightning struck, the entire cloud canopy would light up underneath, like giant hot air balloons. I looked for a camera to capture the moment, but the equipment was stowed, and if I left to get it, I would be over India by the time I returned, since we were moving at 17,000 miles an hour.

I memorized the scene. Now and again the lightning arc would go above the storm cell and hit the center of another cell many miles away. Although Earth was 160 miles below, the lightning arc seemed so high it looked like it was going to hit the shuttle. It was a fantastic sight. With the storms lighting up the scene, I suddenly realized I was over Africa, and my Walkman was playing Enya's "Storms in Africa." Talk about convergence! After we passed over the lightning show, I returned to my acrobatics, enjoying the last minutes of freedom. What I didn't realize until I got back home was that my antics in the lab had triggered motion sensors, and the ground controllers turned the Spacelab camera back on. I'd been having a great time, with my friends down on Earth watching.

The only married couple to fly in space together, Mark Lee and Jan Davis take time out for fun inside Spacelab, STS-47. Opposite: Thunderheads over Africa, STS-32.

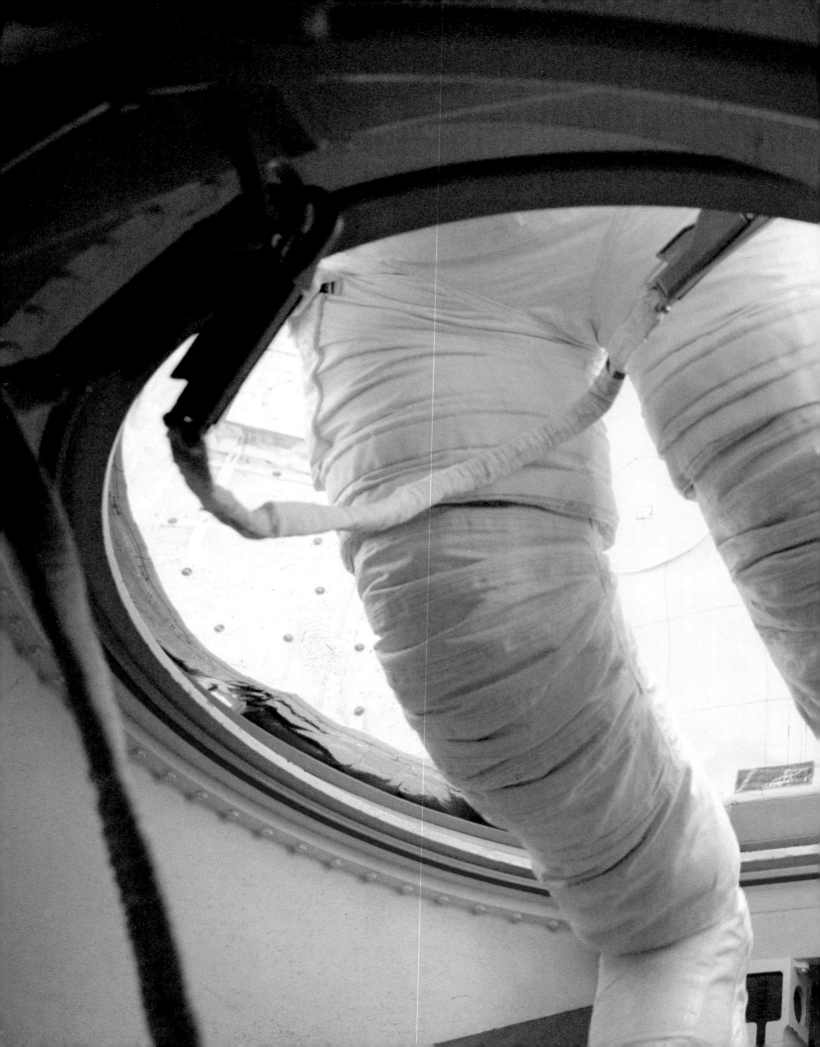

Next to the launch, spacewalking is probably the peak experience for a shuttle astronaut. Working outside the cramped confines of the orbiter, stealing occasional glances at the full Earth below, astronauts log some of the most intense and satisfying hours of their careers.

"The perfect spacewalk is like a ballet," says Story Musgrave, who did the first shuttle Extravehicular Activity, or EVA, in 1983. Each move is choreographed months, sometimes years, in advance. It can be a tiring ballet, and a perilous one, even inside the climate-controlled cocoon of the spacesuit. The ever-present risk prompts veteran shuttle commander Bob Crippen, who was in charge of two EVA-intensive missions in the early 1980s, to say, "Probably the highest stress level I had as a shuttle commander was when I had people out doing spacewalks."

Heading out the airlock, STS-97.

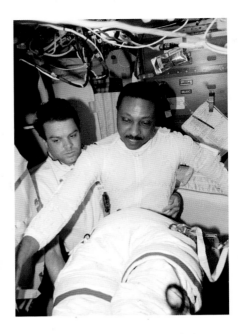

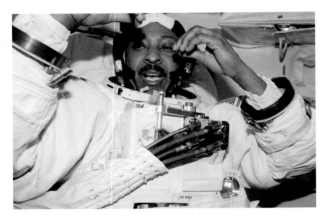

RICH CLIFFORD | **The sound of air escaping**

Winston Scott suits up for Extravehicular Activity (EVA), STS-87. Spacewalkers wear a cooling garment under the suit, which has some rigid and some flexible parts. One astronaut typically wears red stripes on the legs, the other plain white—so they can easily be told apart.

After you do all your functional suit checks before a spacewalk, you're just hanging out in the airlock, nothing to do. You can't even review your checklist because you've reviewed it so many times. Linda Godwin, my EVA partner, and I are just looking at each other saying, "It's time to go. It's time to go."

Finally Ron Sega, the "choreographer" who will direct our spacewalk from the flight deck, closes the hatch inside the shuttle so we can evacuate air from the airlock before opening the hatch to the outside. Now it's just Linda and I in there, two large suits in a small volume, one upside down and the other right side up.

She's down there opening the valve that lets out the air. There's a loud pop like when you burst a balloon, and the air starts rushing out. It's like a huge vacuum cleaner. The noise is *shwoo shwoo*, and both Linda and I are watching the gauges. Her hand is on the valve in case one of our suits doesn't maintain pressure. She'd have to close it quickly, because you've got about 10 seconds to stabilize, otherwise you lose consciousness.

Soon all the air is out of the chamber. The next step is to tether yourselves off, open the hatch, go outside, and be your own satellite.

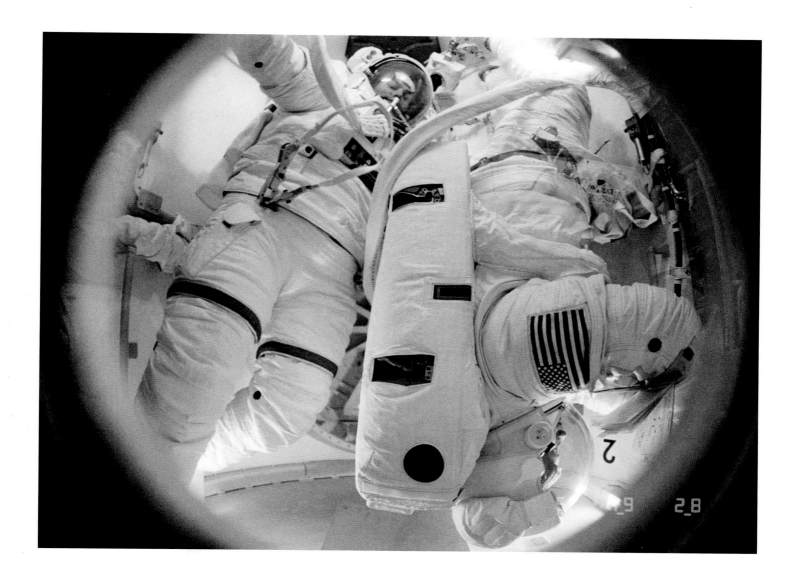

CHARLIE BOLDEN | **These two friends could be in deep trouble**

Inside the airlock, STS-61B. The tiny, airtight chamber has one hatch leading to the mid-deck cabin and another leading to the cargo bay outside.

I always tell people you're relaxed on a spaceflight because you've trained so much that it's old hat. And that was my thinking during STS-31, when it looked for a while like we'd have to do an unplanned spacewalk to fix a stuck solar panel before releasing the Hubble Space Telescope. I went down and started helping Bruce McCandless and Kathy Sullivan suit up in the airlock, then closed the hatch and started depressurizing. But then it was sort of like my son the day before he got married, when we were walking the golf course together. About the 16th or 17th hole, it suddenly hit him that he was about to get married, and he just froze. It was like that for me. Everything was going along very well, but when I started depressurizing the airlock, I realized that, boy, if I didn't do everything right, these two friends could be in deep trouble. Although it had all worked on every spacewalk before, their very lives depended on my having done everything right. That scared me. Even for a Marine who had been in combat and all that, it was kind of a stark reminder of the responsibility I had.

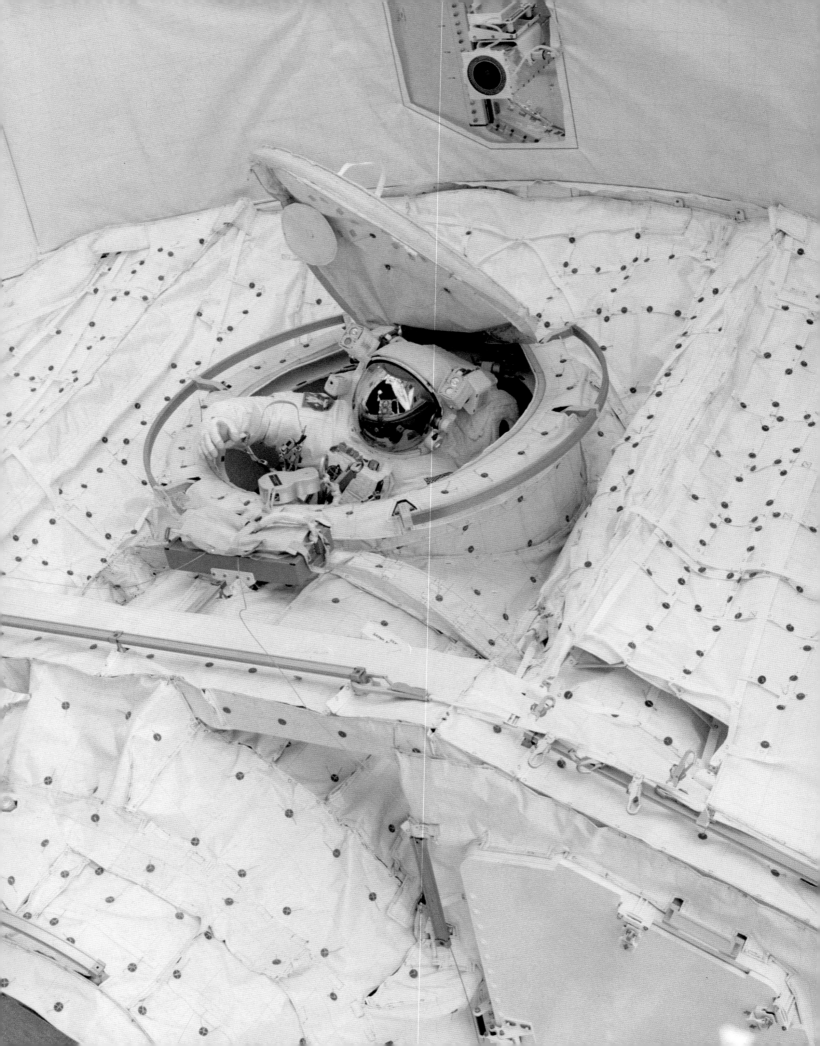

When you do these space-walks, they are very long days. You work basically from the moment you wake up until the moment you go to bed.

—JEFF WISOFF

Opposite: Jeff Wisoff halfway out in the cargo bay, STS-92. Above: Rick Hieb, still halfway in, STS-49.

Overleaf: Dan Barry near the end of the remote manipulator arm, during an STS-105 spacewalk outside the International Space Station.

BERNARD HARRIS | **No, you're not going to fall**

Having been in space for about five days before my first spacewalk on STS-63, I considered myself pretty acclimated to the environment. But when I opened up the hatch to come out of the airlock, I got a face full of Earth. We were flying upside down, so I immediately saw the grandeur of Earth down below, and I had two sensations. The sense of movement was striking. It made me feel dizzy to see Earth moving by at 18,000 miles per hour as I peered out this small aperture I was about to emerge through. I got a little uneasy and a little dizzy, and I didn't get that from looking out the shuttle window.

Then, as I was getting ready to step out of the spaceship, it felt for an instant like gravity was going to grab hold of me and pull me down toward Earth. Being a scientist and an astronaut, you know that's not going to happen. But within a split second I had those two sensations. Your natural response is to hesitate and grab on harder. I felt myself hanging on to the handrail and saying, "No, you're not going to fall toward the Earth—this is the same thing you've been seeing for the last five days." Then I was able to go out and enjoy the view.

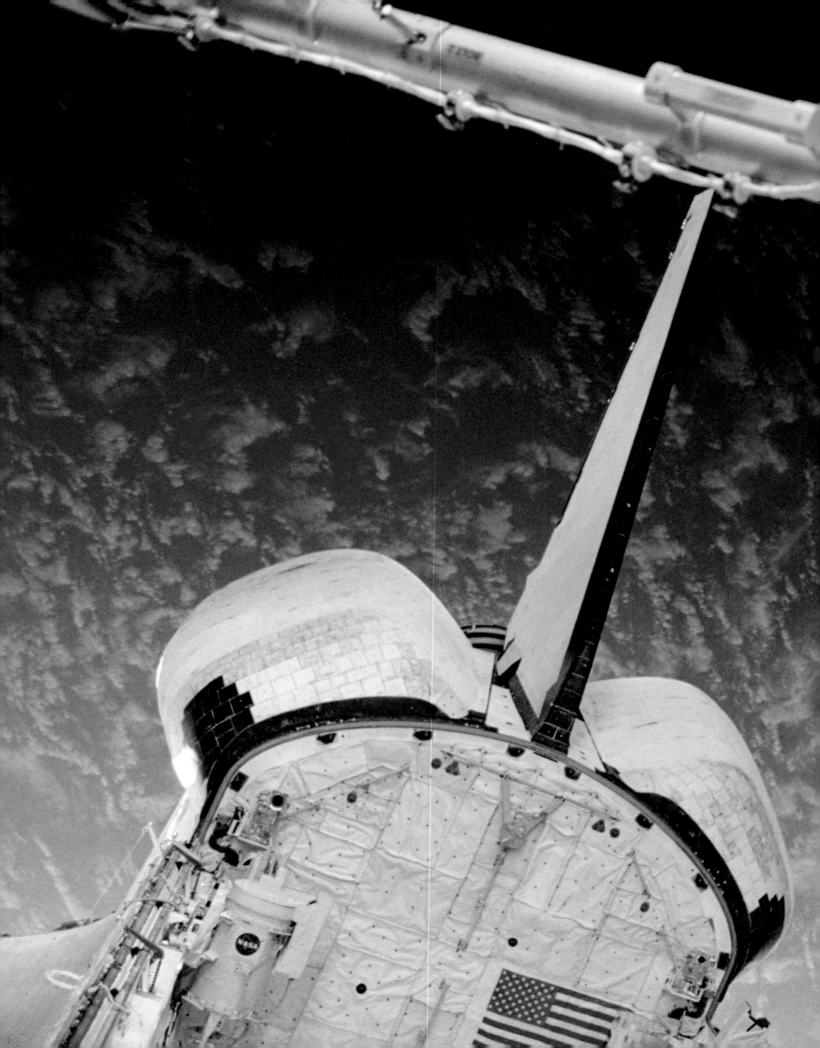

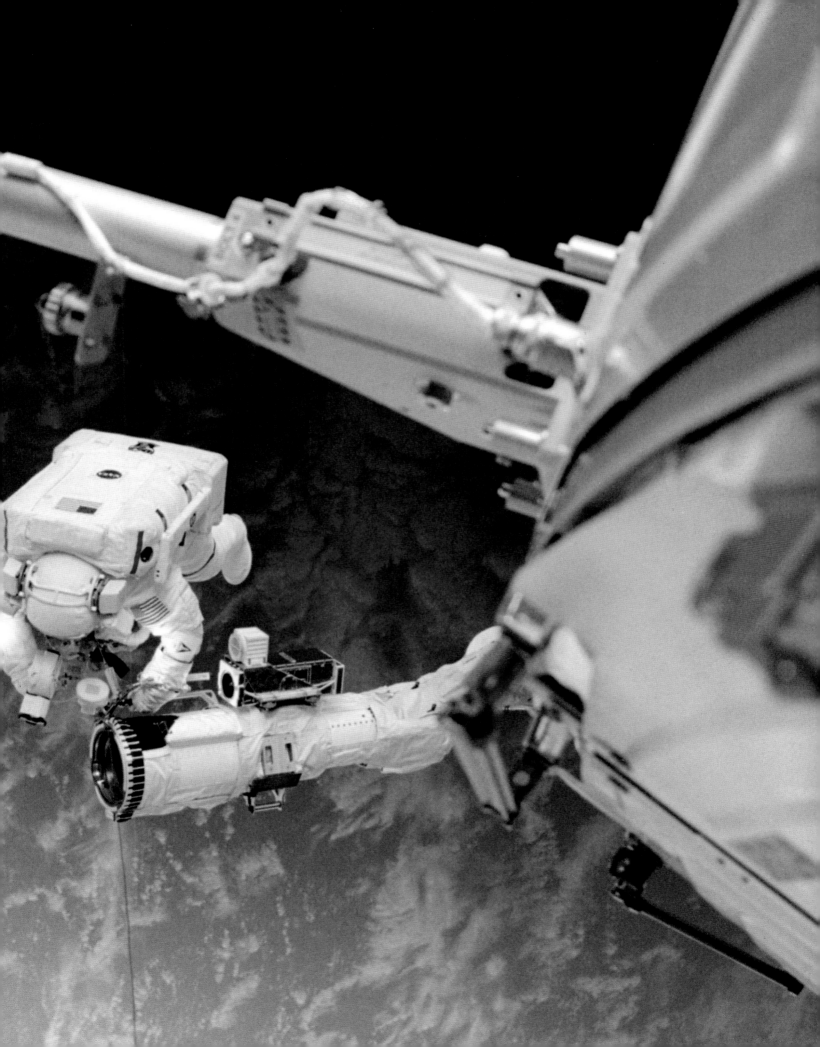

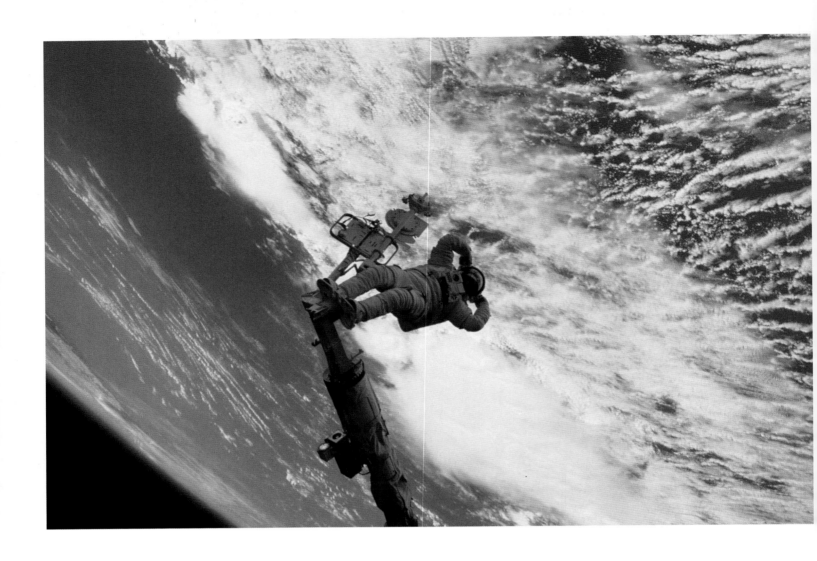

MARIO RUNCO | **I'm tumbling into the stars!**

During a spacewalk on my second mission, STS-54, I had a free moment while waiting for Greg Harbaugh, my EVA partner, to finish some tasks before we could move on to our next work site. I was standing facing outboard on a work platform that was mounted on the sill of *Endeavour*'s payload bay. The platform locks your feet down and frees your hands for work. With the free time available, I took the opportunity to do something I liked to do during underwater training—bend over backward at the knees, sort of like doing the limbo. In the water tank it's a comfortable stretch, and it relieves all the pressure points that are bothering you in the spacesuit. But in space, the viscosity of the water wasn't there to slow me down, so when I relaxed to stand up straight again, the suit twanged forward at what seemed like an incredible velocity. Now I was pitching forward, and as I strained to arrest the motion, I'm thinking, "Shoot, I can't stop this!" It really felt like I would come right out of the foot restraint and go tumbling off into space, even though I knew I couldn't.

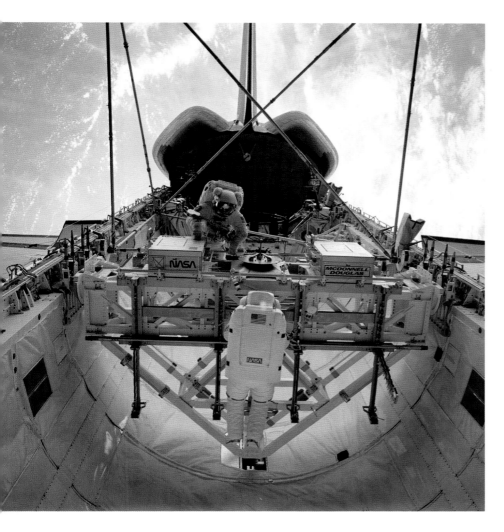

Space construction experiments, STS-49. Kathy Thornton is in the foreground, Tom Akers in back. Opposite: Standing on the end of the shuttle's robot arm, Ox van Hoften tracks a satellite he has just released in orbit, STS-51I.

Fortunately, the suit lets you bend over backward at the knees more easily than it lets you bend forward at the waist, and I began to slow down. As I did, I gazed out into the blackness of space. It was infinitely black, so black it was dizzying, with just a few stars present. Without looking down or behind me at the shuttle, there was no point of reference I could use to orient myself. At first some of the stars would appear closer than others, which I knew was not possible. When I blinked, other stars would appear closer, and the ones that had first appeared close now seemed more distant. Barely had I finished wrestling with this conundrum when my attention shifted to the magnificence of my situation. It felt like I was tumbling into the stars. I had the thought, "Wow, so this is what it must have been like for Frank Poole in the movie 2001!" I shuddered and thought, "Thank God for tethers." I decided to enjoy the moment. I closed my eyes, then opened them, and the stars would roll up over my head when I leaned forward.

As I'm playing with these sensations, I see with my peripheral vision what looks like an explosion, a flash of light below me. I'm thinking, "Oh my God, what was that?" My instantaneous thought was, "Am I the first person to witness a supernova directly from space? No, it couldn't be!" Then there it was again! I finally realized I was looking not out into space, but at the night side of the Earth, filling the lower portion of my field of view. It was lightning—a storm over the Pacific putting on a magnificent light show for my benefit.

The whole experience was incredible. During that moment when I shuddered, as I peered out into infinity, I really had a sense of The Divine, and it was very strong. I now have a better appreciation for the vastness and enormity of the Universe—I guess you can say I had a firsthand look at God's handiwork.

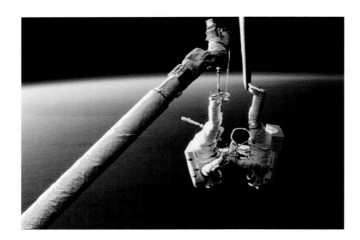

STS-64 astronauts Carl Meade (left) and Mark Lee take turns testing the SAFER jetpack, a backup to their safety tethers. Opposite top: Mike Lounge (left) and Dick Covey peer out of Discovery's aft flight deck windows, STS-51I. Bottom: Same mission, same windows—Bill Fisher and Ox van Hoften look in.

STS-63 flew an orbit tilted 52 degrees to the equator, the same orbit as the Russian Mir station and now the International Space Station. For years, astronauts who'd done spacewalks on the night side of Earth at this higher latitude had come back and told the NASA engineers that they felt cold inside the suit. The engineers would say, "Yeah, but what temperature was it?" The astronauts could only say, "Well, it was very cold."

So on our flight they outfitted the suit with special temperature sensors, and we actually did a study. Mike Foale and I got on the end of the robot arm, and they lifted us out above the cargo bay about 35 feet. The commander of the shuttle turned the vehicle so it was facing deep space, the coldest attitude you can get. And we went into Earth's shadow for a 45-minute "night."

The temperature went down faster than we expected. Within 10 minutes, the temperature inside our suit dropped to 20 degrees. Even with the suit temperature control in full "hot" position, it got so cold that our hands felt like they were in a vat of liquid nitrogen. When we got back, we found out that the temperature outside the suit had dropped to minus 165 degrees. You felt it mostly in your feet and hands. The gloves are the thinnest part of the suit, because you want dexterity. I pulled my fingers away from the edges of the gloves and began to do calisthenics in the suit to increase my body temperature, and I think Mike did the same thing.

We had been given a subjective scale, from 1 to 5, to report how cold we felt so the people inside the shuttle could tell when we'd had enough. You could get in trouble real quickly if you didn't stay on top of it. A couple of years earlier, another astronaut, Story Musgrave, had gotten frostbite during EVA training in an altitude chamber, and everybody understood that we had to turn this around quickly. I think we were at something like 3 on our subjective scale when we gave the signal, and by that time it was almost too late because the temperature had dropped so much. Jim Wetherbee, the shuttle commander, brought the arm down and moved us back into the cargo bay, which is warmer. Then they rotated the ship to face Earth. Even during a night pass, there is some radiant heat coming from Earth, and that raised the temperature enough for us to last the 30 minutes or so until the sun came up. Once it did, we were warm and toasty—200+ degrees Fahrenheit within a matter of a few minutes.

As a result of that test, they added extra heaters to the gloves. In fact, when they saw how low the temperatures got, they began to work on the suit modifications before we came back to Earth.

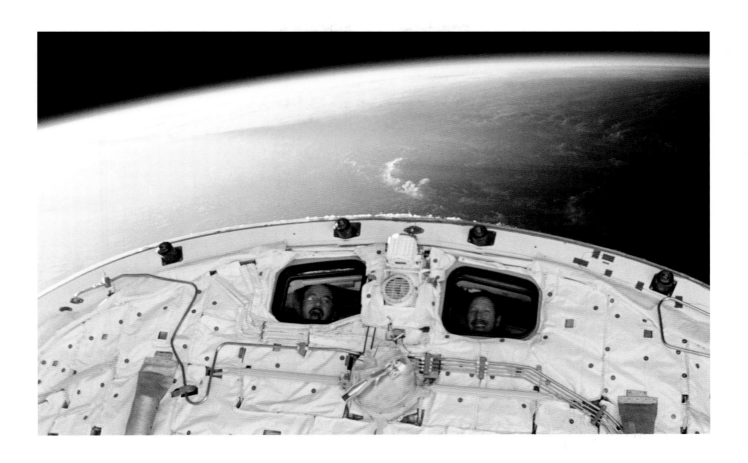

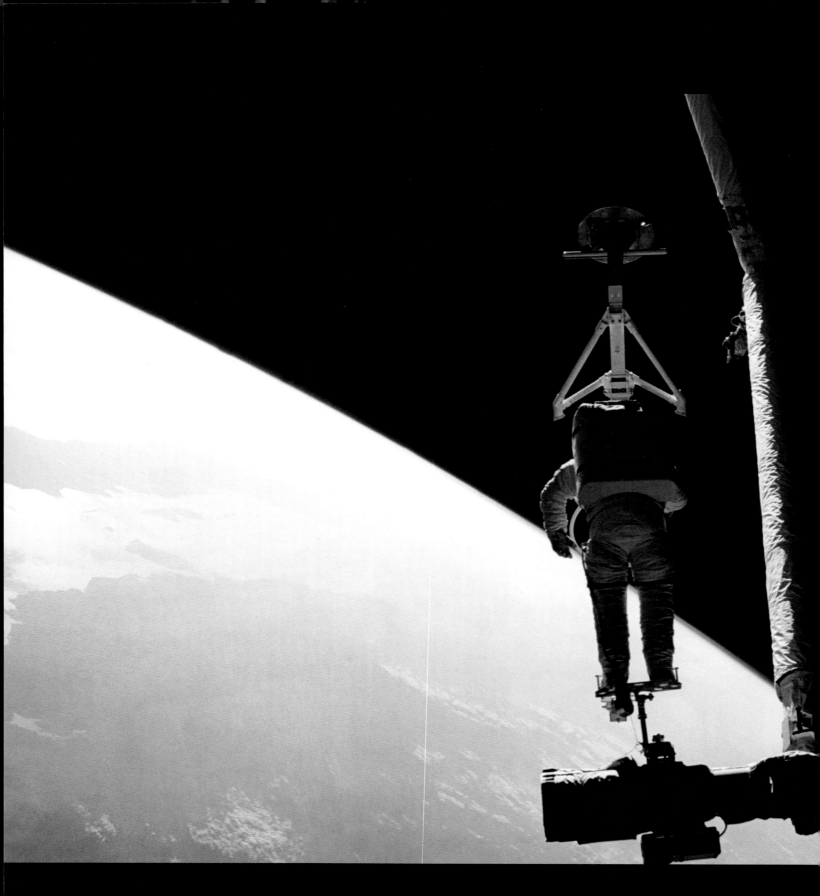

Riding on the end of Endeavour's robot arm, Pierre Thuot carries a "capture bar" meant to stop a slowly turning spacecraft. It didn't work, and the STS-49 crew had to devise another plan (see pages 74-75).

Opposite: STS-103 spacewalker Claude Nicollier takes a power tool to the Hubble Space Telescope.

TOM JONES | **On stage for six or seven hours**

I think that having the helmet camera, which lets people watch a spacewalk from your point of view, changes your interaction with the ground in a very subtle way. I consciously thought of my wife sitting down in Mission Control watching the spacewalks. That's something you're grateful for, that kind of mental and spiritual support. Your mother is watching it on the East Coast, and so are your brothers and sisters. They're not a critical audience, but of course they are pulling for you.

Then you have all your peers down there, too. So not only are you on stage for six or seven hours in a row, but now they're actually able to watch what you're doing moment by moment. It's an extra level of attention that people hadn't had to contend with in the past. But it's also very instructive to have a crewmate inside the shuttle, able to second-guess you or catch you making a mistake before it becomes something you can't correct. He's like your conscience, sitting there on your shoulder.

LINDA GODWIN | **Wow, that was a long day**

The hand work can be fatiguing on a spacewalk. That's kind of the driving factor for a rule saying that the same crew can't go out two days in a row, particularly if there's a lot of hand work. The idea is to give the crew a day to recover.

Maybe you don't realize it while you're out there, but after you get back inside and the adrenaline is gone, you realize, "Wow, that was a long day." On some of these really long EVAs you don't get anything to eat from the time you suit up until you take the helmet off, and that can be up to 10 hours. You start thinking about it after a while. You look inside and see the crew eating. Of course, there's no reason for the people inside to starve out of sympathy.

It's also tiring for the people inside. There's a mental focus that doesn't let up for hours, making sure they're on the procedures and that they're not leaving anything out or losing anything.

CARLOS NORIEGA | **A single drop of water**

Toward the end of my EVA on STS-97, about two-thirds of the way through deploy-
ing the space station's new solar power array, I went to take a sip of water from a
tube inside my helmet. It went down the wrong way, and I coughed. Well, a little
droplet of water took a perfect trajectory from my mouth to the inside of the helmet,
where it bounced off and went into my eye. We coat the inside of our helmets with a
thin coat of soap so they don't fog up. And the droplet picked up just enough soap
that it severely irritated my eye, to the point where I couldn't see out of it anymore.

I suspected what had happened, but I wasn't sure. At the time, Mission Con-
trol was concerned that maybe it could be a break in the lithium hydroxide system
that cleans the carbon dioxide from the air we breathe, or maybe something else
floating around in my suit.

I felt fairly comfortable, other than the fact that my eye hurt like you wouldn't
believe. The bad thing about zero-g is that the tearing mechanism doesn't do every-
thing it's supposed to. The droplet just stays there in your eye, and doesn't run
down your cheek. I thought about shaking my head, but then there's the potential
that you're going to get it in the other eye. It took a long time to dilute, and by that
point the EVA was over. I'm one of those people who's very sensitive to irritants,
and my wife just laughed later, "You and your eyes."

Kathy Thornton follows her checklist during an STS-61 EVA to refurbish Hubble. A finite air supply limits spacewalks to about seven hours.

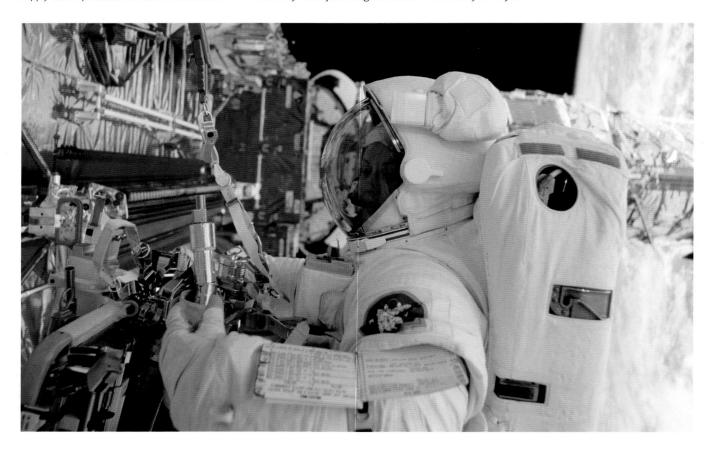

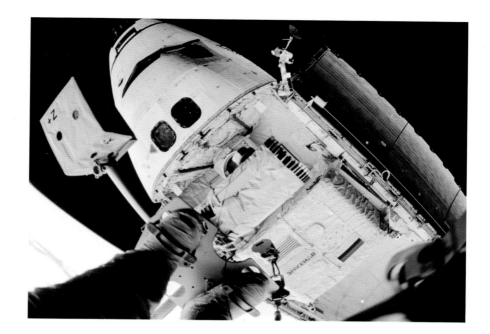

During a spacewalk you move more slowly to work faster. Because the suit is heavy, you don't want to get a big rate of motion going. You want to move carefully, deliberately, and use small forces to make small changes in your orientation.

— TAMMY JERNIGAN

KATHY SULLIVAN | **Venezuela between my boots**

Dave Leestma and I had a very busy timeline during our spacewalk on mission 41-G in 1984. One of the experiments in the payload bay was an Earth-mapping instrument called the Shuttle Imaging Radar, or SIR-B. It had to be turned off while we were outside, since the energy it radiated could interfere with the electronics of our spacesuits. Nobody trains to dawdle during spacewalks, but this drove us to really hustle and get back in the airlock so that SIR-B could resume mapping. I envy astronauts whose spacewalk schedules gave them half an orbit to soak up the views of Earth. Watching our films, I think I got all of about a minute. But it was quite a memorable minute.

My last task was to cross the width of the payload bay to help fix a problem with the shuttle's main communications antenna. The best path was to move "upside down" along the small instrument shelf next to SIR-B, so as to keep my hands and feet up and away from the equipment. I felt like I was doing a handstand next to all these very delicate instruments, and I chuckled to myself, thinking how the radar scientists would have howled if anyone did such a trick on the ground.

Then I looked "up" at my feet. Since I've lived on Earth all my life, my brain is geared to think that whenever I see the tip of my nose, *then* my tummy, *then* my toes, I must be looking "down." Instantly my sense of doing a handstand switched to a sense of hanging from a tree limb. But instead of grass a few feet beneath my toes, I had the Maracaibo Peninsula and the entire northern coast of Venezuela sliding between my boots.

Happily for the sake of my memories, my crewmates captured this moment for a scene in the IMAX movie "The Dream Is Alive." I feel that tree limb and see Venezuela every time I watch it.

Standing on a platform at the end of the robot arm, looking down on Discovery, STS-63.

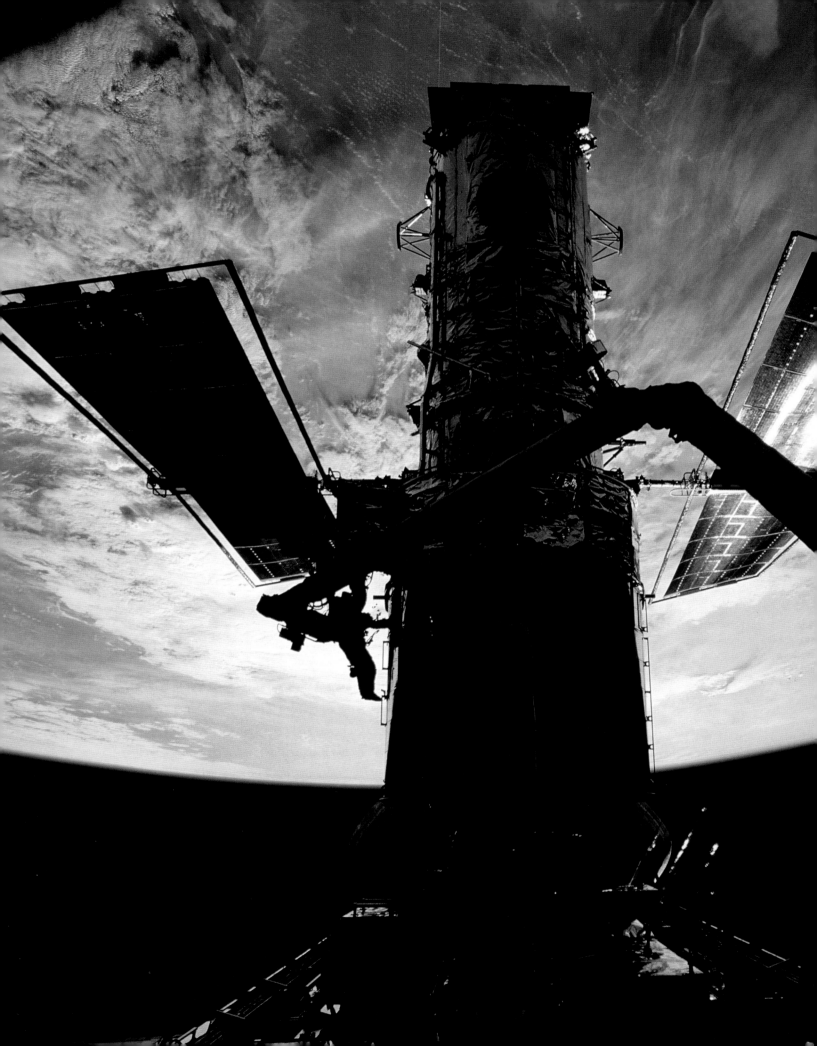

DAN BARRY | **In case anyone was watching**

At the end of my first spacewalk on STS-72, I had the rare experience of seeing stars while out on EVA. We had a task at the very end of the spacewalk to test the lights mounted on our helmets. To get the best test, we did something never done before during a spacewalk; we turned off all of the orbiter's lights, which are so bright that they prevent spacewalkers from seeing the stars. Our helmet lights worked fine— I could see and work without difficulty. After the test I turned off the lights, and suddenly it was so black I couldn't see my hand. I waited for my eyes to adjust and was rewarded by millions of stars, faint at first but eventually turning into brilliant points. Still, they didn't cast enough total light even to see myself. Right at the end I flashed my helmet lights a few times, just in case anyone was watching.

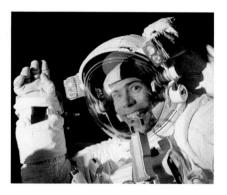

Dan Barry waves for the camera during an STS-72 outing. Opposite: Steve Smith is silhouetted against the Earth while working on the Hubble Space Telescope, STS-82.

MIKE FOALE | **Like climbing over an oil rig**

My spacewalk on Mir was like climbing all over an oil rig that's floating in a blue void. It's a big structure. Your eye gets drawn by the complexity of the equipment as well as the background of the stars at night and Earth during the day. I'll never forget it—utterly astonishing. I don't say it in front of my crew-mates from the Hubble repair mission, but it was much more visually stunning than the Hubble is. The Hubble is a pretty neat, big object but it doesn't match Mir in terms of overall strangeness. Mir stuck out in all directions. You could lose your orientation very quickly, which I actually kind of enjoyed, because you got an idea of scale and complexity.

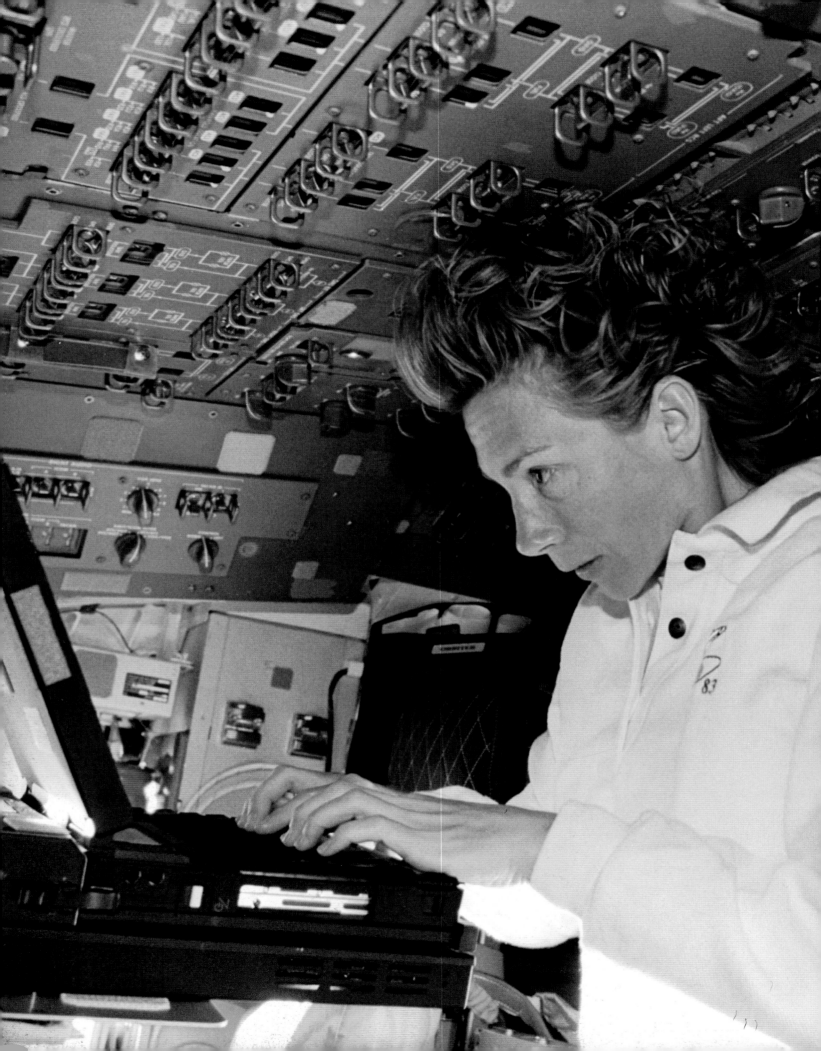

Shuttle astronauts sometimes liken space-flight to a two-week camping trip. You bunk out, you eat packaged food, and you don't mind roughing it when the scenery is so spectacular.

Spartan though it may be, the orbiter still offers a few basic amenities—sleeping berths or bags, a galley for warming up food, water for washing up (but no shower). Crews have frequently struggled with a balky toilet, or Waste Collection System, even though the technology has improved somewhat since the early 1980s.

Like any living quarters, the shuttle requires regular household chores, like switching out lithium hydroxide canisters that remove exhaled carbon dioxide from the air, or stowing (not taking out) the trash. All part of daily life in a tiny, sealed cabin, protected from the deadly vacuum outside.

Susan Kilrain, one of the few women shuttle pilots, uses a portable computer on board Columbia, STS-83.

MARIO RUNCO | Eating in a fine restaurant

I usually don't feel very well during my first couple of days in space, but I know I'm getting better when I get my appetite back. However, it wasn't until my third mission, STS-77, that I was actually hungry in space, and on flight day seven my appetite returned with a vengeance. When it came time for me to eat lunch, Andy Thomas spelled me on the task we were doing back in the Spacehab research module, which was to visually monitor a small Satellite Test Unit that we had deployed from the shuttle. I floated through the tunnel from the Spacehab to *Endeavour*'s mid-deck to prepare my meal. It just so happened that this particular day's menu was the Italian meal I had picked on a whim many months beforehand. I had tomatoes and eggplant, spaghetti and meat sauce, and Italian vegetables. It wasn't Mom's cooking, but it would have to do. I remember putting everything on a meal tray, which is unusual because eating on the go is generally the rule on the shuttle.

Everyone else was busy at the time, and the only place out of the way was up on the forward flight deck. So, tray in hand, I sat down to eat in the commander's seat at the front windows, which happened to be facing Earth at the time. I just sat there and basked in the moment, watching Earth roll by. I had never experienced that before in space, and I don't think many people get the opportunity to really enjoy their meals and the scenery outside. It was like eating in a fine restaurant, overlooking one of the most spectacular views you could find. At one point I remember putting down my spoon and saying to myself, "What would really top off a meal like this would be a glass of fine red wine." It would also have been nice to have my wife, Sue, up there to enjoy that moment with me. I even visualized for a moment that she was in the pilot's seat next to me, with a dinner candle on the console between us.

I just sat there lingering, the tray in my lap, when I got a call on the intercom. "Mario, have you finished yet? I need to eat lunch, too." Apparently Andy's appetite had also returned, and his call wrenched me back to reality. I had been there for something like 40 minutes, almost the whole dayside pass over Earth, and I hadn't realized it. It was one of those moments that was not to be denied.

Bill Lenoir eats alone on the flight deck, STS-5. Bottom: STS-75 astronauts Franklin Chang-Diaz, Jeff Hoffman, and Claude Nicollier take their meal in "bed."

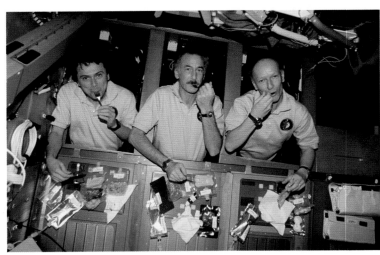

SID GUTIERREZ | **Rice Krispies and taco sauce**

Playing with your food is irresistible in space. Loren Shriver catches some flying candy, STS-46.

Astronauts have learned empirically that your sense of taste is dulled in weightlessness, because the fluid shift to your head feels a lot like having a head cold. Things that are tasty on Earth are bland in space. For this reason astronauts select diets that include spicy foods. On STS-40 we were all aware of this phenomenon, and we specified plenty of shrimp cocktail and spaghetti and meatballs. Despite these efforts, some of the food was still pretty bland. We started spicing it up by adding taco sauce, one of the condiments provided in small packets. Although I didn't do it myself, I observed crewmates putting taco sauce on Rice Krispies in the morning.

On about flight day eight, the commander, Bryan O'Connor, eyed the remaining taco sauce and realized that at the rate we were consuming it, we would run out before the end of the mission. Realizing the risk to crew morale and discipline, he took action. He secured all the remaining taco sauce and divided it equally among the crew members. Thereafter taco sauce became the medium of exchange. For example, if it was your turn to clean the latrine, you could pay someone a taco sauce or two to do it for you. Or you could just eat your cache. On my second flight, I flew as the commander. Needless to say, we did not run short of taco sauce.

> The shuttle in orbit
> is a lot more like
> a submarine than
> like an airplane.
> It's this little
> cocoon in a hostile
> environment.
>
> —MIKE McCULLEY

*Crewmates pressed up against
the overhead window, as seen
from Mir, STS-74.*

RHEA SEDDON | **Safe trip home**

One of the things that struck me when I first went into space in 1985 was that I couldn't call home. Your family could send you a couple of sentences in your tele-type morning updates, but everybody in the world got to read it. So it wasn't very personal, and you couldn't say very much.

Since then we've done better. Now there's a family conference where you can talk to your kids once or twice during a mission on the flight surgeon's private communication loop. But back then, you could feel very remote from your family. It was different from a business trip where you can always call home. I knew that if anything happened to one of my kids while I was in space, they might not tell me until I got back.

That's why it was wonderful that I was able to talk to my 9-year-old son's class with a special ham radio link-up during my second flight in 1991. For one thing, it was the first time he realized that I did something special for a living. He just thought his father and I—my husband Hoot Gibson is also an astronaut—went off to work every day. So for the first time, his classmates were excited, and the news-paper showed up to take pictures and all.

At the same time, Paul didn't want to be singled out when we talked to his classroom from space. He was afraid I was going to embarrass him and be mushy or something. So when it was his turn to ask a question, I answered him just like any other student. Soon afterward we started losing communication. We were getting crackly noises and someone told me we were almost out of time. So I said how much I appreciated their call, that their questions had been good, thank you very much, and we'll have to break it off now. That's when I heard a little voice saying, "Mom, have a safe trip home. I love you."

RICH CLIFFORD | **Why don't you put on your pillow?**

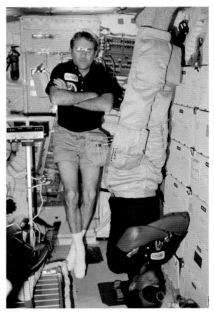

Top: Norm Thagard in his sleep station on board the Russian Mir space station in 1995. Above: Richard Truly (left) and Guy Bluford sack out on Challenger's *mid-deck, STS-8.*

Where you sleep on the orbiter is based on your rank and your own preference. Dave Walker, the commander on STS-53, decided he had to sleep on the flight deck, next to his controls. So he just tied himself off right above the pilot's and commander's seat. Guy Bluford got up on the flight deck, crawled into his sleeping bag, and tied himself off in a tight ball in a corner. Bob Cabana and Jim Voss slept on the starboard side of the mid-deck, which has two stations where you can attach your sleeping bag and leave it without having to pack up each day.

As I was the rookie on the flight, Dave said I could sleep in the airlock, which is a good place because there's not a lot of noise in there. The airlock is about the size of a Volkswagen Beetle, about 5 foot 2 inches long. Since I'm 5 foot 10, my head would stick slightly out into the mid-deck with my feet touching the inner hatch, the one you exit to go outside on a spacewalk.

I stretched out my sleeping bag and tied it to various sections of the airlock, but I didn't put on my pillow, this little Velcro cushion that we can attach. So when people got up in the middle of the night—and there's a constant stream to the bathroom the first day as everybody gets rid of body fluid in weightlessness—they'd cross the cabin, create an air current, and my floating head would bounce against the sides of the airlock hatch.

The next morning I complained, "Hey, can't you go slower to the bathroom?" They'd say, "Why don't you put on your pillow? Then you won't hit the sides."

I was sleeping on my back, with my arms hanging out in front of me. And it just annoyed me. I couldn't sleep. I had to cross them on my chest and wrap them in my sleeping bag for the first two or three days until I got used to it. But once I got over my annoyance, I put Velcro on the back of my shirt and attached myself to the forward wall. It's kind of funny to look at somebody sleeping that way. They look like they're in the fetal position. Without gravity, all your muscles go to the neutral force point, so everything is bent.

On my second flight we had sleep stations, which is like sleeping in a telephone booth. You need these for 24-hour operations where you have one shift working and one shift sleeping, because it gives you some sound attenuation and the capability to make it dark.

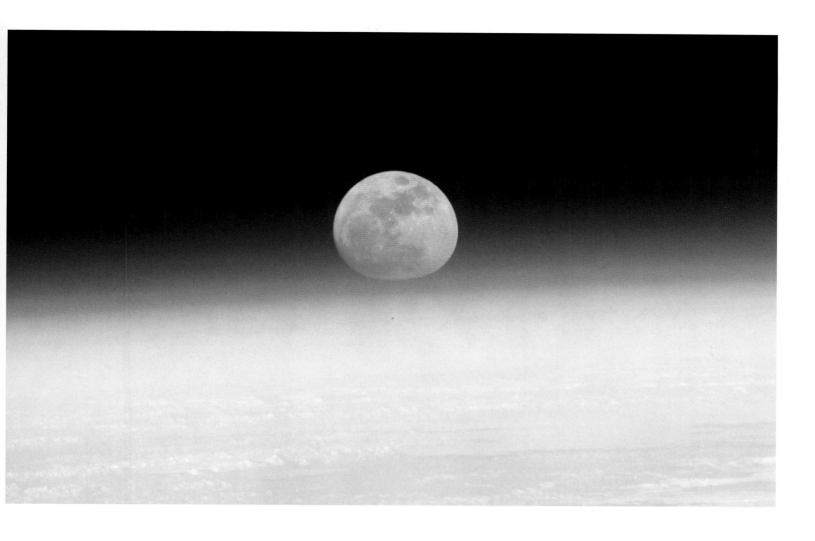

TOM JONES | **Fetal position**

Moonrise from space, STS-103. Astronauts can put a shade over the flight deck windows if they want to block out light at bedtime.

On my first flight Kevin Chilton, who's a good friend, was the pilot. We worked shifts that went on for something like 16 hours when you counted all the house-keeping chores, and everybody was very tired at the end of each day. I was on the other shift, so while I was already at work on the flight deck, Kevin and the others were off duty and getting ready for bed.

After we worked for a while photographing some ground sites, it was time to take a breather. So one of us goes downstairs and says, "Come here guys, you've got to see this. Shhh!" We poke our heads downstairs, and there's Chilton asleep, drifting randomly around the mid-deck. Linda [Godwin] and Sid [Gutierrez] had gone to bed already, and had slid the little door shut on their compartments. But Kevin had stayed up late typing an e-mail home, and he just fell asleep while he was typing. He was in a fetal position, floating around. So Rich Clifford and I, as gently as we could, got his bunk open and unbent him enough to slide him in there. He woke up in the process, sort of groggy. We said, "It's time to go to bed. We're just going to put you in here." It was really a nice moment, because he was just totally relaxed at that point.

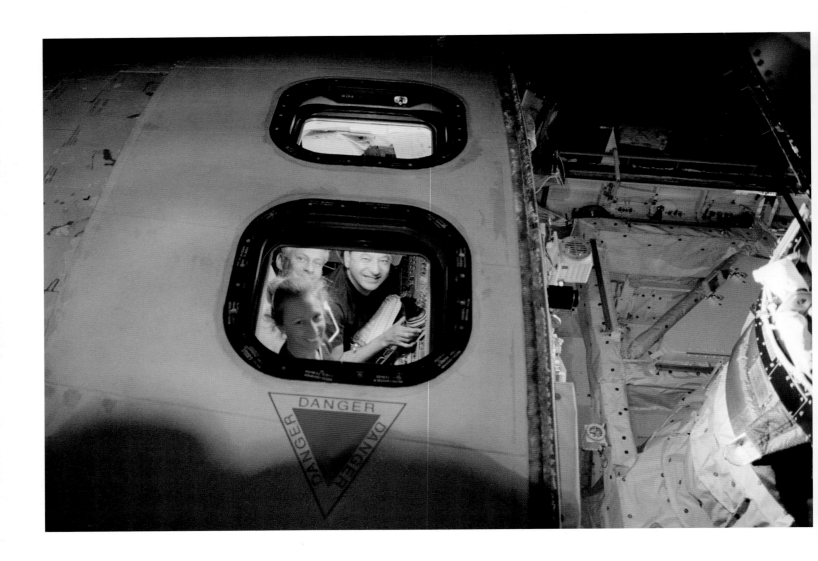

KEN COCKRELL | **Trout fishing**

Marsha Ivins, Ken Cockrell, and Mark Polansky (right) inside Atlantis *during an STS-98 spacewalk. On board the orbiter, seven people share a volume equivalent to that of an average living room.*

All-male crews are not desirable from my point of view, because modesty and decorum go completely out the window. On one of my crews, these guys never closed the screen when they went to the toilet. I remember one of the guys went to use the toilet one time. You get the motor running on the thing, and it creates a little airflow to help draw the waste down into the container. But when this airflow hits the waste that's in there, it seems to come alive. It starts to stir around with the breeze, and these little particles of human excrement look like little fish—they're nicknamed "brown trout." Well, because of the way the airflow was striking some of the trout, one of them bounced off the side and came up out of the hole, coming after him. You never heard such commotion and banging against the wall, and maybe an occasional bad word coming out of his mouth as this fish started swimming away from him. And then, of course, he felt responsible to capture the thing and put it back in the tank. He struggled and he groaned and complained, and finally dug out the plastic gloves in the compartment and captured it and put it back in. It was hilarious.

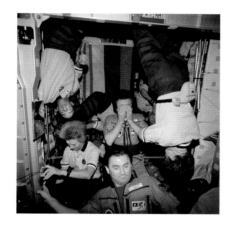

Photo op in orbit: The STS-84 crew and Mir cosmonauts set up, pose for the camera, then disband after taking their official crew picture.

TOM JONES | **The Beefsteak Experiment**

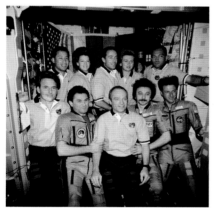

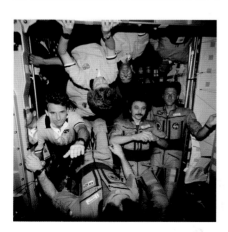

You lose things in zero-g. We were on *Atlantis*, undocking from the space station, and we were reassembling the bicycle so we could get some exercise after a long, busy week. It takes like 25 minutes to set the whole thing up, and three guys were working on it. I was doing computer stuff or something. One of the pieces is a shock mount, a rubber foot that goes on the floor to prevent vibration when you use the bicycle. I saw them getting all these parts out, and I noticed one of these shock mounts floating in the air next to where they were working. I figured they'd just pluck it out of the air and install it.

Well, five minutes later, they're all going, "Where's that fourth shock mount?" You can't operate this device without it. So now you see this ridiculous picture of four grown men who've been paid decent salaries and are privileged to go into space, all looking for a lost piece of machinery about as big as your fist. After a serious half hour of looking all over the orbiter, we figured the airflow would carry it to an inlet filter on the cabin air cleaner. But it didn't show up there after 15 or 20 minutes. So I jokingly said, "Why don't we just take something else and put it where it was?" So we got a sealed package of beefsteak and put it in the same general location. And we all sat there with our thumbs twiddling, watching this beefsteak move by centimeters.

About that time Marsha Ivins sticks her head down from the flight deck, and God only knows what was going through her mind when she saw four people watching a beefsteak drift. We started to joke, and said it was a guy thing, she wouldn't understand. It's science at work. We're doing an experiment to see where this thing might have migrated. We started joking about how maybe the beefsteak isn't behaving the way the shock mount would because we're *watching* it. Like the Heisenberg Uncertainty Principle. You change the outcome by observing it. So Beamer [Bob Curbeam] and Roman [Mark Polansky] turn away and sneak glances over their shoulders, but it still wasn't going anywhere. Marsha was cracking up, and suggested we go upstairs and watch it on a camcorder so it was totally unaware we were watching it. Finally I took a flashlight out and dove up underneath a retention net where all the suit bags and helmets were. The shock mount was buried back behind three spacesuit bags. It would have never come out on its own, and would have been lost for the rest of the mission.

JANET KAVANDI | **Yellow Submarine**

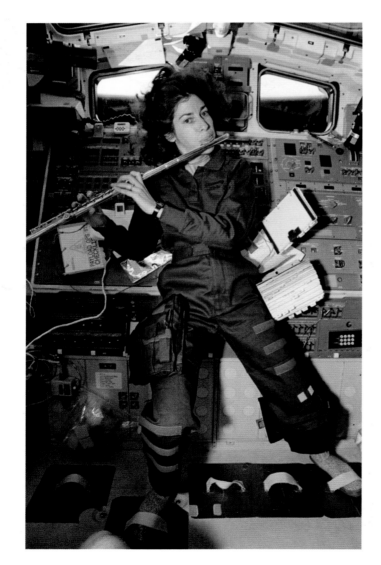

Ellen Ochoa, a classical flutist, plays during the STS-56 flight while anchoring herself in foot straps.

The Russian Mir space station was impressive. One of the most entertaining things to do on board was to float inside the central node and look into the various modules that extended out in all directions. Since there could be no "up" or "down" in a vehicle such as this, it was very amusing to look into one module and see people "standing" on the wall, working on an experiment. In the adjacent module, someone might be jogging on a treadmill on the ceiling. Beneath you, you might see someone else having a meal underneath your feet. Above your head, you'd hear the thumping of a body coming toward you, and you'd have to move aside to make room for them to pass. The passages were very tight, as years' worth of old experiments and tools were strapped to many of the walls, and often only a small tunnel was left to squeeze through. The cloth material covering the walls was starting to lose its adhesive in some places, and a musty odor was in the air.

The table where the crews took their meals was a very nice gathering place to talk at the end of the day. It was surreal to look out the window while having dinner 240 miles above Earth, traveling at a speed of 17,500 miles per hour. I remember once passing over Seattle, where I lived for many years, and realizing that by the time I grabbed a camera, it would be long gone. So while I floated there, I made an effort to capture the image of the beautiful Puget Sound and Cascade Mountains in my mind. Meanwhile, the Russian commander had gotten out his guitar, and was singing "Yellow Submarine." I wondered what the people on the planet below would have thought if they could have heard the faint sound of the Beatles emanating from space.

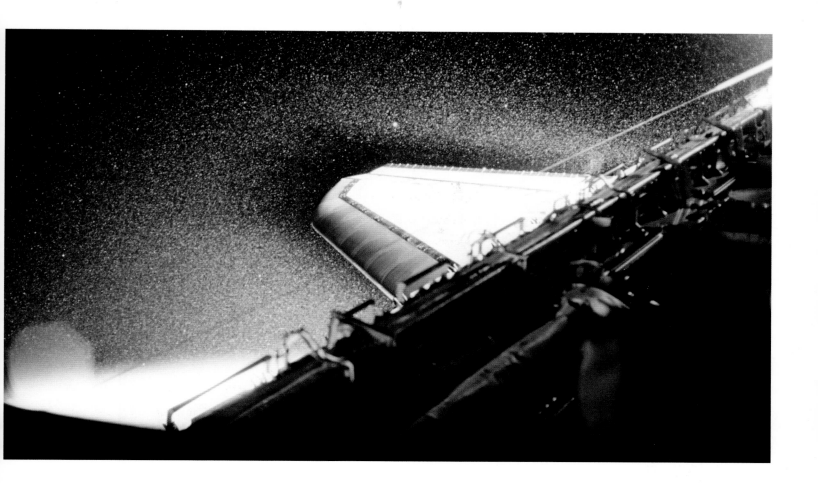

ROGER CROUCH | **Trash satellites**

A water dump from the orbiter produces an ice shower in this STS-91 photo. Excess water is regularly jettisoned during a shuttle flight.

After a work shift had finished, I floated up to the window in the Spacelab module and clung to the handrail of the overhead drawers, staring out the window motion-lessly for almost an hour. When I first looked out, we were over the Atlantic Ocean, and I saw what looked like little satellites flying along with us. I tried to make them disappear by changing my viewing angle and cleaning my glasses and the window glass. But these things really were flying along with us! And they had velocities very similar to ours, although they changed significantly.

They turned out to be bits of trash that had floated out from the cargo bay or other parts of the orbiter—or, as I would later find out, residue from the burning of the thruster rockets. They were now orbiting along with us.

Before I knew it we were over the Pacific, where there were tremendous storm fronts. The thunderclouds looked like little mushrooms, even though they stretched up to 40,000 feet or more. Then suddenly it was dark—so black it was almost eerie. The orbiter's thrusters fired, and I could see the warm red glow and all the little trash satellites spewing out from behind the shuttle.

I had been at the window less than an hour, and we had gone halfway around the planet. I went to bed and slept an incredibly peaceful sleep, dreaming of flying over the world.

Science was never the shuttle's primary purpose, but it was the main focus on many individual flights, especially in the period after the *Challenger* accident and before the shift to space station dockings in the late 1990s. For up to two weeks at a time, shuttle crews would work in shifts, conducting research in materials science, astronomy, space physics, Earth science, gravitational biology, and human physiology. The latter often required astronauts to be test subjects as well as experimenters, a duty not everyone relished.

The most sophisticated research was done inside the European-built Spacelab, particularly when outside scientists augmented the astronaut crews. The pace on dedicated Spacelab flights was hectic, as planners frequently crammed more experiments in the timeline than the crew could gracefully accomplish. The STS-51F (Spacelab 2) astronauts, who included one MD and four PhDs, put it succinctly in their postflight report: "One is always in a hurry on Spacelab."

Rhea Seddon spins crewmate Marty Fettman
on a rotating sled during an experiment to
study balance in space, STS-58.

FRANKLIN CHANG-DIAZ | **Operational scientists**

In the early days of space exploration, the experiments done in orbit were designed to factor out the astronaut. Scientists on the ground assumed the astronaut was not going to be interested in the investigation. Nowadays experiments designed like that are a big mistake. They essentially become black boxes with an on-off switch, and if the experiment fails in space—which happens about 50 percent of the time—there's nothing you can do. We've seen many instances where astronauts have saved an experiment simply because they were able to get in there and modify it.

One of the things I wanted to learn when I came to NASA as a scientist-astronaut was how to be operational. In fact, some of us even coined the phrase "operational scientist." In the old days, you had this mental image of a mad scientist working all alone in his laboratory, on something so esoteric that nobody could understand it. Science today is really done by teams. Go to the big physics labs like Fermilab or CERN, and you don't see a scientist working on something alone. You see scientists organized in research groups, and you see control teams just like we have here in Mission Control. The mentality is very similar to how we do science in space.

Susan Kilrain tends to a materials science experiment, STS-83. Because crew time is scarce, shuttle experiments are often designed to be as automatic as possible.

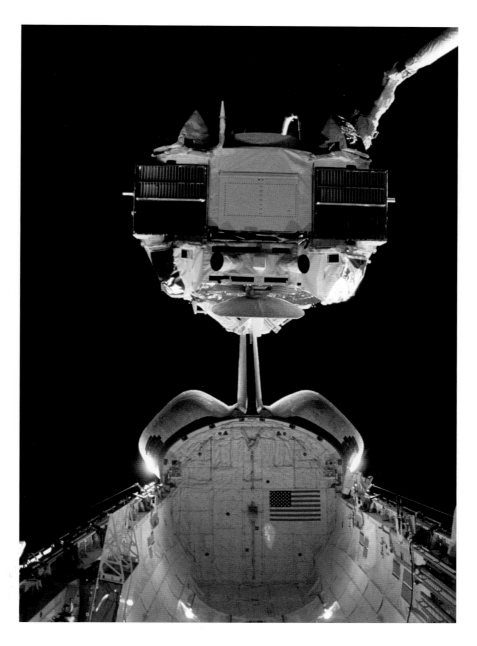

This STS-53 experiment to study the behavior of liquids in microgravity was also useful to engineers designing fuel tanks for spacecraft. Right: The Gamma Ray Observatory, one of many astronomy satellites launched from the shuttle, STS-37.

JERRY LINENGER | **Science!**

Science, and especially life science, is sometimes the butt of jokes among astronauts. Even though Dick Richards, the commander on STS-64, would always sign up to do all the science experiments, do them very seriously, and do a good job of it, he would also joke about it. Whenever he'd go to the head, whether during training or up in space, he would come out holding his urine sample up to the heavens, and yell out "Science!" as if praising the god of science. During the shuttle flight, I'd wake up in the middle of the night and hear someone yelling "Science!" in the background. It was Dick Richards keeping us in stitches.

TAYLOR WANG | **I'm not going back**

I'm a scientist, not an astronaut, and I hadn't really planned on a shuttle flight. But in the 1970s I proposed to NASA to study fluid physics in space, and like any scientist I wanted to conduct my own experiment. So I was selected to fly as a payload specialist. I spent two years training, predominantly to run my own experiment, but also to run others inside the Spacelab. And in 1985, my experiment and I finally flew on mission 51-B.

Everything was fine on the first day of the flight. I turned on everybody else's experiments, and they worked wonderfully. But on the second day, when I turned on my own instrument, it didn't work. You can imagine my panic. I had spent five years preparing for this one experiment. Not only that, I was the first person of Chinese descent to fly on the shuttle, and the Chinese community had taken a great

deal of interest. You have to understand the Asian culture. You don't just represent yourself, you represent your family. The first thing you learn as a kid is to bring no shame to the family. So when I realized my experiment had failed, I could imagine my father telling me, "What's the matter with you? Can't you even do an experiment right?" I was really in a very desperate situation.

I asked ground control if I could repair the instrument, and they were reluctant—for good reason. On a shuttle flight everybody's time is booked, and you don't have much free time to troubleshoot. And even though the shuttle is an engineering marvel, the ability to repair things is extremely limited. They have a couple of screwdrivers, a couple of wrenches, but it's pretty primitive. Plus, there were no real replacement parts.

I understood NASA's point of view, but I said, "Listen, I know the system very well. Give me a shot at it." They were still reluctant. So finally, in desperation, I said, "Hey, if you guys don't give me a chance to repair my instrument, *I'm not going back.*"

Well, NASA got nervous at that point. They actually got a psychologist to talk to the other crew members and ask, "Is Taylor going nuts?" Fortunately my commander, Bob Overmyer, said, "No, he's okay. He's just depressed, and he really wants to repair the experiment. We'll help out." They were on my side. Finally NASA said okay, on a couple of conditions. First, that I wouldn't neglect my other responsibilities, and second, that I would quit after a reasonable effort.

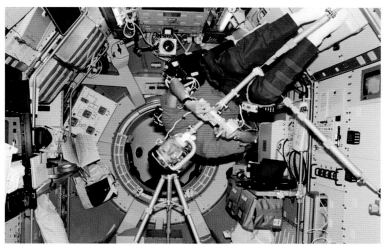

Mamoru Mohri does a test of perception and motor functions during the STS-47 Japanese Spacelab mission. Opposite: Tunnel connecting the Spacelab module to Columbia's mid-deck, STS-9.

I was relieved, because I hadn't really figured out how not to come back if they'd called my bluff. The Asian tradition of honorable suicide, *seppuku*, would have failed, since everything on the shuttle is designed for safety. The knife onboard can't even cut the bread. You could put your head in the oven, but it's really just a food warmer. You wouldn't even burn yourself. And if you tried to hang yourself with no gravity, you'd just dangle there and look like an idiot.

I started the repair job. The only way to do it was to open up this large compartment and crawl inside. I lived inside the instrument for a day and a half, and the only thing my crewmates could see was my two legs hanging out. Meanwhile, they were fantastic—they took over all my housekeeping chores for me.

Luckily I was able to solve the problem and resume the experiment. Emotionally, I went from the bottom of the ocean to the top of the mountain. And once it was fixed I was so high I couldn't sleep. I just worked around the clock. The results turned out to be very good—in fact, we're still using data from that flight more than 15 years later.

DAVE WILLIAMS | **Sharps on deck**

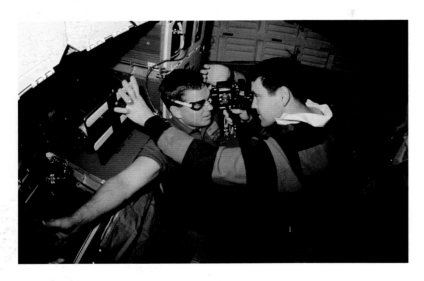

Before the STS-90 Neurolab mission, a big unknown was whether we would be able to perform complex surgical procedures in space, which we needed to do to study how rodents change physiologically in weightlessness. All the scientist-astronauts on the flight were trained in surgery, and I have a fairly diverse set of surgical skills from my research background and my training as a clinician. What we didn't know was how well things would go in space.

On Earth you don't have to worry about restraining the surgeon, because you're standing in the operating room. You don't have to worry about restraining a patient lying on the table. You don't have to worry about restraining your instruments, because gravity holds them on surgical trays. In the absence of gravity, all those things become issues. As the surgeon, you need to have a way to restrain your feet with foot loops. We also used a waist restraint system, so that was the second point of fixation. And then I used my forehead to stabilize myself for some procedures. You also can wedge yourself in with your forearms in a glovebox we had inside the Spacelab, to stabilize your forearms and give a third point of fixation.

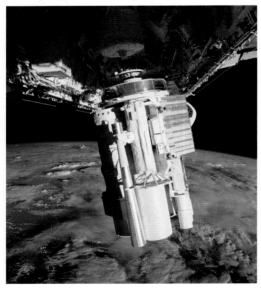

Restraining the instruments is another thing. On the ground you're generally handing instruments back and forth with the operating nurse. In space, you can't just release an instrument or it'll float away and you'll lose it. So you have to be very disciplined. When you use an instrument you put it back where it came from, or flip it around so you're holding it in the palm of your hand, a technique called palming.

One of our biggest concerns came when we had two people performing surgical procedures at the workstation we used to contain materials so they didn't float loose in the cabin. If I was using a scalpel and Jay Buckey was right beside me, I wanted to make sure I didn't inadvertently flip it and cut myself or him. So whenever we used sharp instruments, we would call, "Sharps on deck," so everybody, including people not involved, knew not to hit the workstation or us inadvertently, because we were doing a critical procedure. And it all worked out. Nobody cut themselves at all during the whole two-week mission.

Top: STS-41 pilot Bob Cabana photographs Bruce Melnick's retina in an experiment done on the mid-deck during a non-Spacelab flight. Above: Telescopes carried on the ASTRO-1 astronomy mission, STS-35.

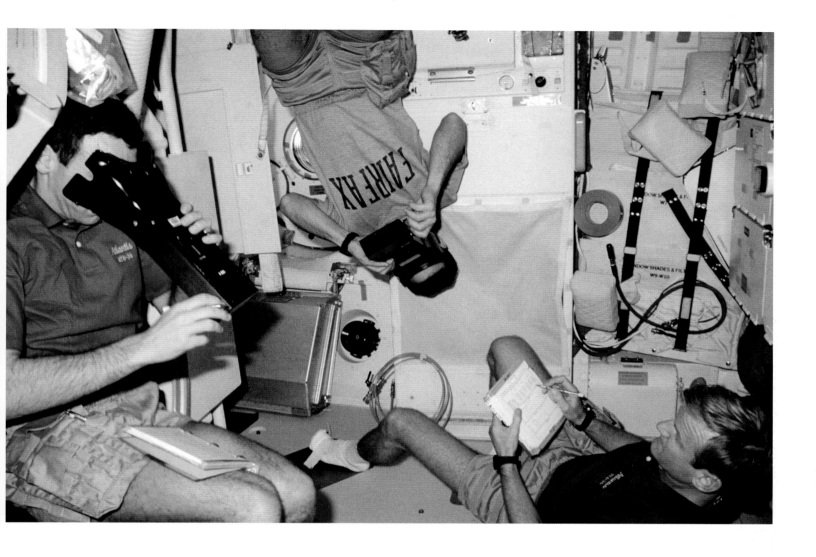

TAMMY JERNIGAN | **24-hour observatory**

Dave Hilmers (left) and Pierre Thuot test their visual acuity in space during an STS-36 experiment on Atlantis' mid-deck, while John Casper records the results.

On STS-67 we got into a rhythm of astronomical observations, and there was a lot of time when the cockpit was darkened. We were running a 24-hour observatory. You would monitor observation of an object for maybe 20 minutes before you had to regroup, repoint the instrument pointing system, and set up the instruments again. So there were whole blocks of time where you could just look out and reflect, talk to the other crew members who were awake on your shift, and really have a sense of what a beautiful Universe we inhabit.

RICK LINNEHAN | **We couldn't just ignore it**

NASA astronauts who lived on Mir conducted a variety of experiments during their months in orbit. Here Shannon Lucid looks in on wheat growing in a Russian space greenhouse.

On our STS-90 Spacelab mission, we ran into a problem with the neonate, or newborn, rats that we had on board for developmental studies. The cages weren't able to handle as many neonates as they contained, even though the designers had done behavioral studies that suggested they could load the cages the way they did. Some of the rat mothers did well in space, but some did not react well to stress, and were not able to gather their pups and nurse them.

We found out by accident, really. We checked out a couple of cages early in the flight, when it wasn't really called for in the schedule, and found that some of the newborn rats had died. So over the course of the next four or five days we took every single neonate out, washed them down, warmed them, and gave them oral fluids. I mixed up a diluted solution of antibiotic and saline that I gave them subcutaneously, under the skin, to help with possible infections and dehydration. It was a lot of work, very intensive. Jim Pawelczyk, Jay Buckey, Dave Williams, and I did that for four to five days. We probably were lucky to get three to four hours of sleep a night, if that much. A lot of us were first-time or one-time-only space fliers, and we gave up free time when we otherwise would have been looking out the window in this amazing place.

But we couldn't in good faith just ignore it. In the end, we still ended up losing over 50 percent of the 90 neonates we had on board. But if we hadn't intervened, we probably would have lost close to 90 percent.

DAVE WILLIAMS | **The Whirl-a-Cam**

All of us on the STS-90 crew were worried about whether we'd get sick in the rotating chair during our Neurolab research flight. NASA had flown such a chair, which is used to study the balance system, on a Spacelab mission in 1992, and the debrief comments from that crew suggested that it wasn't going to be a problem in orbit. We weren't 100 percent sure, though, until we actually did it ourselves. The chair was not a problem from a motion sickness perspective. The sensation was more dominated by the physical feedback to your body. When we were rotating with our head outward, it tended to increase the amount of fluid shift to the head, and I immediately felt like I was upside down. The whole time I was rotating, I felt like I was standing on my head, and it was a really interesting sensation.

Kay Hire (seated) throws a ball during a test of sensory-motor response while Dave Williams looks on, STS-90.

No matter what experiment you're doing, you first want to make sure the hardware is functioning normally and that you don't have any failures. There's no playing around at first. It's very serious—following the checklist, making sure everything's working properly. Then once you've finished the protocol, it's time to relax.

I remember after I finished one rotating-chair run, we started saying, "We really should get some public affairs footage of this." So we did a whole series of photo ops with the chair running, taking video as well as slow-motion photographs so you could see the blur of the chair rotating. Then we decided to be very creative and follow David Letterman's example of putting video cameras in unique places. We had the "Whirl-a-Cam," and I sat there and held the video camera against my chest as I spun. It's great footage, because it shows you what it's like spinning in the chair at 45 rpm. I can honestly say I've ridden a record player.

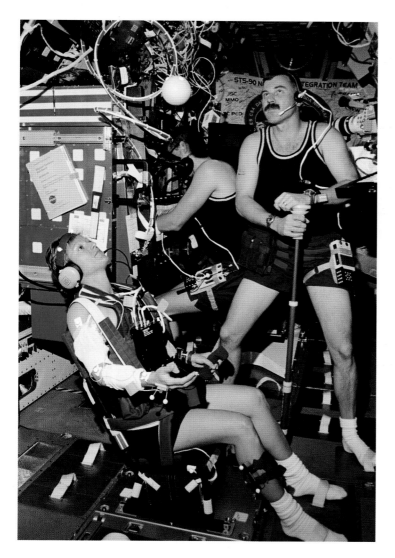

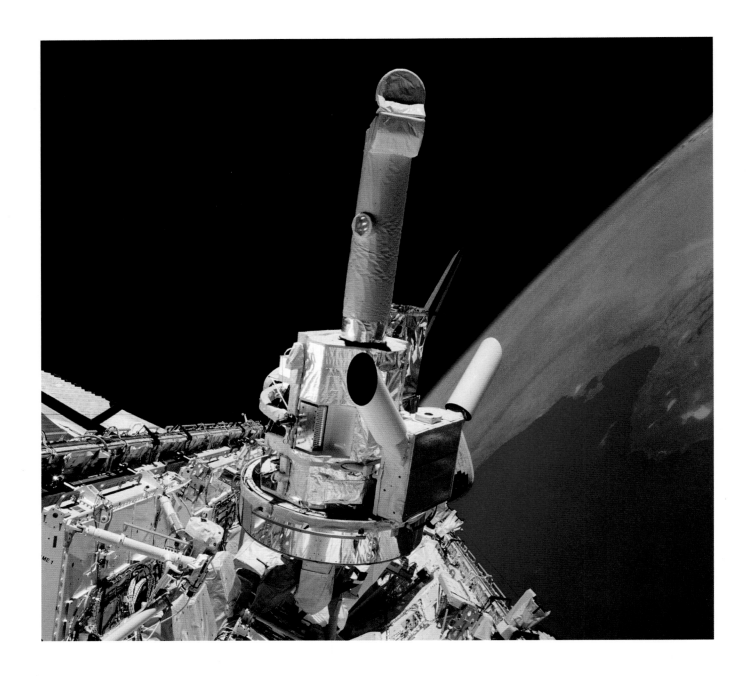

RICK LINNEHAN | **Putting a colander on your head**

A pallet of instruments, including a solar telescope, juts upward from a Spacelab pallet in Challenger's cargo bay, STS-51F.

The payload crew on the STS-90 Neurolab mission performed a sleep study experiment, which involved giving us melatonin to see how it affected our sleep, while our body's electrical impulses were being measured. The investigator who designed the experiment was quoted as saying that the sleep headset we had to wear on our heads caused no problems and no hindrance at all to our sleep. In fact, he said we *enjoyed* sleeping with it, and slept better with it. That made us all laugh, because, in fact, we pretty much *didn't* like putting it on. Picture putting a colander on your head, taping it down with duct tape, then lying down and trying to sleep. It took forever to get on, it was not comfortable, and it did impede our sleep. But that's the nature of the work. To measure things, you have to wear equipment.

TOM HENRICKS | **I can give up a little blood for that**

Carl Walz and Jay Apt work on a biotechnology experiment to investigate development of cartilage cells in microgravity, STS-79.

I'm one of those non-scientist pilots who believes that doing medical experiments in orbit is part of an astronaut's job. If you didn't want to participate in that, why in the world did you ever put in your application? When so few humans go to space, we'd better get as much information as we can out of every person who goes. In my opinion, people who don't want to participate in those experiments picked the wrong profession. But I know there are still some of them in the astronaut corps.

Even if some of the experiments are painful, you get the tradeoff of doing what so many people dream of doing—going to space—and I can give up a little blood for that. As a pilot, I didn't really have it that bad. But the mission specialists on STS-78, who were there to do research, had it the worst. The most painful thing they had to endure was using an electrical charge to contract their calf muscles to their maximum contraction. That's why I'm disappointed when I see astronauts who don't want to participate in minor experiments that cause some discomfort. I saw these guys on STS-78 being so brave, and doing things that were extremely uncomfortable.

Some people when they travel like to bring "home" with them. Others like to experience the new place for what it is. "Surrendering to space" is shuttle veteran Story Musgrave's term for appreciating the strangeness of a shuttle flight. It may be the sudden realization that one is standing on the ceiling. The moments of insight are often random, stolen from the astronauts' busy schedule. They notice something out the window, and are reminded in a flash where they are.

Bob Cenker, a one-time shuttle flier from the early 1980s, remembers watching cloud tops light up in a thunderstorm below: "It was like watching popcorn in a popper. I could almost hear it." Dave Williams recalls listening to Vivaldi while floating in the air, looking out at a sunset in space. "The word 'beauty' just doesn't describe it," he says. Things you could never do on Earth—isn't that, after all, the point of traveling into space?

JIM BUCHLI | **The most beautiful thing I've ever seen**

I really missed the color green. I got so lonesome for the planet that I would sit in a window when I had a break and feel the sun on my face to get a connection back.

— MILLIE HUGHES-FULFORD

We were flying into darkness, passing over Tasmania and heading down toward Antarctica. The southern aurora was just unbelievable. It looked like an octopus sitting over the South Pole, with tentacles of light coming out. The orbiter was flying upside-down with the nose pointing toward the pole, and the tentacles shimmered a fluorescent blue-pink. It was like the whole nose was bathed in aurora—even though we were much higher, you could still see the glow off the front of the nose.

I knew what was coming, because I had seen the same geometry when we passed over the pole the day before. So I went down to the mid-deck and literally grabbed Reinhard Furrer, who was on the other shift. I said, "Reinhard, get up here!" He said, "No, I'm busy, Jim—I've got these things to do." I yanked him off the mid-deck and stuffed him up there in the nose of the vehicle. We're lying upside down, with all the switches and circuit breakers next to our chests, and we're peeking out the front windows, straining to look to the side of the orbiter. For probably ten minutes, we just sat there shoulder to shoulder and watched these shimmering bands coming off the South Pole. The lights were out on the flight deck, so it was dark and quiet.

Pretty soon we came back up over the southern Atlantic. Finally, Reinhard said, "Jim, that was fantastic, that was the most beautiful thing I've ever seen." Then he went back downstairs and went to work. But for that moment, there were just two guys up in this cockpit, experiencing something that—I won't say nobody else has ever seen—but maybe nobody's ever seen that intensely, with that kind of geometry. If I live to be 100 years old, I'll remember it.

Carl Walz aims a camera out the overhead window on Discovery's aft flight deck, STS-51. The orbiter's vertical tail is framed in the aft-facing window in this fish-eye view.

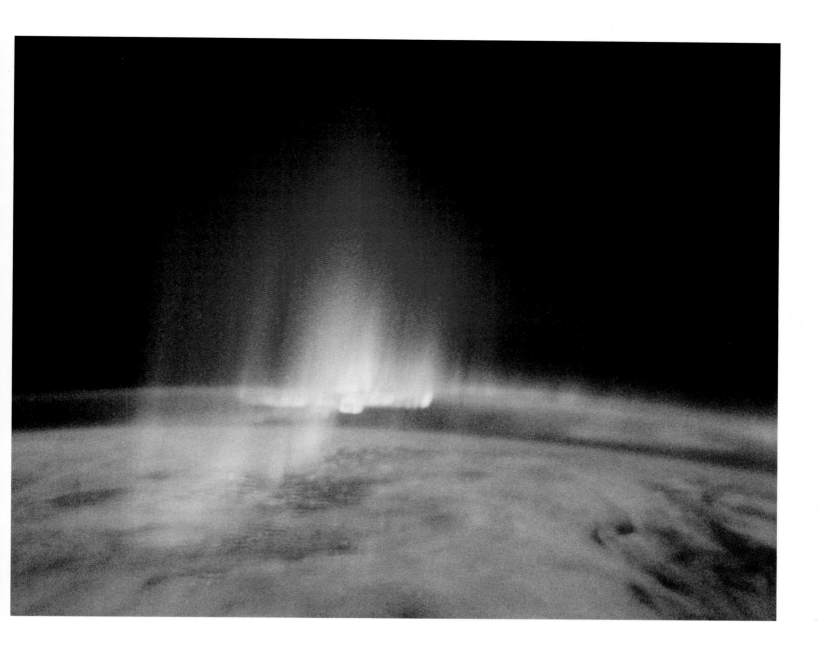

RICK LINNEHAN | **Everything was spinning around something**

The Southern Lights as seen from onboard Discovery, STS-39. Auroras are caused by charged particles streaming in from the sun and interacting with Earth's magnetic field.

When you're up in orbit, you're moving at about 17,500 miles per hour. You can see the curve of Earth below you, and you can see the moon rising and setting. You can see Earth turning from night to day, and you can look up and see the constellations shifting as you're moving around them. I got this overwhelming sensation of rotation, where everything was spinning around something else. It made me realize how insignificant we were in the show, and how unique at the same time. No matter where you go or what you do, you'll never repeat that exact moment or experience again in your lifetime—which makes it all the more important to savor.

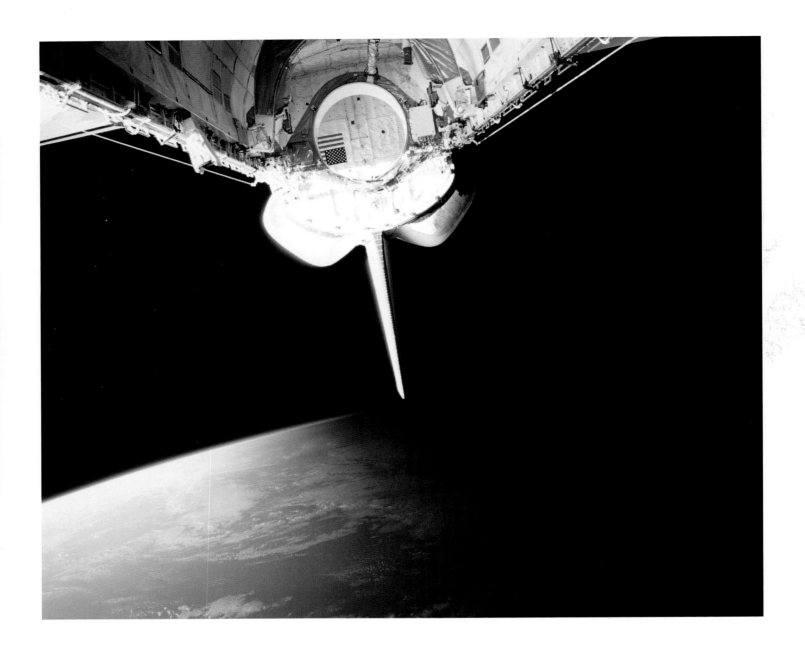

KEN COCKRELL | **You ever flown under the Earth?**

Atlantis's vertical tail points to the dividing line between orbital day and night, called the terminator. The sun "rises" every 90 minutes on the shuttle—the time it takes to circle the Earth.

One day during STS-80 I came up to the flight deck, and Story Musgrave was sort of leaning back with his hands behind his head and his elbows wide out, looking at the Earth. He turned to Tom Jones and said, "Jones, you ever flown under the Earth?" It was at that moment that I floated up from the mid-deck and heard his question. I looked at Story and looked at Tom and thought, "I'm out of here. There's something weird going on up here, and I don't want any part of it." But I said, "Story, what are you talking about, 'fly under the Earth?' " He says, "Well, you see we've got our payload bay toward the Earth, so we're flying around sort of upside down. If you position your body to face away from the windows, and put your arms out as if you were flying with the Earth above your head, you feel like you're skimming along underneath the Earth." And it was true. It really is a unique feeling.

STORY MUSGRAVE | **Falling through the dark**

Story Musgrave strikes a uniquely zero-g pose, STS-51F. Right: Jeff Hoffman plays with a glob of water, STS-75. In the absence of gravity, surface tension makes liquids ball up.

Overleaf: The International Space Station's Destiny science laboratory is reflected in Scott Parazynski's helmet visor during a spacewalk, STS-100.

Weightlessness is like being in an elevator and cutting the cable, and you and the elevator fall together. After my first flight I slept floating, and I wondered why, when you're floating there in the dark with your eyes closed, you don't sense that you are falling. How come you don't sense the reality? Sometimes you have to play mind games to perceive it the way it really is. So I closed my eyes and imagined that I was on a familiar cliff in Colorado. Then I stepped off. Now I'm falling through the dark, which scared me at first, and I interrupted it. "Hey, come on, Story. You can do that." I set to, and did it again. After I had done it enough times I was able to provoke the feeling any time I wanted, which is a most delicious thing.

I wanted to fall toward the Earth. I thought that would be an exciting thing to do. But I could never provoke that feeling. The "fall" was directionless, which was amazing to me. But of course, it's natural. None of your sensors tell you in what direction you're falling, because you're floating nowhere. You have to dig in to your perceptual system. You really have to be sensitive to what is coming to consciousness. Once I got good at it, I would turn all the lights off on the flight deck during a pass over the night side of Earth, and I'd have nothing but the stars out there and the city lights. You're falling through the stars, a really neat thing to do.

KATHY SULLIVAN | **Hopping over a fence**

The aurora reminded me of a huge, richly brocaded theater curtain. It had deep folds, and it looked like a little breeze was blowing, because the folds were slowly changing shape. Except this curtain wasn't hanging down from a bar. It was hung from the bottom of the upper atmosphere, and it went up to never never land. It has the very distinctive green color of the two spectral bands associated with oxygen, so the science part of your brain is going "Chemical fingerprints! This is so way cool!"

I remember during STS-45 looking out through the shuttle's forward windows along our direction of travel. There was one faint bit of an aurora band crossing our path, and I watched as we went over it, like hopping over a fence. I watched this little thin curtain come up, and for a moment it was like looking down the edge of a knife or at a piece of paper edge-on. Even though this isn't physically true, I felt like I was sighting down one of the Earth's magnetic field lines at this one-electron-thick sheet of aurora. Then the little pencil trace of luminescence was gone, and it was like looking at a sheet again.

DAN BARRY | **The fire of monsters**

Kathy Sullivan on her first spaceflight, STS-41G. Opposite: With the southern lights shining below, a faint glow is visible around the orbiter—caused by charged oxygen atoms in the thin, but still existent, atmosphere at shuttle altitudes.

I am often asked what is the most impressive sight I have seen from space. On STS-96, passing over the nightside of Earth just before bedtime, Rick Husband called me urgently to *Discovery's* flight deck. I floated up through the hatch, and he pulled me over to the forward windows without saying a word. Stretched out below us for a thousand miles was a thick, shimmering, undulating, green snake. We were between Tierra del Fuego and Antarctica, the southernmost point of our orbit. The Aurora Australis—the Southern Lights—was unearthly, a stark counterpoint to the warm gemstone colors of Earth during the day. It looked like a neon sign garishly slapped onto the blackness of night.

During our postflight travels we stopped in Iqaluit, Nunavut, the capital of a new north Canadian province. The visit included meeting the elders of the Inuit tribe, and we asked them to tell us stories from their youth about the Northern Lights. One old woman told us she had learned to run fast because her mother said the Northern Lights were the fire of monsters who would eat her if she did not get home before dark. She was always fast enough to get home before being eaten. We told her of our experience seeing the Southern Lights, and heartily agreed that monsters must live among them.

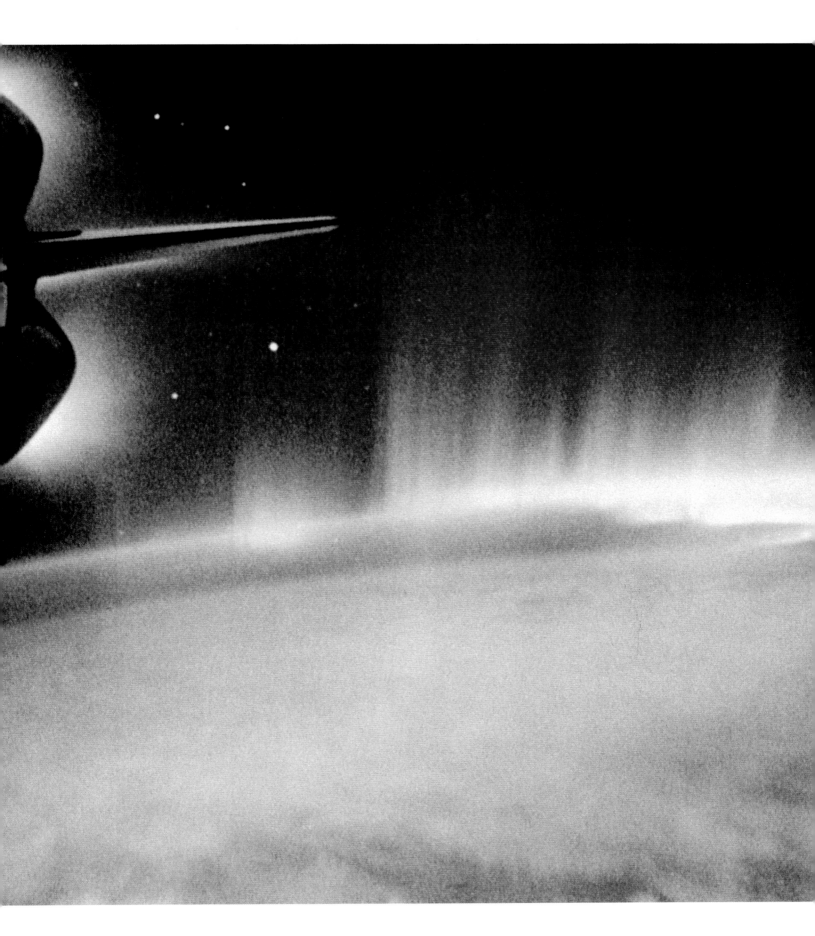

MARIO RUNCO | **The Hair Memo**

The word had gotten around that our STS-44 crew was a little playful and somewhat irreverent—not what one would expect from a crew with only two veterans and four rookies. Not long before our launch in 1991, a memo had been circulated around the astronaut office after a great picture was taken in space of Marsha Ivins with her long hair extended and floating. The infamous Astronaut Office Hair Memo that followed said in so many words that for safety purposes, you shouldn't do that, because there are many snag points on the shuttle, and you could get your hair caught. That was legitimate, but of course a memo like that gets blown out of proportion. In the weeks that followed there were subsequent reminders about all sorts of things, saying "You shouldn't do this and you can't do that." I guess our crew's reputation preceded us, because the rumor went around that for our launch countdown test, which took place a few weeks before our November 24 launch, we were

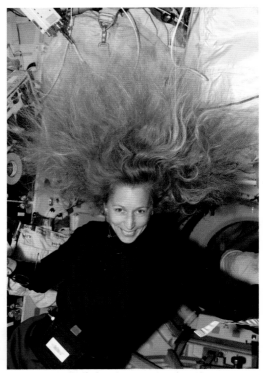

going to walk out in Halloween masks. Inevitably, the word came down from on high to our mission commander, Fred Gregory: No masks!

We never really had a plan to walk out in masks, but being good little campers, we decided, okay, no masks, so we'll go out with no hair instead. Fellow rookie Jim Voss and I bought some of those rubber latex things you put on to make yourself look like a skinhead. Of course, Story Musgrave really is bald. So all of us got the same aviator style sunglasses that Story normally wears, and we got Story Musgrave nametags. When we walked out, there were six Story Musgraves. Of course, many pictures were taken, and one of them made its way onto the front page of *Florida Today*—so much for no masks.

On my second flight in 1993, STS-54, we walked out for our practice countdown in those gag ball caps with long ponytails dangling from the back. It was only when we turned the corner to board the astrobus that everybody saw the ponytails, resulting in a big round of applause and roars of laughter from the crowd. The curious thing is that unlike Fred Gregory, STS-54 Commander John Casper was not known for being a cut-up—and it was his idea!

RHEA SEDDON | **Whoa, what was that?**

Aurora photographed from onboard Endeavour, STS-47. Opposite: Bad hair days in space. From top: Dan Brandenstein, STS-49; Marsha Ivins, STS-98; Judy Resnik, STS-41D. Opposite right: The STS-44 crew heads for a practice countdown having solved the hair problem.

During my first flight we were on the dark side of the Earth, looking down at the lights of cities. All of a sudden this bright light whizzed past below us—that is, between us and the ground. And I said, "Whoa, what was *that?*" My crewmate, who'd flown before, said, "That's a falling star." It was one of those, "Oh, wow!" realizations. Of course that's where they *would* be—the Earth's atmosphere was below us, so rather than looking up to see meteorites, you looked down. But it was something I really hadn't considered, and it surprised me.

JIM BUCHLI | **It's just radiation**

The first night in orbit during mission 51-C, I crawled into my sleeping bag and put my headset on. Everybody carries up their own music—you can take up to six tapes—and I had a pretty eclectic range of stuff. I'm listening to music in my sleeping bag, floating on the mid-deck, and I start seeing these bright flashes going through my closed eyes. It's like a white flash, even though my eyes are shut. I was worried that something was affecting my eyesight, which nobody had ever told me about.

The next morning I told Ken Mattingly about it, and he starts laughing. He had been an astronaut since the Apollo days, and was the commander on this flight. He said, "What's happening is that we're high enough up that you're getting high-speed particles coming through the vehicle. It's radiation. It's hitting your optic nerve and it's triggering a response." Of course, he had seen it before because he had gone to the moon. I never saw it again on any of my flights. That was the only time, on the first night of my first flight.

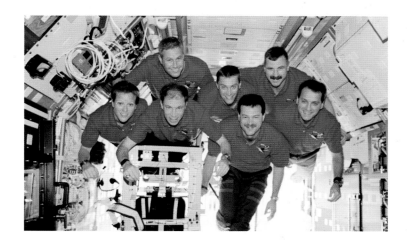

JIM NEWMAN | Shadows that stretch hundreds of miles

The crew of STS-90 pauses for a group float inside the Spacelab research module. Bottom row, from left: Kay Hire, Rick Searfoss, Scott Altman, Rick Linnehan. Top: Jay Buckey, Jim Pawelczyk, Dave Williams. Opposite: Cloud shadows over the Arabian Sea, STS-92.

There are a number of things they don't tell you about spaceflight. Sure, you hear that the atmosphere is "a thin blue line" during the days. But at night, the atmosphere glimmers with a faint glow and is three times as high. The very top of the atmosphere glows the brightest. During the day, some of the atoms and molecules in the air store light from the sun in metastable states, and the photons come back out hours later. This is why clear nights in the mountains are so bright, and only the cloudy nights are truly dark. I had learned about "airglow" in grad school, but to see it so clearly! And the shadows are remarkable. Imagine looking down at the terminator, the line that separates night from day on Earth. Some clouds stick way up above the others, and they can cast shadows that stretch hundreds of miles, all the way to the terminator. Wonderful!

DAVE WOLF | You have to quit looking to find something

On Earth, if I lay a wrench on a table, I am quite easily able to look back and see it. In space, if I let this wrench go, it floats and changes orientation and position. It is uncanny how I am literally unable to see it when I look back. It's as if my mind has evolved filters to block images that are probably not what I am looking for. In space, this hypothesized filter stubbornly conceals the most familiar of objects. I just don't expect the pliers to be pointing straight at me, at eye level, one foot in front of my face.

Interestingly, the following is what usually happens. As soon as I give up looking (turn off my pliers recognition filter) and turn away, I happen to notice a floating object. Take a closer look and there's the pliers. It really works. In this crazy place sometimes you have to quit looking in order to find something. I really think there is something deeper in all of this. It really should come as no surprise that manipulating gravity would help us understand our own bodies.

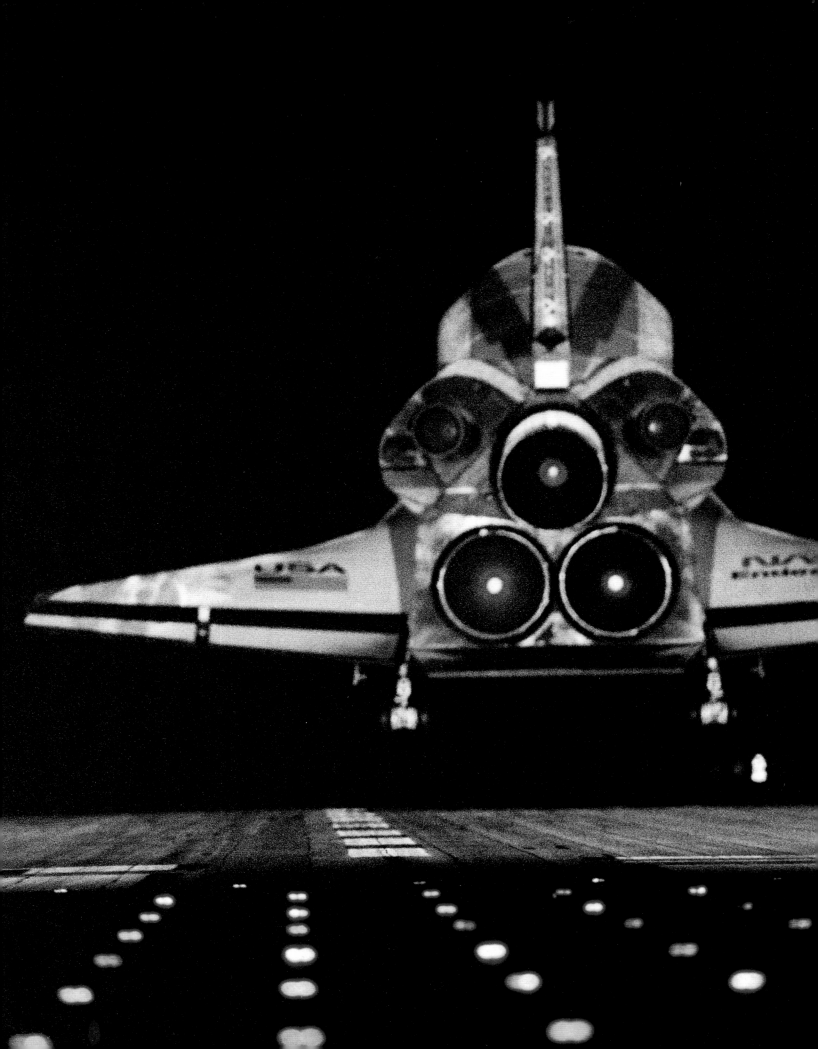

The return to Earth takes only an hour. It begins with an upside-down, backward-facing engine burn to drop the vehicle out of its orbit. Then, with computer software doing the driving, the shuttle descends through the thin upper atmosphere, bleeding off energy with slow, banking s-turns, like a skier slaloming downhill.

The commander takes over for the landing, but the shuttle is an unpowered glider, and there is no way to turn around and try again if it were to miss the runway. Most of the astronauts are along for the ride during that last hour of the mission. Not so the person in the lefthand front seat. Says two-time shuttle commander Steve Nagel, "There's high anxiety in the landing. The rest of the crew can relax after their spacewalks or whatever are done, but the commander worries all the way until you're down."

Endeavour *comes in for a night landing in* Florida, STS-72.

Jan Davis helps STS-85 crewmate Kent Rominger into his Launch and Entry Suit. "Deorbit prep" is a busy time for the crew, as everything has to be stowed for landing.

TOM HENRICKS | **The wrong underwear**

We try to organize everything the night before landing, including our clothes, so that in the morning everybody can just jump into their long john underwear—the cooling garment we wear under our orange flight suits. On STS-78, my pilot Kevin Kregel and I had already gotten dressed in our long johns, and we were up on the flight deck preparing the vehicle for entry. During one of the breaks in the checklist, Kevin turned to me and said, "Has anybody mentioned that your arms get longer in orbit?" It's true that your spine expands and people get taller. I looked over at him, and his long john arms were three inches shorter than they should have been. We decided we'd just tell the docs when we get back—maybe your arms do get longer.

About an hour later, Mary Ellen Weber, who's petite, comes up to the flight deck. She's very concerned that she cannot find her cooling garment. So Kevin, being a helpful guy, offers to help find it. But he's thinking, "There are only five of us on board—how can you lose one?" He goes digging around, and sure enough, finds out that he has on her underwear.

We got waved off from landing that day, so we had to stay in orbit another day. And during the private medical conference with the ground, I had to tell the doctor that we'd discovered another side effect from space flight—a tendency to cross dress.

STORY MUSGRAVE | **An incredible painting**

During entry on STS-80 I took the opportunity to video all the flame and fire that goes on outside the overhead window. I was able to observe it from Mach 25 all the way to the ground, which no one had ever done before. The video is lousy, because I'm standing up with 80 pounds of gear on—helmet, gloves, parachute and so on— ready for bailout. I'm taking all the g's after an 18-day shuttle flight. I have no cooling in my suit, because I'm supposed to be downstairs plugged in to the cooling lines instead of looking out the windows up on the flight deck. So the video is a mess. But for whatever it's worth, I have it.

A pink glow is seen out the flight deck window during the STS-5 entry—caused by interaction of the speeding orbiter with the thin upper atmosphere. The charged air particles also "black out" radio communications with the ground for a short period.

What you see out the overhead window seems like disorganized fire, but it's not when you look at the way the shock waves organize the flame. There is so much flame you cannot believe you are not consumed instantly, and the shock waves organize it into an incredible painting. Then the jets fire and it dissolves the whole structure.

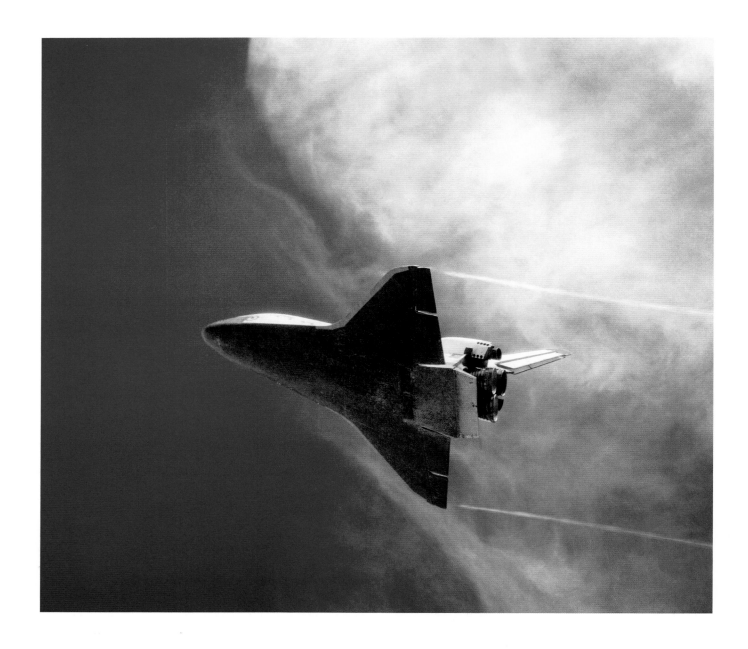

MIKE McCULLEY | **Like being inside a neon light bulb**

Columbia returns to Edwards Air Force Base in California, STS-2. Although Edwards is still used as a backup, the Kennedy Space Center in Florida is now the primary landing site, which saves the cost of ferrying the orbiter across the country after each mission.

When you hit the top of the atmosphere you begin to really slow down, and that's when the heat rises and you ionize the atmosphere. It's like being inside a neon light bulb, with a pinkish-purplish pulsing light. It's really sensational. I remember thinking, no wonder the guys in the early Mercury days had described it in emotional voices. If you didn't expect it—of course we had been briefed on it—it was easy to understand why you'd be surprised.

SCOTT KELLY | **Too low to make Florida**

It takes a long time, over an hour, from the time you do your deorbit engine burn in space until you land in Florida. So it's a matter of being patient and waiting for things to happen. When we left orbit we were at 320 nautical miles altitude, going Mach 25, a little over 17,000 miles per hour, and we burned the orbiter's engines to slow down so we could enter the atmosphere. We did that somewhere over the Indian Ocean, in the dark. And when the sun rose, we were suddenly down to 40 or 50 nautical miles, but still going Mach 25.

When we passed over Baja, California, and then looked down on the NASA hangars that house our Shuttle Training Aircraft in El Paso, Texas, Curt Brown, the commander, joked that we were too low to make it to Florida. But then I realized we were still going Mach 20 and said, "Yeah, but we got a lot of smack," a military term for high airspeed. At that point I started joking that maybe we were going to miss Florida altogether, because now we were going too fast! But the orbiter slows down as it hits the atmosphere, and the whole thing is very controlled and very precise. It works great.

Lining up for the runway, STS-51D. Visible out the right hand window is the giant Vehicle Assembly Building where the orbiter is mated to its tank and booster rockets before launch.

Overleaf: Early morning landing, STS-80.

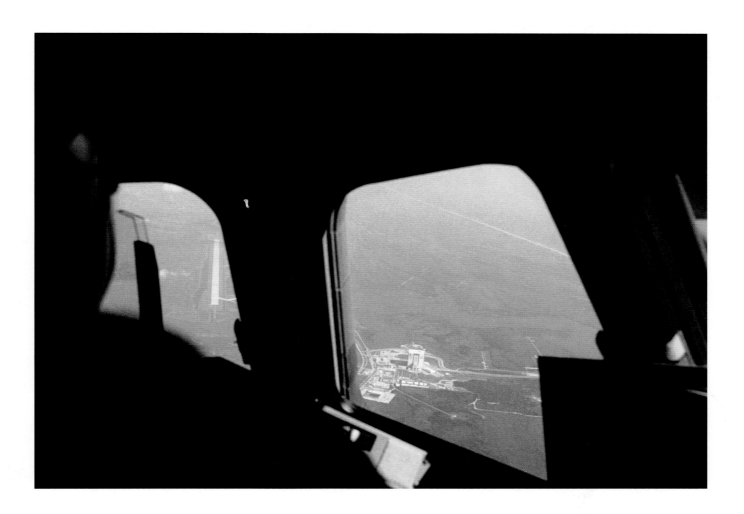

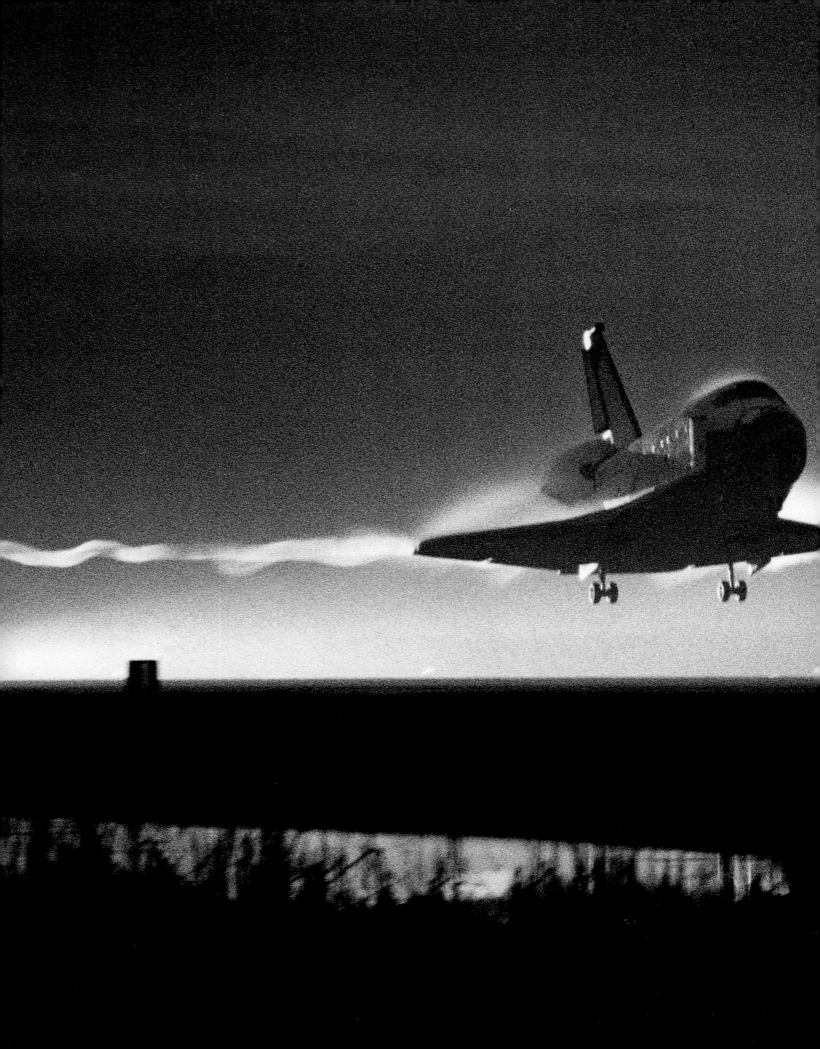

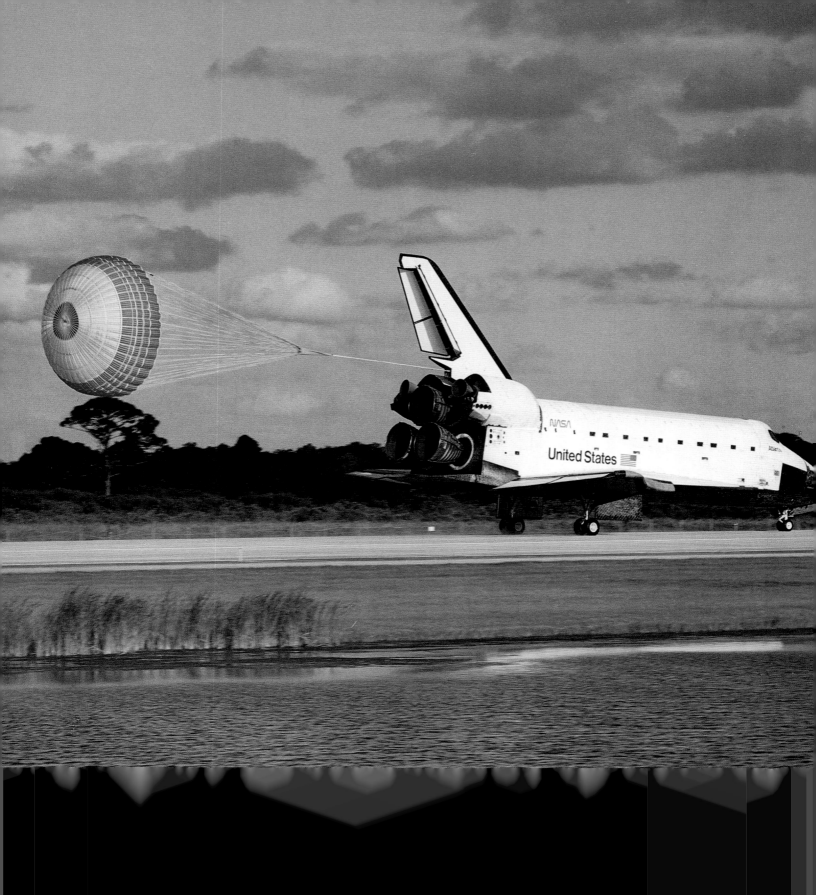

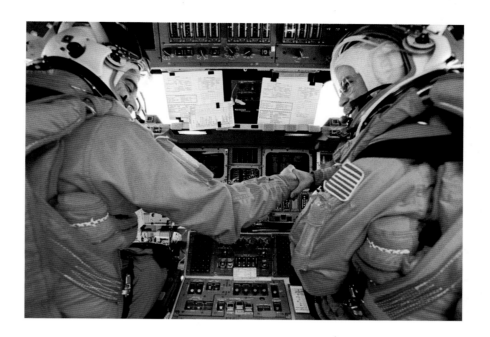

BOB CABANA | **Nailing it**

I remember during my first landing how heavy I felt, just the helmet and suit and everything, on returning to normal gravity. On my third flight, when I was commander for the first time, I didn't feel a thing, the adrenaline was pumping so hard. I mean here I am, landing this two billion-dollar spaceship. You can't screw up.

You talk about analyzing things down to a gnat's hair. That's how your landings get looked at when you get back on the ground. The engineers tear it apart. Before launch I told Al Hochstein, the guy in charge of that analysis, "Al, I'm gonna nail it, okay?" With a heavyweight orbiter like we had on STS-65, we normally land at 205 knots. But I said I'm gonna land at 200 knots, because slow is better than fast. And I landed at 201 knots. When Al came back with the debrief charts after the mission, he had this nail with a hammer coming down on top of it.

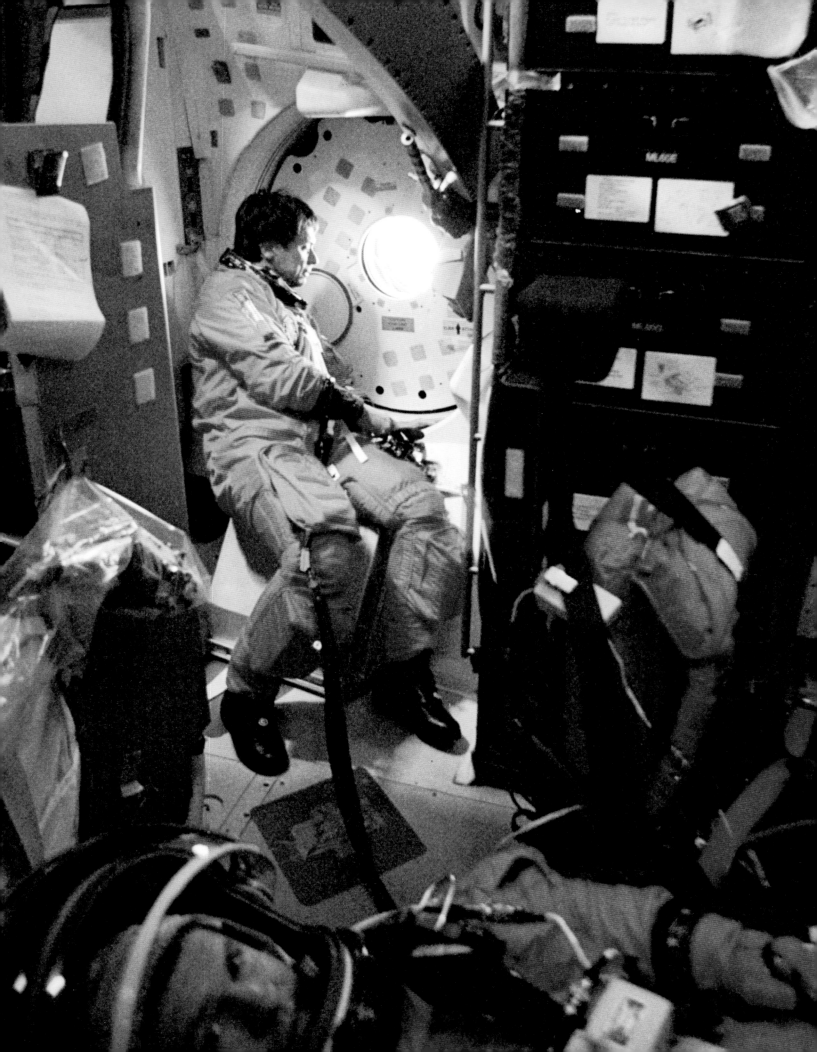

PIERRE THUOT | **They thought the smell was us**

The rinseless soap and rinseless shampoo we use on the shuttle actually does a super job of getting you clean. Each of us took a bath everyday in orbit, at least I did. So I didn't notice any odors or anything when we were in space. But when we landed at Edwards Air Force Base in California, the NASA guys came up to open the hatch. They equalize the pressure first, and when they do that, instead of the air just equalizing, it rushes out. It's sucking all this smelly air out of the wet trash area underneath the deck, and it got really ripe. It smelled like you were standing in a garbage pile. I'm sure they thought it was us, but it was really the garbage.

Opposite: Franklin Chang-Diaz looks out a small hatch window shortly after the STS-91 landing, while Andy Thomas reclines on the mid-deck, having just spent five months weightless onboard Mir. Right: Flight doctors greet the STS-47 crew after hatch opening.

When we came back to Earth, I felt so heavy it was like we had landed on Jupiter. The shuttle sits on the runway at an angle, which is something I had forgotten. The nose is down, so you're at a slight angle, which made it even harder to stand up. When I tried to get up the first time, I didn't make it. Boom, back in my chair. Some people even faint when they return.

They transferred us from the shuttle in one of these people movers, which had a long flight of steps down to the ground. Your families are at the bottom of the steps. I could see my husband, my daughter and her new husband, and I started walking down. And my little prayer was, "Please don't let me distinguish myself in front of all these people. Please let me make it down the steps." Because your equilibrium is totally gone. I was holding onto the rail, trying to move as quickly as possible and not walk like a little old lady. The next thing I saw was my daughter running toward me. I thought, "She's going to knock me over because she's coming at such a high velocity." Of course, she wouldn't know what was going on with me. So when she got to me, I just hugged her and whispered in her ear, "Help hold me up."

STS-41G was the shuttle's second Florida landing, but the first for Commander Bob Crippen. Following him down the stairs are Jon McBride, Dave Leestma, Kathy Sullivan, Sally Ride, Marc Garneau, and Paul Scully-Power.

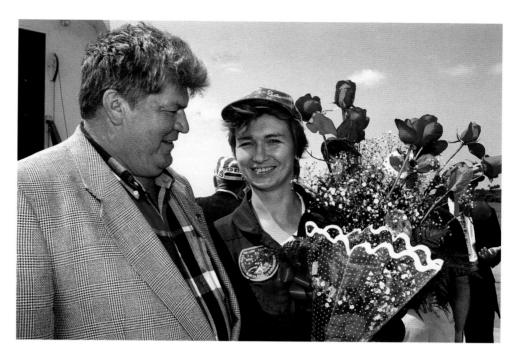

TOM HENRICKS | **No welcome home**

Left: Shortly after becoming the first woman to land the space shuttle, Eileen Collins and daughter head back home to Houston. Right: Russian Cosmonaut Elena Kondakova is greeted by husband Valery Ryumin following her STS-84 flight. Ryumin flew a year later on STS-91.

On STS-44, we had to come home three days early due to a failure in one of the Inertial Measurement Units used for navigation. The flight rules dictated that we abort the mission and land on the dry lakebed at Edwards Air Force Base in California instead of our usual landing site in Florida. The lakebed has lots of runways in the event that our navigation systems degraded further. The down side of coming home early to isolated Edwards was that there was no welcoming party. We landed on a Sunday with less than a day's notice. It would have been spectacular to watch, because we landed on lakebed runway 05, which meant we came right over the top of the buildings. Someone in the control tower could have looked in the shuttle windows as we went by, and if you had been on the ramp where NASA keeps its planes, you practically could have jumped up and touched our wheels.

The bad news was that nobody was there to see all that. Due to the short notice, the usual welcome back to Earth could not be arranged. There we were, we'd had this spectacular week-long space experience and survived a mission abort, but there were no family or friends to greet us. We were put in vans and driven 30 miles out to the middle of nowhere, and put up overnight at a dude ranch that had no phones. We had to take turns on the pay phone, telling everybody what a great experience it had been.

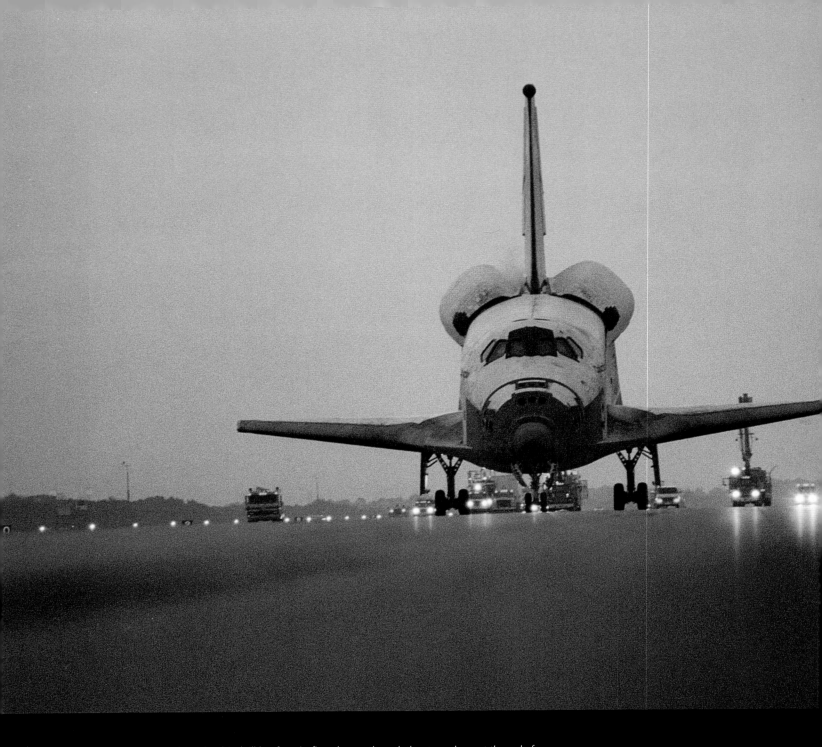

Crews arrive to "safe" Columbia, *still hot from its fiery descent through the atmosphere, at the end of the STS-80 mission. Opposite: STS-77 Pilot Curt Brown, back on the ground after 10 days in space.*

JOE EDWARDS | **All over with**

After we landed, we went back to crew quarters so the flight surgeons could get some bodily fluid samples for research purposes. I was talking to the flight surgeon in my flight suit and tennis shoes. He asked if I wanted some lemonade, and they brought me a little Dixie cup. I'm sitting in a chair, my forearms on my knees, and I reached down to take my shoes off. But before I did, I released my cup without giving it a thought, because I expected it to float. And of course, as soon as I did, it fell right to the floor. We both just sat there and laughed, and I thought to myself, "Well, that's all over with now."

I'm an astronomer, but in my opinion we go into space

for a lot of reasons other than to do astronomy.

We go into space because of the human spirit.

We go into space because it's good for us.

— LOREN ACTON

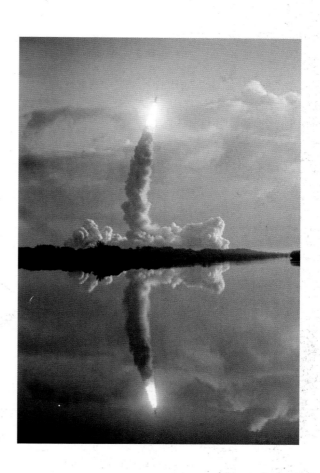

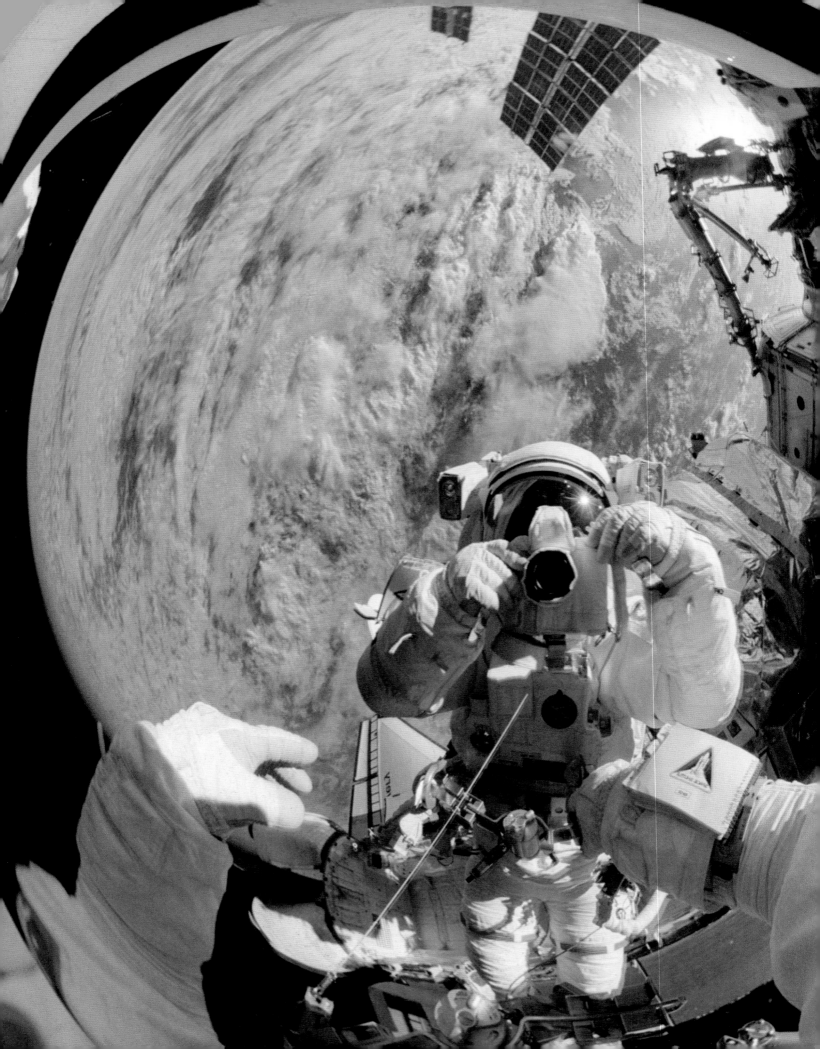

Why fly the space shuttle? The answers are as varied as the people who fly it. For most, it's a matter of deep personal fulfillment, the apex of a pilot's or scientist's career. Most also see it as making a contribution to an important national program. Finally, there's the futuristic sense that one is participating in a grand adventure, the beginning of humanity's move beyond its planet of origin.

The answer to "Why do it?" can be personal or political, economic or technical, practical or spiritual. It's a complex question, one the nation continues to debate even as the space shuttle moves into its third decade of operation.

Jeff Wisoff is reflected in Michael Lopez-Alegria's visor during an STS-92 spacewalk.

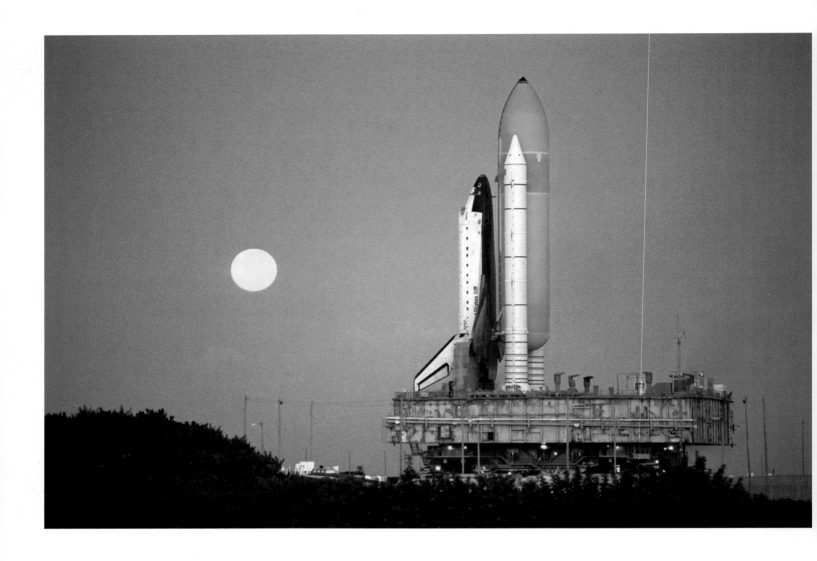

ANDY ALLEN | **We are taking baby steps**

Atlantis *rolls out to the pad for the STS-86 mission in August 1997. The space shuttle launched 103 times in its first 20 years.*

Atlantis *rolls out to the pad for the STS-86 mission in August 1997. The space shuttle launched 103 times in its first 20 years.*

I know spaceflight is a risk, and I know I may not come back from a flight. But for whatever reason, I was chosen to do this job. And even though there are lots of people who could take my place, there are lots of people who *can't* take my place. I think that if you've got the skills and the talent and were picked to perform the task, you've got to go perform the task. And the risk of losing your life is outweighed by what space exploration is going to bring, maybe not directly to your family, but to the world.

I can't think of a time when we as a society haven't benefited from exploration. Certain individuals have perished along the way and made the ultimate sacrifice, but society as a whole has gained from it. It's not an impact you feel in 24 hours, but in ten, fifteen, twenty years. We are taking baby steps. Even though some people think we aren't reaching as far as we did 30 years ago when we went to the moon, we know a whole lot more about space now than we did when we went to the moon. We know a whole lot more about space vehicles. We know a whole lot more about human physiology in space. And all that is going to help us continue to explore if we can budget for it. The hardest part is justifying a long-term goal in a shortsighted world.

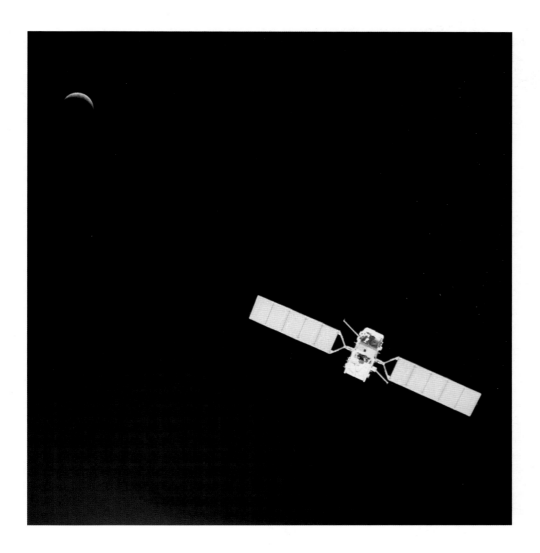

The EURECA satellite orbits near Atlantis with the moon in the background, STS-46. Below: Spacewalk outside the Hubble Space Telescope, STS-103.

PINKY NELSON | **Experience you can't get any other way**

We can't say we contributed a lot to science as the result of the shuttle program. A lot of the science we did on the shuttle was second tier. It's not going to win any Nobel Prizes. Maybe someday it will, though, so I think you have to keep the capability just in case.

But in terms of technology, engineering, learning how to work and live in space, the shuttle's contribution has been incomparable. It showed we can build a spacecraft that we can fly over and over and over again. Who would have ever thought that these old things would keep going? They have it down to an art. The experience that we've gained over a hundred and some launches and thousands of hours of flying in space, what we've learned about repairing satellites and building space stations—it's experience you can't get any other way.

The shuttle has been an incredible workhorse. It's like the DC-2; the next one will be even better. I was proud to be a part of it. I think it's time to build the next generation.

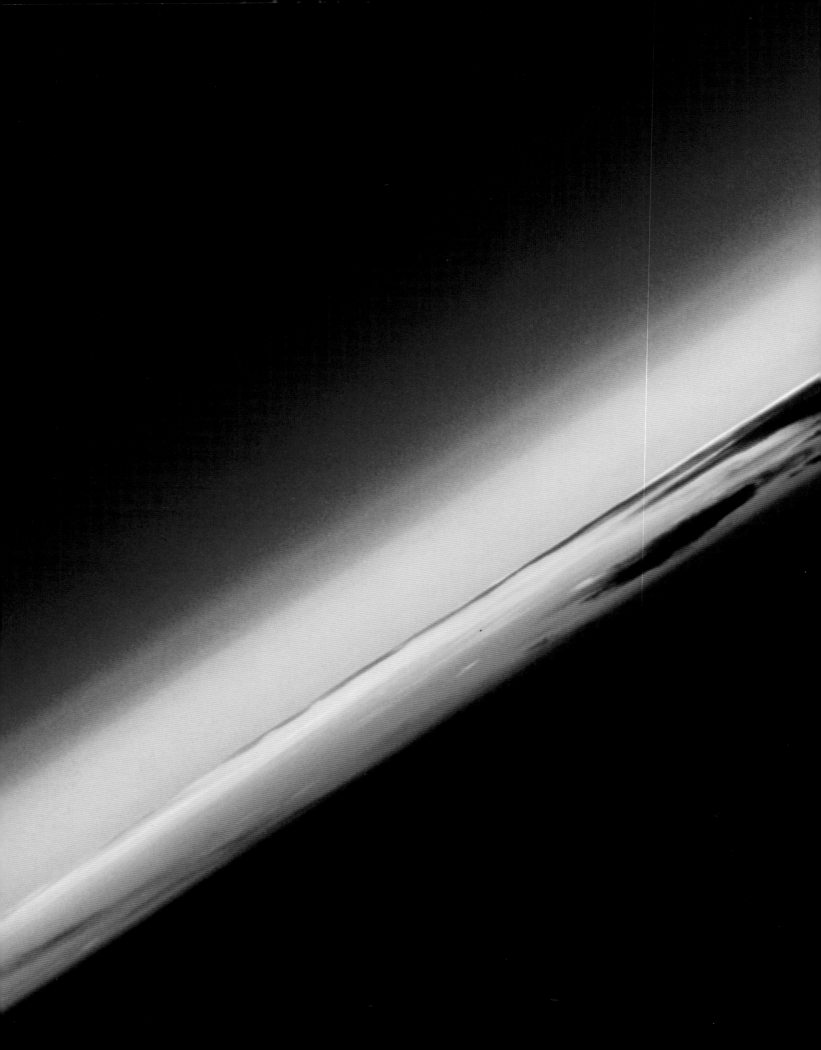

Opposite: Sunset from 200 miles up.

Below: Message posted on a spaceship.

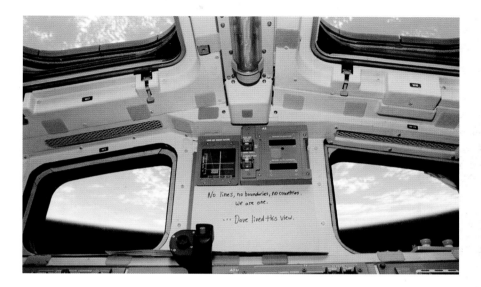

No lines, no boundaries, no countries.
We are one.

... Dave lived this view.

BILL NELSON | **The horse we have to ride now**

The character of the American people is to be explorers, adventurers. We used to go westward. Now we're going upward or we're going inward. The space shuttle is one component of that vision, the horse we have to ride right now. But there will be other horses in the future.

JAKE GARN | **Perspective**

I was not prepared for my initial view of Earth from space. The first time I looked out at this magnificent planet, I thought my heart and lungs had stopped functioning. The view was so far beyond anything I had ever imagined. There is no doubt that the perspective of seeing the entire natural environment, all at once, changed my life. To put it bluntly, I am a nicer person now. I am more considerate. I am more willing to work with people. I am softer in my leadership and how I try to achieve things. Spaceflight had a very profound effect on my life. It made me appreciate how we should treat one another as God's children, regardless of our differences. I hope in the future that many more human beings have the opportunity to share the experience of seeing our planet from space. I believe we will ultimately find solutions to many of our earthly problems from this frontier.

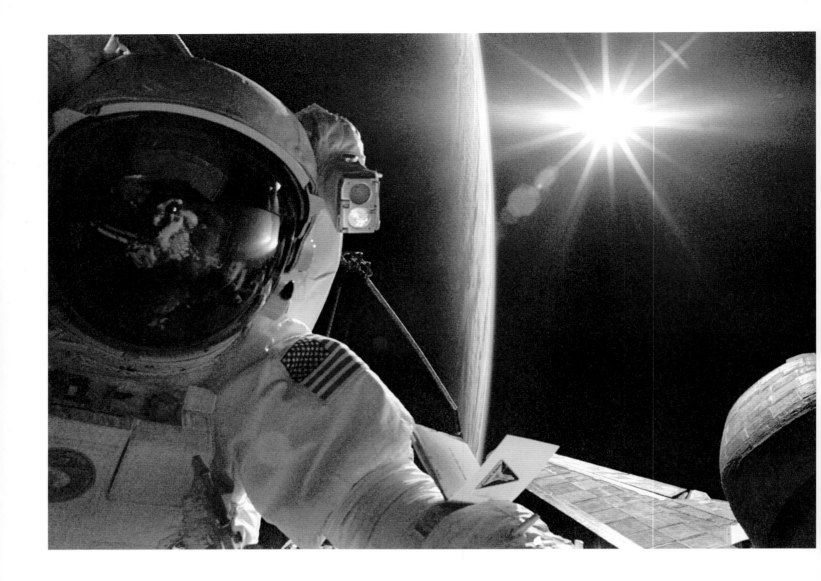

JOE EDWARDS | **Satisfaction**

Joe Tanner is backdropped against Earth in this photo shot by fellow STS-82 spacewalker Greg Harbaugh.

I've had a lot of people say to me they can't wait until tourists can go into space. And I think that would be a really interesting experience. But there is no way they'll ever come back with the satisfaction that the astronauts do. Being involved in something that requires so many people, that is so difficult to do well, and that requires such meticulous attention to detail, gives a satisfaction you'll never duplicate as a tourist just floating around up there.

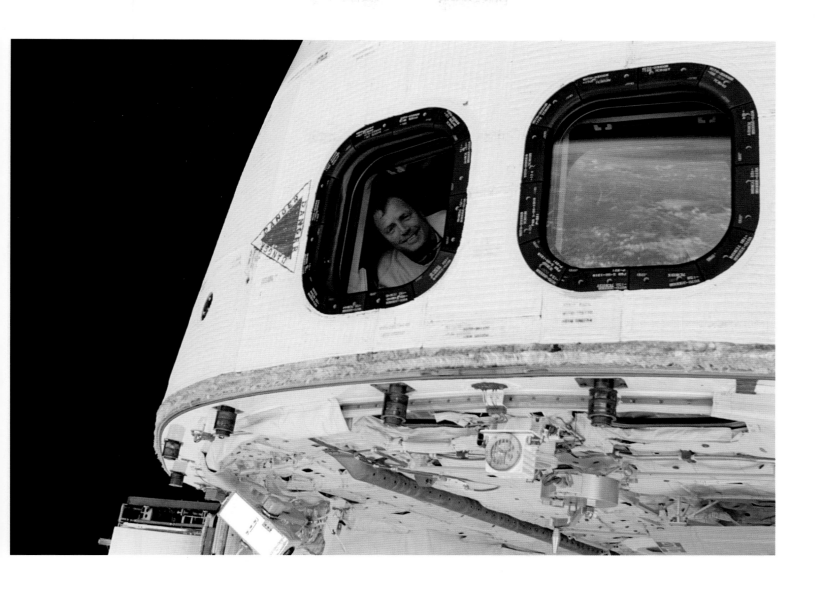

JERRY LINENGER | **Granddaddy was out there colonizing space**

Dave Walker looks out one of Endeavour's *overhead windows, with Earth reflected in the other, STS-69.*

I think each of the astronauts has the feeling that we're just playing a minor role. But when you add up what all the individuals are doing, we're taking big steps. Someday I'll have grandkids on my lap, and I'll tell them, "Back at the turn of the century, your granddaddy was out there colonizing space." I was out there at the leading edge when we were just learning how to really live in space. I was one of the fortunate people who did the transition from Earthling to space man. And in this era we've proven that human beings can live out there for long periods, and that we adapt very nicely.

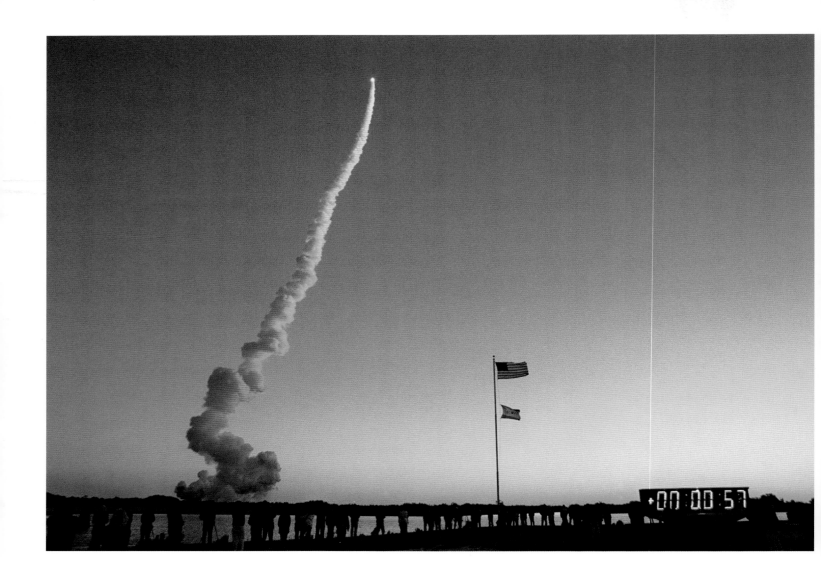

SUSAN HELMS | **The real deal is after we dock**

My perspective on the shuttle changed when I was training to live on the space station. It used to be that launching and flying on the shuttle was the big deal, but now it's just like a public transportation system to get me to the *real* big deal, which is establishing a human outpost for continuous living in space. The real deal is after we dock.

JOE EDWARDS | **We were just born too early**

Opposite: Discovery *rises into the sky, STS-102. Above: Japanese mission specialist Takao Doi made his first spaceflight on STS-87. Above right: Thumbs up, STS-92.*

I would kill to be part of a mission to Mars. I'd still be at NASA if they were going back to the moon or going to Mars in a timeframe that would allow me to be part of it. But I was born a little bit late for Apollo and a little bit early, unfortunately, to make it to Mars.

After Alan Shepard's memorial service in 1998, all the Gemini and Apollo guys were standing around talking at the reception, and the shuttle guys were in another group. I was saying to the shuttle guys, "You know, we were all born too late. We missed the big air war in World War II, we missed Korea and Vietnam. We missed Apollo."

I hadn't even finished that thought when Jim Lovell, who'd flown on Apollo 13, walks up. He says, "Hey, I just wanted to stop by and see you guys. I was just over there with Neil and Buzz and Gene, and we were talking about how we were all born too early." We asked, "What do you mean?" He said, "Well, you guys get the opportunity to go up to a space station. You get to fly the only reusable spacecraft that's ever been built, and you get to do all of these difficult and challenging things. We were just born too early. All we ever got to do was Apollo."

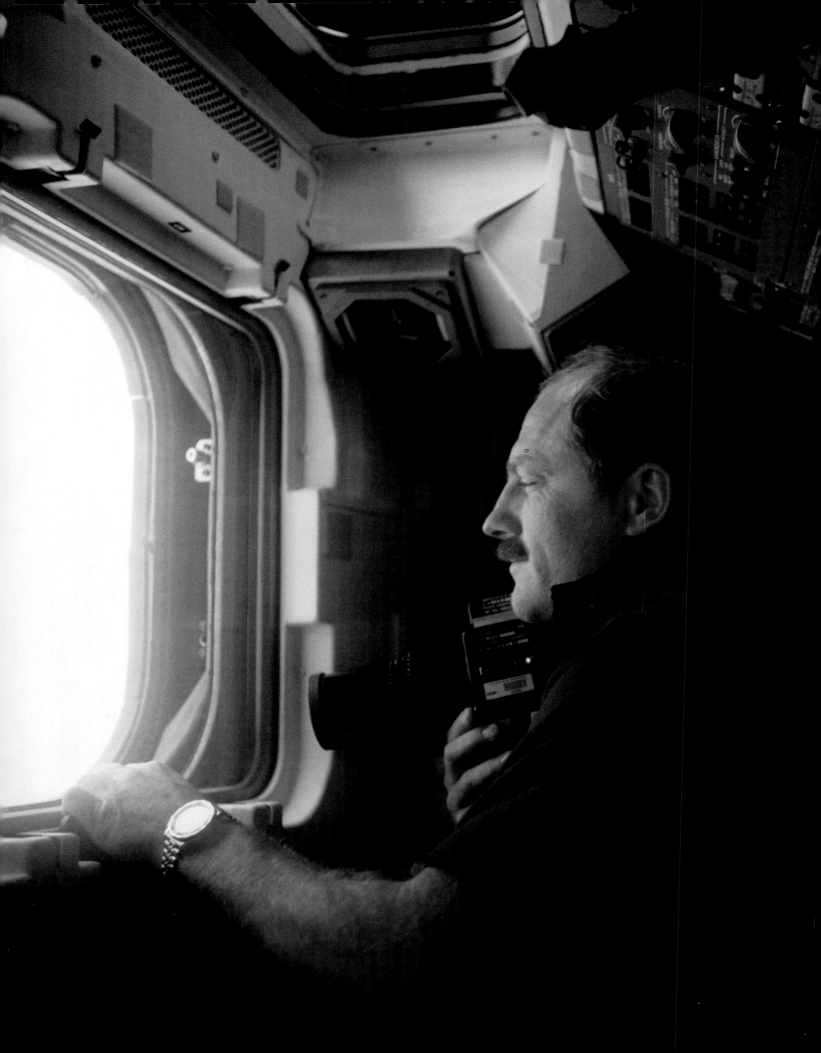

BOB CABANA | **Plant a memory in your brain**

I always tell first-time fliers: You have to appreciate where you are, what a unique opportunity it is, and how fortunate you are to have it. Experience it as much as you can, because you may never get the chance to do it again. Make a memory somewhere during the mission, put your nose up to a window and look out and make a memory. And don't take a picture of it, because you would be disappointed when you get home. Plant it in your brain and don't ever let it go, and you'll have it with you always, and nobody can take it from you.

Rick Hauck during STS-51A, the second of his
three shuttle flights. Hauck left NASA in 1989.

195-foot level Level on the shuttle launch tower where astronauts board the orbiter

abort End a mission short of its objectives due to malfunction or emergency

aft flight deck Area directly behind the cockpit with controls for rendezvous, docking, payload deployment and retrieval, and controlling the shuttle's robot arm

airlock Chamber where space-suited astronauts seal themselves off from the mid-deck cabin before going out on a spacewalk

attitude Orientation of the orbiter's axes in space or in the atmosphere

Capcom Astronaut in Mission Control who communicates directly with shuttle crew in orbit

cargo bay (Also **payload bay**) Large open bay behind the crew compartment where satellites or other cargo are carried up or returned to Earth

downlink Radio communication or data relay from the shuttle to the ground

Expedition crews Early three-person crews on the International Space Station. Typically a Russian commander with two U.S. astronauts, or a U.S. commander with two Russians

External Tank (ET) Large, bullet-shaped tank containing liquid hydrogen fuel and liquid oxygen oxidizer for the shuttle main engines

extravehicular activity (EVA) Spacewalk

flight deck Uppermost compartment of the crew cabin, equivalent to the cockpit

g Term used to connote the force due to gravity at Earth's surface. Experiencing three g's would feel like three times normal Earth gravity.

International Space Station (ISS) NASA-led permanent orbiting space station. Assembly began in 1998.

Launch and Entry Suit Orange pressure suit worn by astronauts during launch and return to Earth

main engine cutoff (MECO) Point during shuttle ascent at which the orbiter's main engines stop firing, about eight and a half minutes into the flight

mid-deck Deck below the flight deck, provides crew sleeping berths, galley, toilet, and access (through the airlock) to the cargo bay

mission specialist Astronaut responsible for mission operations, including spacewalks, experiments and payload activities

Manned Maneuvering Unit (MMU) Large astronaut jetpack used in the early 1980s for untethered spacewalks. No longer used.

orbiter Airplane-like part of the shuttle, the only one that reaches space

payload Satellites, laboratory modules, or other equipment carried into orbit

payload specialist Usually a non-NASA astronaut assigned to operate equipment or experiments on a specific flight

Remote Manipulator System (Also **robot arm** or **RMS**) 50-foot-long mechanical arm used to handle payloads and move astronauts around the cargo bay

Solid Rocket Boosters (Also **solids** or **SRBs**) Twin rockets that provide the main thrust for a shuttle liftoff. After each flight, the empty SRB cases parachute to the ocean for recovery and reuse.

Spacehab Commercial scientific laboratory carried into Earth orbit in the shuttle's payload bay. Similar to Spacelab, but privately owned.

Spacelab Scientific laboratory developed by the European Space Agency to provide additional pressurized volume for conducting experiments. Carried into orbit in the shuttle's payload bay, it flew from the early 1980s to the late 1990s.

STS Space Transportation System, the shuttle's formal name. Also the numbering system by which missions are designated. Missions keep their original number even if they get bumped in the launch schedule; hence, STS-88 can follow STS-95.

Unity U.S.-built connecting "node" on the International Space Station—a small passageway between larger modules

Zarya Russian-built module on the International Space Station that provides propulsion, power, and storage space. Zarya was the first piece of the station to reach orbit.

zero-g Common expression for weightlessness during a spaceflight. "Zero-g" isn't really zero, however—there still are very slight acceleration forces due to gravity on board the shuttle.

Zvezda Russian-built module on the International Space Station that served as living quarters for the early crews

THE SPACE TRANSPORTATION SYSTEM

How NASA Makes It Happen

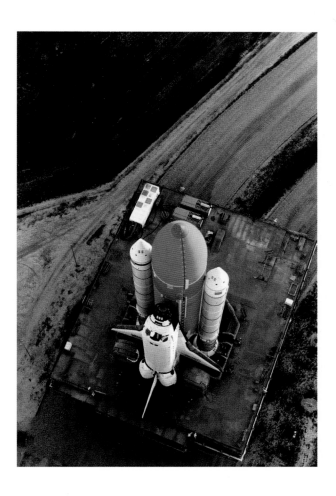

TOOLS OF THE TRADE

NASA'S SPACE TRANSPORTATION SYSTEM, or STS, consists of four shuttle orbiters, *Atlantis*, *Discovery*, *Columbia*, and *Endeavour* (built to replace the lost *Challenger*). Tens of thousands of people work on the STS, including NASA employees and contractors at the Johnson Space Center in Houston, where the astronauts train, and the Kennedy Space Center in Florida, where the shuttle is launched. The fuel tanks are assembled by Lockheed Martin in Michoud, Louisiana, the solid rocket boosters by Cordant Technologies in Brigham City, Utah, and the orbiters themselves by Boeing North American in Palmdale, California. But components of all those systems are fabricated by hundreds of contractors around the country.

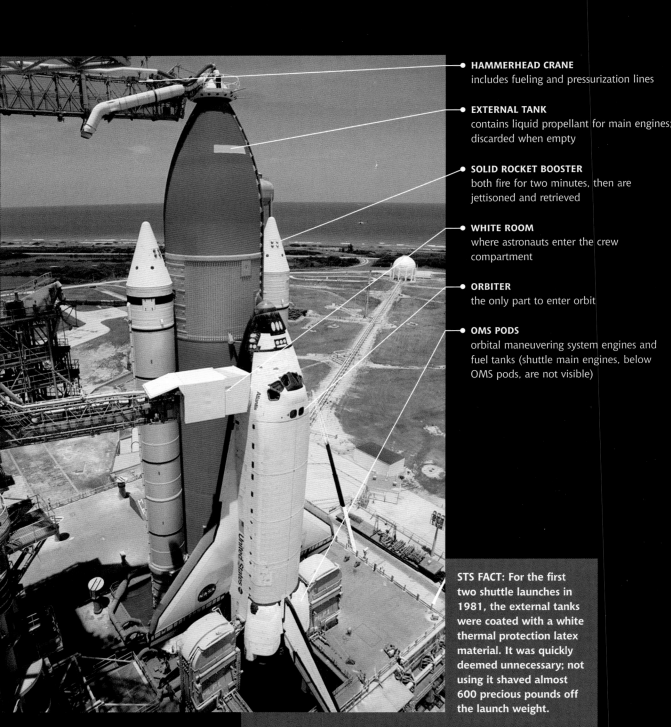

HAMMERHEAD CRANE
includes fueling and pressurization lines

EXTERNAL TANK
contains liquid propellant for main engines; discarded when empty

SOLID ROCKET BOOSTER
both fire for two minutes, then are jettisoned and retrieved

WHITE ROOM
where astronauts enter the crew compartment

ORBITER
the only part to enter orbit

OMS PODS
orbital maneuvering system engines and fuel tanks (shuttle main engines, below OMS pods, are not visible)

STS FACT: For the first two shuttle launches in 1981, the external tanks were coated with a white thermal protection latex material. It was quickly deemed unnecessary; not using it shaved almost 600 precious pounds off the launch weight.

shuttles can carry
●llites, laboratory
dules, experiments,
space station com-
ents into orbit and
rn them to Earth.
● remote manipulator
h can handle objects
t on Earth would
gh more than 30
s. It also serves as a
hly maneuverable
tform for moving
und spacewalking
ronauts—sort of a
h-flying cherry picker.

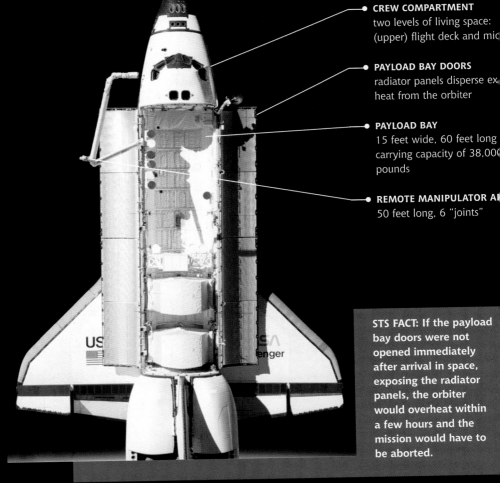

CREW COMPARTMENT
two levels of living space:
(upper) flight deck and mic

PAYLOAD BAY DOORS
radiator panels disperse ex
heat from the orbiter

PAYLOAD BAY
15 feet wide, 60 feet long
carrying capacity of 38,00
pounds

REMOTE MANIPULATOR A
50 feet long, 6 "joints"

**STS FACT: If the payload
bay doors were not
opened immediately
after arrival in space,
exposing the radiator
panels, the orbiter
would overheat within
a few hours and the
mission would have to
be aborted.**

SPACELAB

The European Space Agency developed
the Spacelab laboratory module, which
could be installed in the cargo bay in
different configurations, depending on
the research mission. Astronauts entered
the module through a tunnel to conduct
experiments in life sciences, materials
processing, astronomy, and Earth science.
Different Spacelab configurations flew on
25 shuttle missions until the International
Space Station was put into orbit.

LIVING AND WORKING IN SPACE

UNLESS THEY ARE FLYING with a laboratory module in the payload bay, astronauts inside the space shuttle orbiters are confined to a volume roughly the size of an average living room. With up to seven crew members flying missions that can range from five days to 18, that can be a very tight fit. But weightless astronauts can work on the ceiling just as easily as on the floor, and their work surfaces are very efficiently laid out. Every square inch is crammed with controls or compartments filled with general-purpose or mission-specific equipment. Additional stowage space is under the "floors." A hatchway leads from the cockpit-like flight deck to the mid-deck, which has sleeping berths, lockers for stowage or experiments, a galley for cooking food, the shuttle's toilet or "waste collection system," and the airlock for going out on spacewalks.

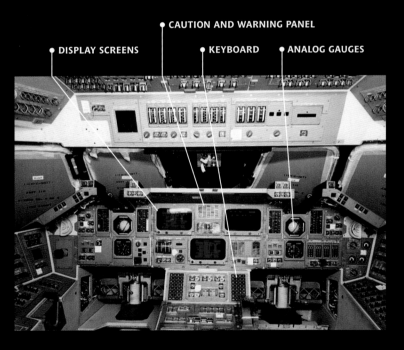

● DISPLAY SCREENS **● CAUTION AND WARNING PANEL** **● KEYBOARD** **● ANALOG GAUGES**

● ELECTRONIC DISPLAY SCREENS **● CAUTION AND WARNING PANEL** **● ABORT PANEL** **● LANDING GEAR CONTROLS**

OLD STYLE

The original cockpit configuration—the one flown for most of the shuttle's first 20 years—featured 32 gauges and electromechanical displays and four cathode-ray tube displays, as well as two keyboards and scores of switches and buttons.

NEW LOOK

The orbiter *Atlantis* was the first to receive the cockpit improvements in 1998. The new "glass cockpit" features 11 full-color, flat-panel displays that show only relevant control systems at any one time. The upgraded system is 75 pounds lighter, uses less power than before, and offers easier pilot recognition of key functions.

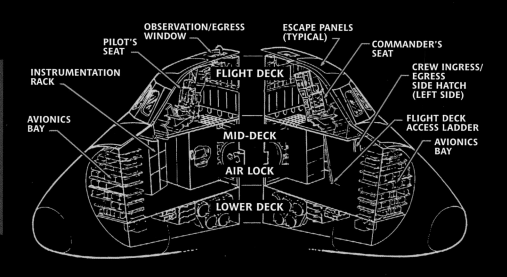

STS FACT: Electricity for the orbiter is generated by fuel cells that combine stored hydrogen and oxygen. The chemical reaction produces electricity, and, as a byproduct, enough water for the crew.

OBSERVATION/EGRESS WINDOW

PILOT'S SEAT

INSTRUMENTATION RACK

AVIONICS BAY

FLIGHT DECK

MID-DECK

AIR LOCK

LOWER DECK

ESCAPE PANELS (TYPICAL)

COMMANDER'S SEAT

CREW INGRESS/ EGRESS SIDE HATCH (LEFT SIDE)

FLIGHT DECK ACCESS LADDER

AVIONICS BAY

MISSION-SPECIFIC CONTROL PANEL

CARGO BAY WINDOWS

ORBITER HAND CONTROLLER

CLOSED-CIRCUIT TV MONITORS

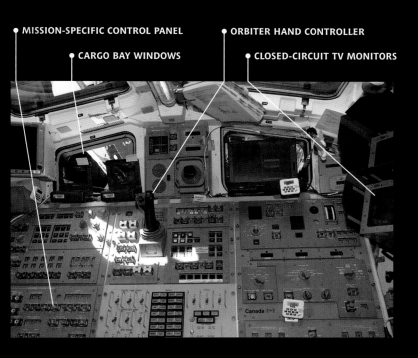

AFT CONTROLS

During any shuttle mission, much of the action takes place at the aft control panel, where crew members can manipulate cargo or capture satellites with the remote manipulator arm and help space-suited astronauts working outside the cabin complete their tasks. Windows above the panel and overhead also allow the astronauts to conduct visual studies of space and Earth.

TO SLEEP, TO DREAM

Lockers and sleeping bags dominate the mid-deck, which sits just beneath the flight deck. On this level, astronauts can conduct additional small experiments in the same space they use to sleep, eat, and wash. This is also where they don space suits and enter the airlock to work in the cargo bay.

SHUTTLE PROCESSING AND CREW TRAINING

TWO THINGS need to happen prior to a shuttle launch: the orbiter must be prepared, and the crew has to be trained. Vehicle preparation takes place at the Kennedy Space Center over the course of three to six months—beginning with the orbiter's return from its previous mission, then refurbishment, mating to the external tank and solid rocket boosters in the enormous Vehicle Assembly Building, and integration of the next mission's payload. Crew training can take several years for a complicated mission. Astronauts, who get most of their training at Johnson Space Center in Houston, must learn the intricacies of the equipment and experiments they'll be carrying on their flights. This training happens concurrently with more generalized shuttle training, including work in simulators, classrooms, and aircraft.

SIMULATION
Astronauts Pat Forrester (left) and Dan Barry use virtual reality to become familiar with International Space Station (ISS) hardware.

SAFETY PROCEDURES
Mission Specialist Catherine "Cady" Coleman trains for an emergency exit.

SCIENCE TRAINING
Chiaki Mukai and Rick Linnehan practice using an experiment workstation.

ASTRONAUT TRAINING

SHUTTLE PREPARATION

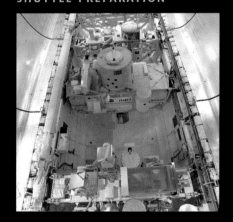

STEP 1: PAYLOAD PROCESSING
The airplane-like orbiter is serviced and outfitted with cargo in the Orbiter Processing Facility. Some cargo is loaded vertically on the pad.

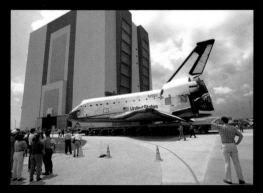

STEP 2: TRANSFER TO VAB
The orbiter heads to the Vehicle Assembly Building—a prelaunch milestone.

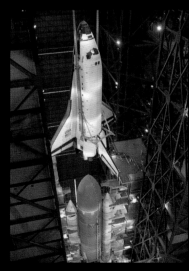

STEP 3: MATING
Slowly, carefully, the nearly 100-ton orbiter is hoisted by crane and mated to the 184-foot-tall external tank/solid rocket booster stack.

UNDERWATER PRACTICE

Joe Tanner (left) and Marc Garneau in the giant Neutral Buoyancy Laboratory (NBL) pool, where they rehearse a spacewalk.

WALKOUT

Members of the STS-106 crew wave to onlookers as they rush to the Astrovan that will take them to Launch Pad 39B.

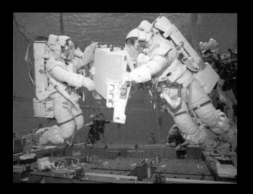

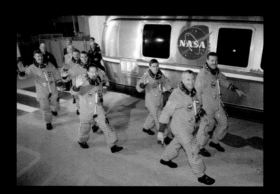

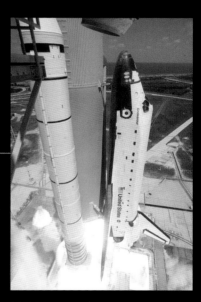

LAUNCH

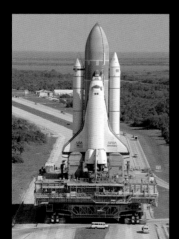

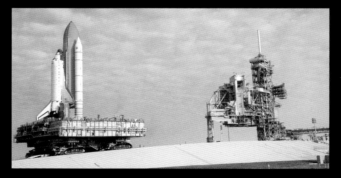

STEP 5: PAD ARRIVAL

The Mobile Launch Platform keeps *Discovery* level during the final ascent up the five percent grade.

STEP 4: ROLLOUT

Now begins the slow trip to one of two shuttle launch pads, at one mile per hour.

LAUNCH, LANDING, AND MISSION CONTROL

THE SHUTTLE COUNTDOWN and launch is orchestrated from the Kennedy Space Center in Florida. But once the shuttle clears the launch tower, all control switches to the Mission Control Center at Johnson Space Center in Houston, where teams work in round-the-clock shifts. Flight controllers monitor all orbiter functions and advise and assist the astronauts with all onboard activities. Mission Control also oversees the landing, as the shuttle re-enters the atmosphere and descends to a touchdown at Kennedy Space Center. The alternate landing site is Edwards Air Force Base in California's Mojave Desert.

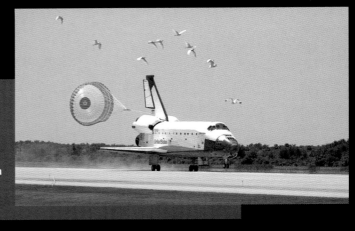

LANDING FACT
During its landing approach, the orbiter is still 49,000 feet above the ground when it is only 25 miles from the runway—20,000 feet higher than the typical cruising altitude for a commercial airliner.

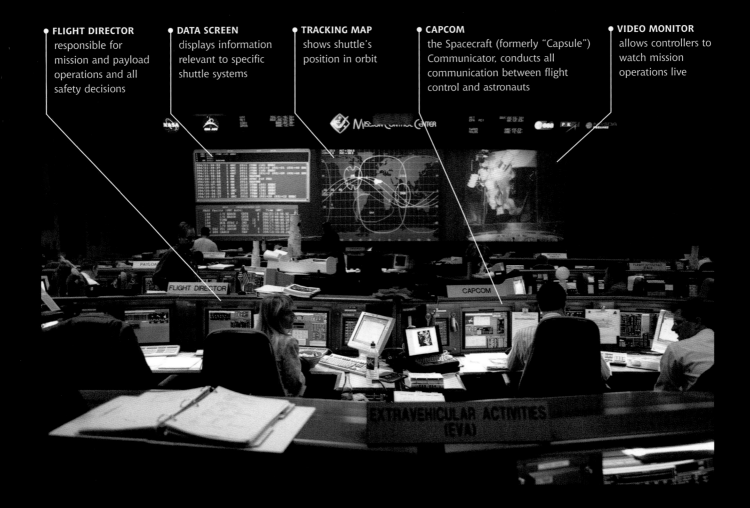

FLIGHT DIRECTOR
responsible for mission and payload operations and all safety decisions

DATA SCREEN
displays information relevant to specific shuttle systems

TRACKING MAP
shows shuttle's position in orbit

CAPCOM
the Spacecraft (formerly "Capsule") Communicator, conducts all communication between flight control and astronauts

VIDEO MONITOR
allows controllers to watch mission operations live

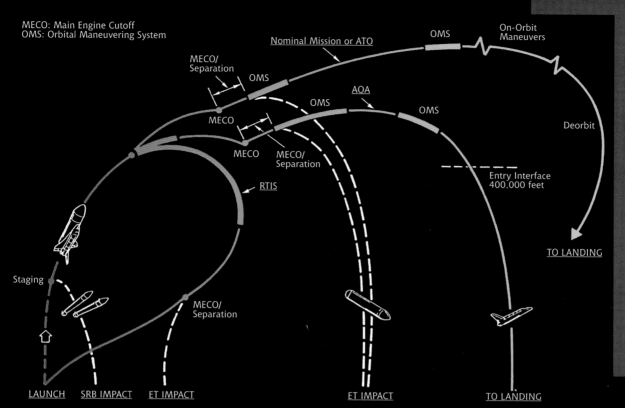

MECO: Main Engine Cutoff
OMS: Orbital Maneuvering System

MECO/
Separation

OMS

<u>Nominal Mission or ATO</u>

OMS

On-Orbit
Maneuvers

MECO

OMS

<u>AOA</u>

MECO

MECO/
Separation

OMS

Deorbit

<u>RTIS</u>

Entry Interface
400,000 feet

Staging

MECO/
Separation

TO LANDING

<u>LAUNCH</u> <u>SRB IMPACT</u> <u>ET IMPACT</u>

<u>ET IMPACT</u>

<u>TO LANDING</u>

STS FACT:
In the event of an emergency during launch, pilots have several abort options depending on how high they are, including Abort-to-Orbit, in which a safe, but lower, orbit can still be achieved; Abort-Once-Around, in which the shuttle executes one orbit and returns to Earth; Transoceanic Abort Landing, in which the shuttle lands at one of several sites in Europe or Africa; and Return-to-Launch-Site, the most desperate option.

GETTING TO ORBIT

During the launch, the solid rocket boosters (SRBs) and the orbiter's three main engines fire simultaneously for more than two minutes. Then the SRBs are jettisoned while the shuttle engines continue firing for another six minutes or more. When they stop, the big external fuel tank is jettisoned. The objective with each launch is to get the spacecraft up over the densest part of the atmosphere, then send it accelerating almost horizontally until it reaches orbital speed, the speed at which it stays in free fall but is going so fast that it never intersects with the Earth. (The fact that Kennedy Space Center is moving with Earth's rotation at 914 miles per hour is factored into the launch trajectory calculations—it gives the shuttle a significant boost.) When the orbiter reaches orbital altitude, typically between 150 and 300 miles above the surface, the orbital maneuvering system (OMS) engines fire to circularize the orbit, and the crew can begin its mission.

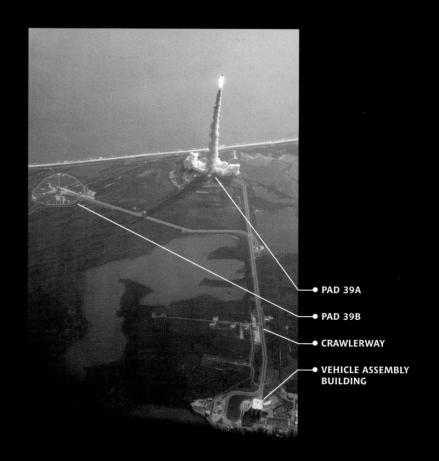

PAD 39A

PAD 39B

CRAWLERWAY

VEHICLE ASSEMBLY
BUILDING

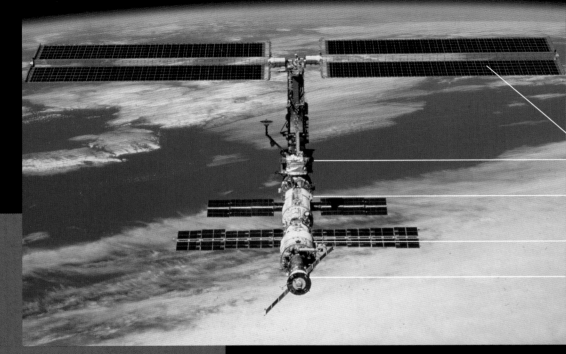

SPACE STATION FACT: The ISS orbits Earth at an altitude of 230 miles and an inclination of 51.6 degrees to the equator. It operates with a three-person crew and can be visited by either the space shuttle or the Russian Soyuz crew transport.

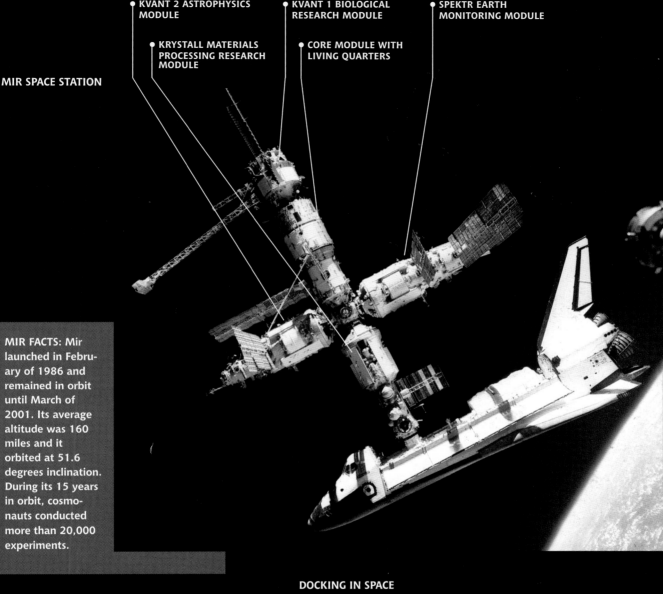

KVANT 2 ASTROPHYSICS MODULE

KVANT 1 BIOLOGICAL RESEARCH MODULE

SPEKTR EARTH MONITORING MODULE

KRYSTALL MATERIALS PROCESSING RESEARCH MODULE

CORE MODULE WITH LIVING QUARTERS

MIR SPACE STATION

MIR FACTS: Mir launched in February of 1986 and remained in orbit until March of 2001. Its average altitude was 160 miles and it orbited at 51.6 degrees inclination. During its 15 years in orbit, cosmonauts conducted more than 20,000 experiments.

DOCKING IN SPACE

A typical space station docking begins with the orbiter approaching the station, usually from below. The shuttle is equipped with a radar navigation system that gives distances to the approaching target. Computers control the gradual approach, and the manual phase of the docking begins when the orbiter is roughly a half-mile from the station. The pilot controls the orbiter from the aft flight deck while communicating with the station commander and the flight directors back on Earth. Beginning at about 30 feet from the station, the orbiter approaches at a rate of roughly 0.1 feet per second until it connects with the station's docking device. When docked operations are complete, usually several days later, the orbiter will undock from the station and slowly back away. When the shuttle is about 500 feet from the station, the pilot will perform a final separation burn to move the orbiter farther away.

STS-1

DATES APRIL 12–14, 1981
ORBITER *COLUMBIA*
CREW JOHN YOUNG
ROBERT CRIPPEN
MISSION FIRST ORBITAL FLIGHT

The space shuttle's debut was a bare-bones test flight—its only payload was diagnostic equipment to measure accelerations, temperatures, and stresses on the vehicle. Young and Crippen verified that *Columbia*'s maneuvering jets fired in space, that the payload bay doors opened and closed properly, and that other onboard systems worked as designed. Most importantly, STS-1 proved that the shuttle could reach orbit and return to land safely.

STS-2

DATES NOVEMBER 12–14, 1981
ORBITER *COLUMBIA*
CREW JOE ENGLE
RICHARD TRULY
MISSION SECOND ORBITAL TEST FLIGHT

Former X-15 pilot Joe Engle and future NASA Administrator Dick Truly had to cut their planned five-day test flight short when one of three electricity-producing fuel cells failed in orbit. But the new vehicle's major systems checked out, and the Canadian-built Remote Manipulator System (RMS) arm for grappling and moving heavy payloads passed its test. First Earth observations from instruments mounted in the cargo bay and first reflight of a space vehicle.

STS-3

DATES MARCH 22–30, 1982
ORBITER *COLUMBIA*
CREW JACK LOUSMA
GORDON FULLERTON
MISSION THIRD ORBITAL TEST FLIGHT

Checkout of the new space shuttle continued with an extensive series of tests in different temperatures. These involved exposing parts of *Columbia* to direct sunlight or shadow for long periods. The first onboard science experiments included materials processing in weightlessness and a student experiment studying insects in microgravity. Minor technical glitches included trouble with a balky toilet. The shuttle made its one and only landing at an alternate site in White Sands, New Mexico, because preferred landing site at Edwards Air Force Base, California, was flooded.

STS-4

DATES JUNE 27–JULY 4, 1982
ORBITER *COLUMBIA*
CREW THOMAS (KEN) MATTINGLY
HENRY HARTSFIELD
MISSION FINAL ORBITAL TEST FLIGHT

Mattingly and his Apollo 16 crewmate John Young were the only veterans of lunar missions to fly on the shuttle. After this fourth and final test flight, during which a two-man crew completed checkout of the orbiter's systems, NASA declared the shuttle operational. On board were a classified Department of Defense payload and the first of the "Get Away Special" experiments, instrument packages carried in a small barrel-shaped

canister mounted to the walls of the cargo bay and designed to provide cheap access to space. President Ronald Reagan was on hand for the Fourth of July return to Edwards, the only President ever to witness a shuttle landing.

STS-5

DATES NOVEMBER 11–16, 1982
ORBITER *COLUMBIA*
CREW VANCE BRAND
ROBERT OVERMYER
JOSEPH ALLEN
WILLIAM LENOIR
MISSION FIRST COMMERCIAL
SATELLITE LAUNCH

The first operational shuttle flight delivered two communications satellites to orbit for paying customers—ANIK C-3 for TELESAT Canada and SBS-C for Satellite Business Systems. Each was equipped with a Payload Assist Module solid rocket motor, which fired about 45 minutes after deployment from the shuttle, boosting each spacecraft to the much higher orbit used by communications satellites. Lenoir and Allen were the shuttle program's first mission specialists—astronauts trained to tend payloads and conduct research while others operated the vehicle. Their planned spacewalk (which would have been the first from the shuttle) was canceled because a spacesuit malfunctioned. First four-person astronaut crew.

STS-6

DATES APRIL 4–9, 1983
ORBITER *CHALLENGER*
CREW PAUL WEITZ
KAROL BOBKO
DONALD PETERSON
STORY MUSGRAVE
MISSION NASA TRACKING SATELLITE

The first flight of *Challenger*, the second orbiter in the shuttle fleet, delivered NASA's first Tracking and Data Relay Satellite-1 (TDRS-1) to orbit, part of an in-space network to improve communications between the shuttle and mission control and ease reliance on ground stations. A malfunction of the satellite's booster rocket placed it into the wrong orbit, but ground controllers were later able to maneuver it to the proper location. First shuttle spacewalk (in a nearly empty cargo bay) by Peterson and Musgrave, and NASA's first in nine years.

STS-7

DATES JUNE 18–24, 1983
ORBITER *CHALLENGER*
CREW ROBERT CRIPPEN
FREDERICK HAUCK
SALLY RIDE
JOHN FABIAN
NORMAN THAGARD
MISSION TWO COMMUNICATIONS
SATELLITES, SPAS PLATFORM

Sally Ride became the first American woman to fly in space, joining Hauck, Fabian, and Thagard as the first members of the 1978 shuttle astronaut class to reach orbit. The crew deployed two communications satellites, ANIK C-2 and

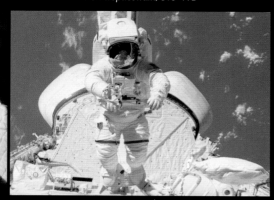

PALAPA-B1, and executed the shuttle's first rendezvous with another satellite, the German-built Shuttle Pallet Satellite (SPAS-01). This free-flying "platform" with experiments and cameras onboard was released from the cargo bay using *Challenger*'s robot arm, then retrieved later in the flight for return to Earth. Cameras on SPAS took the first pictures showing the entire orbiter in space. First five-person space crew.

STS-8

DATES AUGUST 30–SEPT 5, 1983
ORBITER *CHALLENGER*
CREW RICHARD TRULY
DANIEL BRANDENSTEIN
GUION BLUFORD
DALE GARDNER
WILLIAM THORNTON
MISSION INSAT-1B SATELLITE

First night launch and landing, so scheduled because of the orbital positioning requirements of the primary payload, India's INSAT-1B satellite. Besides releasing the satellite in orbit, the crew conducted experiments and studied the shuttle's night-time glow resulting from its interaction with atomic oxygen in the thin upper atmosphere. Six rats flew in the mid-deck to test a new Animal Enclosure Module. Bill Thornton, a medical doctor and astronaut since 1967, was added to the crew late to conduct experiments on space sickness, which had already affected some of the early shuttle crews. Bluford became the first African-American to fly in space.

STS-9

DATES NOV 28-DEC 8, 1983
ORBITER *COLUMBIA*
CREW JOHN YOUNG
BREWSTER SHAW
ROBERT PARKER
OWEN GARRIOTT
BYRON LICHTENBERG
ULF MERBOLD
MISSION SPACELAB-1

First flight of the European-built Spacelab research module, which was carried inside *Columbia*'s cargo bay to add another facility for conducting science experiments ranging from astronomy to life sciences. Lichtenberg, a biomedical engineer from the Massachusetts Institute of Technology, and Merbold, a German astronaut representing the European Space Agency and the first non-American to fly on a U.S. spacecraft, were the program's first payload specialists—non-NASA scientists and engineers assigned to tend a particular payload or set of experiments. The two payload specialists teamed with Garriott and Parker and, working in shifts, crewed the laboratory around the clock, using a connecting tunnel to reach the Spacelab module from the shuttle mid-deck. First six-person crew. At 10 days, longest mission of the early 1980s.

STS-41B

DATES FEBRUARY 3-11, 1984
ORBITER *CHALLENGER*
CREW VANCE BRAND
ROBERT "HOOT" GIBSON
BRUCE MCCANDLESS
ROBERT STEWART
RONALD MCNAIR
MISSION TWO COMMUNICATIONS
SATELLITES, FIRST
UNTETHERED SPACEWALKS

With mission 41-B, NASA switched to a complex numbering system whereby the first digit stood for the year the mission originally was scheduled to launch (1984), the second digit was either "1" (for Florida launches) or "2" (California), and "B" stood for the originally scheduled order of launch for that fiscal year. McCandless, an astronaut since 1966 who had been working on flying jetpacks as far back as NASA's Skylab program of the 1970s, finally got to test in space the Manned Maneuvering Unit he had helped to design. He and Bob Stewart used gas jets on the MMUs to propel themselves as far as 320 feet from the shuttle—the first time astronauts had ever ventured away from their spacecraft without being tethered by a safety line. The crew also deployed two communications satellites, WESTAR-VI and PALAPA-B2. But failures of both satellites' onboard booster rockets left them stranded in useless low-Earth orbits. They were rescued and returned to Earth by the STS-51A crew nine months later. First shuttle landing at the Kennedy Space Center in Florida.

STS-41C

DATES APRIL 6-13, 1984
ORBITER *CHALLENGER*
CREW ROBERT CRIPPEN
FRANCIS "DICK" SCOBEE
GEORGE "PINKY" NELSON
JAMES "OX" VAN HOFTEN
TERRY HART
MISSION FIRST SPACECRAFT REPAIR IN
ORBIT, LONG DURATION
EXPOSURE FACILITY

The Solar Maximum Mission satellite, designed to study the Sun, had lost its fine pointing capability nine months after launch in 1980. Nelson's plan to fly the MMU jetpack out to capture the satellite went awry when the docking hardware he carried didn't fit properly to a pin on the satellite. Hart eventually grabbed Solar Max with the shuttle's robot arm. Nelson and van Hoften made the first in-space repair of a broken satellite, and Solar Max was returned to orbit. The crew also deployed the Long Duration Exposure Facility, a passive satellite designed to test the effects of the space environment on various materials. Although it was meant to orbit for only 10 months, LDEF stayed for almost six years—stranded by the 1986 *Challenger* disaster—before its recovery on STS-32.

STS-41D

DATES AUGUST 30-SEPTEMBER 5, 1984

ORBITER *DISCOVERY*

CREW HENRY HARTSFIELD
MICHAEL COATS
JUDITH RESNIK
STEVEN HAWLEY
RICHARD "MIKE" MULLANE
CHARLES WALKER

MISSION THREE COMMERCIAL SATELLITES, SPACE STATION CONSTRUCTION DEMONSTRATION

The first flight of *Discovery* was delayed two months by the shuttle's first launch pad abort, four seconds before the planned June 26 liftoff. NASA eventually replaced one of the orbiter's three main engines, which had caused the abort. To preserve the launch schedule after the lull, NASA canceled STS-41F and squeezed a record three satellites into *Discovery*'s cargo bay: SBS-D for Satellite Business Systems, TELSTAR-3C for Canada, and the Navy-leased SYNCOM IV-2. Several times the crew unfolded a collapsible solar array, the largest structure ever extended from a manned spacecraft, which stretched 102 feet above the cargo bay. Walker, a McDonnell Douglas payload specialist, was the shuttle's first paying passenger.

STS-41G

DATES OCTOBER 5-13, 1984

ORBITER *CHALLENGER*

CREW ROBERT CRIPPEN
JON MCBRIDE
DAVID LEESTMA
SALLY RIDE
KATHRYN SULLIVAN
PAUL SCULLY-POWER
MARC GARNEAU (CANADA)

MISSION ERBS, FIRST SPACEWALK BY AN AMERICAN WOMAN

Sullivan became the first American woman to walk in space when she and Leestma conducted a three-hour demonstration of satellite refueling. Ride deployed the Earth Radiation Budget Satellite to monitor the ebb and flow of solar energy—but not without using the shuttle robot arm to shake loose a stuck power array. *Challenger* scanned the planet's surface with an updated version of the radar imager first used on STS-2. Payload specialist Garneau, Canada's first astronaut, later became a full-fledged mission specialist. First flight to include two women, Ride and Sullivan. First seven-person crew.

STS-51A

DATES NOVEMBER 8-16, 1984

ORBITER *DISCOVERY*

CREW FREDERICK HAUCK
DAVID WALKER
ANNA FISHER
DALE GARDNER
JOSEPH ALLEN

MISSION DOUBLE SATELLITE RELEASE, DOUBLE SATELLITE RESCUE

The release of Canada's TELESAT-H and the Navy's SYNCOM IV-1 made room in the cargo bay for PALAPA-B2 and WESTAR-VI, communications satellites that malfunctioned on STS-41B. Taking turns in the jet-propelled MMU, Allen and Gardner attached fixtures to each satellite so Fisher (the first mother to fly in space) could grab them with *Discovery*'s robot arm and place them in the cargo bay. The satellites were returned to Earth, refurbished, and resold. NASA mothballed the MMUs after STS-51A.

STS-51C

DATES JANUARY 24-27, 1985

ORBITER *DISCOVERY*

CREW THOMAS (KEN) MATTINGLY
LOREN SHRIVER
JAMES BUCHLI
ELLISON ONIZUKA
GARY PAYTON

MISSION FIRST DEDICATED DEPARTMENT OF DEFENSE MISSION

Operating in secure mode was a challenge for NASA. Even the astronauts fought for access to information about their classified mission. *Discovery* reportedly released the signals intelligence satellite Magnum-1 on an Inertial Upper Stage within hours of reaching orbit. Under pressure to launch nine more missions in 1985, NASA lopped a day off STS-51C to save time. The crew finished its work, but not its adaptation to weightlessness, prompting NASA to set four days as the minimum mission duration. First substitution of an orbiter, after *Challenger* suffered thermal tile problems. First time cold weather scrubbed a launch,

planned for January 23 and postponed till the next day. Later examination of the reusable solid-fuel booster rockets showed soot on the O-ring seals, offering NASA the earliest warning that cold temperatures can shrink the rubbery seals, opening paths for propellant leaks like the one that destroyed *Challenger* in 1986.

STS-51D

DATES APRIL 12-19, 1985

ORBITER *DISCOVERY*

CREW KAROL BOBKO
DONALD WILLIAMS
RHEA SEDDON
DAVID GRIGGS
JEFFREY HOFFMAN
CHARLES WALKER
SENATOR JAKE GARN

MISSION TWO SATELLITES, FIRST POLITICIAN IN SPACE

Republican Senator Jake Garn of Utah, the first "congressional observer" on the shuttle, earned the nickname "Barfin' Jake" for his role as guinea pig in motion sickness studies. Smooth deployment of TELESAT-I for Canada, but desperate measures including an impromptu spacewalk by Griggs and Hoffman failed to save the Navy's SYNCOM IV-3 from a crippling spacecraft sequencer failure. The pair attached a handcrafted "flyswatter" to *Discovery*'s robot arm, with which Seddon tried to flip a start switch on the spinning satellite. SYNCOM IV-3 was rescued on STS-51I. A physics experiment with a paper airplane, a yo-yo, and other simple toys brought a little levity to the mission. Walker became the first

industry-sponsored payload specialist to ride the shuttle twice, reprising his STS-41D flight. After *Discovery* blew a tire and suffered extensive brake damage touching down in Florida, NASA shifted landings to California while it fixed the orbiters' braking and steering problems.

STS-51B

DATES APRIL 29-MAY 6, 1985
ORBITER *CHALLENGER*
CREW ROBERT OVERMYER
FREDERICK GREGORY
DON LIND
NORMAN THAGARD
WILLIAM THORNTON
LODEWIJK VAN DEN BERG
TAYLOR WANG
MISSION SPACELAB-3

Second flight of Spacelab pressurized science module that debuted on STS-9. First flight of live mammals on the shuttle. Twenty-four rats and two squirrel monkeys rode along in the Animal Holding Facility, a high-tech cage that secured the animals but not their feces, which the humans had to vacuum out of the air. *Challenger* orbited with its tail pointed at Earth and its right wing in the direction of travel. This "gravity gradient" orientation minimized disruption from thruster firings on delicate materials and fluids experiments requiring near zero gravity. First satellite deployment from a Get Away Special canister, an air traffic radar calibrator called NUSAT.

STS-51G

DATES JUNE 17-24, 1985
ORBITER *DISCOVERY*
CREW DANIEL BRANDENSTEIN
JOHN CREIGHTON
SHANNON LUCID
STEVEN NAGEL
PATRICK BAUDRY (FRANCE)
SULTAN BIN SALMAN AL-SAUD (SAUDI ARABIA)
MISSION THREE SATELLITES, SPARTAN-1

Distinctively international flight with the first French and Arab payload specialists and U.S., Mexican and Arab domestic communications satellites. Nagel became the 100th American to reach orbit. Baudry traded standard shuttle menu for gourmet jugged hare a l'Asacienne and crab mousse. Al-Saud, nephew of King Fahd, joined the crew late to accompany ARABSAT-A. The crew also released MORE-LOS-A for Mexico and TELSTAR-3D for AT&T. First use of the Shuttle Pointed Autonomous Research Tool for Astronomy (SPARTAN), a low-cost instrument platform that could orbit free for two days, then be retrieved and refitted for a different mission. A high-precision tracking experiment for the Strategic Defense Initiative Organization had *Discovery* taking a direct hit from a four-watt laser in Hawaii. *Discovery* landed in California in a crosswind, and its left wheel dug six inches into the dry lakebed.

STS-51F

DATES JULY 29-AUGUST 6, 1985
ORBITER *CHALLENGER*
CREW GORDON FULLERTON
ROY BRIDGES
STORY MUSGRAVE
KARL HENIZE
ANTHONY ENGLAND
LOREN ACTON
JOHN-DAVID BARTOE
MISSION SPACELAB-2

Second on-pad launch abort. First abort-to-orbit. During a launch attempt 17 days earlier, *Challenger* had been only three seconds from liftoff when a problem in one engine shut down all three. On July 29, *Challenger* limped into orbit on two main engines after the third cut off prematurely, but maneuvered to an altitude high enough to complete its mission. Spacelab-2 turned the orbiter into a solar observatory, with remotely controlled science instruments mounted on the Spacelab Instrument Pointing System (IPS) in the cargo bay. When the ascent crisis threw off time-critical observations, Mission Control launched into a major replanning effort that had *Challenger*'s teleprinters spitting out reams of uplinked messages every day. Software problems hobbled the IPS for all but the last two days. Coca-Cola and Pepsi took their soft-drink duel to new heights in a taste test with zero-g beverage dispensers. The most educated crew in U.S. space program history, with 21 college degrees among the seven.

STS-51I

DATES AUGUST 27-SEPTEMBER 3, 1985
ORBITER *DISCOVERY*
CREW JOSEPH ENGLE
RICHARD COVEY
JAMES "OX" VAN HOFTEN
JOHN "MIKE" LOUNGE
WILLIAM FISHER
MISSION FOUR SATELLITE RELEASES: THREE NEW, ONE SALVAGED IN ORBIT

After clearing the cargo bay of three communications satellites—ASC-1 for the American Satellite Company, AUSSAT-1 for Australia, and SYNCOM IV-4 for the Navy—astronauts turned *Discovery* into an orbiting garage. In two spacewalks, Fisher and van Hoften captured and repaired SYNCOM IV-3, which malfunctioned on STS-51D. Lashed to the robot arm, van Hoften yanked SYNCOM IV-3 out of orbit with his hands. After the duo hotwired its broken starter switch, van Hoften spun the camper-size satellite three times and heaved it back into space. An attached booster took SYNCOM IV-3 to geosynchronous orbit. Not long after the mission came the news that SYNCOM IV-4 malfunctioned in geosynchronous orbit, well beyond the shuttle's reach.

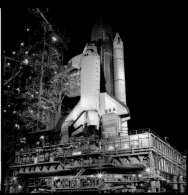

STS-51J

DATES OCTOBER 3-7, 1985
ORBITER *ATLANTIS*
CREW KAROL BOBKO
RONALD GRABE
ROBERT STEWART
DAVID HILMERS
WILLIAM PAILES
MISSION CLASSIFIED, DEPARTMENT OF DEFENSE

First flight of *Atlantis*, the fourth orbiter in the fleet. NASA and the Air Force imposed a news blackout until 24 hours before *Atlantis* landed in California, and then announced little more than the touchdown time. Much later, the government revealed the identity of *Atlantis'* cargo: two spacecraft for the Defense Satellite Communications System atop a single Inertial Upper Stage that boosted them to geosynchronous orbit.

STS-61A

DATES OCTOBER 30-NOVEMBER 6, 1985
ORBITER *CHALLENGER*
CREW HENRY HARTSFIELD
STEVEN NAGEL
JAMES BUCHLI
GUION BLUFORD
BONNIE DUNBAR
REINHARD FURRER
(WEST GERMANY)
ERNST MESSERSCHMID
(WEST GERMANY)
WUBBO OCKELS (EUROPE)
MISSION SPACELAB D-1

First shuttle mission managed by a foreign country. West Germany—"D" is for "Deutschland" in the mission name—paid NASA $65 million for the privilege. From a ground control center near Munich, the Federal German Aerospace Research

Establishment directed science work in the Spacelab module. NASA controlled the orbiter, as usual, from Houston. Largest crew ever assigned to a shuttle flight and the only one with three payload specialists, two German and one Dutch. Spacelab housed 75 experiments in botany, biology, medicine, crystal growth and industrial processing. *Challenger's* landing in California tested a computerized nose wheel steering system designed to prevent dangerous brake lockups and tire blowouts.

STS-61B

DATES NOVEMBER 26-DECEMBER 3, 1985
ORBITER *ATLANTIS*
CREW BREWSTER SHAW
BRYAN O'CONNOR
MARY CLEAVE
SHERWOOD SPRING
JERRY ROSS
RODOLFO NERI VELA
(MEXICO)
CHARLES WALKER
MISSION THREE SATELLITES, TWO SPACEWALKS

Mexico's MORELOS-B, Australia's AUSSAT-2, and SATCOM KU-2 for RCA American Communications were deployed, one at a time, and their booster stages fired automatically to lift them to geosynchronous orbits, where their owners assumed control. Of major interest to space station designers were the truss assembly experiments called EASE and ACCESS. In the most hand-intensive spacewalks to date, Ross and Spring worked their fingers numb putting together and taking apart two large aluminum structures—a

tower and a tetrahedron. Walker made his third flight as a payload specialist. Neri unwittingly solved the shuttle's floating bread crumb dilemma: He ordered flour tortillas with his meals, and they have replaced fresh bread in the shuttle pantry ever since.

STS-61C

DATES JANUARY 12-18, 1986
ORBITER *COLUMBIA*
CREW ROBERT "HOOT" GIBSON
CHARLES BOLDEN
FRANKLIN CHANG-DIAZ
STEVEN HAWLEY
GEORGE "PINKY" NELSON
ROBERT CENKER
CONGRESSMAN BILL NELSON
MISSION ONE SATELLITE, COMET GAZING, SECOND CONGRESSIONAL OBSERVER

Seven launch postponements in 25 days set a record. NASA almost launched *Columbia* Jan. 6, the third try, without enough fuel to reach orbit because of an operator's fatigue-induced mistake. Deployment of SATCOM KU-1 for RCA was a success, but a camera with dead batteries dashed the crew's hopes for good pictures of Halley's Comet. Chang-Diaz, the first Hispanic-American to fly in space, delivered a message from orbit in Spanish. The House of Representatives had its turn on the shuttle with Florida Democrat Bill Nelson observing.

STS-51L

DATE JANUARY 28, 1986
ORBITER *CHALLENGER*
CREW FRANCIS "DICK" SCOBEE
MICHAEL SMITH
JUDITH RESNIK
ELLISON ONIZUKA
RONALD MCNAIR
CHRISTA MCAULIFFE
GREGORY JARVIS
MISSION TDRS-2, SPARTAN-203, TEACHER IN SPACE

The worst accident in the history of the U.S. space program. Crew and shuttle were lost 73 seconds after liftoff when hot combustion gas leaking from a joint between segments of the right-hand solid rocket booster penetrated the external fuel tank and caused it to rupture. The orbiter broke apart rather than exploded. Bitter cold temperatures—it was only 36 degrees Fahrenheit at launch time—stiffened an O-ring seal in the joint, causing the breach. Shuttle flights were halted for 32 months, as a lengthy investigation revealed that NASA managers had emphasized schedule over safety and ignored concerns about solid rocket design flaws. Mission 51-L was to have deployed a NASA tracking satellite and an instrumented platform for observing Halley's Comet. McAuliffe, a social studies teacher, was to have broadcast lessons from orbit as NASA's first "civilian" in space.

STS-26

DATES	SEPTEMBER 29-OCTOBER 3, 1988
ORBITER	*DISCOVERY*
CREW	FREDERICK HAUCK
	RICHARD COVEY
	JOHN "MIKE" LOUNGE
	DAVID HILMERS
	GEORGE "PINKY" NELSON
MISSION	NASA TRACKING AND DATA RELAY SATELLITE (TDRS)

When shuttle flights resumed 32 months after *Challenger*, astronauts were required to wear partial pressure suits for launch and landing. A telescoping pole designed to help the crew bail out in the event of an ocean ditching was just one of numerous safety additions to *Discovery* and its sister spaceships. Six hours after liftoff, Lounge sprung TDRS-3 and its Inertial Upper Stage booster out of the cargo bay. The satellite joined TDRS-1 (STS-6) in geosynchronous orbit. TDRS-2 was lost on *Challenger*.

STS-27

DATES	DECEMBER 2-6, 1988
ORBITER	*ATLANTIS*
CREW	ROBERT "HOOT" GIBSON
	GUY GARDNER
	RICHARD "MIKE" MULLANE
	JERRY ROSS
	WILLIAM SHEPHERD
MISSION	CLASSIFIED, DEPARTMENT OF DEFENSE

Three members of the all-military crew were decorated Vietnam combat veterans. The astronauts wore Lone Ranger masks to a pre-flight news briefing to spoof *Atlantis'* cargo, which NASA kept secret but published reports identified as a low-altitude photo reconnaissance satellite called Lacrosse. The huge radar imager apparently malfunctioned after the shuttle's robot arm placed it in orbit. According to Gibson, *Atlantis* rendezvoused with the spy satellite so the crew could assist with repairs.

STS-29

DATES	MARCH 13-18, 1989
ORBITER	*DISCOVERY*
CREW	MICHAEL COATS
	JOHN BLAHA
	JAMES BUCHLI
	ROBERT SPRINGER
	JAMES BAGIAN
MISSION	NASA TRACKING AND DATA RELAY SATELLITE

Discovery added TDRS-4 to the Tracking and Data Relay Satellite System to complete the network that allows shuttles to remain in almost constant contact with the ground. STS-6 and STS-26 deployed the first two. After TDRS-4 popped out of the cargo bay, the satellite's Inertial Upper Stage motor drove it to geosynchronous orbit. Air bubbles beset tests of an ammonia-convection cooling system for a future space station. An unusual biology experiment studied embryo development with chicken eggs. For the first time, astronauts used a fax machine to receive daily work schedules. First flight during the George H.W. Bush administration; the President called the orbiting crew.

STS-30

DATES	MAY 4-8, 1989
ORBITER	*ATLANTIS*
CREW	DAVID WALKER
	RONALD GRABE
	NORMAN THAGARD
	MARY CLEAVE
	MARK LEE
MISSION	MAGELLAN

First U.S. planetary mission in 11 years and the first on a shuttle. About six hours after liftoff, Lee flipped switches activating springs that pushed Magellan out of its cradle in the cargo bay. The radar mapping probe was mounted on an Inertial Upper Stage that fired as planned, dispatching Magellan on a 15-month journey to Venus. One of five onboard computers broke down May 7, forcing the astronauts to attempt the first computer swap in orbit. They succeeded with that, but weren't as handy with another office machine. When the shuttle fax machine suffered a paper jam, they had to turn it off.

STS-28

DATES	AUGUST 8-13, 1989
ORBITER	*COLUMBIA*
CREW	BREWSTER SHAW
	RICHARD RICHARDS
	DAVID LEESTMA
	JAMES ADAMSON
	MARK BROWN
MISSION	CLASSIFIED, DEPARTMENT OF DEFENSE

Columbia was the last of the remaining three orbiters, which were all modified after *Challenger*, to return to space. Breaking a news blackout on the orbiter's location and mission, Air Force Secretary Donald Rice confirmed release of a payload, but it took experts years to determine that *Columbia* carried the first SDS-2, keystone of the Air Force's second-generation Satellite Data System for communications and missile warning. A second small, unidentified object was released. A short-circuit in a teleprinter cable caused a spark and a trace of smoke in the cockpit on the fourth flight day. NASA said a solar flare during the mission posed no significant danger to the crew, although radiation exposure was the highest recorded on a space flight since the early 1970s.

STS-34

DATES	OCTOBER 18-23, 1989
ORBITER	*ATLANTIS*
CREW	DONALD WILLIAMS
	MICHAEL MCCULLEY
	ELLEN BAKER
	FRANKLIN CHANG-DIAZ
	SHANNON LUCID
MISSION	GALILEO

Galileo, the first satellite to orbit Jupiter, carried about 50 pounds of radioactive plutonium in its power supply, launching NASA into a global debate about the use of nuclear material in space. The launch of *Atlantis* drew protesters to Kennedy Space Center's security gates. Several hours after liftoff, Lucid released the Jovian probe and its attached two-stage Inertial Upper Stage from the cargo bay. The IUS fired to send Galileo on its six-year voyage. Science work during the STS-34 mission included the first-ever photographs of lightning spiking up from the top of a thunderstorm.

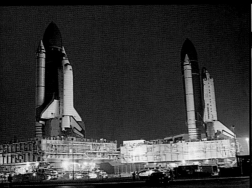

STS-33

DATES NOVEMBER 22-27, 1989

ORBITER *DISCOVERY*

CREW FREDERICK GREGORY
JOHN BLAHA
STORY MUSGRAVE
KATHRYN THORNTON
MANLEY "SONNY" CARTER

MISSION CLASSIFIED, DEPARTMENT OF
DEFENSE

Atlantis lofted a secret payload later identified as the second Magnum signals intelligence satellite. STS-51C deployed Magnum-1. Gregory, the first African-American shuttle commander, was at the controls of *Atlantis* for the first nighttime launch of the return-to-flight era. Blaha filled the seat left vacant when the mission's original pilot, David Griggs, died in an airplane crash in June 1989.

STS-32

DATES JANUARY 9-20, 1990

ORBITER *COLUMBIA*

CREW DANIEL BRANDENSTEIN
JAMES WETHERBEE
BONNIE DUNBAR
MARSHA IVINS
DAVID LOW

MISSION SYNCOM IV-5, LDEF
RETRIEVAL

Release of SYNCOM IV-5 for the Navy completed a five-flight series that started in 1984 with STS-41D. That cleared the cargo bay for the retrieval of the Long Duration Exposure Facility (LDEF) after one of the most complicated rendezvous ever attempted with the shuttle. Released by the crew of STS-41C, LDEF was five years overdue for a shuttle pickup. It was a treasure chest of knowledge about how materials and living tissue withstand long stays in the vacuum of space. Later in the mission, *Columbia* tumbled out of control for 20 minutes after Mission Control radioed inaccurate navigation data while the astronauts slept. The ground awakened the crew to correct the error. The crew also endured false smoke alarms and constant dehumidifier leaks as the orbiter set a flight duration record, almost 11 days.

STS-36

DATES FEBRUARY 28-MARCH 4, 1990

ORBITER *ATLANTIS*

CREW JOHN CREIGHTON
JOHN CASPER
DAVID HILMERS
RICHARD "MIKE" MULLANE
PIERRE THUOT

MISSION CLASSIFIED, DEPARTMENT OF
DEFENSE

First time since Apollo 9, when all three crewmembers caught colds, that sickness postponed a space mission. Creighton was sidelined with an upper respiratory infection. The commander got the "go" for launch after three days, but foul weather and a broken range safety computer grounded *Atlantis* three more days. The shuttle rocketed to its highest latitude ever; the 62.5-degree orbit covered military installations in the northern Soviet Union. Despite a Pentagon-imposed gag order, word got out: *Atlantis* was outfitted with a new satellite carrier that rolled an enhanced KH-11 spy probe out of the open cargo bay. *Atlantis* landed safely although a burst hose robbed its wing flaps and landing gear of full hydraulic pressure.

STS-31

DATES APRIL 24-29, 1990

ORBITER *DISCOVERY*

CREW LOREN SHRIVER
CHARLES BOLDEN
STEVEN HAWLEY
BRUCE MCCANDLESS
KATHRYN SULLIVAN

MISSION HUBBLE SPACE TELESCOPE

First attempt to launch a shuttle ahead of schedule—eight days early—but a mechanical failure bumped liftoff six days past the original calendar target. The Hubble Space Telescope's deployment altitude of 380 statute miles set a shuttle record. When the spacecraft had trouble spreading its wing-like solar power arrays, Hawley suspended it at the end of the robot arm while McCandless and Sullivan prepared for a spacewalk. They were almost ready to open the hatch when ground controllers fixed the problem. Later Hawley and Sullivan showed off for TV viewers an eyepiece that namesake Edwin Hubble had used on the 100-inch telescope at Mount Wilson Observatory. First use of sturdier carbon brakes for landing.

STS-41

DATES OCTOBER 6-10, 1990

ORBITER *DISCOVERY*

CREW RICHARD RICHARDS
ROBERT CABANA
WILLIAM SHEPHERD
BRUCE MELNICK
THOMAS AKERS

MISSION ULYSSES

Demonstrations against Ulysses and its plutonium-filled power generator drew 150 protesters; two were arrested. The fuel leaks that had vexed *Columbia* and *Atlantis* through summer 1990 did not show up on *Discovery*, which was within a day of liftoff when a federal judge threw out a lawsuit by antinuclear groups wanting to stop the launch. Six hours after liftoff, *Discovery* delivered the European solar probe to low-Earth orbit. A unique three-stage rocket boosted Ulysses toward its polar orbit around the sun. For three more days, the crew studied the gravity-free behavior of rats, plants, flames and new technology. Akers lit the first fire on a shuttle, in a sealed chamber. Melnick, first Coast Guardsman in space, commanded *Discovery*'s TV cameras with his voice.

STS-38

DATES NOVEMBER 15-20, 1990

ORBITER *ATLANTIS*

CREW RICHARD COVEY
FRANK CULBERTSON
CHARLES "SAM" GEMAR
CARL MEADE
ROBERT SPRINGER

MISSION CLASSIFIED, DEPARTMENT OF
DEFENSE

Last classified military shuttle flight because, according to the Air Force, encrypting the shuttle's radio communication with the ground cost too much. Published reports identified the satellite aboard *Atlantis* as Magnum-3. STS-51C and STS-33 deployed the first two in the series. The only public chatter of the flight came from Commander Covey, who greeted Ameri-

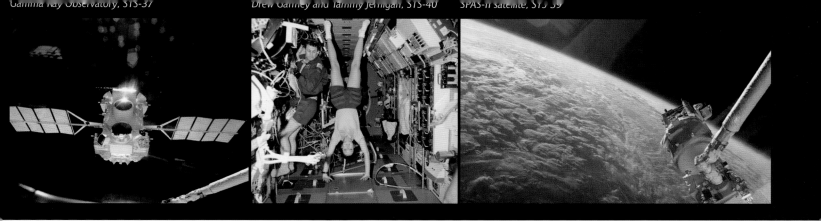

can troops in the Persian Gulf war zone. Launch delayed from July by fuel leaks, hail damage, and a processing mishap. First Florida landing since April 1985.

STS-35
DATES DECEMBER 2-10, 1990
ORBITER *COLUMBIA*
CREW VANCE BRAND
GUY GARDNER
JEFFREY HOFFMAN
JOHN "MIKE" LOUNGE
ROBERT PARKER
RONALD PARISE
SAMUEL DURRANCE
MISSION ASTRO-1 OBSERVATORY

Columbia was delayed more than six months by cooling system trouble, fuel leaks, a telescope breakdown, and a tropical storm. The hard-luck orbiter was even hauled off Pad 39A to make room for STS-38. First crew to use the call sign "Huntsville," for the Astro-1 command post at Marshall Space Flight Center in Alabama. Second flight for the Spacelab Instrument Pointing System, which held three automated ultraviolet telescopes for the mission. From the first day, computer failures forced the astronauts to point the telescopes with a joystick. They salvaged roughly half the science. Largest post-*Challenger* crew. First orbiter equipped with a trash compactor.

STS-37
DATES APRIL 5-11, 1991
ORBITER *ATLANTIS*
CREW STEVEN NAGEL
KENNETH CAMERON
JAY APT
LINDA GODWIN
JERRY ROSS
MISSION GAMMA RAY OBSERVATORY

First spacewalks by U.S. astronauts since 1985. A satellite emergency on the third day of the flight sent Ross and Apt outside to fix an antenna that got stuck as NASA's second Great Observatory (the Hubble telescope was the first) was being placed in orbit. The pair went out again the next day to evaluate a variety of equipment carts designed to help the builders of a future space station. It was such hand-intensive work that Apt rubbed a small hole in one of his spacesuit gloves. Gliding back to Edwards Air Force Base in California, *Atlantis* touched down 600 feet short of the runway—its energy sapped by a wide turn and unexpectedly brisk wind.

STS-39
DATES APRIL 28-MAY 6, 1991
ORBITER *DISCOVERY*
CREW MICHAEL COATS
BLAINE HAMMOND
GUION BLUFORD
RICHARD HIEB
GREGORY HARBAUGH
DONALD MCMONAGLE
CHARLES "LACY" VEACH
MISSION FIRST UNCLASSIFIED DEPARTMENT OF DEFENSE

Except for a tiny satellite released without identification, nothing on the mission was secret. First seven-member crew composed entirely of NASA astronauts gathered data on rocket exhaust for the Strategic Defense Initiative Organization, making record use of *Discovery*'s maneuvering engines and steering jets in an orbital ballet with an instrument-laden Shuttle Pallet Satellite. Cracked fuel door hinges and a faulty fuel pump sensor postponed launch almost six weeks. On touchdown in Florida, Coats brought the spaceplane down fast and early to keep from being blown off the runway by an unexpected wind shift. *Discovery*'s right wheels hit pavement a moment before the left, damaging a tire.

STS-40
DATES JUNE 5-14, 1991
ORBITER *COLUMBIA*
CREW BRYAN O'CONNOR
SIDNEY GUTIERREZ
JAMES BAGIAN
TAMARA JERNIGAN
RHEA SEDDON
DREW GAFFNEY
MILLIE HUGHES-FULFORD
MISSION SPACELAB LIFE SCIENCES (SLS)-1

First Spacelab mission dedicated to life sciences. The most comprehensive study of human adaptation to weightlessness since Skylab probed six key body systems with 18 medical investigations. Ten tests involved the seven humans; the rest involved 30 rats and 2,478 baby jellyfish. To preserve the scientific results when *Columbia* landed in California, doctors

whisked the astronauts away in NASA's new "crew transport vehicle"—an airport people mover outfitted with hospital gear.

STS-43
DATES AUGUST 2-11, 1991
ORBITER *ATLANTIS*
CREW JOHN BLAHA
MICHAEL BAKER
JAMES ADAMSON
DAVID LOW
SHANNON LUCID
MISSION NASA TRACKING AND DATA RELAY SATELLITE

TDRS-5, the fourth Tracking and Data Relay Satellite, was an operational spare for the constellation completed on STS-29. Like the three before it, it made a rocket-assisted trek to geosynchronous orbit. The astronauts unloaded *Atlantis*' cargo bay on the first day, then spent the remaining eight days on biomedical and technology research aimed at furthering U.S. space station development goals. NASA initially planned a five-day flight, but nearly doubled its length to collect more physiological data from the crew as it perfected an extended-duration capability for the orbiter fleet.

STS-48
DATES SEPTEMBER 12-18, 1991
ORBITER *DISCOVERY*
CREW JOHN CREIGHTON
KENNETH REIGHTLER
MARK BROWN
CHARLES "SAM" GEMAR
JAMES BUCHLI
MISSION UPPER ATMOSPHERE RESEARCH SATELLITE

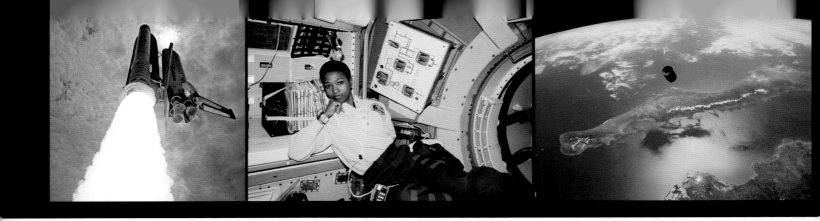

NASA's first "Mission to Planet Earth" deployed the UARS observatory with devices to examine the troposphere, the outer layer of the atmosphere where radiation-blocking ozone is found. For the first time, an orbiter had to swerve to avoid colliding with a piece of space junk. Without the maneuver, *Discovery* would have passed within 1,000 feet of a spent Soviet rocket stage.

STS-44

DATES NOVEMBER 24-DECEMBER 1, 1991
ORBITER *ATLANTIS*
CREW FREDERICK GREGORY
TERENCE "TOM" HENRICKS
MARIO RUNCO
JAMES VOSS
STORY MUSGRAVE
THOMAS HENNEN
MISSION DEFENSE SUPPORT PROGRAM SATELLITE

First minimum-duration flight since STS-2. NASA cut the 10-day mission short after one of *Atlantis'* three navigation units failed. The crew already had deployed a military payload in full view for the first time—a Defense Support Program missile warning satellite and its Inertial Upper Stage booster. Gregory substituted for the original mission commander, David Walker, who was suspended for flying an airplane too close to a Pan Am jet. Gregory's second Thanksgiving in orbit with Musgrave featured rehydratable turkey in new plastic pouches that collapsed, unlike the old rigid boxes, taking up less space in the trash.

STS-42

DATES JANUARY 22-30, 1992
ORBITER *DISCOVERY*
CREW RONALD GRABE
STEPHEN OSWALD
WILLIAM READDY
NORMAN THAGARD
DAVID HILMERS
ROBERTA BONDAR (CANADA)
ULF MERBOLD (EUROPE)
MISSION INTERNATIONAL MICRO-GRAVITY LABORATORY (IML)-1

First flight of the International Space Year opened a new era of cooperation in orbital science research. Fifth use of Spacelab science workshop. More than 200 researchers from 14 nations contributed to 55 IML-1 experiments exploring how microgravity and cosmic radiation affect materials, small life forms, and certain life functions. Bondar was the first Canadian woman in space. Crew paid tribute to the *Challenger* seven and to former crewmate Sonny Carter, who died in a private airplane crash while in training for the mission. First detailed analysis of the ergonomics of a computer workstation in weightlessness.

STS-45

DATES MARCH 24-APRIL 2, 1992
ORBITER *ATLANTIS*
CREW CHARLES BOLDEN
BRIAN DUFFY
KATHRYN SULLIVAN
DAVID LEESTMA
MICHAEL FOALE
DIRK FRIMOUT (EUROPE)
BYRON LICHTENBERG
MISSION ATMOSPHERIC LABORATORY FOR APPLICATIONS AND SCIENCE (ATLAS)-1

Atlantis undershot its intended orbit because of a computer miscalculation that cut off the main engines too soon and an unrelated piloting error. The premature steering maneuver left the crew with an alarming close-up view of the external tank spewing fuel as it fell away from the orbiter several minutes after liftoff. Neither situation hindered around-the-clock mapping of manufactured pollutants and ultraviolet radiation in Earth's atmosphere. First of 10 planned ATLAS missions using Spacelab cargo bay pallets. Twelve automated instruments came from eight nations including Belgium, which also sent its first astronaut, Frimout. First female flight director, Linda Hamm. NASA administrator Richard Truly, the former astronaut who led the agency's recovery from *Challenger*, oversaw his last launch. A new administrator, Daniel Goldin, greeted the crew when *Atlantis* touched down.

STS-49

DATES MAY 7-MAY 16, 1992
ORBITER *ENDEAVOUR*
CREW DANIEL BRANDENSTEIN
KEVIN CHILTON
BRUCE MELNICK
THOMAS AKERS
RICHARD HIEB
KATHRYN THORNTON
PIERRE THUOT
MISSION INTELSAT VI RESCUE

First flight of *Endeavour*, *Challenger's* replacement, restored the orbiter fleet to full strength. Rescuing INTELSAT VI exposed inadequacies in NASA's space-walk training. The massive spacecraft was stranded by a botched Titan launch, and its owners paid NASA $93 million to reboost it. Thuot and Hieb trained to grab it in one spacewalk, but the job took three spacewalks and an unprecedented three spacewalkers. Two days in a row, Thuot perched himself on the end of *Endeavour's* robot arm and tried in vain to capture Intelsat VI with a special clamp. After discussions among the crew, Brandenstein proposed to Mission Control that Akers join Hieb and Thuot outside in a last-ditch, six-handed grab. NASA balked, then relented. The trio undertook the daring feat on the mission's seventh day and shattered spacewalk duration records in the process. Once the rescuers had the satellite in their grasp, they attached a live rocket motor—another first. After INTELSAT VI had departed for its 51,000-mile-high orbit, Akers and Thorton demonstrated self-rescue tools in the fourth spacewalk of the mission.

STS-50

DATES JUNE 25-JULY 9, 1992
ORBITER *COLUMBIA*
CREW RICHARD RICHARDS
KENNETH BOWERSOX
BONNIE DUNBAR
CARL MEADE
ELLEN BAKER
LARRY DELUCAS
EUGENE TRINH
MISSION U.S. MICROGRAVITY LABORATORY (USML)-1

First extended duration orbiter flight. *Columbia* broke its own

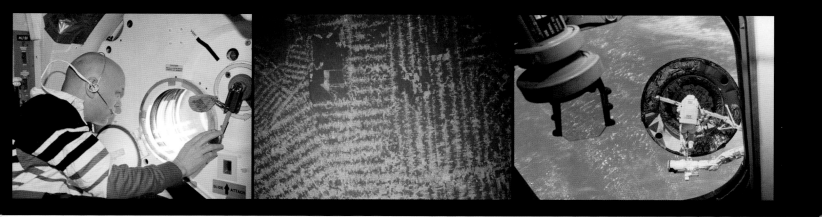

duration record on the 11th day of the longest-lasting shuttle mission up to that point. Freshly overhauled, *Columbia* was the first orbiter outfitted with a removable pallet of five extra fuel cell reactant storage tanks designed to permit longer stays in space. Among its other new technologies: a regenerative air purification system and more durable synthetic-tread tires for its first landing in Florida. USML-1 kicked off a series of Spacelab missions advancing microgravity research in several disciplines including human adaptation, bioprocessing, fluid physics, combustion physics, and crystal growth. Trinh was the first Vietnamese-American to fly on the shuttle.

STS-46

DATES JULY 31-AUGUST 8, 1992
ORBITER *ATLANTIS*
CREW LOREN SHRIVER
ANDREW ALLEN
JEFFREY HOFFMAN
FRANKLIN CHANG-DIAZ
MARSHA IVINS
CLAUDE NICOLLIER (EUROPE)
FRANCO MALERBA (ITALY)
MISSION TETHERED SATELLITE SYSTEM (TSS)-1, EUROPEAN RETRIEVABLE CARRIER (EURECA)

EURECA explored a new capability for long-term microgravity research. Cast away by Nicollier, the experiment-laden satellite would operate autonomously until its retrieval on STS-57 the following year. Nicollier, from Switzerland, was the first non-U.S. astronaut to deploy a payload with the shuttle's robot

arm. The other key payload reeled out of *Atlantis* at the end of a thin, insulated copper cord. Italy's TSS was designed to test the century-old theory that conductive cables can be used to generate power and thrust in space. More than 12 miles of string were supposed to unspool, but the tether hopelessly jammed, stopping the spherical satellite at a distance of 40 feet. The disappointed astronauts reeled in and returned TSS-1 to Earth for an investigation that found a protruding bolt. It got a second try four years later on STS-75. Shriver took the place of Robert "Hoot" Gibson, whom NASA grounded after his airplane collided with another at an air show, killing the other pilot.

STS-47

DATES SEPTEMBER 12-20, 1992
ORBITER *ENDEAVOUR*
CREW ROBERT "HOOT" GIBSON
CURTIS BROWN
MARK LEE
JAN DAVIS
JAY APT
MAE JEMISON
MAMORU MOHRI (JAPAN)
MISSION SPACELAB-J

The 50th shuttle flight, co-sponsored by the National Space Development Agency of Japan, made Mohri, the first Japanese shuttle astronaut, a hero in his homeland. Americans were more interested in Jemison, the first African-American woman in space, and Lee and Davis, the first spouses to fly together in space. To NASA's dismay, the unprecedented pairing of astro-

nauts who married after being assigned to the mission prompted press speculation about whether the couple would have sex in space. If five other crew members in close quarters and zero-g were not prohibitive enough, the work schedules were. Lee and Davis were on opposite teams carrying out 43 experiments in life and materials sciences around the clock. First embryos fertilized and developed in space, in an experiment with frogs. Absence of weather and mechanical delays made it the first on-time shuttle launch since STS 61-B was launched in 1985.

STS-52

DATES OCTOBER 22-NOVEMBER 1, 1992
ORBITER *COLUMBIA*
CREW JAMES WETHERBEE
MICHAEL BAKER
CHARLES "LACY" VEACH
TAMARA JERNIGAN
WILLIAM SHEPHERD
STEVEN MACLEAN (CANADA)
MISSION U.S. MICROGRAVITY PAYLOAD (USMP)-1, LAGEOS II

LAGEOS II, a prism-covered sphere, reflected beams from four Earth-based lasers to ground stations measuring continental drift for earthquake research. After leaving the shuttle, it rode to a 2,200-mile orbit atop a pair of rocket motors that ignited in succession. USMP-1 featured the first cooperative research by France and the United States into how materials change state in the absence of gravity. First demonstration of a machine

vision system designed to make it easier to operate robotic devices like the shuttle arm.

STS-53

DATES DECEMBER 2-9, 1992
ORBITER *DISCOVERY*
CREW DAVID "RED DOG" WALKER
ROBERT "MIGHTY DOG" CABANA
GUION "DOGGONE" BLUFORD
JAMES "DOGFACE" VOSS
MICHAEL "RICH" "PUPPY DOG" CLIFFORD
MISSION DEPARTMENT OF DEFENSE

Tenth and last planned mission for the Department of Defense. The Air Force tried a new mode of secrecy. NASA's public space-to-ground broadcast channel was disconnected until after *Discovery*'s DOD-1 cargo—reported to be the second SDS-2 missile warning communications satellite—was released on the first day. When normal mission commentary and television coverage resumed, NASA shielded the empty cargo bay by showing only in-cabin views of the self-proclaimed "Dogs of War" crew testing unclassified hardware for reconnaissance and covert communications. Walker, stripped of his STS-44 command, got his wings back. After *Endeavour* landed, toxic fumes from a leaky thruster trapped the crew in the orbiter for two hours.

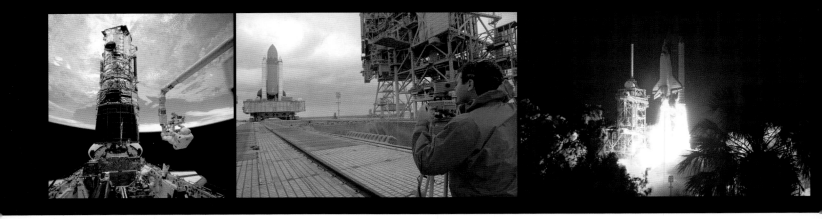

STS-54

DATES JANUARY 13-19, 1993
ORBITER *ENDEAVOUR*
CREW JOHN CASPER
DONALD MCMONAGLE
MARIO RUNCO
GREGORY HARBAUGH
SUSAN HELMS
MISSION TDRS-6, DIFFUSE X-RAY
SPECTROMETER (DXS),
SPACEWALK

TDRS-6 was the fifth member of the Tracking and Data Relay Satellite System. Like TDRS-5 (STS-43), it replaced a degraded member of the network, which handles voice, video, and data communications between space shuttle crews and NASA Mission Control. First in a series of "generic" spacewalks to evaluate ground-training fidelity after STS-49 revealed neutral buoyancy simulations did not match the astronauts' actual experience. The automated DXS detected invisible clouds of hot gas in the seemingly empty space between the stars. Debut of a ballyhooed $30 million zero-g potty promising to require less in-flight maintenance than the original shuttle toilet. First deliberate shutdown and restart of an electricity-making shuttle fuel cell. Crew and Mission Control rang handbells for President Bill Clinton's inauguration.

STS-56

DATES APRIL 8-17, 1993
ORBITER *DISCOVERY*
CREW KENNETH CAMERON
STEPHEN OSWALD
KENNETH COCKRELL
MICHAEL FOALE
ELLEN OCHOA
MISSION ATLAS-2, SPARTAN-201-01

Discovery flew following an abortive launch attempt with STS-55. Trouble-free ascent despite pliers lodged in the shuttle's right-hand solid rocket booster found in a post-flight inspection. ATLAS-2 complemented STS-45 by examining the atmosphere over the northern hemisphere for evidence of ozone depletion with seven remote-controlled instruments. Astronauts also made a study of solar wind with SPARTAN, the reusable carrier that debuted on STS-51G. Ochoa became the first Hispanic woman in space. Foale, who later would live aboard the Russian space station, made the first ship-to-ship radio contact with Mir by shuttle amateur radio.

STS-55

DATES APRIL 26-MAY 6, 1993
ORBITER *COLUMBIA*
CREW STEVEN NAGEL
TERENCE "TOM" HENRICKS
JERRY ROSS
CHARLES PRECOURT
BERNARD HARRIS
ULRICH WALTER (GERMANY)
HANS SCHLEGEL (GERMANY)
MISSION SPACELAB D-2

Launch succeeded on fourth try, five weeks after a pad abort in which a contaminated engine valve stopped *Columbia* three

seconds short of liftoff. Germany's second exclusively financed and managed Spacelab mission was its last, owing to the high cost of reunification. German payload specialists Schlegel and Walter worked with five Americans around the clock on 88 mostly German studies in human physiology, biology, materials science, fluid physics, robotics, Earth observation, and astronomy. Many were sequels to experiments on Nagel's STS-61A mission. *Columbia* logged its 100th day and the shuttle fleet's 365th day in orbit on its 14th flight.

STS-57

DATES JUNE 21-JULY 1, 1993
ORBITER *ENDEAVOUR*
CREW RONALD GRABE
BRIAN DUFFY
DAVID LOW
NANCY SHERLOCK (CURRIE)
JANICE VOSS
PETER "JEFF" WISOFF
MISSION SPACEHAB-1, EURECA
RETRIEVAL, SPACEWALK

A low-key spacewalk by Low and Wisoff suddenly became top priority when EURECA—captured by the robot arm 11 months after its deployment on STS-46—needed repair. The experiment carrier's two communications antennas could not be stowed. Low forced them into their latches to ensure the shuttle's safe return to Earth. First flight of the Spacehab mid-deck augmentation module, quadrupling habitable volume with commercial accommodations for small, astronaut-tended experiments.

STS-51

DATES SEPTEMBER 12-22, 1993
ORBITER *DISCOVERY*
CREW FRANK CULBERTSON
WILLIAM READDY
JAMES NEWMAN
DANIEL BURSCH
CARL WALZ
MISSION ACTS/TOS, ORFEUS-SPAS,
SPACEWALK

An accident during deployment of NASA's Advanced Communications Technology Satellite left *Discovery* with a hole in its aft bulkhead. When Walz fired explosive connectors to spring-eject ACTS and its Transfer Orbit Stage, the satellite's cradle broke apart and a small piece of metal punctured the cargo bay wall in front of the orbiter's engines. *Discovery* and crew got home safely after the incident, which investigators blamed on a design flaw. Only one of the two major payloads was left in orbit. Germany's Orbiting and Retrievable Far and Extreme Ultraviolet Spectrograph-Shuttle Pallet Satellite (ORFEUS-SPAS) came back after six days of astronomy research. Walz and Newman walked in space to test a hand-warming procedure for the Hubble Space Telescope repair crew. First nighttime landing in Florida.

STS-58

DATES OCTOBER 18-NOVEMBER 1, 1993
ORBITER COLUMBIA
CREW JOHN BLAHA
RICHARD SEARFOSS
RHEA SEDDON
WILLIAM MCARTHUR
DAVID WOLF
SHANNON LUCID
MARTIN FETTMAN
MISSION SLS-2

First animal dissections in space: five of the 48 lab rats aboard *Columbia*. The other 43 returned with the crew. Two medical doctors, a veterinarian, and a biochemist conducted most of the 14 major experiments on the follow-up mission to STS-40. The astronauts drew blood, gave urine and saliva samples, and exercised vigorously so scientists could learn more about human health in the absence of gravity. Two members of the original shuttle astronaut class marked space flight milestones. Lucid set a duration record for women. Seddon surpassed her husband, Robert "Hoot" Gibson, in cumulative hours in orbit.

STS-61

DATES DECEMBER 2-13, 1993
ORBITER ENDEAVOUR
CREW RICHARD COVEY
KENNETH BOWERSOX
STORY MUSGRAVE
JEFFREY HOFFMAN
KATHRYN THORNTON
THOMAS AKERS
CLAUDE NICOLLIER (EUROPE)
MISSION FIRST HUBBLE SPACE
TELESCOPE SERVICING

NASA's most ambitious shuttle mission yet, with five spacewalks back-to-back, lasting more than 35 hours altogether. Astronauts working in pairs on alternate days—Musgrave and Hoffman, then Akers and Thornton—fixed the Hubble Space Telescope's power and pointing systems and corrected its fuzzy focus. The refurbishment included solar arrays, gyroscopes, an improved planetary camera, and a system of tiny mirrors designed to compensate for the flaw in the primary mirror discovered after STS-31. The successful flight boosted NASA's confidence in the astronaut corps' ability to assemble and maintain an even bigger satellite—the International Space Station.

STS-60

DATES FEBRUARY 3-11, 1994
ORBITER DISCOVERY
CREW CHARLES BOLDEN
KENNETH REIGHTLER
FRANKLIN CHANG-DIAZ
JAN DAVIS
RONALD SEGA
SERGEI KRIKALEV (RUSSIA)
MISSION FIRST COSMONAUT ON A
SHUTTLE, WAKE SHIELD,
SPACEHAB-2

First joint U.S.-Russian space mission since 1975. Krikalev, veteran of two lengthy stays aboard Russia's space station, kicked off an exchange that let several Russians ride shuttles and seven Americans live on Mir. As a full-fledged mission specialist, Krikalev enjoyed privileges payload specialists do not—such as operating *Discovery*'s robot arm. The Wake Shield Facility (WSF)-1 was supposed to fly free of the shuttle for two days making semiconductors, but a guidance glitch confined the saucer-shaped factory to the end of the robot arm. Left without a satellite to cast away and capture, the crew also had trouble with some of the science experiments conducted in the commercial Spacehab module.

STS-62

DATES MARCH 4-18, 1994
ORBITER COLUMBIA
CREW JOHN CASPER
ANDREW ALLEN
CHARLES "SAM" GEMAR
MARSHA IVINS
PIERRE THUOT
MISSION USMP-2, OAST-2

Astronauts did space station prep work in the mid-deck, while automated equipment in the cargo bay carried on the mission's main objectives. Together, United States Microgravity Payload (USMP)-2 and Office of Aeronautics and Space Technology (OAST)-2 focused on metallurgical research into lighter and stronger alloys for the automotive, aerospace, construction, and electronics industries. Late in the flight, the crew exercised *Columbia*'s robot arm with a magnetic gripper that improved its dexterity in handling large objects. First crew to view a video replay of launch while still in orbit.

STS-59

DATES APRIL 9-20, 1994
ORBITER ENDEAVOUR
CREW SIDNEY GUTIERREZ
KEVIN CHILTON
LINDA GODWIN
JAY APT
MICHAEL "RICH" CLIFFORD
THOMAS JONES
MISSION SPACE RADAR LABORATORY
(SRL)-1

First of two nearly identical missions using two sophisticated radars—one from the United States, the other provided by Germany and Italy—to gather data about Earth's changing environment. Crewmember training for the flights was equivalent to a college degree in geography. *Endeavour* maneuvered a record 412 times as the astronauts trained the radars on environmentally sensitive locales around the globe. The crew supplemented the radar pictures with 14,000 photographs. SRL-1 verified the imagers' operation and performance. Gutierrez was the first Hispanic shuttle commander.

STS-65

DATES JULY 8-23, 1994
ORBITER COLUMBIA
CREW ROBERT CABANA
JAMES HALSELL
RICHARD HIEB
DONALD THOMAS
CARL WALZ
LEROY CHIAO
CHIAKI MUKAI (JAPAN)
MISSION IML-2

Investigations on the second International Microgravity Laboratory mission represented 13

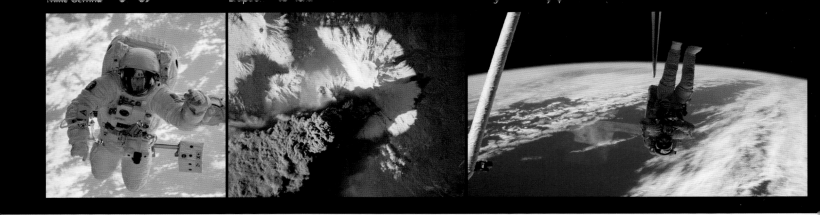

countries and six of the world's space agencies. Spacelab housed more than 80 experiments, double the number on STS-42, two years earlier. Half the agenda involved metals, fluids, and manufacturing processes. The other half involved the reproductive behaviors of living creatures. *Columbia* returned to Earth with more than 30 fish and 75 newts born in the absence of gravity. For the first time, a video camera placed in the cockpit recorded launch and re-entry from the crew's perspective. Mukai became the first Japanese woman to fly in space.

STS-64
DATES SEPTEMBER 9-20, 1994
ORBITER *DISCOVERY*
CREW RICHARD RICHARDS
BLAINE HAMMOND
SUSAN HELMS
CARL MEADE
MARK LEE
JERRY LINENGER
MISSION LITE, SPARTAN-201-02, SPACEWALK

First untethered extravehicular activity since STS-51A in 1984. Lee and Meade unhooked safety restraints but stayed close to the cargo bay as they test-flew SAFER, the Simplified Aid for EVA Rescue. Much smaller and less versatile than the Manned Maneuvering Units flown on satellite rescues in the 1980s, the SAFER jetpack would help an astronaut who accidentally came untethered during a spacewalk. The Lidar in Space Technology Experiment (LITE) used laser beams to measure the altitude and density of clouds

and their effect on climate. SPARTAN-201 repeated its STS-56 study of solar wind. *Discovery* flew before *Endeavour* following an abortive launch attempt with STS-68.

STS-68
DATES SEPTEMBER 30-OCTOBER 11, 1994
ORBITER *ENDEAVOUR*
CREW MICHAEL BAKER
TERRENCE WILCUTT
THOMAS JONES
DANIEL BURSCH
PETER "JEFF" WISOFF
STEVEN SMITH
MISSION SRL-2

Launch succeeded on second attempt. A faulty fuel pumping mechanism snuffed out *Discovery*'s engines only 1.9 seconds before the attempted liftoff on August 18. Fifth pad abort—third in 18 months—denied Jones an astronaut corps record for shortest turnaround between shuttle flights. SRL-2 focused on seasonal changes in Earth's environment with the most advanced civilian radars ever made. *Endeavour* passed over the same targets observed on STS-59 earlier that year, allowing scientists to combine slightly different viewing angles to generate extremely accurate topographical maps.

STS-66
DATES NOVEMBER 3-14, 1994
ORBITER *ATLANTIS*
CREW DONALD MCMONAGLE
CURTIS BROWN
ELLEN OCHOA
JOSEPH TANNER
SCOTT PARAZYNSKI
JEAN-FRANCOIS CLERVOY (EUROPE)
MISSION ATLAS-3, CRISTA-SPAS

Like the two previous ATLAS missions, STS-45 and -56, ATLAS-3 gathered data on the health of Earth's sun-blocking ozone layer. Despite the first-day failure of a key atmospheric sounder, eight remaining instruments carried on—six from their perch in the cargo bay and two on a Shuttle Pallet Satellite called CRISTA that flew free of *Atlantis* for eight days. First time a U.S. spacecraft returned to Earth with ice attached. The frozen lump was part of a huge icicle, formed on the orbiter's cargo bay door during a water dump, big enough to survive the searing heat of re-entry.

STS-63
DATES FEBRUARY 3-11, 1995
ORBITER *DISCOVERY*
CREW JAMES WETHERBEE
EILEEN COLLINS
BERNARD HARRIS
MICHAEL FOALE
JANICE VOSS
VLADIMIR TITOV (RUSSIA)
MISSION MIR RENDEZVOUS, SPARTAN-204, SPACEWALK, SPACEHAB-3

First woman shuttle pilot, Collins, operated radar for an unprecedented rendezvous with Russia's space station. Commander Wetherbee flew *Discovery*

within 37 feet of Mir, and crews aboard both spacecraft waved at each other. Fearing the orbiter's leaky thrusters would contaminate Mir, Russian Mission Control almost canceled the close encounter. *Discovery* was approaching as Houston hammered out a last-minute agreement. The rendezvous was a pathfinder for STS-71, which months later became the first shuttle docking at Mir. Most diverse crew since STS-8 included Titov, the second cosmonaut to board a shuttle, and Harris, the first African-American spacewalker. Harris and Foale complained of bitter cold in a test of spacesuit heater improvements, and curtailed a spacewalk in which they briefly practiced handling techniques with SPARTAN-204. The reusable satellite (STS-51G) had been released to observe galactic dust clouds earlier in the flight.

STS-67
DATES MARCH 2-18, 1995
ORBITER *ENDEAVOUR*
CREW STEPHEN OSWALD
WILLIAM GREGORY
TAMARA JERNIGAN
WENDY LAWRENCE
JOHN GRUNSFELD
SAMUEL DURRANCE
RONALD PARISE
MISSION ASTRO-2 OBSERVATORY

Astro-2 had none of the technical problems that beset the first mission in the series, STS-35. The computerized Spacelab Instrument Pointing System worked as designed. The crew tracked a long list of quasars,

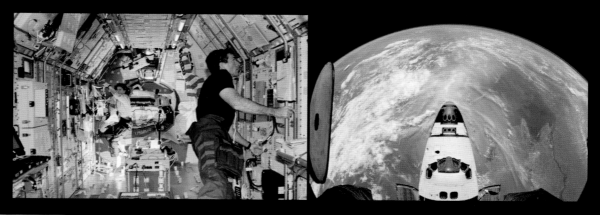

explosive stars, and colliding galaxies with three ultraviolet telescopes. First shuttle mission with its own site on the Internet. More than 200,000 computers in 59 countries logged on to an Astro-2 home page and left 2.4 million information requests in 15 days.

STS-71

DATES JUNE 27-JULY 7, 1995
ORBITER *ATLANTIS*
CREW ROBERT "HOOT" GIBSON
CHARLES PRECOURT
ELLEN BAKER
GREGORY HARBAUGH
BONNIE DUNBAR
UP: ANATOLY SOLOVYEV (RUSSIA)
NIKOLAI BUDARIN (RUSSIA)
DOWN: VLADIMIR DEZHUROV
(RUSSIA)
GENNADY STREKALOV
(RUSSIA)
NORMAN THAGARD
MISSION FIRST MIR DOCKING

Second of 10 "shuttle-Mir" missions in which the United States gained experience in long-duration flight operations aboard Russia's station. *Atlantis* was fitted with a special docking mechanism to enable the first linkup of U.S. and Russian orbiting spacecraft since the Apollo-Soyuz Test Project. When linked, *Atlantis* and Mir formed the largest spacecraft ever in orbit. In the first on-orbit shuttle crew change out, *Atlantis* retrieved Thagard—who went to Mir in a Soyuz capsule—after his 115-day stay. Mir 19 crewmen Solovyev and Budarin relieved Dezhurov and Strekalov of Mir 18—with Thagard, the first space travelers to return to Earth

in a vehicle other than the one that took them to orbit. For five days, the combined crews conducted biomedical investigations and transferred equipment and supplies between the two spacecraft. The 100th U.S. human space flight carried an American flag flown on the first, Alan Shepard's 1961 Freedom 7 Mercury mission. For the first time since STS-51L, hot gas damage was seen on O-rings in a shuttle solid rocket booster.

STS-70

DATES JULY 13-22, 1995
ORBITER *DISCOVERY*
CREW TERENCE "TOM" HENRICKS
KEVIN KREGEL
NANCY CURRIE
DONALD THOMAS
MARY ELLEN WEBER
MISSION NASA TRACKING AND DATA
RELAY SATELLITE

Woodpeckers poked 200 holes in the foam insulation on *Discovery*'s external fuel tank, forcing the shuttle off the launchpad for repairs. The mission lost its original designation as the 100th U.S. human spaceflight but set a record for the quickest turnaround between a landing and a launch. First flight of a new "Block 1" shuttle main engine with an improved oxidizer turbopump. TDRS-7, the sixth and last NASA Tracking and Data Relay Satellite deployed from a shuttle, replaced one lost with

Challenger. While *Discovery* was aloft, STS-71 post-flight inspections found soot on primary O-rings in *Atlantis*' solid rocket booster nozzles. *Discovery*'s O-rings suffered similar damage, prompting NASA to ground the shuttle fleet briefly.

STS-69

DATES SEPTEMBER 7-18, 1995
ORBITER *ENDEAVOUR*
CREW DAVID "RED DOG" WALKER
KENNETH "CUJO" COCKRELL
JAMES "DOGFACE" VOSS
MICHAEL "UNDERDOG"
GERNHARDT
JAMES "PLUTO" NEWMAN
MISSION WSF-2, SPARTAN 201-03,
SPACEWALK

First crew to deploy and retrieve two payloads. Improving on STS-60, the Wake Shield Facility (WSF)-2 flew free of *Endeavour* for three days. It manufactured a few thin gallium arsenide wafers for advanced electronics, but wobbled and flipped in the process. It was the first spacecraft to maneuver itself away from the orbiter, rather than the other way around. Frequent free-flyer SPARTAN made its third study of solar wind (STS-64). Spacesuits with improved heaters kept Voss and Gernhardt comfortable during a spacewalk to test tools and techniques for space station assembly. Second flight of a "dog crew" with original members Walker and Voss from the 1992 mission STS-53.

STS-73

DATES OCTOBER 20-NOVEMBER 5,
1995
ORBITER *COLUMBIA*
CREW KENNETH BOWERSOX
KENT ROMINGER
KATHRYN THORNTON
CATHERINE "CADY"
COLEMAN
MICHAEL LOPEZ-ALEGRIA
FRED LESLIE
ALBERT SACCO
MISSION USML-2

A successful launch after six scrubs tied STS-73 with STS-61-C for most postponed. USML-2 built on Spacelab research from STS-50 in five areas—fluid physics, materials science, biotechnology, combustion science, and commercial space processing. Crew videotaped Bowersox throwing the ceremonial first pitch for Game 5 of baseball's World Series; the television audience saw the ball head toward the camera then appear to fall from the sky into Jacob's Field, home of the Cleveland Indians.

STS-74

DATES NOVEMBER 12-20, 1995
ORBITER *ATLANTIS*
CREW KENNETH CAMERON
JAMES HALSELL
CHRIS HADFIELD
JERRY ROSS
WILLIAM MCARTHUR
MISSION SECOND MIR DOCKING

Atlantis attached a Russian-built docking module to Mir, a permanent extension that afforded better clearance for the U.S. winged orbiters. Two solar power arrays were stowed on

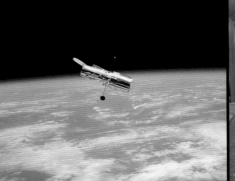

the module for spacewalking cosmonauts to install later. The crew dropped off fresh water and air purifiers and picked up numerous life science experiment specimens.

STS-72

DATES JANUARY 11-20, 1996
ORBITER *ENDEAVOUR*
CREW BRIAN DUFFY
BRENT JETT
DANIEL BARRY
LEROY CHIAO
WINSTON SCOTT
KOICHI WAKATA (JAPAN)
MISSION SFU, SPARTAN-206 (OAST-FLYER), TWO SPACEWALKS

First NASA capture of another country's satellite for return to Earth. Plucked from orbit on the third day, Japan's Space Flyer Unit (SFU) completed a 10-month scientific mission involving almost a dozen experiments ranging from materials science to biology. NASA's experiment-laden Office of Aeronautics and Space Technology Flyer (OAST-Flyer) marked the first non-astronomy use of the adaptable SPARTAN carrier (STS-51G). Chiao walked in space on two days—first with Barry, then with Scott—while the astronauts tested work platforms, utility boxes, and connectors designed for space station assembly. President Bill Clinton attended the crew's homecoming ceremony in Houston.

STS-75

DATES FEBRUARY 22-MARCH 9, 1996
ORBITER *COLUMBIA*
CREW ANDREW ALLEN
SCOTT "DOC" HOROWITZ
FRANKLIN CHANG-DIAZ
JEFFREY HOFFMAN
MAURIZIO CHELI (EUROPE)
CLAUDE NICOLLIER (EUROPE)
UMBERTO GUIDONI (ITALY)
MISSION TSS-1R, USMP-3

Five STS-46 crew members were back to try again with Italy's Tethered Satellite System (TSS), a risky mission to generate electricity by flying a satellite at the end of a 12.8-mile-long braided wire. The bolt that tangled the insulated copper cord on the earlier mission was gone. But some metal shavings that escaped NASA's inspection punctured the tether and triggered a short circuit. The tether was nearly at full length, generating electricity and producing scientific data when it snapped. NASA considered giving chase as the satellite sped away from the orbiter, but *Columbia* did not have enough propellant. In contrast, the materials and fluids experiments in U.S. Microgravity Payload (USMP)-3 operated free of trouble, controlled from a Spacelab science headquarters on the ground. Seventy-fifth flight of the space shuttle program and 50th flight since *Challenger*.

STS-76

DATES MARCH 22-31, 1996
ORBITER *ATLANTIS*
CREW KEVIN CHILTON
RICHARD SEARFOSS
RONALD SEGA
MICHAEL "RICH" CLIFFORD
LINDA GODWIN
UP: SHANNON LUCID
MISSION THIRD MIR DOCKING, SPACEWALK

Lucid became the first American woman to live on the Russian station, kicking off a two-year period of continuous U.S. presence in space. *Atlantis* took Lucid to the Mir 21 crew of Yuri Onufrienko and Yuri Usachev, left supplies, and came back to Earth with 1,200 pounds of trash, used science equipment, and experiment specimens. Godwin and Clifford mounted four orbital debris detectors outside the station on the sixth flight day, damaging their spacesuit gloves as they climbed over and around the docking module attached to Mir on STS-74. The first astronauts to float outside two mated spacecraft wore SAFERs, the maneuverable rescue backpacks tested on STS-64, because *Atlantis* could not break free to rescue them if their safety tethers broke.

STS-77

DATES MAY 19-29, 1996
ORBITER *ENDEAVOUR*
CREW JOHN CASPER
CURTIS BROWN
ANDREW THOMAS
DANIEL BURSCH
MARIO RUNCO
MARC GARNEAU
MISSION SPARTAN-207 (IAE), SPACEHAB

Rendezvous activities with a parabolic reflector the size of a tennis court highlighted the first shuttle research mission devoted to expansion of the commercial space frontier. The Inflatable Antenna Experiment (IAE) popped out of a small box on the frequent-flying SPARTAN carrier (STS-51G). Astronauts took pictures and video as IAE ballooned into a structure 50 feet in diameter and 92 feet long, then they jettisoned the antenna before retrieving SPARTAN. Spacehab supported 10 commercial development experiments in agriculture, biotechnology, and space-based drug and semiconductor manufacturing.

STS-78

DATES JUNE 20-JULY 7, 1996
ORBITER *COLUMBIA*
CREW TERENCE "TOM" HENRICKS
KEVIN KREGEL
SUSAN HELMS
RICHARD LINNEHAN
CHARLES BRADY
JEAN-JACQUES FAVIER
ROBERT THIRSK
MISSION LIFE AND MICROGRAVITY SPACELAB (LMS)

LMS work mimicked future space station operations, with the most extensive telescience to

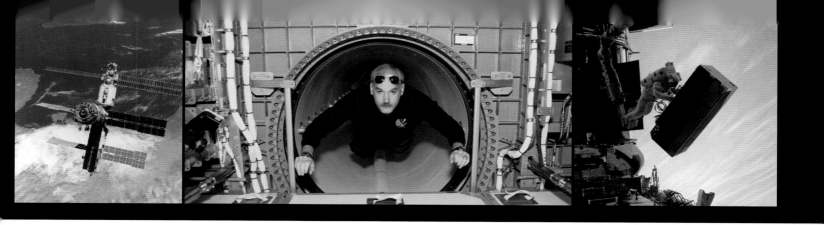

date by investigators located at eight remote locations in Europe and the United States. Ten nations and five of the world's space agencies provided more than 40 experiments in human physiology, space biology, fluid physics, and materials science. Mission made extensive use of video to help crewmembers fix broken experiment hardware. First live cockpit views during strap-in and launch, plus touch-down from pilot's-point-of-view camera. A year-long spate of solid rocket booster problems continued, with evidence of damage to thermal barriers that had been added to booster joints to protect critical O-rings after STS-51L.

STS-79
DATES SEPTEMBER 16-26, 1996
ORBITER *ATLANTIS*
CREW WILLIAM READDY
TERRENCE WILCUTT
THOMAS AKERS
JAY APT
CARL WALZ
UP: JOHN BLAHA
DOWN: SHANNON LUCID
MISSION FOURTH-MIR DOCKING

First U.S. crew exchange at Russia's space station, Mir, Blaha for Lucid. The combined crews hauled two tons of food, water, and supplies from *Atlantis* into Mir and a ton of science experiments and specimens in the other direction. Lucid set a world space flight duration record for women—and for U.S. astronauts—while waiting on Mir for her ride back to Earth. Two hurricanes chased the shuttle off its launch pad, and solid

rocket booster concerns conspired to delay *Atlantis* almost seven weeks. The shuttle got a fresh set of boosters because its original pair was assembled with an adhesive blamed for leakage on STS-78, but insulation in the right booster nozzle still suffered unusual hot-gas erosion. After the launch, inspectors found a stray wrench in an electronics compartment atop one of the spent boosters but said no damage had been done.

STS-80
DATES NOVEMBER 19-DECEMBER 7, 1996
ORBITER *COLUMBIA*
CREW KENNETH COCKRELL
KENT ROMINGER
TAMARA JERNIGAN
THOMAS JONES
STORY MUSGRAVE
MISSION WSF-3, ORFEUS-SPAS II, SPACEWALKS

The first spacewalks ever attempted from *Columbia* were canceled when a loose screw jammed the latching mechanism in the airlock's outer hatch, keeping Jernigan and Jones inside. The orbiter led an unprecedented parade of three spacecraft in close formation. For three days, the Wake Shield Facility (WSF)-2 trailed by 25 miles. After a shaky start, WSF-2 made up for its poor performance on STS-60 and STS-69. The 12-ton, 12-foot-wide steel disk almost collided with *Columbia* when it was released, but still produced a full order of semiconductor wafers in a "clean zone" on its lee side. Bringing up the rear was Germany's ORFEUS-SPAS II, released shortly

after liftoff for two weeks of uninterrupted astronomy research. Launch postponed three weeks for a hurricane and a probe of STS-79's severe booster rocket nozzle erosion. With two bad-weather landing delays, *Columbia* set the shuttle duration record. Musgrave, at 61, became the oldest person in space to date. He tied fellow astronaut John Young's record of six launches from Earth and became the first person to fly on all five shuttles.

STS-81
DATES JANUARY 12-22, 1997
ORBITER *ATLANTIS*
CREW MICHAEL BAKER
BRENT JETT
PETER "JEFF" WISOFF
JOHN GRUNSFELD
MARSHA IVINS
UP: JERRY LINENGER
DOWN: JOHN BLAHA
MISSION FIFTH MIR DOCKING

Atlantis delivered food, clothing, water and other vital supplies to Mir as the cash-strapped Russian space program acknowledged it was depending on NASA to keep the 11-year-old station alive. Among science gear and specimens returned were the first plants to complete a life cycle in space, a crop of wheat grown from seed to seed. Linenger relieved Blaha, then endured life support system breakdowns and fought a fire that almost forced an evacuation. Late in his stay, Linenger became the first American to spacewalk outside a foreign spacecraft, with Mir 23's Vasily Tsibliev.

STS-82
DATES FEBRUARY 11-21, 1997
ORBITER *DISCOVERY*
CREW KENNETH BOWERSOX
SCOTT "DOC" HOROWITZ
MARK LEE
STEVEN HAWLEY
GREGORY HARBAUGH
STEVEN SMITH
JOSEPH TANNER
MISSION SECOND HUBBLE SPACE TELESCOPE SERVICING

Second of four planned service calls. Five spacewalks tied STS-61 record. Working in pairs on alternating days, Lee, Smith, Harbaugh and Tanner installed 11 major components in the Hubble Space Telescope—updating 1970s technology with 1990s parts. Impromptu fifth spacewalk had Lee and Smith patching sun-damaged thermal covering with items scrounged aboard *Discovery*. Total duration of 33 hours 11 minutes was two hours shy of STS-61 record. Hawley, who deployed Hubble on STS-31, used the robot arm to retrieve the telescope for repairs, then released it in a higher orbit. For *Discovery*'s nighttime return, Kennedy Space Center's runway sported new halogen centerline lights for better visibility.

STS-83
DATES APRIL 4-8, 1997
ORBITER *COLUMBIA*
CREW JAMES HALSELL
SUSAN STILL (KILRAIN)
JANICE VOSS
MICHAEL GERNHARDT
DONALD THOMAS
ROGER CROUCH
GREGORY LINTERIS
MISSION MICROGRAVITY SCIENCES LABORATORY (MSL)-1

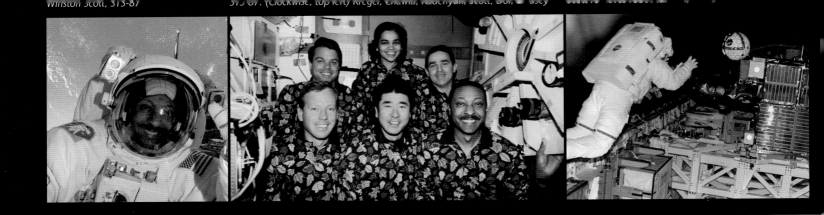

Threat of fire and explosion from a faulty power generator cut the mission 12 days short. Suspect fuel cell exhibited a voltage spike during the launch countdown but nonetheless was cleared to fly. Its loss cut more than half the electricity available to the Spacelab, where most of 33 MSL-1 experiments were located. Crew squeezed 15 percent of desired data from two dozen experiments conducted by flashlight while waiting to land. Astronauts dimmed lights and turned off non-essential equipment to conserve power. Mission repeated three months later as STS-94.

STS-84

DATES MAY 15-24, 1997
ORBITER *ATLANTIS*
CREW CHARLES PRECOURT
EILEEN COLLINS
JEAN-FRANCOIS CLERVOY
(EUROPE)
CARLOS NORIEGA
EDWARD LU
ELENA KONDAKOVA (RUSSIA)
UP: MICHAEL FOALE
DOWN: JERRY LINENGER
MISSION SIXTH MIR DOCKING

Urgent deliveries—a spare oxygen generator, plugs for a leaky air conditioner, air-quality monitors, and fresh drinking water—accompanied Foale, who was trained to repair life support systems that broke down during Linenger's stay on Russia's space station. For weeks, NASA debated whether it was safe to send Foale. Foale later would struggle to revive electrical and computer systems crippled when a careening cargo ship

breached Mir's hull and would search for the puncture in a spacewalk with Mir 24 Commander Anatoly Solovyev. Foale had been to Mir, but not inside, on STS-63. Kondakova, now the first Russian woman to fly on a U.S. spaceship, had been aboard the station then.

STS-94

DATES JULY 1-17, 1997
ORBITER *COLUMBIA*
CREW JAMES HALSELL
SUSAN STILL (KILRAIN)
JANICE VOSS
MICHAEL GERNHARDT
DONALD THOMAS
ROGER CROUCH
GREGORY LINTERIS
MISSION MSL-1 REFLIGHT

First reflight of same orbiter, crew, and payloads. MSL-1 investigated effects of weightlessness on combustion, metal casting, and other physical processes. Unlike STS-83, the mission was completed in near-perfect form. Many experiments were precursors to ones planned aboard the new International Space Station. Some tested scientific hardware that would be installed there. Three-month turnaround between launches of same orbiter was a post-*Challenger* record.

STS-85

DATES AUGUST 7-19, 1997
ORBITER *DISCOVERY*
CREW CURTIS BROWN
KENT ROMINGER
JAN DAVIS
ROBERT CURBEAM
STEPHEN ROBINSON
BJARNI TRYGGVASON
(CANADA)
MISSION CRISTA-SPAS-02

Data from STS-66 and the second flight of Cryogenic Infrared Spectrometers and Telescopes for the Atmosphere-Shuttle Pallet Satellite (CRISTA-SPAS)-02 yielded new insight into the distribution of ozone in Earth's atmosphere. Once 200 hours of data-taking with the free-flyer were complete, CRISTA-SPAS stood in for the International Space Station's massive propulsion module as the crew rehearsed robot arm movements that would be used later to join the first ISS components. Davis and Robinson also exercised a small Japanese-built robot arm, then stood guard to make sure the arm did no damage as ground controllers took a turn operating it. Tryggvason was the first native of Iceland to fly in space.

STS-86

DATES SEPTEMBER 25-OCTOBER 6, 1997
ORBITER *ATLANTIS*
CREW JAMES WETHERBEE
MICHAEL BLOOMFIELD
JEAN-LOUP CHRETIEN
(FRANCE)
WENDY "TOO SHORT" LAWRENCE
SCOTT "TOO TALL" PARAZYNSKI
VLADIMIR TITOV (RUSSIA)
UP: DAVID WOLF
DOWN: MICHAEL FOALE
MISSION SEVENTH MIR DOCKING

Atlantis' last trip to Mir. First shuttle visit since a Russian cargo ship collided with the space station three months earlier. Wolf became the sixth American tenant on Mir, despite objections by NASA insiders and members of Congress who believed the outpost had become a deathtrap. Administrator Goldin's 11th-hour approval ended one of the most agonizing debates in space flight history. Wolf substituted for Lawrence because her arms were too short to fit in a Russian spacewalking suit, and officials on both sides wanted someone who could assist with collision repairs. Foale had gone in place of Parazynski, dumped for being too tall to fit in the Soyuz escape capsule. *Atlantis* delivered a replacement for Mir's central computer and patching materials for its crash-damaged hull. On the first joint U.S.-Russian spacewalk during a shuttle mission, Titov and Parazynski retrieved debris collectors left outside Mir the previous year on STS-76.

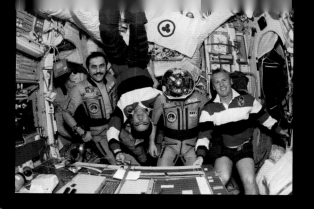

STS-87

DATES NOVEMBER 19-DECEMBER 5, 1997

ORBITER: *COLUMBIA*

CREW KEVIN KREGEL
STEVEN LINDSEY
KALPANA CHAWLA
TAKAO DOI (JAPAN)
WINSTON SCOTT
LEONID KADENYUK (UKRAINE)

MISSION USMP-4, SPARTAN-201-04, SPACEWALKS

First spacewalks from *Columbia*. Doi—the first Japanese spacewalker—and Scott rescued SPARTAN 201-04 after *Columbia*'s crew botched its deployment with the robot arm. Chawla accidentally released the satellite in idle mode, then knocked it into a tumble when she tried to grab it. SPARTAN's solar physics mission was retried on STS-95 a year later. A second outing tested space station construction tools considered indispensable—a crane and a radio-controlled flying camera. The U.S. Microgravity Payload (USMP)-4 suite of 11 automated experiments focused on materials science, combustion science, and fundamental physics. Eighth mission in 11 months capped shuttle's busiest year since 1992. Payload specialist Kadenyuk had been a Russian space shuttle pilot.

STS-89

DATES JANUARY 22-31, 1998

ORBITER *ENDEAVOUR*

CREW TERRENCE WILCUTT
JOE EDWARDS
MICHAEL ANDERSON
BONNIE DUNBAR
JAMES REILLY
SALIZHAN SHARIPOV (RUSSIA)

UP: ANDREW THOMAS

DOWN: DAVID WOLF

MISSION EIGHTH MIR DOCKING

Endeavour sported three new, more robust main engines with wider combustion throats. First orbiter other than *Atlantis* to dock at Mir. Routine deliveries included new air conditioner and spare computer. Last of seven Americans to live aboard the Russian station, Thomas was a backup pressed into service after the STS-86 Wolf-for-Lawrence crew switch. Wilcutt and Dunbar were repeat visitors. During the mission senior government officials from 15 nations signed formal agreements for International Space Station Phase 2—assembly and operation—in Washington, D.C., and the first section, a Russian-built propulsion module, moved to its launch site in Kazakhstan.

STS-90

DATES APRIL 17- MAY 3, 1998

ORBITER *COLUMBIA*

CREW RICHARD SEARFOSS
SCOTT ALTMAN
RICHARD LINNEHAN
DAFYDD "DAVE" WILLIAMS (CANADA)
KATHRYN "KAY" HIRE
JAY BUCKEY
JAMES PAWELCZYK

MISSION NEUROLAB—LAST SPACELAB

Sixteenth flight since STS-9 in 1983 of the European-built Spacelab pressurized module, being phased out in anticipation of the International Space Station. Neurolab's 26 experiments examined how the nervous system develops and functions in weightlessness. Test subjects were crewmembers and more than 2,000 critters—rats, mice, crickets, snails, and fish. More than 40 rodents were dissected, with brains preserved by the first embalmings in space. More than 50 baby rats died of maternal neglect, and astronauts spent several sleepless nights nursing other newborns back to health. Hire was first Kennedy Space Center employee chosen to be an astronaut. A one-inch-square piece of aluminum tape saved *Columbia*'s 25th flight. Searfoss used it to plug a leaky valve in the orbiter's air purification system.

STS-91

DATES JUNE 2-12, 1998

ORBITER *DISCOVERY*

CREW CHARLES PRECOURT
DOMINIC GORIE
WENDY LAWRENCE
FRANKLIN CHANG-DIAZ
JANET KAVANDI
VALERY RYUMIN (RUSSIA)

DOWN ANDREW THOMAS

MISSION NINTH MIR DOCKING

Discovery's only visit to the Russian space station concluded the three-year series of 10 shuttle missions in preparation for joint missions aboard the International Space Station. From Norman Thagard (STS-71) to Thomas, seven Americans spent 977 days in space—907 aboard Mir. No television views of the mission, thanks to a Ku-band antenna system glitch—which also prevented data transmissions from Chang-Diaz's experiment seeking antimatter particles in cosmic radiation. Chang-Diaz broke astronaut Jeff Hoffman's cumulative shuttle duration record of 50 1/2 days. Global Positioning System satellites generated guidance information for *Discovery*'s main computers—a first for an occupied spacecraft. The crew was the first to phone home with a new satellite telephone system for space travelers. Launch marked debut of a super-lightweight metal alloy fuel tank, designed to increase payload capacity of shuttles flying to the ISS.

STS-95

DATES OCTOBER 29-NOVEMBER 7, 1998

ORBITER *DISCOVERY*

CREW CURTIS BROWN
STEVEN LINDSEY
SCOTT PARAZYNSKI
STEPHEN ROBINSON
PEDRO DUQUE (EUROPE)
CHIAKI MUKAI (JAPAN)
JOHN GLENN

MISSION JOHN GLENN RETURNS

More than 36 years after John Glenn became the first American to orbit Earth, the 77-year-old Mercury 7 pioneer returned to space as the world's oldest astronaut. His presence on *Discovery*'s 25th flight overshadowed most of the mission's work, including the redo of a botched two-day SPARTAN 201-05 solar telescope deployment from STS-87. Among 84 experiments: tests on

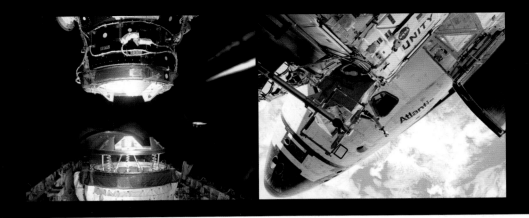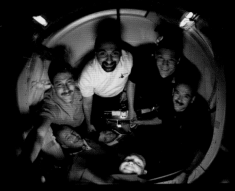

Glenn that compared the bodily effects of weightlessness with the aging process. Glenn volunteered as a payload specialist for geriatric studies to get the shuttle ride. Bill Clinton was in Florida to watch him fly—the first U.S. President to view a shuttle launch.

STS-88
DATES DECEMBER 4-15, 1998
ORBITER *ENDEAVOUR*
CREW ROBERT "MIGHTY DOG"
CABANA
FREDERICK "DEVIL DOG"
STURCKOW
NANCY "LAIKA" CURRIE
JERRY "HOOCH" ROSS
JAMES "PLUTO" NEWMAN
SERGEI "SPOTNIK" KRIKALEV
(RUSSIA)
MISSION ISS 2A — UNITY NODE

Linked the U.S. Unity node with the first component of the International Space Station, Russia's Zarya power, propulsion, and guidance module. First persons to enter the new outpost were Cabana and Krikalev, side by side on December 13. Using *Endeavour*'s robot arm, Currie plucked Zarya from orbit and stacked it on Unity in the cargo bay. Ross and Newman strung utility cables, mounted handrails, and raised Zarya's antennas in three spacewalks outside the station tower. Inside, Krikalev—who would return to the ISS on Expedition 1—helped crewmates make the coupled modules habitable. Sturckow undocked *Discovery* from Unity to depart the ISS. Third flight of a "dog crew" with Cabana from STS-53 and Newman from STS-69.

STS-96
DATES MAY 27-JUNE 6, 1999
ORBITER *DISCOVERY*
CREW KENT ROMINGER
RICK HUSBAND
ELLEN OCHOA
TAMARA JERNIGAN
DANIEL BARRY
JULIE PAYETTE (CANADA)
VALERY TOKAREV (RUSSIA)
MISSION ISS 2A.1—LOGISTICS

Launch postponed three weeks for fuel tank hail damage. First docking at a U.S. space station since Skylab. *Discovery* delivered clothing, drinking water, computers, tools and housekeeping supplies for occupants yet to arrive. Fighting headaches and nausea from stagnant air inside, the crew replaced batteries, fixed a communication system, and installed mufflers on noisy fans. Outside, Barry and Jernigan spacewalked to mount American and Russian construction cranes.

STS-93
DATES JULY 23-27 1999
ORBITER *COLUMBIA*
CREW EILEEN COLLINS
JEFFREY ASHBY
STEVEN HAWLEY
CATHERINE "CADY" COLEMAN
MICHEL TOGNINI
MISSION CHANDRA X-RAY
OBSERVATORY

First mission commanded by a woman, Collins. Despite a near-disastrous start, the crew successfully deployed NASA's third Great Observatory (STS-31, STS-37) on the first day. Launched on third try, *Columbia* leaked explosive hydrogen from a damaged main engine all the way to orbit. Damaged orbiter wiring

caused an unrelated electrical short that shut down primary controllers on two engines after liftoff. Backups worked, averting an engine shutdown that would have required an emergency landing. NASA grounded the fleet for wiring inspections and repairs.

STS-103
DATES DECEMBER 19-27, 1999
ORBITER *DISCOVERY*
CREW CURTIS BROWN
SCOTT KELLY
STEVEN SMITH
MICHAEL FOALE
JOHN GRUNSFELD
CLAUDE NICOLLIER
JEAN-FRANCOIS CLERVOY
(EUROPE)
MISSION THIRD HST SERVICING

Originally scheduled for June 2000. After three of the Hubble Space Telescope's six stabilizing gyroscopes failed, NASA split the mission in two and flew the first half early, rushing a crew to replace the gyros. Orbiter rewiring problems from STS-93 and propulsion system problems delayed launch two months. Mission shortened to avoid flying during Year 2000 transition. In three spacewalks crew restored Hubble (STS-31) to working order and upgraded some systems to begin a second decade of astronomical observations. Smith and Grunsfeld serviced solar panels and replaced gyroscopes, data transmitter, and data recorder. Foale and Nicollier upgraded a computer and fine guidance sensor. Hubble was released on shuttle's first Christmas in space.

STS-99
DATES FEBRUARY 11-22, 2000
ORBITER *ENDEAVOUR*
CREW KEVIN KREGEL
DOMINIC GORIE
JANET KAVANDI
JANICE VOSS
MAMORU MOHRI (JAPAN)
GERHARD THIELE (EUROPE)
MISSION SHUTTLE RADAR
TOPOGRAPHY MISSION

Endeavour made an unrivaled digital topographic database of Earth's surface in two wavelengths with a 200-foot radar mast extended from the cargo bay. SRTM was spearheaded by the Pentagon-associated National Imagery and Mapping Agency and NASA, with participation by Germany. Launch delayed four months by fleet-wide wiring concerns stemming from STS-93, and delayed further by an engine controller problem.

STS-101
DATES MAY 19-29, 2000
ORBITER *ATLANTIS*
CREW JAMES HALSELL
SCOTT "DOC" HOROWITZ
MARY ELLEN WEBER
JAMES VOSS
JEFFREY WILLIAMS
SUSAN HELMS
YURI USACHEV (RUSSIA)
MISSION ISS 2A.2a—MAINTENANCE

Mission to the idle International Space Station made urgent by Russia's repeated delays launching the Zvezda service module. First visitors in a full year included the crew of future Expedition 2. They fixed a degrading power system, tightened down a cargo crane installed on STS-96, and boosted

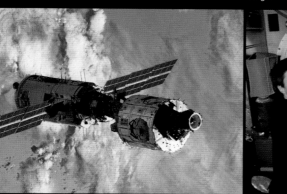

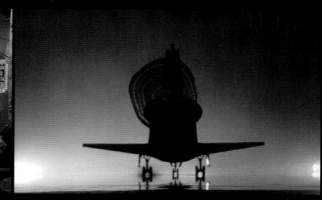

the ISS to higher altitude. Weeks of launch delays included one for Commander Halsell's sprained ankle. New "glass cockpit" updated *Atlantis'* instrument displays with commercial airliner technology. A one-man submarine, instead of divers, recovered spent solid rocket boosters from the Atlantic Ocean.

STS-106
DATES SEPTEMBER 8-20, 2000
ORBITER *ATLANTIS*
CREW TERRENCE WILCUTT
SCOTT ALTMAN
EDWARD LU
YURI MALENCHENKO (RUSSIA)
BORIS MORUKOV (RUSSIA)
RICHARD MASTRACCHIO
DANIEL BURBANK
MISSION ISS 2A.2b—LOGISTICS

Short call-up mission spun out of STS-101 included crewmembers bumped to accommodate Usachev, Voss, and Helms on the previous mission. ISS 2A.2b set up housekeeping for future Expedition 1, following the addition of the Zvezda service module and living quarters. Astronauts unloaded equipment from *Atlantis* and a Russian Progress cargo ship already docked. Among the items they installed: an oxygen generator, an air purifier, an exercise machine, and a toilet. In the shuttle program's 50th spacewalk, Lu and Malenchenko climbed to the top of the towering station to route cables between Zvezda and the Zarya control module. Shortest shuttle launch window to date, just two and a half minutes.

STS-92
DATES OCT 11-24, 2000
ORBITER *DISCOVERY*
CREW BRIAN DUFFY
PAMELA MELROY
LEROY CHIAO
WILLIAM MCARTHUR
PETER "JEFF" WISOFF
MICHAEL LOPEZ-ALEGRIA
KOICHI WAKATA (JAPAN)
MISSION ISS 3A—Z1 TRUSS, PMA 3

100th shuttle flight began construction of ISS power supply. First assembly mission since STS-88 attached another shuttle docking port (PMA 3) and framework (Z1 Truss) for U.S. solar arrays to come on the next mission, STS-97. Five mission specialists in four back-to-back spacewalks hooked up the new sections, added a U.S. high-speed antenna for science and television, and installed gyroscopes for attitude control. Rendezvous was tricky. *Discovery's* high-speed antenna broke, forcing Duffy to dock without radar. *Discovery* carried a swatch of fabric from the Wright Flyer and a vial of sand from Kitty Hawk, North Carolina.

STS-97
DATES NOVEMBER 30—DECEMBER 11, 2000
ORBITER *ENDEAVOUR*
CREW BRENT JETT
MICHAEL BLOOMFIELD
JOSEPH TANNER
CARLOS NORIEGA
MARC GARNEAU (CANADA)
MISSION ISS 4A—P6 TRUSS, PV6 SOLAR ARRAYS

Discovery delivered mail, fresh food and Christmas presents to the first occupants of the Inter-

national Space Station, named Alpha. The U.S. solar arrays and their associated framework dramatically increased the ISS size and capability. The new power source made all sections habitable and enabled future expansion. In three spacewalks, Tanner and Noriega bolted down the giant arrays with their associated electronics, batteries, radiators, and heaters. A close call during ascent when an explosive bolt in solid rocket booster separation system failed to fire; a backup likely saved the crew.

STS-98
DATES FEBRURARY 7-20, 2001
ORBITER *ATLANTIS*
CREW KENNETH COCKRELL
MARK POLANSKY
ROBERT CURBEAM
THOMAS JONES
MARSHA IVINS
MISSION ISS 5A—U.S. LABORATORY DESTINY

Launch delayed for solid rocket booster wiring inspection after STS-97. The addition of Destiny made the International Space Station more spacious than Russia's Mir. Ivins attached the U.S. laboratory with *Atlantis'* robot arm during a spacewalk by Curbeam and Jones, who hooked up power and cooling. Curbeam accidentally got sprayed with ammonia refrigerant and had to bake in the sun to evaporate toxic ice from his spacesuit before returning to the orbiter. Flight's third spacewalk was NASA's 100th. Milestone mission saw ISS guidance switch from Russian thrusters to solar-

powered U.S. gyroscopes, and ground control shift from Moscow to Houston.

STS-102
DATES MARCH 8-21, 2001
ORBITER *DISCOVERY*
CREW JAMES WETHERBEE
JAMES KELLY
ANDREW THOMAS
PAUL RICHARDS
UP JAMES VOSS
SUSAN HELMS
YURY USACHEV (RUSSIA)
DOWN BILL SHEPHERD
YURI GIDZENKO (RUSSIA)
SERGEI KRIKALEV (RUSSIA)
MISSION ISS 5A.1—FIRST CREW EXCHANGE

Second crew, Expedition 2, relieved a trio who occupied the International Space Station since November 1, 2000. Outgoing skipper Shepherd handed command to the first Russian, Usachev, March 19. Two spacewalks by four astronauts outfitted the U.S. laboratory added on the previous mission, STS-98, and prepped the outpost for future expansion. Multipurpose Logistics Module Leonardo—the first of three reusable cargo carriers from Italy—was attached to the ISS, unloaded, filled with trash and dirty laundry, and replaced in *Atlantis* for return to Earth. The shuttle-station complex had to swerve to avoid a clamp that got away during a spacewalk by Voss and Helms, who broke the spacewalk duration record set on STS-49 in 1992, installing a cradle for the Canadian robot arm. Landing capped 141 days in space for Expedition 1 crew.

BIBLIOGRAPHIC NOTE

Because this book focuses more on the experiences of shuttle astronauts than on the space shuttle vehicle or specific missions, readers may find themselves hungry for more detailed information on the Space Transportation System. Relatively few books—other than children's titles—have been written on the shuttle in its two decades of operation (at least compared to the number written about the earlier Mercury and Apollo programs). But several good ones do exist. For exhaustive technical detail, there is *Space Shuttle, The History of the National Space Transportation System*, by Dennis Jenkins. Apogee Books has published a series of NASA document collections, including a volume on the early orbital test flights, *Space Shuttle STS 1-5 : The NASA Mission Reports*, edited by Robert Godwin.

Several popular books published in the 1980s also stand out: Astronaut Joe Allen's *Entering Space*; former New Yorker writer Henry Cooper's *Before Lift-Off*, which goes behind the scenes of shuttle astronaut training; and *The Space Shuttle Operator's Manual* by Kerry Joels and Gregory Kennedy, which may be outdated, but includes many diagrams and drawings that put readers in the shuttle pilot's seat. A number of shuttle-era astronauts, many of them non-U.S. fliers, also have written or edited books for adults or children, including Jay Apt, Roberta Bondar, Reinhard Furrer, Umberto Guidoni, Jeffrey Hoffman, Tom Jones, Franco Malerba, Richard (Mike) Mullane, Bill Nelson, Rodolfo Neri-Vela, and Sally Ride.

NASA Historian Roger Launius has placed on the Web a helpful bibliography of articles, reports, and books about the shuttle at: www.hq.nasa.gov/office/pao/History/Shuttlebib/ cover.html. The Web is in fact the best place to go for detailed information about shuttle flights past, present, and future. Among the most useful sites are:

NASA Human Spaceflight Website:
 spaceflight.nasa.gov
Shuttle Mission Summaries:
 science.ksc.nasa.gov/shuttle/missions
Shuttle Press Kits (for current missions):
 www.shuttlepresskit.com

Links to these and other information resources on the shuttle can be found at the *Air & Space/Smithsonian* website at www.airspacemag.com.

STORY SOURCES

Loren Acton (Tony Reichhardt interview, 10/9/00); Andy Allen (Beth Dickey interview, 4/25/01); Sultan bin Salman Al-Saud (TR interview, 9/28/00); Dan Barry (written submission); John Blaha (written submission); Guy Bluford (TR interview, 8/11/00); Charlie Bolden (BD interview, 11/22/00); Roberta Bondar (written submission); Dan Brandenstein (BD interview, 8/2/00); Roy Bridges (written submission); Jim Buchli (BD interview, 1/12/01); Bob Cabana (BD interview, 11/16/00); Bob Cenker (TR interview, 9/12/00); Franklin Chang-Diaz (BD interview, 1/12/01); Kalpana Chawla (written submission); Rich Clifford (Linda Shiner interview, 8/2/00); Mike Coats (BD interview, 6/12/01); Ken Cockrell (BD interview, 11/16/00); Eileen Collins (BD interviews, 1/23/01 and 1/29/01); Bob Crippen (written submission and TR interview, 8/21/00); Roger Crouch (written submission); Brian Duffy (BD interview, 8/6/01); Joe Edwards (TR interview, 9/7/00); Mike Foale (BD interview, 1/12/01); Gordon Fullerton (TR interview, 7/25/00); Jake Garn (written submission); Hoot Gibson (written submission and BD interview, 6/4/01); John Glenn (BD interview, 10/26/00); Linda Godwin (BD interview, 1/12/01); Sid Gutierrez (written submission); Bernard Harris (TR interview, 8/21/00); Rick Hauck (written submission); Susan Helms (BD interview, 11/19/00); Tom Henricks (BD interview, 10/22/00); Rick Hieb (BD interview, 8/31/00); Millie Hughes-Fulford (written submission and TR interview, 9/11/00); Rick Husband (written submission); Tammy Jernigan (BD interview, 11/16/00); Tom Jones (BD interview, 3/1/01); Janet Kavandi (written submission); Scott Kelly (Eric Adams interview, 9/13/00); Fred Leslie (written submission); Jerry Linenger (BD interview, 8/16/00); Rick Linnehan (TR interview, 4/12/01); Michael Lopez-Alegria (TR interview, 12/15/00); Jack Lousma (TR interview, 5/8/01); Franco Malerba (written submission); Mike McCulley (BD interview, 11/15/00); Mamoru Mohri (written submission); Mike Mullane (written submission); Story Musgrave (BD interview, 12/1/00); Steve Nagel (BD interview, 9/6/00); Bill Nelson (BD interview, 12/17/00); Pinky Nelson (BD interview, 5/23/01); Jim Newman (written submission); Carlos Noriega (TR interview, 1/8/01); Steve Oswald (TR interview, 11/6/00); Scott Parazynski (written submission and TR interview, 1/8/01); Jim Pawelczyk (written submission); Gary Payton (John Sotham interview, 8/28/00); Charlie Precourt (BD interview, 6/14/01); Ken Reightler (written submission); Mario Runco (BD interviews, 1/17/01 and 2/22/01); Rhea Seddon (TR interview, 8/3/00); Brewster Shaw (BD interview, 3/1/01); Loren Shriver (BD interview, 1/12/01); Kathy Sullivan (written submission and BD interview, 8/11/00); Norm Thagard (Eric Adams interview, 8/10/00); Pierre Thuot (BD interview, 10/26/00); Jim Voss (BD interview, 11/20/00); Charlie Walker (written submission); Taylor Wang (Daniel Weidinger interview, 7/25/00); Terry Wilcutt (BD interview, 11/14/00); Dave Williams (TR interview, 12/12/00); Jeff Wisoff (BD interview, 11/17/00); Dave Wolf (written submission); John Young (BD interview, 5/9/01).

ACKNOWLEDGMENTS

Scott Norr, Maura White, Mary Wilkerson, Warren Harold, Larry Jefferson, and the rest of the staff in the Imagery Sciences Branch at NASA's Johnson Space Center (JSC) went to heroic lengths to support us in our photo research, and digitally scanned and processed close to 2,000 space shuttle images specifically for this book. Thanks also to Richard Slater of the Imagery Sciences Branch and to Marsha Ivins of the Astronaut Office for their participation in this project, which turned out to be bigger than any of us had expected.

Various people in NASA Public Affairs, both at Headquarters in Washington, D.C., and at the Johnson Space Center, helped facilitate photo research and interviews, notably Brian Welch, Steve Nesbitt, Doug Peterson, and Lucy Lytwynsky. Mike Gentry at JSC, Margaret Persinger at the NASA Kennedy Space Center in Florida, and Gayle Bonish at IMAX were also extremely helpful in providing photos.

Valuable editorial assistance came from Kathleen McCarthy, and also from Daniel Weidinger, Frances Jackson, Joanne Pischiera, and Michele Skroch. Lloyd Behrendt provided research assistance.

Others who helped, gave advice, or read some or all of the manuscript: Scott Andrews, Bernard Reichhardt, Terry Reichhardt, Kathy Sullivan, Glen Swanson, Tom Usciak, and Charlie Walker.

Finally, most of the credit for this book goes to the space shuttle astronauts, current and former, who kindly shared their stories with us.

The Challenger Center for Space Science Education

A percentage of the proceeds from this book will go to support the Challenger Center for Space Science Education, a global, not-for-profit education organization created in 1986 by the families of the astronauts tragically lost during the last flight of the *Challenger* space shuttle. Dedicated to the educational spirit of that mission, Challenger Center develops Learning Centers and other educational programs worldwide to continue the mission to engage students in science and math education. Challenger Center's network of Learning Centers throughout the United States, Canada, and the United Kingdom has been a recognized leader in educational simulation, with a strong standards-based emphasis. Challenger Learning Centers and Challenger Center's award-winning classroom and teacher training programs all use the excitement of space exploration to create positive learning experiences that:

- Raise students' expectations of success;
- Foster in them a long-term interest in math, science, and technology;
- Help them develop critical communication, decision-making, team-building, and collaborative skills.

For more information, visit the Challenger Center website at www.challenger.org

Photo Credits

All photos NASA except:
Scott Andrews: pages 132-35, 136 (right), 137-141, 143, 146, 149, 150, 153
IMAX: page 36: © 1995 Smithsonian Institution/Lockheed Martin Corporation. From the IMAX® film "Blue Planet" page 95 (bottom): © 1995 NASA. From the IMAX film "Mission To MIR" page 222 (top): © 1995 NASA. From the IMAX film "Mission To MIR" page 301 (left): © 1989 Smithsonian Institution/Lockheed Martin Corporation. From the IMAX® film "Blue Planet"
Jon Schneeberger: page 21 (right)
National Oceanic and Atmospheric Administration: page 59 (top)
Joe McNally, *National Geographic* (for NASA): pages 105, 124

Smithsonian Institution

A visit to the Smithsonian's 16 museums and galleries or the National Zoo is an adventure into the world's largest museum complex. The Smithsonian Institution holds more than 140 million artifacts and specimens in trust for the American people. The Institution, also a center for research, is dedicated to public education, national service, and scholarship in the arts, sciences, and history.

Air & Space/Smithsonian magazine is published bimonthly in association with the National Air and Space Museum in Washington, D.C., the world's most visited museum. The magazine brings the excitement of aviation and space exploration to a non-technical readership, and is known for vivid, true-to-life portraits of pilots and astronauts at work.

Subscription Information: U.S. and possessions: $24 a year payable in U.S. funds. Canada and all other countries: add $6 (U.S. dollars). For subscription orders, write to *Air & Space/Smithsonian*, PO Box 420113, Palm Coast FL 32142-0113, or call 1-800-766-2149. Outside U.S., call 1-386-445-4662. *Air & Space* editorial offices: 750 9th St. NW, 7th Floor, Washington DC 20001. Website: www.airspacemag.com

Space Shuttle: The First 20 Years

EDITOR
Tony Reichhardt

LEAD INTERVIEWER
Beth Dickey

DESIGN
Bill Marr, Open Books, LLC
Jamie Sims
Melissa Farris

SPACE SHUTTLE FLIGHT SUMMARIES
Beth Dickey

SPACE TRANSPORTATION SYSTEM APPENDIX
Eric Adams

Staff, Air & Space/Smithsonian Magazine

EDITOR
George C. Larson

EXECUTIVE EDITOR
Linda Musser Shiner

SENIOR EDITOR
Patricia Trenner

SENIOR ASSOCIATE EDITOR
Perry Turner

ASSOCIATE EDITORS
Eric Adams
John Sotham
Diane Tedeschi

CONSULTING EDITOR
Tony Reichhardt

PHOTOGRAPHY/ILLUSTRATION
Caroline Sheen

GRAPHIC DESIGN
Ted Lopez, Eason Associates, Inc.

PRODUCTION ASSISTANT
Frank Matthew Hale II

Staff, DK Publishing

PUBLISHER
Sean Moore

CREATIVE DIRECTOR
Tina Vaughan

ART DIRECTOR
Dirk Kaufman

EDITORIAL DIRECTOR
Chuck Wills

PRODUCTION MANAGER
Chris Avgherinos

DTP MANAGER
Russell Shaw

LONDON, NEW YORK, MUNICH, MELBOURNE, and DELHI

Published in the United States by
DK Publishing, Inc.
95 Madison Avenue
New York, New York 10016

00 01 02 03 04 05 10 9 8 7 6 5 4 3 2 1

A catalog record for this title is available from the Library of Congress.

ISBN 0-7894-8425-0

The stories by Kalpana Chawla on p. 173 and Mike Mullane on p. 135 first appeared in different form in *Air & Space/Smithsonian* magazine. A longer version of the account by Jim Pawelczyk on p. 139 originally appeared in *The Penn Stater*, the Penn State alumni magazine. The story by Dave Wolf on p. 253 was originally published on the Web in a collection of Wolf's "Letters Home" from Mir. The story by Franco Malerba on page 159 is from his book, *La Vetta* (The Summit), and is used by permission.

DK Publishing offers special discounts for bulk purchases for sales promotions or premiums. Specific, large-quantity needs can be met with special editions, including personalized covers, excerpts of existing guides, and corporate imprints. For more information, contact Special Markets Department, DK Publishing, Inc., 95 Madison Avenue, New York, NY 10016 Fax: 800-600-9098.

Printed and bound in Spain by Artes Graficas Toledo S.A.

See our complete product line at www.dk.com